AN ILLUSTRATED HISTORY OF
EQUESTRIAN SPORTS

Editorial Directors: Gaëlle Lassée and Kate Mascaro
Editors: Sam Wythe and Helen Adedotun, assisted
by Valentine Ferrante
Translated from the French by Elizabeth Heard,
Philippa Hurd, and Kate Ferry-Swainson
Design and Typesetting: Alice Leroy
Copyediting: Penelope Isaac and Lindsay Porter
Proofreading: Sam Wythe
Production: Titouan Roland
Color Separation: Bussière, Paris
Printed in Spain by Indice

Simultaneously published in French as
Anthologie des sports équestres
© Flammarion, S.A., Paris, 2019

English-language edition
© Flammarion, S.A., Paris, 2019

19 20 21 3 2 1
ISBN: 978-2-08-020391-5
Legal Deposit: 09/2019

AN ILLUSTRATED HISTORY OF
EQUESTRIAN SPORTS

DRESSAGE · JUMPING · EVENTING

Marie de Pellegars-Malhortie and Benoit Capdebarthes

Flammarion FEI

Contents

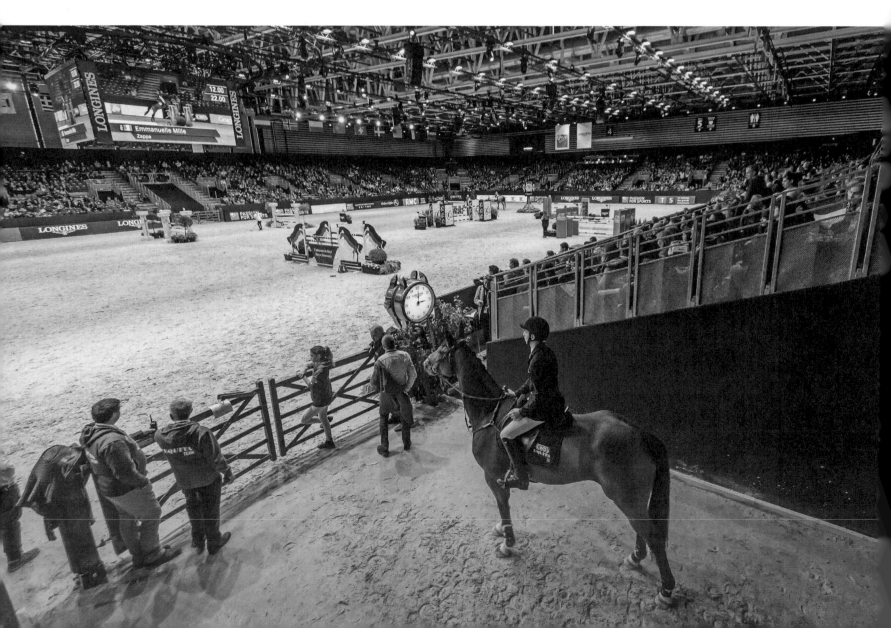

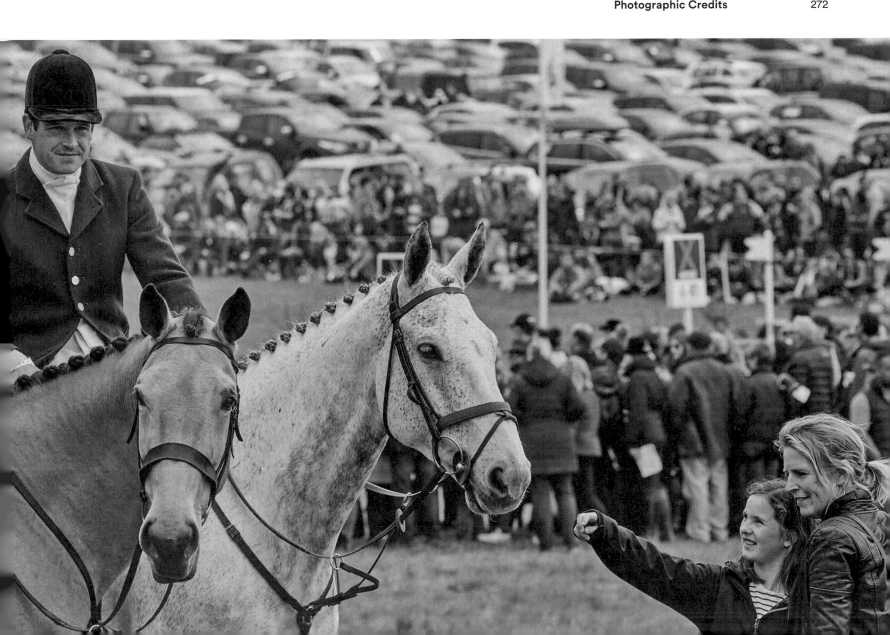

Presidents of the FEI

Baron du Teil
1921–27

Baron du Teil became a member of the Société Hippique Française (SHF, or French Equestrian Society) in 1879. He was elected to the SHF bureau in 1886 and served as its president from 1902 to 1933. From 1921 to 1931 he was the first president of the French Equestrian Federation. He attended the military academy of Saint-Cyr and was promoted to the rank of colonel in World War I. Baron du Teil died on June 29, 1933, in Paris.

General Gerrit Johannes Maris
1927–29

General Gerrit Johannes Maris was born on September 22, 1868, in Klundert. In 1923 he was one of the founders of the Dutch Equestrian Federation. He served as its president from 1923 to 1929. He was also president of the organizing committee for equestrian events at the 1928 Olympic Games. In 1902 he placed tenth in the famous endurance ride at Brussels Ostend. He was promoted to the rank of major general (cavalry). General Maris died on 25 July, 1938, in Breda.

Major Jhr. Karel F. Quarles van Ufford
1929–31, 1936–39

Jhr. Karel F. Quarles van Ufford was born on November 4, 1880, in Loosduinen and was president of the Dutch Equestrian Federation from 1929 to 1940. He was a successful competitor in national events in jumping and eventing, and was a member of the ground juries at the Olympic Games of 1924, 1928, and 1936. He was secretary of the organizing committee for equestrian events at the 1928 Olympic Games. He was also promoted to lieutenant colonel of the mounted artillery. Quarles van Ufford died on March 19, 1942, in The Hague.

General Guy V. Henry
1931–35

General Guy V. Henry was born on January 28, 1880, in an army tent in the Red Cloud Indian Territory, Nebraska. He was a member of the US Army team at the 1912 Olympic Games in Stockholm, where he competed in all three equestrian disciplines and received a bronze medal for eventing. He was a veteran of three wars and chief of US Calvary from 1930 to 1934. General Henry retired in 1947 as major general. He was also president of the organizing committee for equestrian events at the 1932 Olympic Games and was a member of the ground jury for the 1936 Olympic Games. General Henry died on November 29, 1967, in Wenatchee, Washington.

General Baron Max von Holzing-Berstett
1935–36

Baron Max von Holzing-Berstett was born on January 1, 1867, in Karlsruhe and had a prominent army career with the dragoons, the imperial guard, and the uhlans. From 1909 to 1914 he served as aide-de-camp to Emperor Wilhelm II. He was promoted to major general in World War I. He rode nationally and was influential in shaping the riding style in the Imperial Army. He also served as a member of the ground jury at the 1928 Olympic Games. Baron von Holzing-Berstett died on September 9, 1936, in Freiburg.

Magnus Rydman
1939–46

Magnus Rydman was born on November 8, 1891. He was the managing director of the Ford Corporation from 1936 to 1956, and president of the National Federation of Finland from 1935 to 1946 and again from 1948 to 1952. He was a member of the Finnish National Olympic Committee from 1938 to 1953 and was elected president of the FEI at the last FEI Congress before World War II, on April 4, 1939. Magnus Rydman died on June 3, 1970, in Helsinki.

General Baron Gaston de Trannoy
1946–54

Baron Gaston de Trannoy was born on October 18, 1880. He had an army career in the guides and was promoted to general. He competed in the 1912 Olympic Games in all three equestrian disciplines, and in the 1920 Games placed seventh in dressage. Baron Gaston de Trannoy was president of the Belgian Royal Equestrian Sports Federation from 1932 to 1954 and was a member of the organizing committee for equestrian events at the 1920 Olympic Games. He was also a member of the ground jury at four Olympic Games (1924, 1928, 1936, and 1956). Baron Gaston de Trannoy died on December 22, 1960, in Villers-la-Ville.

HRH Prince Bernhard of the Netherlands
1954–64

Prince Bernhard of the Netherlands was born on June 29, 1911, in Woynowo, Brandenburg (in present-day Poland). In 1937 he married Princess (later Queen) Juliana of the Netherlands. He spent two years at the Netherlands Cavalry School training in dressage and jumping. He was an active competitor both nationally and internationally in jumping, dressage, and eventing, and was a member of the Dutch national jumping team in Het Zoute. At several Olympic Games he served as a member of the appeals jury. He was for many years president of the World Wildlife Fund.

HRH Prince Philip, Duke of Edinburgh
1964–86

Prince Philip, Duke of Edinburgh was born on June 10, 1921, on Corfu, Greece. He was educated in the United Kingdom and was active in cricket, hockey, rowing, and sailing; he also had a naval career from 1939 to 1951, in which he served as lieutenant commander. In 1947 he married Princess (later Queen) Elizabeth. Prince Philip was an excellent polo player and took up four-in-hand driving when it became an FEI discipline in the early 1970s. He competed in six World Championships and three European Championships, and placed sixth individually in the 1982 World Championships. He was a member of the British gold medal team at the 1980 World Championships and the British bronze medal teams at the 1978, 1982, and 1984 World Championships. Prince Philip was UK president of the World Wildlife Fund from 1961 to 1982, international president from 1981, and president emeritus from 1996.

HRH Anne, Princess Royal
1986–94

Anne, Princess Royal, was born on August 15, 1950, and is the daughter of Queen Elizabeth II and Prince Philip, Duke of Edinburgh. Riding since the age of three, the princess took part in her first eventing competition in 1970. She was the European eventing champion in 1971 at Burghley on Doublet, and was a member of the silver medal team and placed second individually in the 1975 European Championships at Luhmühlen on her mount Goodwill. She also competed in the 1973 European Championships, the 1974 World Championships, and the 1976 Olympic Games. She was president of the British Olympic Association (NOC). Princess Anne is the patron of Riding for the Disabled, president of the Save the Children Fund, and patron of the World Breeding Federation for Sport Horses.

HRH The Duchess of Badajoz
1994–2006

Pilar de Borbón, Duchess of Badajoz, the daughter of Infante Juan, Count of Barcelona, and Princess María Mercedes of Bourbon-Two Sicilies, was born in 1936 and subsequently lived in Italy, Switzerland, and Portugal. In Portugal, she obtained her nursing diploma and practiced her profession for three years in various hospitals. She speaks six languages fluently. She is actively involved in several charities: the Red Cross, Friends of the Monasteries, Foundation for the Defense of Life, Nuevo Futuro, Action Aid, and the Foundation for Investigation and Training in Oncology, as well as other institutions of cultural interest. She is honorary president of the Spanish Equestrian Federation and member of the Spanish Olympic Committee. From an early age, she has been involved with equestrian activities alongside her mother and brothers. During her youth in Portugal, she took part in various local horse shows. In Spain, she presided and promoted eventing for beginners as well as numerous other equestrian events. Her Royal Highness was elected member of the International Olympic Committee in 1996.

HRH Princess Haya Bint Al Hussein
2006–14

HRH Princess Haya became the thirteenth FEI president on May 1, 2006, and was re-elected to serve a second term in November 2010. Many important developments and initiatives came to fruition during and after her presidency, from the commercial aspects of sponsorship and broadcasting to the far-reaching campaigns of Clean Sport and FEI Solidarity. HRH Princess Haya was elected to the IOC in 2007 and served until 2014. She also served on the IOC Athletes' Commission (2005–10) and on the Commission for Culture and Olympic Education. In June 2010 she became a global patron for the World Academy of Sport. At age thirteen, HRH Princess Haya was the first woman to represent Jordan internationally in an equestrian sport, in jumping. She won an individual bronze medal in the Pan-Arab Equestrian Games in 1992, and is the only woman ever to have won a Pan-Arab medal in equestrian sport. In 2000, HRH Princess Haya fulfilled a lifelong dream by competing at the Sydney Olympic Games in jumping, and two years later competed for Jordan in the FEI World Equestrian Games in Jérez de la Frontera, Spain, making her the first Arab woman to qualify for and compete in equestrian sport at Olympic, world, and continental championship level.

Ingmar De Vos
2014–

Ingmar De Vos was elected president of the FEI by an overwhelming majority in the first round of voting at the FEI General Assembly 2014 held in Baku, Azerbaijan and re-elected for a second term in 2018. His presidential manifesto, presented in 2014 and reiterated in 2018, focused on five main pillars: "Serving our community," "Sport: our core business," "Equestrian Sport in the Olympic and Paralympic Games," "FEI Solidarity," and "Horses as our Partners." De Vos holds degrees in political science, business administration, and international and European law, and is fluent in Dutch, English, and French. He started his career as an advisor to the Belgian Senate. He joined the Belgian Equestrian Federation as managing director in 1990 and was also secretary general from 1997 to 2011. While there, De Vos was chef de mission for the Belgian equestrian team at all FEI World Equestrian Games from 1990 to 2010 and at several Olympic Games. He was also secretary general of the European Equestrian Federation from 2010, the year it was formed, until 2011, when he joined the FEI as secretary general. A member of the Belgian National Olympic Committee, he was elected an IOC member in September 2017 and was appointed to the Global Association of International Sports Federations (GAISF) Council, serving as the GAISF representative on the World Anti-Doping Agency Executive Committee. In 2019 he was elected onto the council of the Association of Summer Olympic International Federations.

Foreword

I am delighted to introduce this beautiful retrospective on equestrian sports, a journey through time and around the world, celebrating the very best human and equine athletes as well as the twists and turns that have built our sport into the vibrant industry it is today.

It is wonderful to have a book of this elegance focusing on and delving deep into the characters and the atmosphere of each and every major event since the first appearance of equestrian sports at the Stockholm 1912 Olympic Games to the FEI World Equestrian Games 2018 in Tryon, USA.

Flammarion and the authors of this book—Benoit Capdebarthes and Marie de Pellegars-Malhortie—have been uncompromising in their approach, faithfully researching and reviving memories and anecdotes that had long been forgotten.

These stories and images reveal just how far the sports have come in one hundred years and, importantly, how far we have come as a society. The inclusion of women in dressage in the Olympic Games in 1952 was a revolutionary moment. Women competing alongside men on a completely equal footing was unthought-of at the time, and today it is one of our unique values as a sport, but it's important not to forget that gender equality was hard fought for and did not happen overnight. It took another four years for women to be allowed to compete alongside men in the jumping events, and it was not until 1964 that women were permitted to compete in eventing at the Olympic Games. Yet today, when you attend an event, when you look at the results at Olympic, World, and European Championships, it is hard to imagine there was ever a time when this was not the case.

And we should never forget where we came from. This is why retracing the sport is so important and why the FEI was delighted to partner with Flammarion on this wonderful publication: sport is about life and culture—it represents who we are, and it can sometimes push us as a society to new heights.

It's wonderful to be able to retrace history in such an elegant and thoughtful way, and I am sure equestrians, historians, and anyone who appreciates beauty, style, and our ability to evolve will revel in every detail of this book. Happy browsing!

Ingmar De Vos
FEI President

Introduction

As a magical hybrid, half horse and half human, the centaur of classical mythology is an excellent symbol of the powerful and inextricable bond that unites these two species. The abiding relationship between humans and horses has undergone many changes over the centuries, however.

In 776 BCE, when the first Olympic Games were held in ancient Greece, horses and men performed together in chariot races, including the legendary four-horse *quadriga*. As the form taken by these games gradually evolved, equestrian competitions began to take place in vast hippodromes. But the Christian emperor Theodosius's decree banning the observance of pagan cults in 393 CE put an end to such spectacles, and the horse was relegated to its original utilitarian functions in transportation, agriculture, and warfare.

By the middle of the 1800s, some fifteen centuries later, horses were ubiquitous in both military and civilian life. They were still used for transportation and farming, but horse-breeding itself had also developed into a lucrative business. Horses featured prominently in agricultural fairs, where they were evaluated, judged, and awarded prizes according to their appearance. Enthusiasts promoted the distinctive qualities of various breeds and organized jumping competitions. In 1865, the earliest show-jumping contests were held in Dublin.

During the decades that followed, the concept of horse riding as a competitive sport received a boost from French historian and thinker Baron Pierre de Coubertin's plans for a modern version of the Olympic Games, announced in 1892. Although horses were absent from the first modern Olympic Games, organized in Athens in 1896, the second edition, held in Paris in 1900 during the Exposition Universelle, did include horse riding. These equestrian competitions were generally ignored, however, and were not even mentioned in the minutes of the International Olympic Committee. Nonetheless, they included several disciplines: a show-jumping Grand Prix, both long and high jumping events, and two additional contests in "hunting" and carriage racing. At the 1912 Stockholm Olympics, riders received medals for the first time, thanks to the insistence of the host nation, a country devoted to equestrian sports. At this stage only military officers were eligible to compete.

Industrialization and the advent of the automobile gave riding a new cachet. Horses became valued companions in both leisure and sporting activities. Over time, three distinct disciplines emerged: dressage, show jumping, and the so-called "Military," which developed into cross country. Riding was now recognized as a sport in its own right. Junior officers and civilians began to circumvent established regulations, increasingly challenging the exclusionary policy that limited participation in the Olympic Games to officers. Women were emboldened to display their own equestrian capabilities.

Equestrian sports proliferated, as more and more people took them up. There was an obvious need to establish regulations on an international level that would govern the many competitions and, most of all, the Olympics. Guidelines had to be adapted to changing circumstances and evolving practices. The Fédération Équestre Internationale (FEI) was established in 1921 as a governing body charged with ensuring regulatory consistency on qualifications and procedures. The FEI subsequently instituted the European and World Championships for each of the three main disciplines.

Today, any rider looking to gain an Olympic, World, or European title has an extremely challenging path ahead of them. It demands exceptional talent and unstinting dedication. These coveted awards are highly sought-after, even though champions rarely earn substantial financial rewards, even after attaining recognition. Although the digital era offers extraordinary potential, it does not facilitate a comprehensive understanding of the careers of the men and women who have shaped equestrian sports. We felt that it was of the utmost importance, therefore, that someone should collect the life stories that no search engine can ever reveal. We have written this book as a recognition and celebration of these athletes, and we hope that our work will make their achievements readily accessible to a wider audience. Listing the total number of medals won by every athlete, we have selected the top riders of each decade in each discipline, and lingered over the careers of the true champions. As we study these biographies, it becomes apparent that each of these exceptional riders has a touch of madness, a hint of genius, deep resolve, a singular gift, and the tenacity to overcome every challenge. We have also highlighted the top trophy-winning horse for each decade. Finally, by recounting the development of the sport through anecdotes and reminiscences, we hope to give readers a sense of participating in every great equestrian contest since the Stockholm Olympics of 1912.

Marie de Pellegars-Malhortie
and Benoit Capdebarthes

1912–1948

RESULTS 1912–1948

1912
♣ OLYMPIC GAMES, STOCKHOLM

DRESSAGE
GOLD Carl Gustaf Bonde (SWE) and Emperor
SILVER Gustaf Adolf Boltenstern (SWE) and Neptun
BRONZE Hans von Blixen-Finecke (SWE) and Maggie

JUMPING
— *Individual*
GOLD Jacques Cariou (FRA) and Mignon
SILVER Rabod Wilhem von Kröcher (GER) and Dohna
BRONZE Emmanuel de Blommaert de Soye (BEL) and Clonmore
— *Team*
GOLD Sweden: Carl Gustaf Lewenhaupt (Medusa), Gustaf Kliman (Gätan), Hans von Rosen (Lord Iron), and Fredrik Rosenkrantz (Drabant)
SILVER France: Pierre Dufour d'Astafort (Amazone), Jacques Cariou (Mignon), Bernard Meyer (Allons-y), and Gaston Seigner (Cocotte)
BRONZE Germany: Sigismund Freyer (Ultimus), Wihlem von Hohenau (Pretty Girl), Ernst Deloch (Hubertus), and Friedrich Karl von Preussen (Gibson Boy)

EVENTING
— *Individual*
GOLD Axel Nordlander (SWE) and Lady Artist
SILVER Harry von Rochow (GER) and Idealist
BRONZE Jacques Cariou (FRA) and Cocotte
— *Team*
GOLD Sweden: Axel Nordlander (Lady Artist), Nils Adlercreutz (Atout), Ernst Casparsson (Irmelin), and Henric Horn af Åminne (Omen)

SILVER Germany: Harry von Rochow (Idealist), Richard von Schaesberg (Grundsee), Eduard von Lütcken (Blue Boy), and Carl von Moers (May Queen)
BRONZE United States: Benjamin Lear (Poppy), John Montgomery (Deceive), Guy Henry (Chiswell), and Ephraim Graham (Connie)

1920
♣♣ OLYMPIC GAMES, ANTWERP

DRESSAGE
GOLD Janne Lundblad (SWE) and Uno
SILVER Bertil Sandström (SWE) and Sabel
BRONZE Hans von Rosen (SWE) and Running Sister

JUMPING
— *Individual*
GOLD Tommaso Lequio di Assaba (ITA) and Trebecco
SILVER Alessandro Valerio (ITA) and Cento
BRONZE Carl Gustaf Lewenhaupt (SWE) and Mon Coeur
— *Team*
GOLD Sweden: Claës König (Tresor), Hans von Rosen (Poor Boy), Daniel Norling (Eros II), and Frank H. Martin (Kohort)
SILVER Belgium: Henri Laame (Biscuit), André Coumans (Lisette), Herman de Gaiffier (Miss), and Herman d'Oultremont (Lord Kitchener)
BRONZE Italy: Ettore Caffaratti (Traditore), Alessandro Alvisi (Raggio di Sole), Giulio Cacciandra (Fortunello), and Carlo Asinari di San Marzano (Varone)

EVENTING
— *Individual*
GOLD Helmer Mörner (SWE) and Germania
SILVER Åge Lundström (SWE) and Ysra
BRONZE Ettore Caffaratti (ITA) and Caniche
— *Team*
GOLD Sweden: Helmer Mörner (Germania), Åge Lundström (Yrsa), Georg von Braun (Diana), and Gustaf Dyrsch (Salamis)
SILVER Italy: Ettore Caffaratti (Caniche), Garibaldi Spighi (Otello), Giulio Cacciandra (Facetto), and Carlo Asinari di San Marzano (Savari)
BRONZE Belgium: Roger Moeremans d'Emaüs (Sweet Girl), Oswald Lints (Martha), Jules Bonvalet (Weppelghem), and Jacques Misonne (Gaucho)

1924
♣♣♣ OLYMPIC GAMES, PARIS

DRESSAGE
GOLD Ernst von Linder (SWE) and Piccolomini
SILVER Bertil Sandström (SWE) and Sabel
BRONZE Xavier Lesage (FRA) and Plumarol

JUMPING
— *Individual*
GOLD Alphonse Gemuseus (SUI) and Lucette
SILVER Tommaso Lequio di Assaba (ITA) and Trebecco
BRONZE Adam Królikiewicz (POL) and Picador
— *Team*
GOLD Sweden: Ake Thelning (Loke), Axel Stähle (Cecil), Åge Lundström (Anvers), and Georg Von Braun (Diana)
SILVER Switzerland: Alphonse Gemuseus (Lucette), Werner Stuber (Girandole), Hans E. Bühler (Sailor Boy), and Henri von der Weid (Admiral)

BRONZE Portugal: António Borges de Almeida (Reginald), Hélder de Souza Martins (Avro), José Mouzinho de Albuquerque (Hetrugo), and Luis de Menezes Margaride (Profond)

EVENTING
— *Individual*
GOLD Adolf van der Voort van Zijp (NED) and Silver Piece
SILVER Frode Kirkebjerg (DEN) and Metoo
BRONZE Sloan Doak (USA) and Pathfinder
— *Team*
GOLD Netherlands: Adolf van der Voort van Zijp (Silver Piece), Charles Pahud de Mortanges (Johnny Walker), Gerard de Kruijff (Addio), and Anton Colenbrander (King-of-Hearts)
SILVER Sweden: Claës König (Bojar), Torsten Sylvan (Anita), Gustaf Hagelin (Varius), and Carl Gustaf Lewenhaupt (Canter)
BRONZE Italy: Alberto Lombardi (Pimplo), Alessandro Alvisi (Capiligio), Emmanuele Beraudio di Pralermo (Mount Felix), and Tommaso Lequio di Assaba (Torena)

1928
♣♣ OLYMPIC GAMES, AMSTERDAM

DRESSAGE
— *Individual*
GOLD Carl-Friedrich von Langen (GER) and Draufgänger
SILVER Pierre Marion (FRA) and Linon
BRONZE Ragnar Olson (SWE) and Günstling
— *Team*
GOLD Germany: Carl-Friedrich von Langen (Draufgänger), Hermann Linkenbach (Gimpel), and Eugen von Lotzbeck (Caracalla)
SILVER Sweden: Ragnar Olson (Günstling), Janne Lundblad (Blackmar), and Carl Gustaf Bonde (Ingo)

BRONZE Netherlands: Jan Hermannus van Reede (Hans), Pierre Versteegh (His Excellence), and Gerhard le Heux (Valerine)

JUMPING
— *Individual*
GOLD František Ventura (TCH) and Eliot
SILVER Pierre Bertran de Balanda (FRA) and Papillon XIV
BRONZE Charles Kuhn (SUI) and Pepita
— *Team*
GOLD Spain: José Navarro Morenes (Zapataso), Julio García Fernández (Revistado), and Marquez de los Trujillos (Zalamero)
SILVER Poland: Kazimierz Gzowski (Mylord), Kazimierz Szosland (Ali), and Michael Antoniewicz (Readgleadt)
BRONZE Sweden: Karl Hansén (Gerold), Carl Björnstierna (Kornett), and Ernst Hallberg (Loke)

EVENTING
— *Individual*
GOLD Charles Pahud de Mortanges (NED) and Marcroix
SILVER Gerald de Kruyff (NED) and Va-t-en
BRONZE Bruno Neumann (GER) and Ilja
— *Team*
GOLD Netherlands: Charles Pahud de Mortanges (Marcroix), Gerard de Kruyff (Va-t-en), and Adolf van der Voort van Zijp (Silver Piece)
SILVER Norway: Bjart Ording (And Over), Arthur Quist (Hidalgo), and Eugen Johansen (Baby)
BRONZE Poland: Michal Antoniewicz (Moja Mila), Józef Trenkwald (Lwi Pazur), and Karol von Rómmel (Doneuse)

1932
♣♣♣ OLYMPIC GAMES, LOS ANGELES

DRESSAGE
— *Individual*
GOLD Xavier Lesage (FRA) and Taine
SILVER Pierre Marion (FRA) and Linon
BRONZE Hiram E. Tuttle (USA) and Olympic
— *Team*
GOLD France: Xavier Lesage (Taine), Pierre Marion (Linon), and André Jousseaume (Sorella)
SILVER Sweden: Bertil Sandström (Kreta), Thomas Byström (Gulliver), and Gustaf Adolf Boltenstern (Ingo)
BRONZE United States: Hiram E. Tuttle (Olympic), Isaac Kitts (American Lady), and Alvin Moore (Water Pat)

JUMPING
— *Individual*
GOLD Takeichi Nishi (JPN) and Uranus
SILVER Harry Chamberlin (USA) and Show Girl
BRONZE Clarence von Rosen (SWE) and Empire
No teams completed the competition.

EVENTING
— *Individual*
GOLD Charles Pahud de Mortanges (NED) and Marcroix
SILVER Earl Foster Thomson (USA) and Jenny Camp
BRONZE Clarence von Rosen (SWE) and Sunnyside Maid
— *Team*
GOLD United States: Earl Foster Thomson (Jenny Camp), Harry Chamberlin (Pleasant Smiles), and Edwin Argo (Honolulu Tomboy)
SILVER Netherlands: Charles Pahud de Mortanges (Marcroix), Karel Schummelketel (Duiveltje), and Aernout van Lennep (Henk)
Only two teams completed the competition.

1936

☙ OLYMPIC GAMES, BERLIN

DRESSAGE
— *Individual*
GOLD Heinz Pollay (GER) and Kronos
SILVER Friedrich Gerhard (GER) and Absinth
BRONZE Alois Podhajsky (AUT) and Nero
— *Team*
GOLD Germany: Heinz Pollay (Kronos), Friedrich Gerhard (Absinth), and Hermann von Oppeln-Bronikowski (Gimpel)
SILVER France: André Jousseaume (Favorite), Gérard de Balorre (Débaucheur), and Daniel Gillois (Nicolas)
BRONZE Sweden: Gregor Adlercreutz (Teresina), Sven Colliander (Kal), and Folke Sandström (Pergola)

JUMPING
— *Individual*
GOLD Kurt Hasse (GER) and Tora
SILVER Henri Rang (ROU) and Delfis
BRONZE József von Platthy (HUN) and Sellö
— *Team*
GOLD Germany: Kurt Hasse (Tora), Marten von Barnekow (Nordland), and Heinz Brandt (Alchimist)
SILVER Netherlands: Johan J. Greter (Ernica), Jan A. de Bruine (Trixie), and Henri L. M. van Schaik (Santa Bell)
BRONZE Portugal: José Beltrão (Biscuit), Luís Mena e Silva (Faussette), and Marquez de Funchal (Merle Blanc)

EVENTING
— *Individual*
GOLD Ludwig Stubbendorff (GER) and Nurmi
SILVER Earl Foster Thomson (USA) and Jenny Camp
BRONZE Hans Mathiesen Lunding (DEN) and Jason
— *Team*
GOLD Germany: Ludwig Stubbendorff (Nurmi), Rudolf Lippert (Fasan), and Konrad von Wangenheim (Kurfürst)
SILVER Poland: Henryk Rojcewicz (Arlekin III), Stanislaw Kawecki (Bambino), and Severyn Kulesza (Toska)
BRONZE Great Britain: Alec Scott (Bob Clive), Edward Howard-Vyse (Blue Steel), and Richard Fanshawe (Bowie Knife)

1948

☙ OLYMPIC GAMES, LONDON

DRESSAGE
— *Individual*
GOLD Hans Moser (SUI) and Hummer
SILVER André Jousseaume (FRA) and Harpagon
BRONZE Gustaf Adolf Boltenstern (SWE) and Trumpf
— *Team*
GOLD France: André Jousseaume (Harpagon), Jean Saint-Fort Paillard (Sous-les-Ceps), and Maurice Buret (Saint Queen)
SILVER United States: Robert Borg (Klingsor), Earl Foster Thomson (Pancraft), and Franck Henry (Reno Overdo)
BRONZE Portugal: Fernando Paes (Matamas), Francisco Valadas (Feitico), and Luís Mena e Silva (Fascinante)

JUMPING
— *Individual*
GOLD Humberto Mariles Cortés (MEX) and Arete
SILVER Rubén Uriza Castro (MEX) and Hatuey
BRONZE Jean d'Orgeix (FRA) and Sucre de Pomme
— *Team*
GOLD Mexico: Humberto Mariles Cortés (Arete), Rubén Uriza Castro (Hatuey), and Alberto Valdés-Ramos (Chihuahua)
SILVER Spain: Jaime García Cruz (Bizarro), José Navarro Morenes (Quorum), and José Gavilan y Ponce de Leon (Foratido)
BRONZE Great Britain: Harry Llewellyn (Foxhunter), Henry Nicoll (Kilgeddin), and Arthur Carr (Monty)

EVENTING
— *Individual*
GOLD Bernard Chevallier (FRA) and Aiglonne
SILVER Frank Henry (USA) and Swing Low
BRONZE Robert Selfelt (SWE) and Claque
— *Team*
GOLD United States: Frank Henry (Swing Low), Charles Anderson (Reno Palisades), and Earl Foster Thomson (Reno Rhythm)
SILVER Sweden: J. Robert Selfelt (Claque), Nils Olof Stahre (Komet), and Sigurd Svensson (Dust)
BRONZE Mexico: Humberto Mariles-Cortés (Arete), Raúl Campero (Tarahumara), and Joaquin Solano-Zagoya (Malinche)

1912
Olympic Games, Stockholm

Sixty-two riders, representing ten countries, and a total of seventy horses took part in these Games. The US team included just four riders, who had arrived in Sweden after a sixteen-day ocean crossing preceded by a three-day train trip from the army base in Fort Riley, Kansas, to New York. Although the Games were open to civilians, only military riders participated.

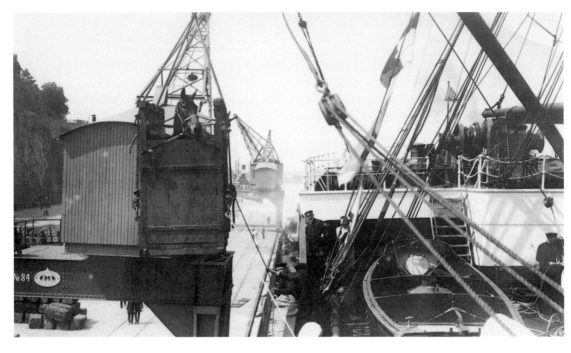

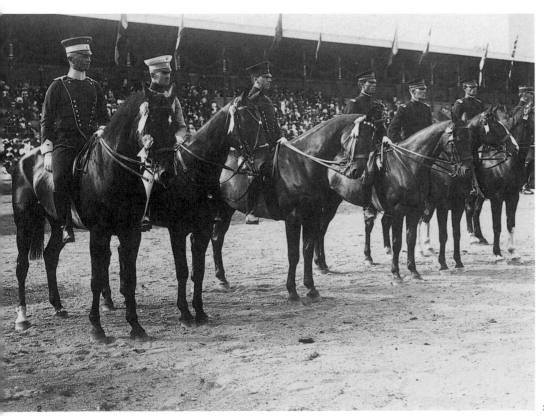

— dressage

The test consisted of executing a series of riding figures before seven judges. Haute Ecole movements (piaffes, passages, the Spanish walk, etc.) were accepted but not graded. The competition was held in a rectangular arena that measured 131 ft. × 65½ ft. (40 × 20 m) and included only nine letters. In addition to dressage, competitors had to complete a sequence of jumps over five obstacles with a maximum height of 3 ft. 7¼ in. (1.1 m), including a triple bar that was 9 ft. 10 in. (3 m) wide. There was also an obedience test. At the conclusion of the competition, participants had to jump over a painted cylinder that was rolled toward them. Bonus marks were awarded to riders who held both reins in one hand.

Jumping was similar to hunter competitions at this time; merely touching a bar, without knocking it down, was considered a fault that was penalized differently depending on whether the front or rear legs of the horse touched the bar. Refusals were penalized in points, as were falls and exceeding the time allowed. The course included fifteen obstacles jumped several times for a total of twenty-nine efforts. The maximum dimensions of the obstacles were 4 ft. 7 in. (1.4 m) in height and 1 ft. 1½ in. (4 m) in width. The speed was ¼ mile per minute (400 m/min). Jacques Cariou riding Mignon, representing France, and Rabod Wilhelm von Kröcher riding Dohna, representing Germany, were tied on penalties, necessitating a jump-off between the two. Jacques Cariou won the first individual Olympic gold medal for jumping.

1. The boat transporting the US team's horses arrives in Stockholm.

2. Awards ceremony for the eventing competition.

3. Alexis Selikhoff (Russia) and Tuelga, ranked 22nd among individual competitors.

4. The French jumping team receiving the silver medal: (left to right) P. Dufour d'Astafort (Amazone), B. Meyer (Allons-y), J. Cariou (Mignon), G. Seigner (Cocotte).

1919: The Inter-Allied Games, Paris

The first international sports competition to be organized after the end of World War I, the Inter-Allied Games were open only to soldiers from the Allied armed forces who had served between 1914 and 1918. The Games featured numerous disciplines, including a military contest and two jumping events, one individual and the other in teams of two. Commandant Joseph de Sauras won the Military competition. It took him 3 hours 42 minutes and 5 seconds to complete the 34 mile (55 km) endurance phase, which ended with a cross-country course of about 15 minutes. After a day of rest, all the partnerships went on to compete in the jumping phase.

3

4

Inspired by the French "Warhorse Championship," the eventing competition, known as "Military," began with a 34 mile (55 km) endurance race and a 3.1 mile (5 km) cross-country course on the first day. Two days later, following a day of rest, the competitors participated in a 2.1 mile (3.5 km) steeplechase made up of ten obstacles. The next day's obstacle course included fifteen jumping efforts with a maximum height and width of 4 ft. 3¼ in. and 9 ft. 10 in. (1.3 and 3 m) respectively. The final day featured a dressage test similar in form to the dressage event. Horses were required to carry a minimum weight of 175 lb. (80 kg). Jacques Cariou came third with Cocotte, a few days before winning Olympic gold in the individual jumping events riding Mignon.

Jacques Cariou

French national icon

Jacques was born on September 23, 1870, in Peumerit, in the French department of Finistère. His father, also called Jacques, was a career soldier and his mother, Antoinette Joséphine Hascoët, was an innkeeper. After a classical education at school, where he also began working with horses, for his national service he acted as a riding instructor at the military school in Fontainebleau between September 1890 and October 1891, before joining the army in 1892. Entering the 28th Artillery Regiment, he quickly became a brigadier, then progressively rose through the ranks while working in successive regiments. Ambitious and brave, Cariou was promoted to lieutenant in 1899. Four years later, he joined the 32nd Artillery Regiment in Fontainebleau where, on the strength of his talent and his successes as a rider, he was appointed to assistant riding instructor at the School of Applied Artillery and Engineering in 1908, devoting most of his time to horses from that moment on.

In 1912, at the age of forty-one, Cariou was selected for the Stockholm Olympic Games. At the time, each competitor participated in all the equestrian events: jumping, dressage, and eventing, then known as "Military." Jacques selected the horse Mignon for the first two disciplines and Cocotte for the third.

In jumping, Jacques took the top title and was a member of the silver-medal-winning team, alongside Pierre Dufour d'Astafort, Ernest Meyer, and Albert Seigner, the latter riding Jacques's mare Cocotte in this event. But the team lost out in the eventing, with the four musketeers just failing to take podium places, although this did not prevent Jacques from winning an individual bronze medal. This was the extent of his haul, however, as he finished a mere fourteenth in the dressage.

After his Olympic adventures, the champion returned to the ranks of the army and the 51st Artillery Regiment, in which he would serve during World War I. Jacques proved his courage during the Battle of the Marne in September 1914, maintaining fire until all his ammunition was exhausted, when he and his men were caught in an infantry firefight at close range. This act of bravery, as well as his courageous actions during the Battle of Champagne in 1915, earned him the title of Chevalier of the Legion of Honor that same year. Gassed in the Battle of the Somme in 1916, he was evacuated and spent the remainder of the war convalescing.

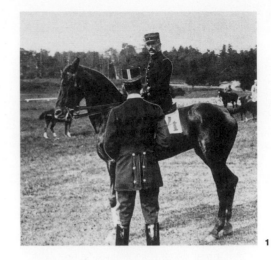

1

With the war over, Jacques was assigned to the under-secretary of state for aeronautics and air transport. He became a departmental head and continued his rise, joining the staff and becoming a lieutenant colonel in 1926, after having been elevated to the rank of Officer of the Legion of Honor in 1924.

Cariou died suddenly in Toulon on October 7, 1931, at the age of sixty-one, and was buried in the church of Notre-Dame in Boulogne-Billancourt on October 19. His wife, Marie Bezançon, whom he had married in December 1920, and with whom he had a son, requested that the army grant him a funeral with military honors.

1. On Cocotte in Stockholm, 1912.

2. At the jumping event in Stockholm, 1912.

Career Highlights

Jumping

1912
Individual gold and team silver at the Olympic Games in Stockholm with Mignon

Eventing

1912
Individual bronze at the Olympic Games in Stockholm with Cocotte

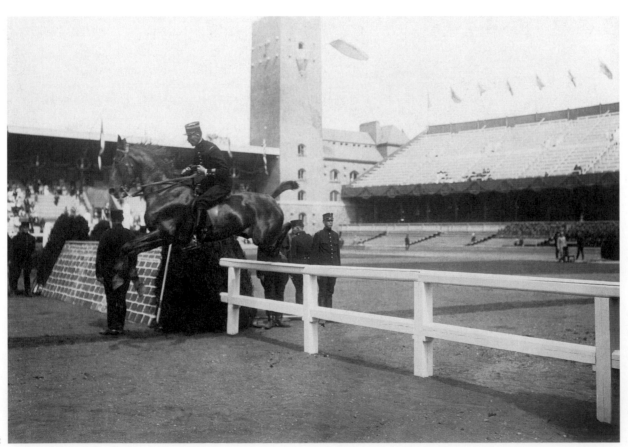

2

Axel Nordlander

A legendary cavalry captain

Born on September 21, 1879, in Hagge, Sweden, Axel was the son of Harald Nordlander, a wealthy industrialist and landowner, and Sigrid Klingberg. Axel was introduced to equestrian sports at a young age, as was the case with most officer families. When he was a young adult he joined the hussar regiment of the Swedish army based at Helsingborg, and was promoted to lieutenant in 1907 and captain in 1916. In 1929 he joined the cavalry regiment, where he remained until his retirement in 1946.

In addition to being passionate about horses, Nordlander was enthusiastic about aviation and ballooning. He received a nasty scare one day in July 1910 when, accompanied by his friend Gustaf von Hofsten, he crossed the Baltic Sea in a hot-air balloon and reached the coast of Courland, today in Latvia but at that time under Russian control. The two partners in crime were immediately arrested by the police, who were particularly vigilant that day because Tsar Nicholas II was visiting Riga. This legendary antic sums up the character of this enthusiastic and passionate dreamer. He was equally keen on bobsleigh, at that time a popular sport in Sweden; the national daily newspaper *Svenska Dagbladet* reported in 1912 that he had smashed the world descent record at Åre, the local ski resort.

Axel's greatest triumph, however, was in eventing. Having achieved success in numerous competitions in Sweden and abroad, Axel was selected for the 1912 Olympic Games in Stockholm, with Lady Artist. After a tough battle against the German Harry von Rochow riding Idealist, Axel and his mare became the first Olympic world champions in the history of eventing. The pair won on home ground with a 0.17-penalty lead and also shared the Swedish squad's victory. After this, Axel continued competing but did not win any further medals. However, he did win the Cavalry Horse Championship in Nice in 1921.

Axel's private life was as ever-changing as his sporting career. He was married three times, the first time to Aslög Sofia Maria Annhild Adelsköld, in 1906, but he divorced her five years later for Märit Lithander, whom he married in 1914. This couple also divorced but not before Axel had fathered baby Mary, born in 1918 in Helsingborg. In 1941 the captain married for the last time, to Sonia von Medem.

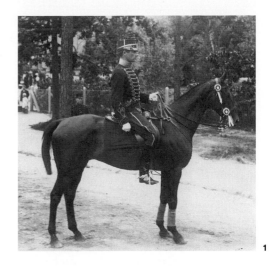

1

In addition to his meager army pay, Axel received money throughout his life from his family inheritance. Never one for moderation, the eccentric champion spent so recklessly that he brought about the collapse of his family business. He passed away on April 30, 1962, in Helsingborg.

1. On Lady Artist in Stockholm, 1912.

2. The Swedish eventing team in Stockholm, 1912: (left to right) A. Nordlander, N. Adlercreutz, E. Casparsson.

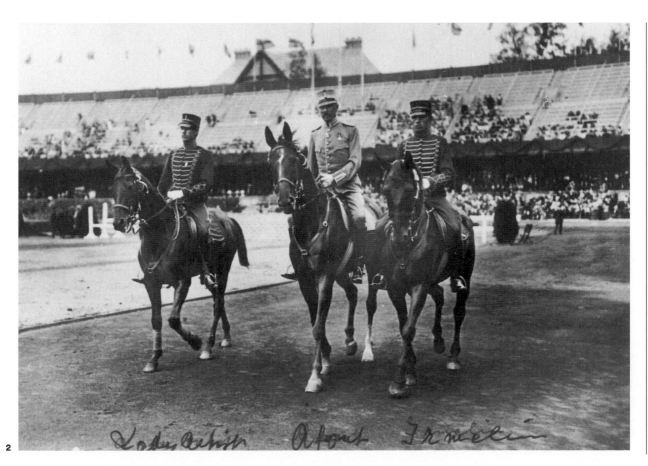

2

Career Highlight

Eventing

1912
Individual gold and team gold at the Stockholm Olympics with Lady Artist

Carl Gustaf Bonde

The first Olympic dressage champion

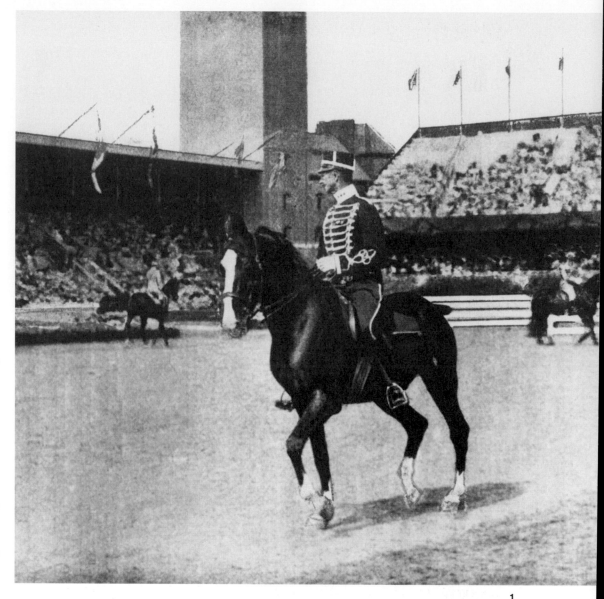

Carl Gustaf Bonde was born in Stockholm on April 18, 1872, to an important landowner, Count Gustaf Fredrik Bonde af Björnö, and an Englishwoman, Ida Horatia Charlotta Marryat, who had emigrated to Sweden upon her marriage. At the age of twenty, Carl obtained the Swedish school-leaving qualification and joined the army as sergeant in the hussars. He was promoted to second-lieutenant in 1894 and lieutenant in 1900. Although he retired from the army in 1908, he became cavalry captain in the reserves two years later and could therefore indulge his passion for horses and equestrian sports. His skills in this field earned him the position of Court Equerry in 1909, and it was as such that he took part in the 1912 Olympic Games in Stockholm on his horse Emperor. The pair excelled, taking the gold for dressage. Thanks to this achievement and his various activities in the army, Carl was promoted to Crown Equerry in 1916.

During a sporting break enforced by World War I, Carl acted as inspector of prisoner-of-war camps in Siberia in 1917–18. Sixteen years after his first Olympic medal, he competed in the 1928 Amsterdam Olympics, this time riding Ingo. The champion of 1912 could not repeat his success in the individual competition and finished nineteenth, but he and Ingo shared the silver team medal with the rest of the Swedish team. He ceased riding after these Olympics but remained involved in the equestrian world.

As president of the Stockholm horsemen's association since 1900, Carl had right from the start been very involved in the development of his sport, and he officiated as an international judge in the 1932 Los Angeles Olympics. The following year he became vice-president of the Swedish Equestrian Federation, a role he performed until 1938. In addition to the duties related to his sport, he was also major landowner and owned several castles inherited from his father.

Carl married twice. Blanche Charlotte Eleonore Dickson became his first wife in 1896, but the couple separated in 1919 after having two children, Thord Bonde (who became chief of the Swedish army) and Carl Carlsson Bonde (who became a Swedish army officer). Newly divorced, in 1920 Carl married Ebba Wallenberg, daughter of banker Marcus Wallenberg, who was president–director general of the first private bank in Sweden. The couple had a child, Peder Bonde, who went on to become a chamberlain and businessman, and who played an active role in the Wallenberg family business, one of the most important in Sweden. Carl divorced for a second time in 1941 and died on June 13, 1957, in Hörningsholm.

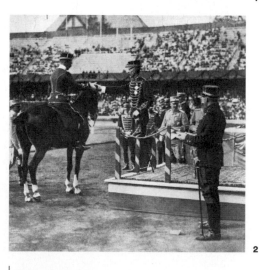

1. and 2. In Stockholm, 1912 (below, with King Gustaf V).

Career Highlights

Dressage

1912	1928
Individual gold in the Stockholm Olympic Games with Emperor	Team silver in the Amsterdam Olympics with Ingo

Idealist

The Trakehner
with an Olympic destiny

Idealist was a powerful chestnut Trakehner whose abundant talents made Harry von Rochow a brilliant competitive rider. Von Rochow became the first Olympic medalist in the history of German equestrian sports in the 1912 Summer Games in Stockholm. The young rider, twenty-one years old, and his Trakehner mount starred in the eventing competition (then referred to as "Military"). They earned an individual and team silver in the company of lieutenants Eduard von Lütcken and Richard von Schaesberg, and Captain Carl von Moers, respectively mounted on Blue Boy, Grundsee, and May Queen.

An officer in the Royal Prussian Army in World War I, von Rochow fought with the cavalry on the eastern front. He was seriously wounded by a bullet to his lung and was transported to a Russian hospital. He was subsequently transferred to a prisoner-of-war camp, from which he escaped in 1916. He fled over 9,000 miles (about 15,000 km) across Siberia in a coach, finally reaching Stockholm and a safe haven in the city where he had experienced his earlier equestrian victory.

When the war ended, the German champion returned to his family estate in Brandenburg. He spent the rest of his life breeding and raising Trakehners, in memory of his beloved horse Idealist. Von Rochow died on August 17, 1945.

Career Highlight

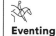

Eventing

1912
Individual
and team silver
in the Stockholm
Olympics with
Harry von Rochow

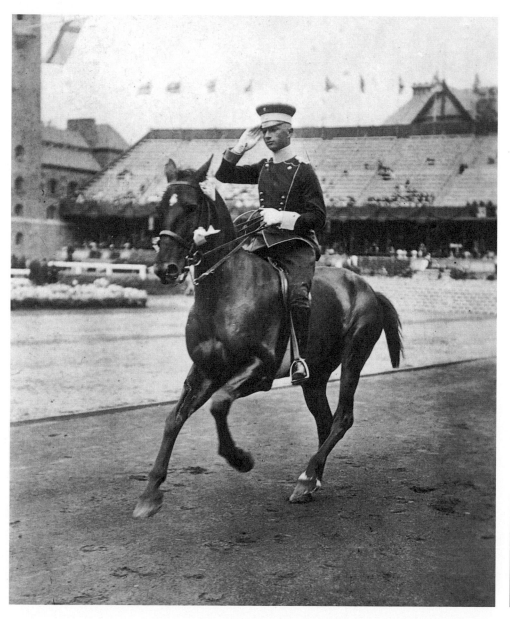

Idealist and
H. von Rochow
in Stockholm, 1912.

1920 Olympic Games, Antwerp

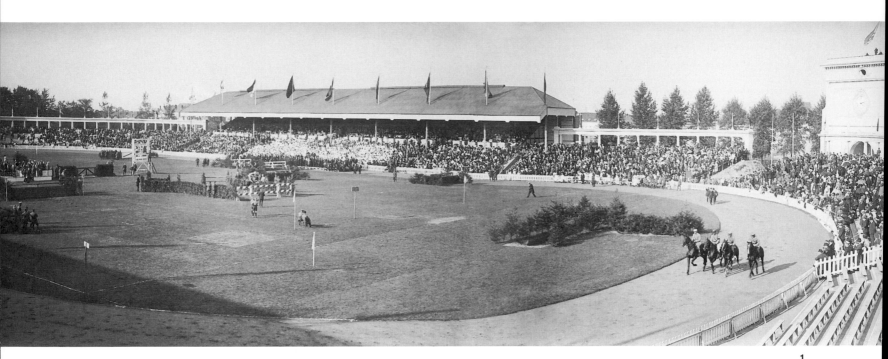

1

The Games that had been scheduled for Berlin in 1916 were canceled owing to the onset of war. The next edition of the Games was allocated to Belgium in honor of the many Belgian soldiers who had perished in the conflict. The countries that had been defeated in 1918 — Germany, Austria, Hungary, Turkey, and Bulgaria— were excluded from these Games, and Russia, immersed in civil war, did not participate.

This was the first and last time that vaulting featured in the Olympics. Military officers dominated the equestrian sports scene, which provided them with a platform to demonstrate their equestrian prowess as the cavalry was slowly replaced by motorized vehicles. The equestrian events were exclusively male.

The Swedish team were impressive, picking up half of all the medals on offer. They owed their success to their preparation with General Alexander Rodzianko of Russia. The former officer introduced the Caprilli style to Russia, Poland, and Sweden. It was an approach that revolutionized modern riding, requiring the rider to balance above the saddle while jumping, relying on shorter stirrups. This technique also lengthened the reins, giving the horse more freedom in its neck movements.

1. The Olympic stadium in Antwerp.

2. Helmer Mörner, individual eventing champion.

3. Award ceremony for the dressage competition.

4. Åge Lundström, silver medalist in individual eventing, on Germania.

1921: Creation of the Fédération Équestre Internationale (FEI)

As proposed by the International Olympic Committee, several federations were created in conjunction with the Congress of Lausanne in 1921. The Fédération Équestre Internationale was inaugurated at this time, and Baron du Teil was named its president. He was French, in accordance with the rule that the FEI president must be a citizen of the next Olympic host country.

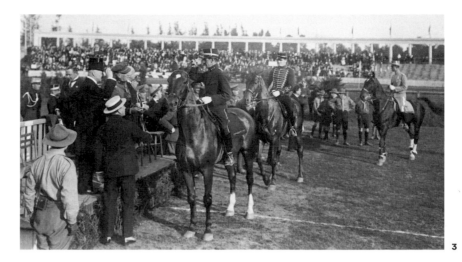

— dressage

Haute Ecole movements (piaffes, passages, the Spanish walk) were banned. The test took place in a 164 × 65½ ft. (50 × 20 m) rectangular arena and lasted for approximately 10 minutes. The concept of collection and flying changes started to take shape. Obstacles and the obedience test were eliminated, and new riding figures were introduced. A few days before the official competition, Colonel Boltenstern of Belgium was practicing in the arena with the permission of the guards when he realized that the field was 6½ ft. (2 m) short of the regulation length. Since training on the field was prohibited, he was disqualified but was allowed to participate unofficially. His performance would have earned him a bronze medal.

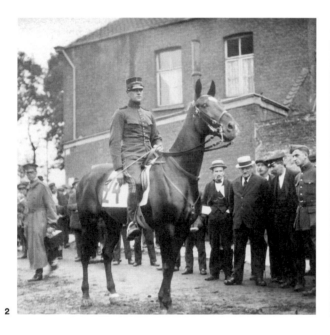

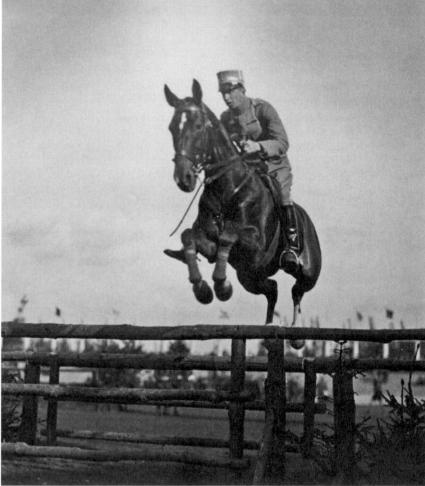

— jumping

The competition took place over a single round, with riders required to choose between the individual and the team competition. Sweden had six representatives in the individual competition and four in the team competition. The system was disadvantageous for countries fielding fewer competitors following the war.

— eventing

The eventing format was in the process of change, and took place over three days. The first day consisted of a 30 mile (45 km) roads-and-tracks phase followed by a 3.1 mile (5 km) cross-country course with eighteen obstacles ranging from 3 ft. 7¼ in. to 3 ft. 9¼ in. (1.1 to 1.15 m), to be completed in 3 hours and 30 minutes. The second day consisted of another 12½ mile (20 km) roads-and-tracks phase to be completed in 1 hour, followed by a steeplechase at a speed of ⅓ mile per minute (500 m/min) with a vet check in between. The final day was devoted to show jumping over a ¾ mile (1,150 m) course with eighteen obstacles of a maximum height of 4 ft. 1¼ in. (1.25 m). The dressage phase was removed from the eventing format. One of the challenges of the jumping course was the sandpit that the riders had to enter with a jump, before making a half-turn to jump over another obstacle. The American rider Major Barry, who had broken two fingers in the cross-country course and had the use of only one hand, was unable to execute the turn. His team lost a medal as a result.

CHAMPIONNAT ÉQUESTRE
ÈPREUVE DE FOND : 36 K^m.

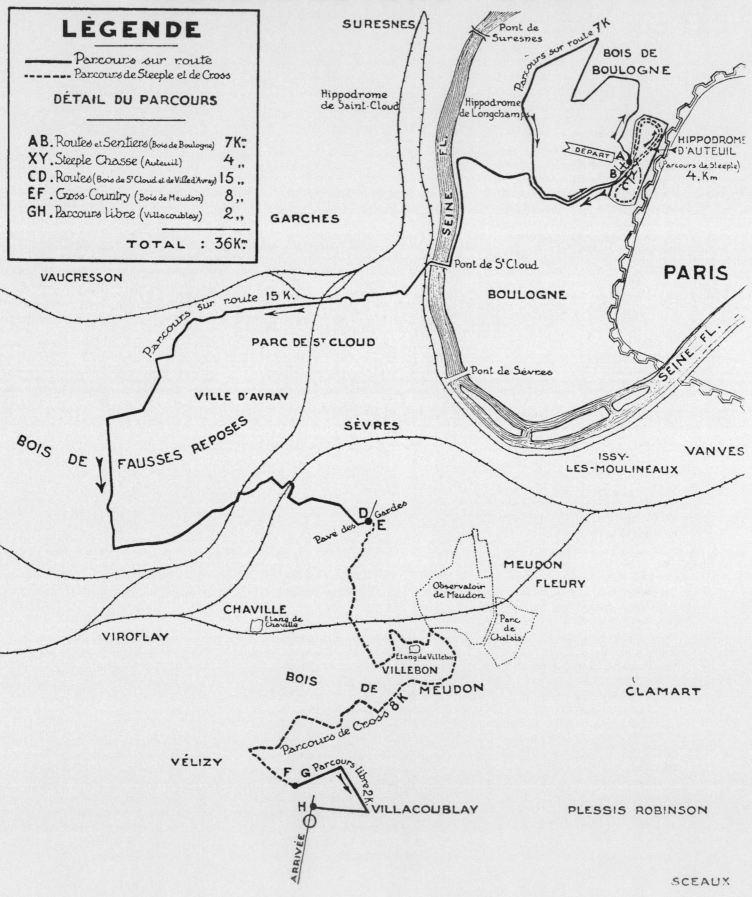

LÉGENDE

—————— Parcours sur route
- - - - - - Parcours de Steeple et de Cross

DÉTAIL DU PARCOURS

AB. Routes et Sentiers (Bois de Boulogne)	7 K^m.	
XY. Steeple Chasse (Auteuil)	4 ,,	
CD. Routes (Bois de St Cloud et de Ville d'Avray)	15 ,,	
EF. Cross-Country (Bois de Meudon)	8 ,,	
GH. Parcours Libre (Villacoublay)	2 ,,	
TOTAL :	36 K^m.	

SURESNES

Pont de Suresnes

Parcours sur route 7 K

BOIS DE BOULOGNE

Hippodrome de Saint-Cloud

Hippodrome de Longchamps

DÉPART

HIPPODROME D'AUTEUIL (Parcours de Steeple) 4 Km

GARCHES

VAUCRESSON

Pont de St Cloud

BOULOGNE

PARIS

Parcours sur route 15 K.

PARC DE St CLOUD

Pont de Sèvres

VILLE D'AVRAY

SÈVRES

BOIS DE FAUSSES REPOSES

ISSY-LES-MOULINEAUX

VANVES

Pavé des Gardes

MEUDON FLEURY

Observatoire de Meudon

Parc de Chalais

CHAVILLE

Etang de Chaville

VIROFLAY

Etang de Villebon

VILLEBON

BOIS DE MEUDON

CLAMART

Parcours de Cross 8 K

VÉLIZY

Parcours Libre 2 K

VILLACOUBLAY

PLESSIS ROBINSON

ARRIVÉE

SCEAUX

1

1924 Olympic Games, Paris

— dressage

This marked the introduction of the 197 × 65½ ft. (60 × 20 m) arena with the same seventeen letters used today. The test included the three paces with collected work and half passes. Haute Ecole movements were not permitted. The five judges were seated at the same table on the shorter side of the arena. The time allowed was 10½ minutes, which was insufficient and saw the first riders penalized. A retired fifty-six-year-old Swedish officer won the gold medal.

— jumping

The individual and team medals were awarded in a single round. The course was 3,477 ft. (1,060 m) and included sixteen obstacles ranging from 4 ft. 1¼ in. to 4 ft. 7 in. (1.25 to 1.4 m) to be completed at a speed of ¼ mile per minute (400 m/min). The course was so difficult that not one of the forty-three contestants achieved a clear round. There was no jump-off. The silver medalist Tommaso Lequio di Assaba from Italy also competed in the eventing competition.

— eventing

The competition's format, referred to as the "equestrian championship," was modified once again. It would now take place over four days. The dressage test returned and was held over the first two days. Then, the big challenge consisted of an initial 4⅓ mile (7 km) roads-and-tracks phase, a 2½ mile (4 km) steeplechase, a second 9⅓ mile (15 km) roads and tracks, followed by a 5 mile (8 km) cross-country course, with the addition of a 1¼ mile (2 km) free gallop. The final day was devoted to show jumping—twelve obstacles ranging from 3 ft. 7 ¼ in. to 3 ft. 9¼ in. (1.1 to 1.15 m) at 1,230 ft. per minute (375 m/min)—used as a test to see if the horses had recovered from the previous days' exertions. The minimum weight carried by the horse was set at 165 lb. (75 kg), and lighter riders had to pack their saddle pad with lead weights. The rider Van der Voort van Zijp registered a protest because time penalties were added to his score. Apparently the results had been reversed, and he moved from twenty-seventh to second place. The general timekeeping seems to have been unreliable, and only two riders did not receive time penalties.

2

1. Map of the Olympic courses.
2. Ernst von Linder, gold medalist in dressage, on Piccolomini.

1927: FEI Championships, Lucerne

In addition to its Olympic prerogatives, the FEI sought to develop ancillary activities such as the FEI Championships. This goal was achieved with the organization of an event in Lucerne, which included an eventing competition held over three days with dressage, endurance, and jumping phases, as well as a Grand Prix in dressage.

1928
Olympic Games,
Amsterdam

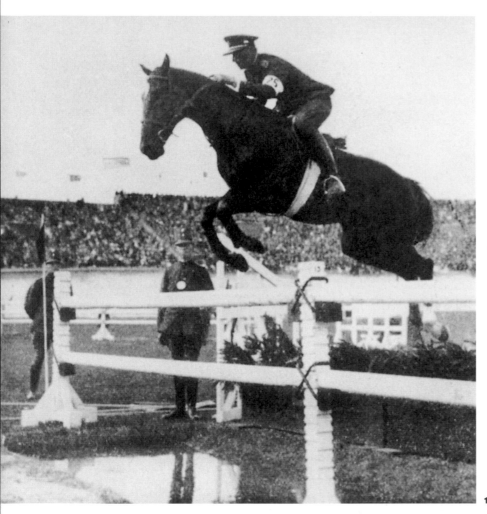

The FEI decided to reduce the number of participants per nation from four to three in this Olympiad. Twenty nations took part, including Germany, returning for the first time since the end of World War I.

— dressage

The team competition was inaugurated and eight national teams took part. Only officers and gentlemen-riders were allowed to compete. The test involved performing figures for a panel of five judges, still within a rectangular arena and in accordance with the dimensions used at previous Olympic Games. The time was extended to 17 minutes. The judging led to scandal: Nils Bonde ranked his brother Carl in third place, while three other judges ranked him twenty-third, and the last ranked him twenty-sixth.

— jumping

The course was 2,362 ft. (720 m) long and had sixteen obstacles with heights ranging from 4 ft. 1¼ in. to 4 ft. 7 in. (1.25 m to 1.4 m). It was considered too easy, and two jump-offs were required to determine the medalists. The first jump-off had seven riders, producing three clear rounds, followed by a second jump-off, in which some obstacles were raised to 5 ft. 3 in. (1.6 m).

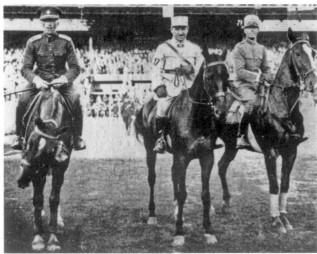

— eventing

The steeplechase speed increased from 1,804 ft. per minute to 1,968 ft. per minute (550 m/min to 600 m/min). The weighting (coefficient) of the points earned in the dressage phase was lowered and shifted over to the jumping phase, but the total number of points remained unchanged. Only three teams completed the competition; a large number of riders were eliminated in the endurance race, having missed out parts of the course.

1. F. Ventura and Eliot (Czechoslovakia), gold medalists in jumping.

2. The individual jumping podium: (left to right) F. Ventura (Eliot), P. Bertran de Balanda (Papillon XIV), C. Kuhn (Pepita).

3. The Olympic stadium in Amsterdam.

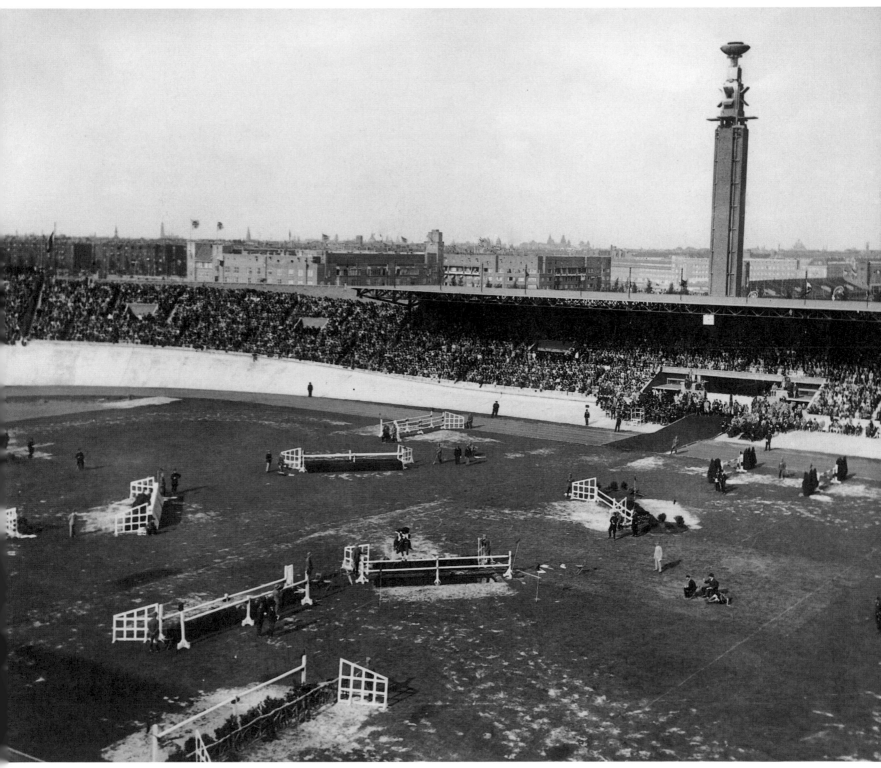

3

Tommaso Lequio di Assaba

Pioneer of modern show jumping

Born on October 21, 1893, in Cuneo, Italy, Tommaso Lequio di Assaba was the son of a highly decorated artillery general. While Tommaso was still a very young boy, the family followed Tommaso's father to Pinerolo, where Tommaso took to the saddle for the first time. Thanks to a riding lesson for cavalry officers in the royal army, Tommaso, or Tom, as he was known, was given permission to ride accompanied for a short time. Tom grew up in the city's famous riding school, which had trained Federico Caprilli, an instructor at the school since 1904, a renowned show jumper, and inventor of the "forward seat" position.

From the start, Tommaso showed great passion for riding and horses. As the school had no ponies, the boy constantly asked the officers if he could ride a horse—rarely with any success. The tenacious Tommaso never gave up, however, not even when a certain instructor, Sig. Bolla, asked him to go up and down stairs repeatedly, while keeping his heels down, in order to drum into him one of the fundamental principles of the riding position before subjecting him to real riding conditions.

The year he turned thirteen, Tommaso's dream finally came true. His undeniable talent and courage when faced with jumps were immediately apparent. Full of drive and motivation, he acquired the basics of so-called natural riding, for which the school was famous throughout the world. The school welcomed riders of all nations who came to learn their revolutionary method, and Tom, who was a local boy, was probably the school's purest product.

He also showed strength of character and bravery on the battlefield, distinguishing himself as a platoon leader during World War I. For his actions, he was awarded a medal for bravery, the first in a long line of military honors.

A keen competitor, Tommaso got back in the saddle at the end of the war, and with his faithful horse Trebecco was selected for the 1920 Antwerp Olympics, where he gave a masterful performance in the individual show jumping. The Italian was unstoppable, and four years later flew to Paris for the 1924 Games, where he competed in show jumping and won silver as well as team eventing bronze for Italy. His list of prizes also boasts three victories at the famous Piazza di Siena international horse show in Rome in 1926, 1928, and 1934, after which he gave up his sporting career.

Deployed on the ground during the Second Italo-Ethiopian War (1935–36), Major di Assaba served with distinction, making his platoon one of the best. In 1942, Tommaso was made commander of the Tor di Quinto military school in northern Italy, before taking part in the Tunisian Campaign where, as regimental colonel, he was taken prisoner by the British in May 1943. Liberated a few months later, Tommaso returned to Italy and continued his prestigious career in uniform. In April 1947, Tom was awarded the title of Knight

of the Military Order of Italy as a reward for his courage. He retired with the rank of lieutenant general.

Tommaso's last years were devoted to his lifelong passion: he was president of the Italian Equestrian Federation from 1960 until his death five years later. He was also in charge of training the national team for the 1964 Tokyo Olympics.

Recognized by all as an incredible example of success, wisdom, and elegance, he had, like any human being, his flaws: he was an incurable womanizer, despite the fact that he was married, to Maria Felice Santostefano, and father to Luisa, born in 1926. One day, his obsession culminated in a duel with a betrayed husband. Today, Tommaso is still admired for having breathed new life into show jumping, thus following in the footsteps of the legendary Caprilli.

Career Highlights

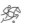

Jumping

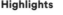

Eventing

1920
Individual gold
at the Antwerp
Olympics
with Trebecco

1924
Individual silver
at the Paris Olympics
with Trebecco

1924
Team bronze
at the Paris Olympics
with Torena

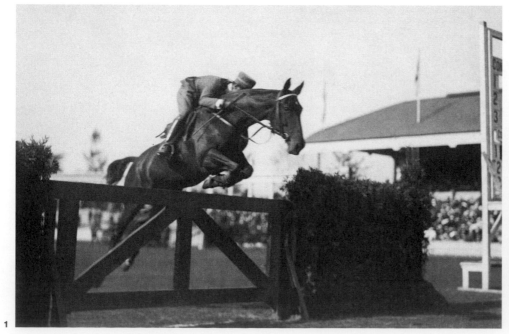

1. In Antwerp, 1920.

2. At the awards ceremony for the FEI European Championships in Aachen, 1965.

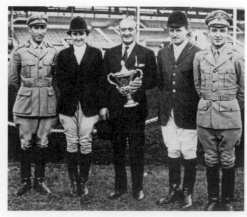

Charles Pahud de Mortanges

An energetic, unstoppable champion

Charles's destiny seemed obvious from the day of his birth, on May 13, 1896, in The Hague, Netherlands. His father, Charles Ferdinand, had dreamed of a long military career; when this was cut short owing to health problems he transferred all his hopes onto his son. Following the premature death of his father in 1903, Charles was brought up by his mother, Sophia Kol, who came from a banking family. From a very young age Charles showed great interest in military parades, particularly the horses. He started horse riding in a nearby riding school at sixteen, and then joined the Royal Military Academy (KMA) at Breda in 1915. After graduating, he was assigned to The Hague regiment in 1918 and was appointed riding instructor there the following year. The riding prowess of this prodigy was spotted, and he was enrolled in the Dutch cavalry school at Amersfoort. Following success at several competitions, Charles was chosen, along with Adolf van der Voort van Zijp, Gerard de Kruijff, and Antonius Colenbrander, to represent the Netherlands in eventing in the 1924 Paris Olympic Games. Riding Johnny Walker, he was declared Olympic team champion and finished fourth in the individual competition. Four years later, in Amsterdam, the Dutchman reached the pinnacle of his sport, taking double gold in the individual and team competitions, riding Marcroix.

In 1932, the Olympic Games took place in Los Angeles, and the competitors traveled there by ship. Charles was both painstaking and ingenious in the care of his horses, and devised a treadmill to help them keep fit. The strategy bore fruit: the intrepid rider was awarded the individual Olympic gold for the second time and was decked out in silver alongside his team. His final participation at the Olympics, in Berlin in 1936, was less pleasing, as he returned home empty-handed after his horse refused three times to jump an obstacle on the cross-country course. Two years later, when he was still at the top of his game, Charles sustained a serious wrist injury and had to bring his sporting career to an abrupt end.

Then World War II broke out. Charles was captured by the Germans in May 1942 along with other senior Dutch officers and interned in the Stanislau camp in present-day Ukraine. Brave and wily, however, he orchestrated his own escape: in the summer of 1943 he was repatriated to the Netherlands in order to take care of his injured wrist, and on the journey, while still in Poland, managed to flee. He then crossed Occupied Belgium and Occupied France to reach Gibraltar, where an airplane waited to take him to Great Britain. His only son was less fortunate: captured while trying to cross the Franco-Swiss border, he was executed by the Germans in 1942.

In 1944, Charles joined the Royal Dutch Brigade with the rank of major, taking part in Dutch troop operations during the Normandy landings and in the liberation of the Netherlands. At the end of the war, no longer able to practice his passion for all things equestrian, the soldier threw himself into a new venture and created a rehabilitation center in Aerdenhout for Dutch soldiers injured during the war. However, he could not keep away from the sporting world: he was president of the Dutch Olympic Committee from 1946 to 1951 and again from 1959 to 1961, and was also a member of the International Olympic Committee from 1946 to 1964. At the same time, he became inspector general of the army, and in 1954 the royal family gave him the responsibility of organizing all important court ceremonies; he officiated behind the scenes until December 1961.

Painful rheumatism paralyzed him in the last years of his life. He passed away in 1971 at Leiden, leaving the memory of a life filled with daring and courage.

With Marcroix in Los Angeles, 1932.

Carl-Friedrich Freiherr von Langen

Tenacious and determined

Carl was born on July 25, 1887, at Klein Belitz, near Rostock in northeast Germany. He grew up on the landed estate of his father, who was passionate about horses, and he began horse riding at a young age. He joined the 1st Guards Uhlans cavalry regiment at Potsdam, near Berlin, and at the start of World War I was sent to the Eastern Front. He was seriously wounded in the Carpathian Mountains in 1915, which led to an infection that paralyzed both his legs, and he returned home. Both determined and daring, the soldier fought his disability and in 1917 regained use of his legs.

Carl got straight back in the saddle—riding Hanko, a French horse captured on the battlefield and subsequently sold to him by one of his captain colleagues. Initially used for agricultural work, Hanko began his sporting career in 1920 after his rider discovered in him an aptitude for dressage and show jumping. At this time, when equestrian sports had lost their luster at the end of the war, Carl devised a project called the Reich Association for the Breeding and Screening of German Warmbloods, which aimed to re-establish the competitive sport as well as a national breeding program. In addition to his notable successes as a rider in dressage, show jumping, and eventing during this period, his desire for change made him an important figure in the German equestrian world.

From 1921 onward, Carl made a name for himself in twenty-six show-jumping competitions and received a number of honorable mentions in dressage in the German arenas. The following year, he tried his luck on the international stage but was not successful at first. By dint of dogged hard work, however, this previously injured war veteran managed to realize his goals, and he became a force to be reckoned with abroad, winning competitions in several disciplines and riding different horses: Goliath and Falkner share his trophies along with Hanko.

Carl's moment of glory came in 1928, at the Amsterdam Olympic Games, where he was competing with Draufgänger. The pair were unbeatable in dressage, and Carl was crowned Olympic champion on August 11, beating thirty competitors from thirteen nations. The greatest moment was when Germany won the team gold. Carl also competed with Falkner for the show-jumping event but was not as successful, finishing twenty-eighth in the individual competition and seventh in the team.

In 1933, when Adolf Hitler became German Chancellor and announced the birth of the Third Reich, Carl assumed command of a cavalry regiment, with the rank of lieutenant-colonel. Although he was an officer in the Führer's army, Carl always maintained vociferously that he did not share the Nazis' ideology and that horses and riding were his only passion.

At the top of his game, the rider set his sights on the 1936 Berlin Olympic Games. Unfortunately, however, on July 25, 1934, his forty-seventh birthday, Carl had a serious accident during a selection trial on the military training ground in Döberlitz. The course was demanding—only two of the twenty-five candidates managed to finish—and Carl suffered a fall, during which his horse Irene fell on top of him. Unconscious, and with a crushed pelvis, he waited an hour to be rescued.

The champion succumbed to his injuries several days later, on August 3, 1934, in Potsdam. His son with Marie Louise, Karl Anton Freiherr von Langen, went on to found Hamburg's Riding and Driving Association.

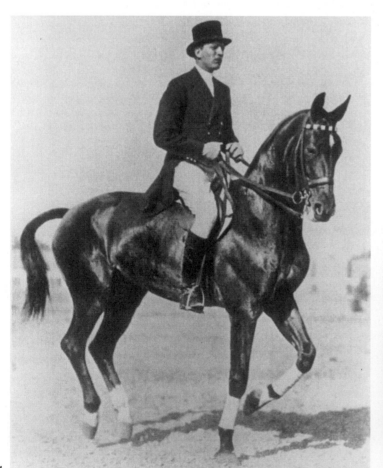

Career Highlight

Dressage

1928
Individual gold and team gold at the Amsterdam Olympics with Draufgänger

1. In the dressage competition, Amsterdam, 1928.

2. The gold-medal German dressage team at the Amsterdam Olympics, 1928: (left to right) C.-F. von Langen (Draufgänger), E. von Lotzbeck (Caracalla), H. Linkenbach (Gimpel).

Silver Piece

Three-time Dutch champion

Silver Piece entered Dutch equestrian lore as the partner of Lieutenant Adolf van der Voort van Zijp. After racking up numerous triumphs in national and international competitions, the duo participated in the 1924 Olympic Games in Paris. Silver Piece was owned by the Dutch military and was entrusted to Adolf's competent hands: the lieutenant was already highly regarded for his performance in eventing. Ranked second after the dressage test, the duo demonstrated mastery in the endurance competition, which consisted of cross-country, steeplechase, and roads-and-tracks phases at the time. But despite this stellar performance, and against all expectations, Silver Piece and his rider were listed in only twenty-seventh place in the general ranking. Adolf and the entire Dutch team challenged the ruling and finally proved their case: it transpired that Adolf's scores had been confused with those of another rider. When this error was corrected, the pair was ranked second in cross country, which put them at the top of the provisional rankings. A gifted show jumper, Silver Piece cleared every obstacle and crossed the finish line without a single fault. Adolf and his horse won the individual gold, and they shared in the Dutch team's gold medal with Charles Pahud de Mortanges, Gérard de Kruiff, and Antonius Colenbrander. In the Amsterdam Games held four years later, Silver Piece and Adolf replicated their success, once again taking top place on the team podium.

Career Highlights

Eventing

1924
Individual and team gold in the Paris Olympics with Adolf van der Voort van Zijp

1928
Team gold in the Amsterdam Olympics with Adolf van der Voort van Zijp

In the eventing competition, Paris, 1924.

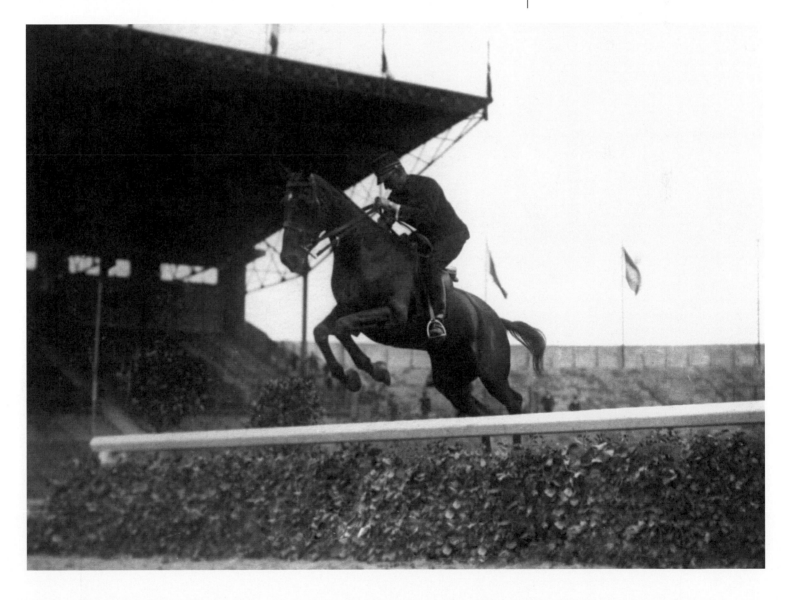

1932
Olympics Games, Los Angeles

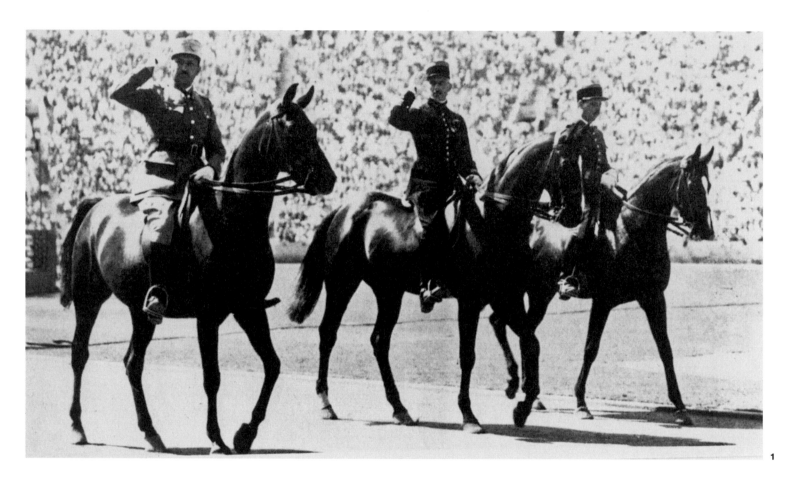

1

The Games were not as successful as planners had hoped. The world economy was undergoing a deep depression, and lengthy travel time was required to reach California.

The French and Swedish teams crossed the Atlantic by ship as far as New York and completed their journey by train. Others, including the Dutch team, sailed through the Panama Canal. They installed a treadmill to exercise their horses during the long voyage and keep them in shape for the Games.

— dressage

Four nations were represented, with only ten riders assessed by three judges. Only officers and gentlemen-riders were allowed to participate. The test was held in a rectangular arena of the same dimensions as in previous years; its duration was increased to 16 minutes. Piaffe and half-pass were authorized and graded for the first time. After Swedish rider Bertil Sandström performed, an American official said that he had encouraged his horse with tongue-clicking sounds. The rider denied this, claiming that the sound the judge had heard was his new saddle creaking. The appeal committee finally ruled against the Swedish rider (potentially a silver medalist),

ranking him last in the individual title; this ranking was also taken into account in the team competition. The American and French judges thereby made it possible for their teams to obtain medals— an individual bronze for the USA and a team gold for France.

1930: FEI Dressage Championships
The FEI held dressage championships annually between 1930 and 1939, except for Olympic years. Despite their name, these competitions were considered to be European Championships. Riders rode the Grand Prix and the Prix St-Georges tests.

— jumping

No medals for the team competitions were awarded. The 3,477½ ft. (1,060 m) course comprised twenty jumping efforts and devastated the three competing teams. Not a single one of them completed the course. The riders were overwhelmed by two 5 ft. 3 in. (1.6 m) high obstacles, a wall, and a 16 ft. 4¾ in. (5 m) wide water jump. The Swedes were the only European riders, but they were riding their event horses. The Japanese rider Takeichi Nishi won the gold medal. To this day, he remains the only Japanese athlete ever to have won an Olympic medal in an equestrian discipline.

— eventing

The technical aspects of this competition were virtually identical to those of the preceding Olympics. Charles Pahud de Mortanges won the individual Olympic title for the second time, also claiming a silver team medal for the Netherlands. The bronze medal was not awarded following the elimination of the Japanese and Swedish teams.

2

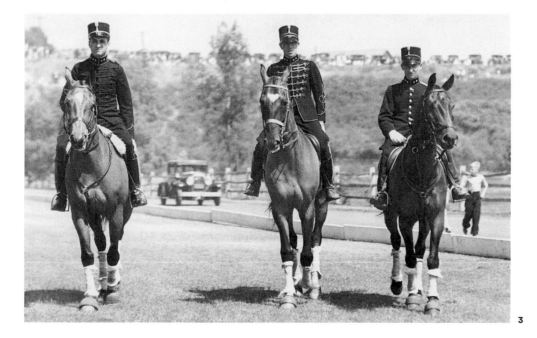

3

1. The gold-medal French dressage team: (left to right) P. Marion (Linon), X. Lesage (Taine), A. Jousseaume (Sorella).

2. Japanese rider T. Nishi, gold medalist in jumping, on Uranus.

3. The Dutch eventing team: (left to right) K. Schummelketel (Duiveltje), C. Pahud de Mortanges (Marcroix), A. van Lennep (Henk).

1936
Olympic Games, Berlin

The 1936 Olympics had strong political undercurrents. Adolf Hitler transformed the occasion into a showcase for his Nazi regime, intent on demonstrating the superiority of the Aryan race with the victory of German athletes. Germany won six gold medals in the three disciplines, as well as a silver medal in dressage.

— dressage

German Heinz Pollay, at twenty-eight the youngest rider in the competition, became individual and team Olympic champion. It was a surprising outcome: France and Sweden had traditionally dominated the discipline.

— jumping

Japanese rider Takeichi Nishi, the 1932 Olympic champion, was suspected of having intentionally fallen so as not to antagonize the Führer. His country was engaged in negotiations with the Third Reich; the suggestion was that the rider was afraid of compromising these talks by defeating his German competitors. Seven of the eighteen nations that embarked on the team competition completed it.

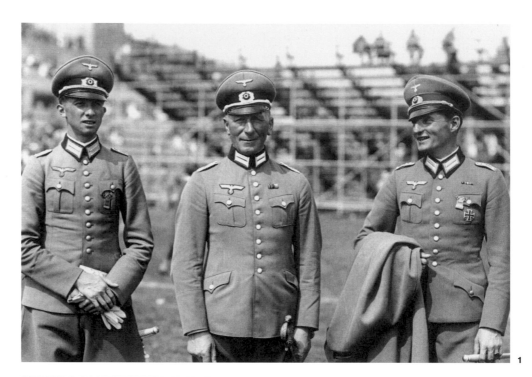

1. The German Olympic-champion dressage team: (left to right) H. Pollay (Kronos), F. Gerhard (Absinth), H. von Oppeln-Bronikowski (Gimpel).

2. Kurt Hasse and Tora, individual Olympic jumping champions.

3. Dino Ferruzzi and Manola at a cross-country obstacle.

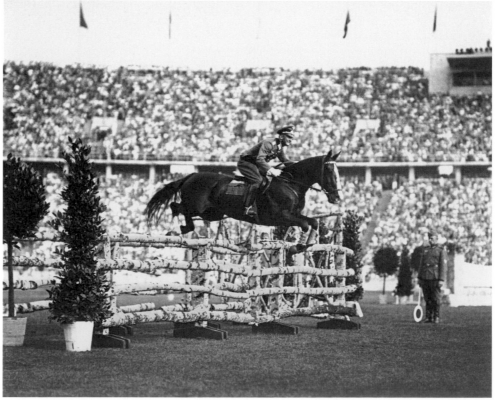

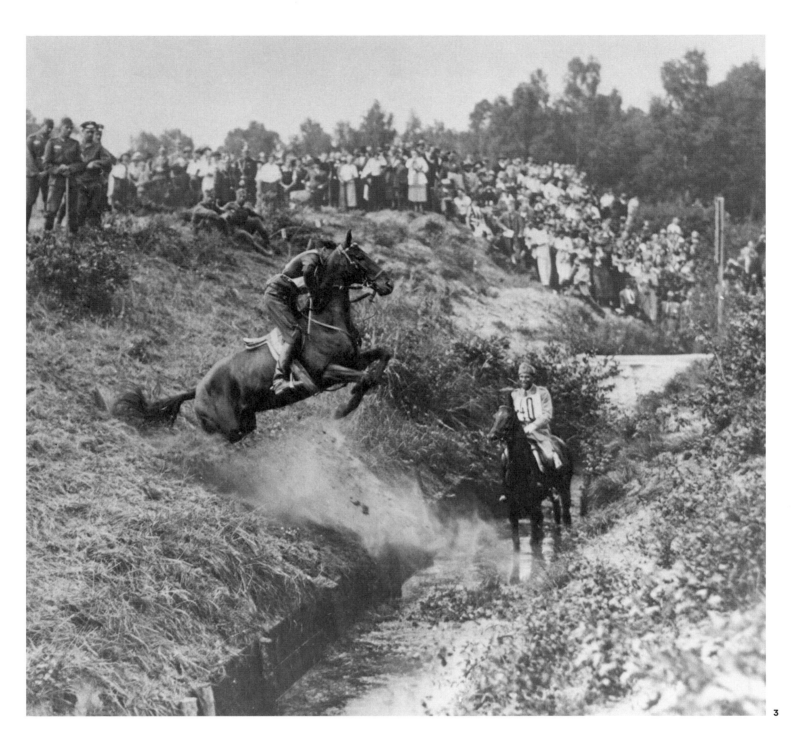

The cross-country course was extremely challenging, and ten of the fourteen teams were eliminated. Three horses were so seriously injured that they had to be put down. Germany seemed to make light of the cross-country course's challenges and won the team gold medal. When Konrad von Wangenheim fell and fractured his clavicle, he got back on his horse and completed the course.

The next day he lined up for the jumping phase and fell again, along with his horse, which took some time getting back on its feet. Once again, von Wangenheim completed the course. The Czech rider, Otomar Bureš, took an incredible 2 hours and 36 minutes to complete the cross-country course, which had an ideal time of 17 minutes and 46 seconds.

1939: FEI Eventing Championships, Turin

As had been the case with dressage in Lucerne in 1927, the FEI successfully organized its first eventing championships. But this first edition was also to be the last. The advent of World War II put a premature end to this newly established event.

Kurt Hasse

A winner who died on the battlefield

Kurt was born on February 7, 1907, in Mainz, near Frankfurt. He came from a family of expert riders, including his father, a general in the infantry. Kurt followed the example of his older brother Ernst, a future German champion of show jumping and dressage, and enrolled in the legendary Hanover cavalry school in 1930. He trained there for six years, demonstrating outstanding riding skills. Werner, the youngest of the three brothers, shared these gifts and had a brilliant career as a jockey with an imposing record of 195 wins.

With the completion of his training in 1936, Kurt took part in the Berlin Olympics, becoming the youngest rider to enter the show-jumping competition. He claimed the individual title mounted on Tora in a heart-pounding jump-off, snatching victory from the Romanian rider Henri Rang riding Delfis. His performance also contributed to the Reich's win of the team gold, an outcome that provoked heated controversy.

The top Japanese rider was Takeichi Nishi, mounted on Uranus, the horse he had ridden to win the Olympic gold in 1932. But Nishi fell and withdrew from the competition. Given the delicate political context, this startling mishap immediately aroused suspicion. Rumors circulated that the Japanese military command had secretly ordered Nishi to fall to assure a German Olympic victory in hopes of facilitating an alliance between Japan and Nazi Germany. The Tripartite Pact was indeed signed by Germany, Japan, and Italy in 1940. Political considerations were a focal point of these Games: whether by chance or by sinister design, Germany claimed all the medals awarded for equestrian sports. It remains the only time in history that a single country has won all six equestrian medals. The competition concluded with Nazi chants and salutes to the greater glory of Adolf Hitler.

Following this victorious performance, Tora returned as a heroine to the cavalry school. She enjoyed her retirement with a full array of privileges, and disported herself freely, dying at the advanced age of thirty. Kurt, a career soldier, was sent to the front to fight with the Wehrmacht. He died in combat on the Eastern Front in the Soviet Union, on January 9, 1944. A number of riders who competed in the 1936 Olympics met the same fate in various theaters of World War II. Among them was Kurt's one-time adversary Nishi, who perished at Iwo Jima in 1945.

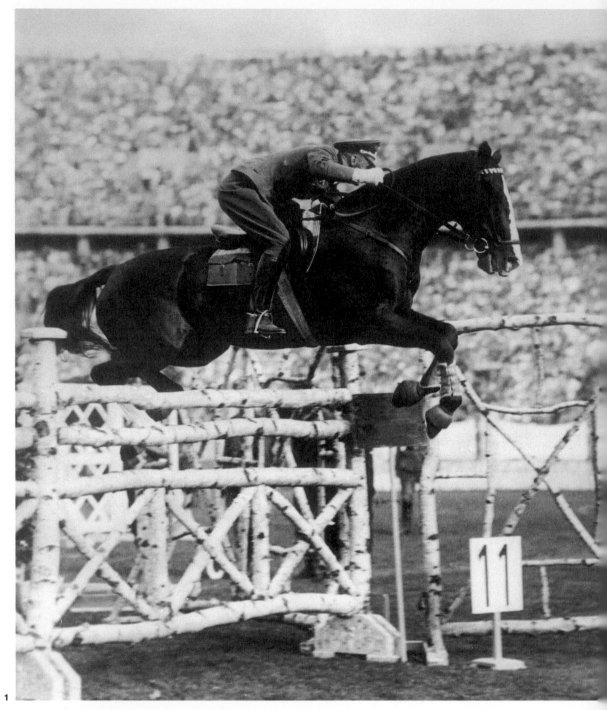

1

2

Career Highlight

Jumping

1936
Individual and team gold in the Berlin Olympics with Tora

1. In the jumping competition, Berlin, 1936.
2. At the Berlin Olympic Games, 1936.

Earl Foster Thomson

A multidisciplinary champion

Earl Foster Thomson—known as "Tommy"—was born on August 14, 1900, in Cleveland, Ohio. He came into contact with horses soon after he entered West Point Military Academy in 1918, graduating four years later with the rank of cavalry second lieutenant. He launched his sporting career in polo, and was a member of the US team alongside Harry Chamberlin, who was also renowned in eventing. Chamberlin became his trainer and, more importantly, his mentor, because he firmly believed in Earl's talent and in the partnership Earl formed with Jenny Camp.

The three trained intensively, and Earl and his mare were selected for the 1932 Los Angeles Olympic Games. Earl won the individual silver and the team gold in eventing alongside Harry. Hungry for medals, Earl sought to build on these successes by taking part in the 1936 Berlin Olympic Games, again with Jenny Camp.

In unfavorable weather conditions, Earl tackled the cross-country course brilliantly, notably clearing the fourth obstacle, a water jump 3 m (10 ft.) wide, that had defeated most of the other competitors. He was once again awarded Olympic individual silver.

Earl continued to pursue his military career all the while, and became military chief of staff of the 10th Mountain Division in Italy, in which he served during World War II. Decorated for bravery, he returned to competition at the end of the war and was selected for the 1948 London Olympic Games. The war had serious repercussions for the Games' competitors, as there were fewer riders available to partner good horses. Earl made the most of this opportunity and took up dressage with Pancraft, riding Reno Rhythm in eventing. This talented rider bagged the team silver in the first discipline and the team gold in the second, becoming, at the age of

forty-eight, the oldest American to receive an Olympic medal.

Although he went into well-deserved sporting retirement shortly afterward, he never strayed far from horses: he presided as dressage judge at the 1952 Helsinki Olympic Games, then was US chef d'équipe in eventing at the 1960 Olympics in Rome. He retired from military duties in 1954 with the rank of colonel and reinvented himself as a math teacher.

Earl died in July 1971 at the age of seventy.

In the eventing competition, Los Angeles, 1932.

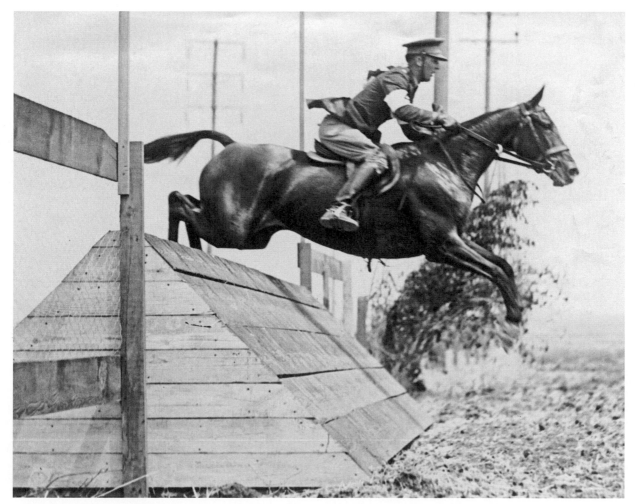

Career Highlights

Eventing

1932
Individual silver and team gold at the Los Angeles Olympics with Jenny Camp

1936
Individual silver at the Berlin Olympics with Jenny Camp

1948
Team gold at the London Olympics with Reno Rhythm

Dressage

1948
Team silver at the London Olympics with Pancraft

Heinz Pollay

From Wehrmacht champion to Olympic judge

Heinz Pollay was born on February 4, 1908 in Köslin, Pomerania (a province of the German Empire at the time and part of Poland today). He was fascinated by horses at an early age and joined the national police as a very young man. In 1935 he became an officer in the ranks of the Wehrmacht, the unified armed forces established by the Third Reich on May 21 of that year. He rapidly rose through the ranks, aided by his masterly performance as a dressage rider. Heinz explored all aspects of the sport riding Kronos, a black Hungarian gelding born in East Prussia in 1928.

The eight-year-old horse and its rider turned in a brilliant performance in the 1936 Berlin Olympic Games, dazzling the spectators and capturing the individual gold. He also won the team gold, along with Friedrich Gerhard and Hermann von Oppeln-Bronikowski. At the age of just twenty-eight, Heinz was the youngest championship rider when he and Kronos began to compete in dressage events. Heinz credited his success to Otto Lörke, a master of the discipline who trained him daily at the national cavalry school. Absinth, another horse trained by Lörke and ridden by Friedrich Gerhard, also demonstrated the success of this trainer's technique, winning the individual silver. Admirers hailed the elegance of Pollay's Olympic performance, as well as his seat, the use of his hands, and the energy that he conveyed to his mount, who was very similar to today's horses—lighter, moving with more grace, and with better balance and neck position compared with the other horses of that time.

Promoted to lieutenant colonel in 1943 and then to colonel in 1945, Heinz resigned from the army in 1947 and became a public relations director at the headquarters of the Max Planck Society for the Advancement of Science, a position he held until his retirement in 1973.

Meanwhile, he continued to pursue his riding activities and was again a member of the German team in the 1952 Olympics in Helsinki, riding Adular. They were ranked seventh in the individual competition and shared the team bronze.

Following the Helsinki Games, Heinz decided to retire from competitive riding, devoting his time to a different aspect of his sport and becoming an international dressage judge. He began judging in Lower Saxony and, with his expertise, served as judge in the northern Rhineland and then abroad, obtaining the designation of judge for the Fédération Équestre Internationale. Heinz was the first in his profession to take the judges' oath, during the opening ceremony at the Olympic Games in Munich in 1972.

Heinz died suddenly in Munich on March 14, 1979. The equestrian world mourned the loss of an extremely gifted and respected horseman who was revered for his generosity of spirit.

In the dressage competition, Berlin, 1936.

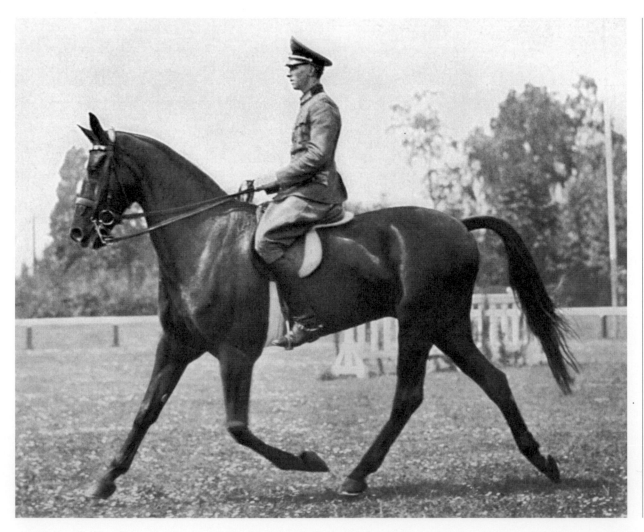

Career Highlights

Dressage

1936
Individual and team gold in the Berlin Olympics with Kronos

1952
Team bronze in the Helsinki Olympics with Adular

Taine

A spectacular Thoroughbred in the dressage arena

Career Highlight

Dressage

1932
Individual
and team gold
in the Los Angeles
Olympics

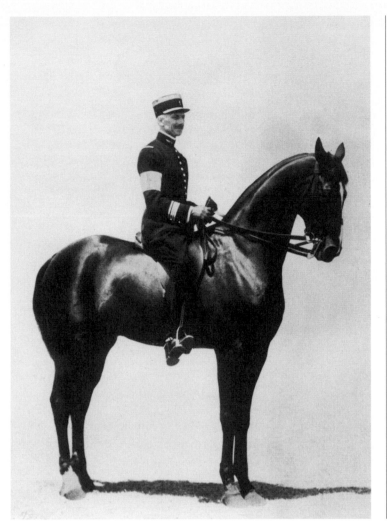

Taine and Xavier Lesage,
Los Angeles, 1932.

Taine was born in 1922 in Petit Tellier, André Chédeville's stud farm in Sévigny in the Orne department of France. The young Thoroughbred's parents were renowned racehorses. His sire, Mazzara, performed in flat racing and steeplechasing, earning numerous awards in both disciplines. His dam, Truffe, was also born in Chédeville's farm, and competed in flat races before being bred. The mare was known for her innate grace and poise, traits she passed on Taine.

Like most Thoroughbreds, Taine was sold as a yearling and began racing at a young age. The elegant black horse was soon purchased by the French army, which was always on the lookout for well-mannered, handsome horses for the calvary school in Saumur. Taine was assigned to Captain Robert Wallon, a French dressage rider who had already participated in two Olympic Games. He trained the horse in military maneuvers as well as Grand Prix dressage movements, although not without considerable effort. Taine had a rebellious nature, and his physique was not well suited to dressage. He had a long back and almost straight hocks, which made movements that involved lowering of the haunches very difficult. This posed a real challenge to Wallon, who needed to collaborate effectively with his mount, using gentle actions in order to achieve results. Despite these challenges, the duo began to participate in competitions for young horses. Once Taine had mastered the basics, he entered the limelight in 1928, winning the renowned Concours de Paris.

Following this successful debut, Taine was sold to Colonel Xavier Lesage's stables, where he continued his training. He continued to experience a variety of challenges, particularly in executing the piaffe and the walk. However, he managed the flying change of leg with startling ease. Taine impressed all the judges with his natural grace and distinction; these traits were very rare at that time in competitions, where heavy horses predominated.

In an effort to address Taine's imperfections, Colonel Lesage committed himself to working under the watchful gaze of Colonel Danloux. He was chief écuyer at the Cadre Noir in Saumur, and a rider in the 1928 Olympics. Lesage and Danloux worked together to establish correct contact with the horse's mouth, as Taine tended to carry his neck in an improper position, making it difficult to engage his back and hindquarters. Having addressed this issue, Lesage focused on the horse's walk, piaffe, and passage. With patience and concentration, he succeeded in enhancing Taine's skills, as the horse continued to demonstrate natural grace. Their hard work ultimately bore fruit, and Taine and the colonel were outstanding in their first competitions. They won the qualifying test in Paris and earned a place in the 1931 FEI Dressage Championships in Vichy, which was the most important event on the circuit at that time. Confronting six competitors from two other countries, they were in the lead after two sensational tests before a captivated audience, and Taine earned a place in the 1932 Los Angeles Olympics. The French team embarked on an ocean crossing of several weeks, followed by a long train trip, to reach their destination.

The event was held on the Santa Monica polo grounds and consisted of a 16-minute program that included piaffe and passage. Taine came through perfectly, performing with extraordinary brilliance in a faultless test that earned him the individual Olympic title as well as the team championship. During the closing ceremonies, the champion duo was given the opportunity to replicate their starring performance in a stadium filled to capacity with a hundred thousand people. For 16 minutes, Taine performed even more brilliantly than he had a few days earlier. Very few horses would be capable of demonstrating such concentration and skill twice in a single week. The extraordinary patience of Colonel Lesage and his predecessor had served them well.

Returning to France as national heroes, Taine and Lesage were invited to repeat their performance before an audience of celebrities, including President of the Republic Albert Lebrun. They rode beneath the splendid glazed roof of the Grand Palais in Paris.

Taine went on to enjoy a peaceful retirement in Saumur. He died in 1940, at the age of eighteen, when the Cadre Noir was being evacuated in the early days of World War II. The gelding broke a leg as an écuyer was trying to load him in a truck, a maneuver Taine had always resisted. Colonel Lesage did not have the opportunity to bid his horse a final farewell.

1948 Olympic Games, London

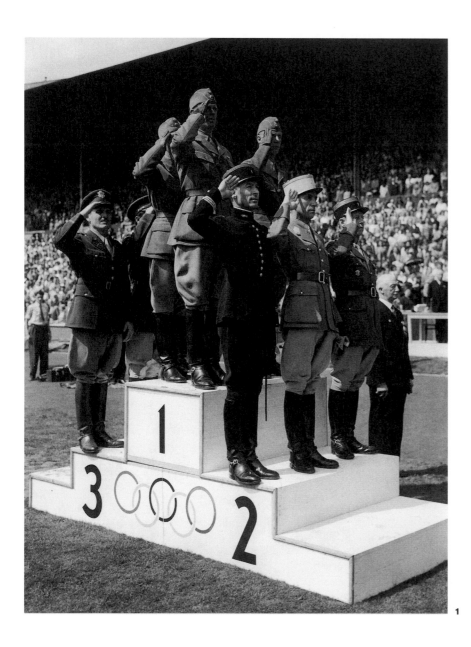

1. The dressage team podium before the disqualification of the Swedish team: (left to right) the United States, Sweden, France.

2. Humberto Mariles Cortés and Arete, Olympic jumping champions.

3. The gold-medal American eventing team.

These were the first Games to be organized following the war; the preceding Olympics had been held in Berlin in 1936. The Germans were not invited, and the Japanese refused to participate. Given the lack of preparation, the FEI reduced the difficulty of the competitions and changed some of the regulations to make the competitions less demanding.

— dressage

In deference to the long years of war, the FEI decided to limit the length of the test to 13 minutes and reduce the technical challenges by eliminating passage and piaffe movements. There were now three judges rather than five, as there had been previously. Participation in equestrian competitions was open only to military officers. A few weeks after the Games finished, it was revealed that Gehnäll Persson, one of the members of the gold-winning Swedish team, was not what he pretended to be. He had been temporarily promoted to second lieutenant on July 20, 1948, three weeks before the event, in order to qualify, but was then downgraded back to the rank of sergeant (a non-commissioned officer) afterward. This deception cost Sweden its title, which was withdrawn by the FEI in 1949 and awarded to France instead.

1949: FEI Dressage Championships, Het Zoute

It proved difficult to revive the FEI Dressage Championships, held in the Belgian town of Het Zoute in 1949. The competition had been abandoned in 1939 at the onset of the war. There were very few participants, and it was not until 1957 that the competition became an established annual event, anticipating the first European Championships that were held in 1963 in Copenhagen.

To win the individual and team medals, competitors were required to complete a single course with a jump-off to decide among the riders who were tied. The course proved brutal, however. The ground was slippery because of heavy rains, and twenty-one riders were eliminated. Only three of the fourteen competing teams made it to the end of the competition. The Mexican team made history twice by winning gold medals in both the team and the individual competitions. It was the last time a Mexican rider has succeeded in winning an Olympic medal in an equestrian discipline.

2

Frenchman André Jousseaume won the first phase of the eventing competition in the discipline of dressage, which was his specialty. He fell twice during the endurance race and eventually had to withdraw because his horse was lame. The cross-country course was reasonably designed and did not inflict major injuries on the competitors.

3

Humberto Mariles Cortés

An Olympic gangster

Career Highlights

Eventing

1948
Team bronze
in the London
Olympic Games
with Arete

Jumping

1948
Individual
and team gold
in the London
Olympic Games
with Arete

Humberto Mariles
Cortés in London, 1948.

We've all heard tales of national heroes idolized for feats of athleticism who come to believe themselves above the law. Humberto was one of these figures: he made a variety of missteps, and eventually he paid the price.

He was born on June 13, 1913, in Parral, a village in the state of Chihuahua, Mexico, and grew up around horses. But Humberto had a rebellious nature, and his parents, Colonel Antonio Mariles and Doña Virginia Cortés, sent him to a Mexican military academy at the age of twelve. His equestrian skills and love of horses impressed his teachers. He was soon named cadet sergeant and was promoted to second lieutenant at the age of eighteen.

In 1926, General Amaro, Mexican secretary of war, decided that equestrian standards in Mexico needed improvement, and so he sent officers to Europe to train in highly regarded riding schools. Despite these efforts, none of the three Mexican riders who participated in the 1932 Olympics managed to complete the course, and the nation became a laughing stock. Four years later, Humberto's mentor, General Avila Camacho, under-secretary of war, sent him to observe the Berlin Olympics. He returned, convinced that the Mexicans should follow the German example, and adopted a rigorous training regime. When General Camacho was elected president in 1940, he named Humberto to head the national equestrian team and provided him with the financial support necessary to finally implement this strategy.

While pursuing training activities, Humberto also performed brilliantly in the saddle, but he began to defy the orders of his superiors. Teamed with Resorte, a small horse with an awkward build, Humberto was refused authorization to travel with his mount to New York in 1939; his commanding officer feared that Mexico would lose face. Humberto defiantly concealed Resorte among the other horses in the train and journeyed north to the competition. Warned by a telegram from his superior that he would have to answer for his insubordination upon his return, the seething officer completed the course with the threat hanging over his head.

The suspense was palpable, but Humberto was victorious. He received yet another telegram from his superior—this time a note of congratulations.

Resorte retired after several successful years competing in the Americas, in venues ranging from Canada to the United States and Chile. His departure made way for his successor, Arete. Readily distinguished in a crowd by the naturally occurring notch in his ear and a defective left eye, the ten- year-old chestnut arrived in Humberto's stables in January 1948. Now head of the riding school for Mexican army officers, Humberto continued to chart his own course. When President of the Republic Miguel Alemán refused to allow the Mexican team to be represented by the ungainly Arete, Humberto once again ignored orders and led his team to Europe for a training program in preparation for the London Olympics. While in Rome—despite the entreaties of Ambassador Antonio Armendáriz, who begged him to return to Mexico—Humberto entered the competition, and the Mexican team embarked on four triumphant days in the Italian capital. So successful was the performance that Pope Pius XII held an audience expressly for Humberto and the team. They earned the right to participate in the London Olympics, where the Mexicans dazzled spectators, carrying off the gold in jumping and the bronze in eventing. Humberto himself was awarded the Olympic title in jumping.

The victorious riders returned to a hero's welcome in Mexico.

Basking in success and prestige, Humberto pursued his mission of education in equestrian sports. But 1952 marked the end of this golden period. Not only did the team return empty-handed from the Helsinki Games, but the newly elected President of the Republic Adolfo Ruiz Cortines had no interest whatsoever in horses. Fallen into disgrace, Humberto lost his position as director of national equestrian training, and the institution that had been so patiently constructed over the years fell into ruin.

The next chapter of the story is even bleaker. In 1964, Humberto was involved in an altercation with a car driver, whom he shot in the stomach. The man died of his injuries, and Humberto was sentenced to twenty years in prison for homicide. Released in 1971 after seven years of detention, he spent the next year on a mysterious trip to Paris at the government's orders, ostensibly on a mission to purchase horses. While in the French capital, Humberto met with drug traffickers on several occasions and was arrested. On December 6, 1972, Humberto's family learned through the Mexican embassy that he had died from complications of a pulmonary edema. This explanation was viewed with suspicion by family members, who believed it was more likely that Humberto had poisoned himself. To this day, mystery surrounds the cause of his death.

Bernard Chevallier

Victorious against the odds

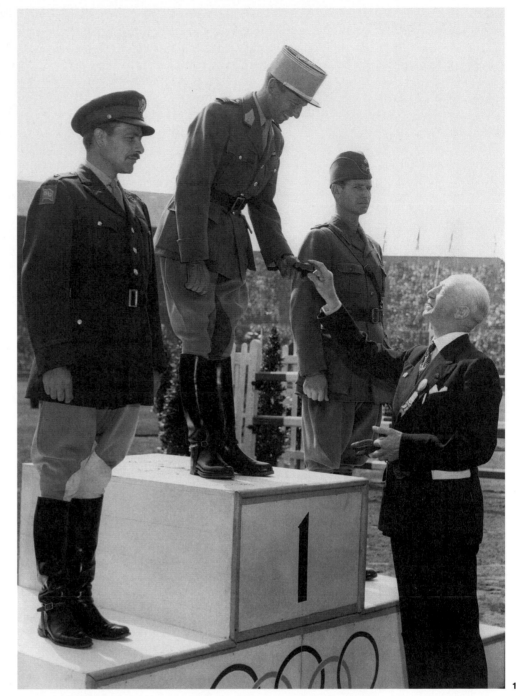

Bernard was born on October 4, 1912, into a family that was not part of the equestrian world; his father, André Chevallier, was director of a mutual insurance company and town councillor in the Eure region of France, and his mother, Blanche Boivin, took care of the family. Bernard joined the army and quickly gained promotion. In 1938, the captain demonstrated his riding skills and gained a reputation in several international competitions.

At the end of World War II, Bernard put his military career on hold in order to focus on his passion: eventing. When the Olympic Games resumed in London in 1948, the Frenchman attended with the intention of showcasing his abilities. However, he found himself without his main horse, Mars 8, who had a leg injury; instead he rode his reserve horse, Aiglonne, a nine-year-old Anglo-Arabian mare from the equestrian center at Tarbes. The pair worked wonderfully well together. Coming in seventh after the dressage phase, he achieved the best time in the endurance race. However, victory was unlikely, as the French rider's mare was felled by a serious, sudden fatigue at the end of the race, which meant that taking part in the show-jumping phase would be at best difficult and at worst impossible. Fortunately, however, twenty-four hours later, Aiglonne had made a full recovery and executed a clear final round, granting her rider the individual Olympic champion title and contributing to the team gold medal for the French. This meant that Bernard beat fellow-competitors American lieutenant colonel Frank Henry and Swedish captain Robert Selfelt.

He was given a hero's welcome upon his return to his native region: Bernard was in fact the first rider from Eure to win an Olympic medal. After this feat, the young captain resumed his military career, and attained the rank of general before he left the army. He passed away on April 6, 1997, at Orsennes, in Indre, France.

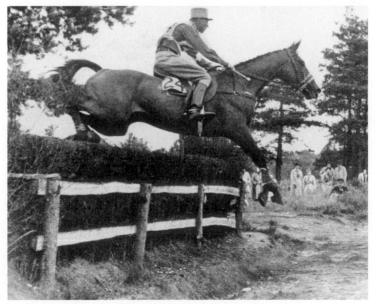

Career Highlight

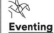

Eventing

1948
Individual gold and team gold at the London Olympics with Aiglonne

1. On the podium in London, 1948: (left to right) F. Henry, B. Chevallier, R. Selfelt.

2. In the eventing competition, London, 1948.

André Jousseaume

Prisoner of war and Olympic champion

Born on July 27, 1894, in Yvré-l'Évêque, not far from Le Mans in the Sarthe department of France, André showed an interest in equestrian sports from an early age, taking part in eventing, show jumping, and dressage concurrently. At the age of eighteen, on October 2, 1912, he joined the artillery. During World War I, he saw action in the ranks of the 44th and subsequently the 13th artillery regiments, and was twice mentioned in dispatches, notably during the Chemin des Dames offensive in 1918.

In 1920, he was promoted to the rank of lieutenant, and in 1924 he joined the cavalry school at Saumur, becoming a cavalry instructor. Promoted again to captain in 1928, he was transferred to the School of Applied Artillery in Fontainebleau, where he worked as an officer instructor. He began to make his mark regularly at cavalry horse championships.

André took part in the 1932 Los Angeles Olympics, riding his mare Sorella. Achieving fifth place in the individual competition, the pair also helped the French squad to win team gold. Selected in 1936 for the Berlin Olympics, André rode Favorite, finishing fifth once again in the individual competitions and winning a team silver medal. Over the next two years, he appeared in many events in pursuit of success, winning some of the most important events in the world, from Paris to New York via London and Toronto. He took honors in both eventing and his specialty, dressage. The outbreak of World War II in 1939 brought equestrian competitions to an abrupt halt. Appointed squadron leader in February 1940, Commandant Jousseaume saw action in the Meuse but was taken prisoner the following May in Bapaume, in the Pas-de-Calais. He was liberated in April 1945 and, soon promoted to the rank of colonel, became chief instructor at the Artillery School in the occupied Rhineland before rejoining his base at Fontainebleau, where he trained for the 1948 London Olympics, competing with his mount Harpagon. Riding his mighty chestnut horse, André won individual silver and was crowned Olympic champion with the French team. He also took part in the eventing competition but did not manage to finish.

Four years later, in Helsinki, André made his last Olympic appearance. Still on Harpagon, the distinguished rider once again achieved a podium place, receiving the individual bronze medal. To this day he is the most medaled Frenchman in his discipline in Olympic history.

Colonel Jousseaume subsequently retired from the sport, and in 1956 he joined the equestrian society at Chantilly, instructing many riders at the château's Great Stables in the art of dressage. He devoted himself to this discipline almost until he drew his last breath, on May 26, 1960, at his home in Chantilly. In his book, *Dressage*, published in 1951 but written during his years of captivity as a prisoner of war, André bequeathed his vision of equestrianism for generations to come. A strong believer in natural techniques and respect for animals, he dedicated two sections of his book to breaking in horses, key to their future success.

In the dressage competition, Helsinki, 1952.

Career Highlights

Dressage

1932
Team gold
at the Los Angeles
Olympics
with Sorella

1936
Team silver
at the Berlin Olympics
with Favorite

1948
Individual silver
and team gold
at the London
Olympics with
Harpagon

1952
Individual bronze
at the Helsinki
Olympics with
Harpagon

Hatuey
The unruffled warrior

Hatuey became a legend in the annals of the 1948 Olympic Games in London with a brief but memorable competitive career. Born in Chihuahua in northeastern Mexico, Hatuey had an Arabian sire, while his dam was an Anglo-Arabian mare. It was clear that the foal with the distinctive white star on his forehead had a future: he was destined to be a show-jumping champion. Hatuey was a relatively small horse, measuring 15 hands (1.52 m), but his long, powerfully muscled back provided him with the physical strength required for the discipline. With a courageous and spirited personality, Hatuey was named after the legendary Cuban hero who gave his life in the revolt against the Spanish conquistadors in 1512.

Hatuey's first rider in several international competitions was the brilliant Raúl Campero. He was then assigned to Rubén Uriza Castro in late 1947 at the direction of Humberto Mariles Cortés, the famous chef d'équipe for the Mexican team. Rubén and Hatuey got along famously, and it took them just six months to be ready to compete in the London Olympics.

On August 14, 1948, they surpassed themselves in Wembley Stadium before an audience of almost eighty thousand spectators. Hatuey and Rubén collected 8 penalties in the team final round and fought like lions beside Humberto Mariles Cortés and Alberto Valdés Ramos to take the team gold medal, the first top prize to be awarded to the Mexicans. In the individual competition, the duo was in second place before the last round, tying with Jean d'Orgeix (France) and Franklin Wing (USA). The French competitor was first to launch on the course, and could not avoid a fault on Obstacle 6. The American entered the arena as the top favorite but knocked down the bar of the same obstacle. Slower than d'Orgeix, Wing was now in third place. When Rubén entered the arena, he knew that he had everything to lose and that he would have to perform with steely concentration. Adding to the pressure, he was the last of the four thousand athletes in these Olympics to compete across all the sport. Battle-ready, Hatuey did not flinch from the challenge. He executed an exemplary clear round, the only one in the competition to do so, earning the duo the honor of Olympic silver. This memorable event was the only championship in which Rubén and Hatuey participated.

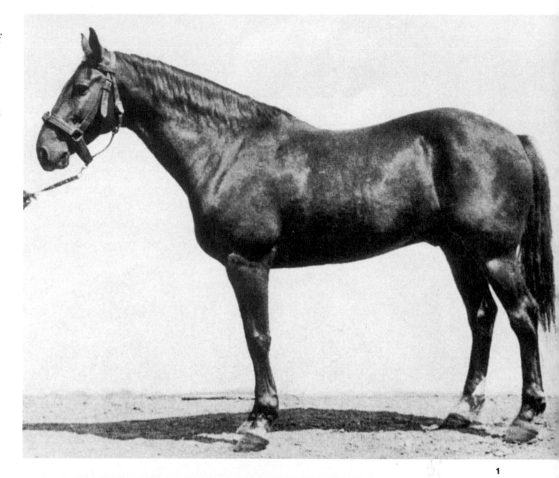

1

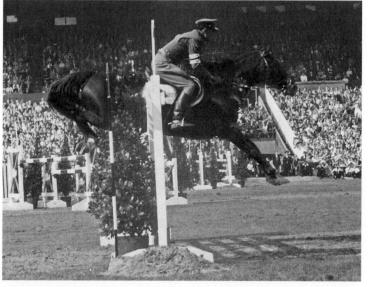

2

Career Highlight

Jumping

1948
Individual silver and team gold in the London Olympics with Rubén Uriza Castro

1. In London, 1948
2. In the jumping competition, London, 1948.

The 1950s

RESULTS
1950–1959

1952
● OLYMPIC GAMES, HELSINKI

DRESSAGE
— *Individual*
GOLD Henri Saint Cyr (**SWE**) and Master Rufus
SILVER Lis Hartel (**DEN**) and Jubilee
BRONZE André Jousseaume (**FRA**) and Harpagon
— *Team*
GOLD Sweden: Henri Saint Cyr (Master Rufus), Gustaf Adolf Boltenstern (Krest), and Gehnäll Persson (Knaust)
SILVER Switzerland: Gottfried Trachsel (Kursus), Henri Chammartin (Wöhler), and Gustav Fischer (Soliman)
BRONZE Federal Republic of Germany: Heinz Pollay (Adular), Ida von Nagel (Afrika), and Fritz Thiedemann (Chronist)

JUMPING
— *Individual*
GOLD Pierre Jonquères d'Oriola (**FRA**) and Ali Baba
SILVER Óscar Cristi (**CHI**) and Bambi
BRONZE Fritz Thiedemann (**GER**) and Meteor
— *Team*
GOLD Great Britain: Wilfred White (Nizefela), Douglas Stewart (Aherlow), and Harry Llewellyn (Foxhunter)
SILVER Chile: Óscar Cristi (Bambi), César Mendoza (Pillan), and Ricardo Echeverria (Lindo Peal)
BRONZE United States: William Steinkraus (Hollandia), Arthur McCashin (Miss Budweiser), and John Russell (Democrat)

EVENTING
— *Individual*
GOLD Hans von Blixen-Finecke (**SWE**) and Jubal
SILVER Guy Lefrant (**FRA**) and Verdun
BRONZE Wilhelm Büsing (**FRG**) and Hubertus
— *Team*
GOLD Sweden: Hans von Blixen-Finecke (Jubal), Nils Olof Stahre (Komet), and Karl Folke Frölén (Fair)
SILVER Federal Republic of Germany: Wilhelm Büsing (Hubertus), Klaus Wagner (Dachs), and Otto Rothe (Trux von Kamax)
BRONZE United States: Charles Hough (Cassivellanus), Walter Staley (Craigwood Park), and John Wofford (Benny Grimes)

1953
♟ FEI WORLD CHAMPIONSHIPS, PARIS

JUMPING
GOLD Francisco Goyoaga (**ESP**) and Quorum
SILVER Fritz Thiedemann (**FRG**) and Diamant
BRONZE Pierre Jonquères d'Oriola (**FRA**) and Ali Baba

1953
♛ FEI EUROPEAN CHAMPIONSHIPS

EVENTING
Badminton, United Kingdom
— *Individual*
GOLD Arthur Laurence Rook (**GBR**) and Starlight
SILVER Frank Weldon (**GBR**) and Kilbarry
BRONZE Hans Schwarzenbach (**SUI**) and Vae Victis
— *Team*
GOLD Great Britain: Frank Weldon (Kilbarry), Reg Hindley (Speculation), Albert "Bertie" Hill (Bambi)
Only one team completed the event.

1954
♟ FEI WORLD CHAMPIONSHIPS, MADRID

JUMPING
GOLD Hans Günter Winkler (**FRG**) and Halla
SILVER Pierre Jonquères d'Oriola (**FRA**) and Arlequin
BRONZE Francisco Goyoaga (**ESP**) and Baden

1954
♛ FEI EUROPEAN CHAMPIONSHIPS

EVENTING
Basel, Switzerland
— *Individual*
GOLD Albert "Bertie" Hill (**GBR**) and Crispin
SILVER Frank Weldon (**GBR**) and Kilbarry
BRONZE Arthur Laurence Rook (**GBR**) and Starlight

— *Team*
GOLD Great Britain: Frank Weldon (Kilbarry), Albert "Bertie" Hill (Crispin), Arthur Laurence Rook (Starlight), and Diana Mason (Tramella)
SILVER Federal Republic of Germany: Wilhelm Büsing (Trux), August Lücke-Westhues (Hubertus), Klaus Wagner (Dachs), and Max Huck (Fockdra von Kamax)
Only two teams completed this competition.

1955
♟ FEI WORLD CHAMPIONSHIPS, AACHEN

JUMPING
GOLD Hans Günter Winkler (**FRG**) and Orient
SILVER Raimondo D'Inzeo (**ITA**) and Merano
BRONZE Ronnie Dallas (**GBR**) and Bones

1955
♛ FEI EUROPEAN CHAMPIONSHIPS

EVENTING
Windsor, United Kingdom
— *Individual*
GOLD Frank Weldon (**GBR**) and Kilbarry
SILVER John Oram (**GBR**) and Radar
BRONZE Albert "Bertie" Hill (**GBR**) and Countryman
— *Team*
GOLD Great Britain: Frank Weldon (Kilbarry), Albert "Bertie" Hill (Countryman II), Arthur Laurence Rook (Starlight), and Diana Mason (Tramella)
SILVER Switzerland: Anton Bühler (Uranus), Hans Bühler (Richard), Marc Büchler (Tizian), and Andreas Zindel (Vae Victis)
Only two teams completed this competition.

1956
● OLYMPIC GAMES, MELBOURNE (STOCKHOLM)

DRESSAGE
— *Individual*
GOLD Henri Saint Cyr (**SWE**) and Juli
SILVER Lis Hartel (**DEN**) and Jubilee
BRONZE Liselott Linsenhoff (**GER†**) and Adular
— *Team*
GOLD Sweden: Henri Saint Cyr (Juli), Gehnäll Persson (Knaust), and Gustaf Adolf Boltenstern (Krest)
SILVER Germany†: Liselott Linsenhoff (Adular), Hannelore Weygand (Perkunos), and Anneliese Küppers (Afrika)
BRONZE Switzerland: Gottfried Trachsel (Kursus), Henri Chammartin (Wöhler), and Gustav Fischer (Vasello)

JUMPING
— *Individual*
GOLD Hans Günter Winkler (**GER†**) and Halla
SILVER Raimondo D'Inzeo (**ITA**) and Merano
BRONZE Piero D'Inzeo (**ITA**) and Uruguay
— *Team*
GOLD Germany†: Hans Günter Winkler (Halla), Fritz Thiedemann (Meteor), and Alfons Lütke-Westhues (Ala)
SILVER Italy: Raimondo D'Inzeo (Merano), Piero D'Inzeo (Uruguay), and Salvatore Oppes (Pagoro)
BRONZE Great Britain: Wilfred White (Nizefela), Pat Smythe (Flanagan), and Peter Robeson (Scorchin)

EVENTING
— *Individual*
GOLD Petrus Kastenman (**SWE**) and Illuster
SILVER August Lütke-Westhues (**GER†**) and Trux von Kamax
BRONZE Frank Weldon (**GBR**) and Kilbarry
— *Team*
GOLD Great Britain: Frank Weldon (Kilbarry), Arthur Laurence Rook (Wild Venture), and Albert Edwin Hill (Countryman III)
SILVER Germany†: August Lütke-Westhues (Truc von Kamax), Otto Rother (Sissi), and Klaus Wagner (Prinzess)
BRONZE Canada: John Rumble (Cilroy), James Elder (Colleen), and Brian Herbinson (Tara)

1956

🏆 FEI WORLD CHAMPIONSHIPS

JUMPING
Aachen, West Germany
GOLD Raimondo D'Inzeo (ITA) and Merano
SILVER Francisco Goyoaga (ESP) and Fahnenkönig
BRONZE Fritz Thiedemann (FRG) and Meteor

1957

🎖 FEI EUROPEAN CHAMPIONSHIPS

JUMPING (MEN'S)
Rotterdam, Netherlands
GOLD Hans Günter Winkler (FRG) and Sonnenglanz (Halla)
SILVER Bernard de Fombelle (FRA) and Bucephale (Buffalo)
BRONZE Salvatore Oppes (ITA) and Pagoro

JUMPING (WOMEN'S)
Spa, Belgium
GOLD Pat Smythe (GBR) and Flanagan (Prince Hal)
SILVER Giulia Serventi (ITA) and Doly (Perseo)
BRONZE Michèle d'Orgeix-Cancre (FRA) and Océane (Hector)

EVENTING
Cophengagen, Denmark
— *Individual*
GOLD Sheila Willcox (GBR) and High-And-Mighty
SILVER August Lütke-Westhues (FRG) and Franko
BRONZE Jonas Lindgren (SWE) and Eldorado

— *Team*
GOLD Great Britain: Sheila Willcox (High-And-Mighty), Ted Marsh (Wild Venture), Derek Allhusen (Laurien), and Kit Tatham-Warter (Pampas Cat)
SILVER Federal Republic of Germany: August Lütke-Westhues (Franko), Siegfried Dehning (Fechtlanze), Reiner Klimke (Lausbub), and Dieter Fösken (Fifina)
BRONZE Sweden: Jonas Lindgren (Eldorado), Evert Pettersen (Tom Raid), Petrus Kastenman (Illuster), and K. G. Holm (Air)

1958

🎖 FEI EUROPEAN CHAMPIONSHIPS

JUMPING (MEN'S)
Aachen, West Germany
GOLD Fritz Thiedemann (FRG) and Meteor
SILVER Piero D'Inzeo (ITA) and The Rock
BRONZE Hans Günter Winkler (FRG) and Halla

JUMPING (WOMEN'S)
Palermo, Italy
GOLD Giulia Serventi (ITA) and Doly
SILVER Anna Clement (FRG) and Nico
BRONZE Irene Jansen (NED) and Adelboom

1959

🎖 FEI EUROPEAN CHAMPIONSHIPS

JUMPING (MEN'S)
Paris, France
GOLD Piero D'Inzeo (ITA) and Uruguay (The Quiet Man)
SILVER Pierre Jonquères d'Oriola (FRA) and Virtuoso (Isofelt)
BRONZE Fritz Thiedemann (FRG) and Godewind (Retina)

JUMPING (WOMEN'S)
Rotterdam, Netherlands
GOLD Ann Townsend (GBR) and Bandit IV
SILVER Pat Smythe (GBR) and Flanagan
BRONZE (JOINT) Giulia Serventi (ITA) and Poly
BRONZE (JOINT) Anna Clement (FRG) and Nico

EVENTING
Harewood, United Kingdom
— *Individual*
GOLD Hans Schwarzenbach (SUI) and Burn Trout
SILVER Frank Weldon (GBR) and Samuel Johnson
BRONZE Derek Allhusen (GBR) and Laurien
— *Team*
GOLD Federal Republic of Germany: August Lütke-Westhues (Franko II), Ottokar Pohlmann (Polarfuchs), S. Dehning (Fechtlanze), and Reiner Klimke (Fortunat)
SILVER Great Britain: Frank Weldon (Samuel Johnson), Derek Allhusen (Laurien), Jeremy Beale (Fulmer Folly), and Sheila Waddington (née Willcox) (Airs and Graces)
BRONZE France: Jean-Raymond Le Roy (Garden), Pierre Durant (Guilliano), Guy Lefrant (Nicias), and Jacques Landon (Espionne)

† Editor's Note: In the 1956, 1960, and 1964 Olympic Games, German athletes from both nations participated as a United Team of Germany.

1952 Olympic Games, Helsinki

The 1940 Games were originally planned for Tokyo, but the intensification of the Second Sino-Japanese War meant they were awarded to the Finnish capital instead. In the end, the Games were canceled due to the onset of World War II, and did not resume until 1948.

To avoid the problems caused in 1948, when a Swedish non-commissioned officer had been temporarily promoted so that he could compete in the Games, non-commissioned officers and soldiers were allowed to participate in 1952. The Games were also open to civilians, who embraced the opportunity and made up over half of the riders. There was yet another innovation: women were allowed to compete, but only in the dressage events.

— dressage

There were twenty-seven participants in this event, four of whom were women. The piaffe and passage movements were reintroduced in the test. The scoring system changed. There were now five judges, but only three of the rankings were taken into account, with the highest and lowest scores disregarded. Lis Hartel of Denmark won the silver medal in the individual competition. It was a remarkable feat, not least because she was one of the few women who ventured to test her skills against those of her male counterparts. Even more remarkably, however, this Danish rider was disabled: stricken with polio in 1944, she was paralyzed below the knees. The Swedish rider Henri Saint Cyr, winner of the competition, helped her dismount from her horse and climb onto the podium.

2

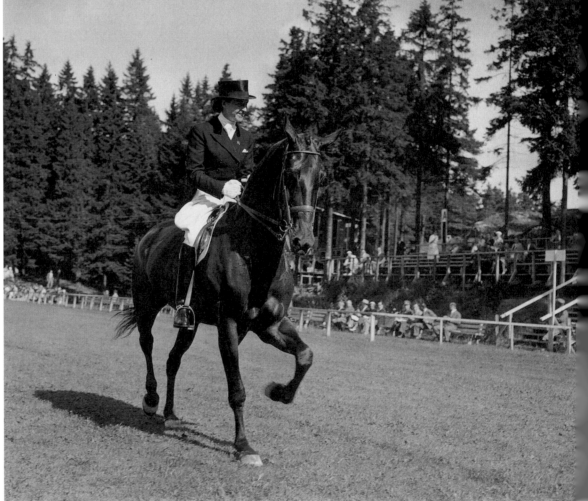

1

Pierre Jonquères d'Oriola became the second Frenchman to take home the gold medal in jumping, following Jacques Cariou's achievement in the 1912 Stockholm Olympics. The career of British rider Harry Llewelly was closely associated with his gelding Foxhunter. Together they won the King George V Cup on three separate occasions, in 1948, 1950, and 1953, at Hickstead. The pair contributed to the British team's gold medal in 1952. The British public had such a deep-seated admiration for Foxhunter that his skeleton was kept in the Royal Veterinary College's collection, London.

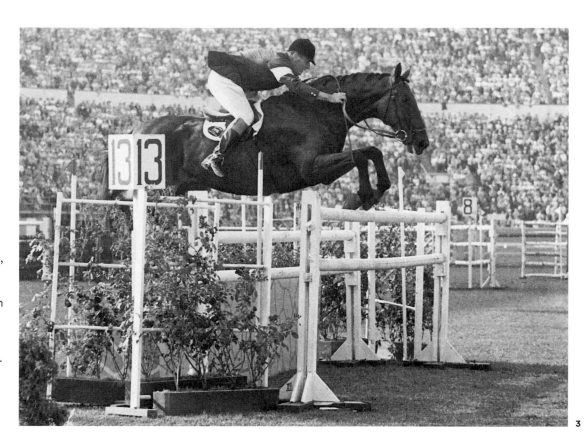

3

Hans von Blixen-Finecke, the individual gold medalist, was the son of the bronze medal-winner in dressage at the 1912 Olympics.

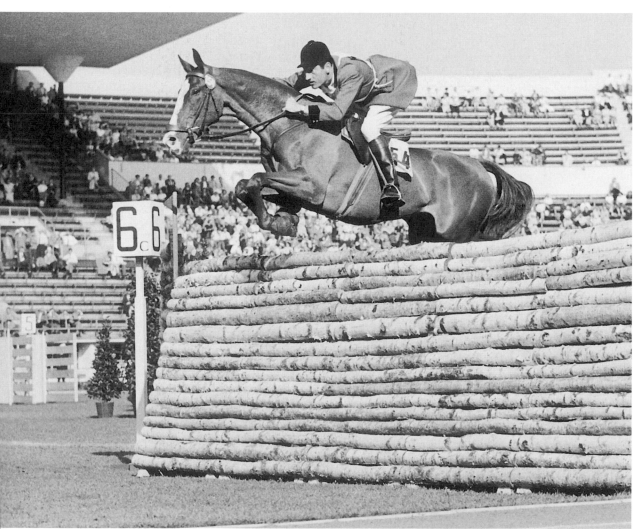

4

1. The individual dressage podium: (left to right) L. Hartel, H. Saint Cyr, A. Jousseaume.

2. L. Hartel, dressage silver medalist, on Jubilee.

3. H. Llewellyn, team gold medalist in jumping, on Foxhunter.

4. P. Jonquères d'Oriola, gold medalist in jumping, on Ali Baba.

1953
FEI World Championships

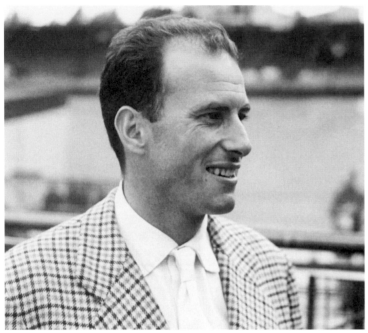

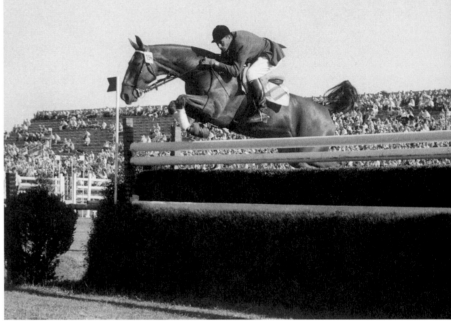

1 2

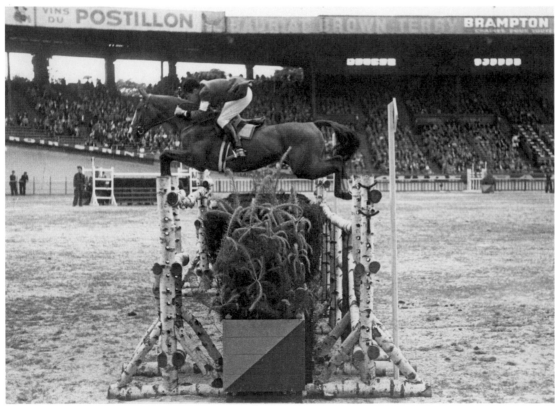

3

— jumping

Paris, France
The first World Championships were organized by the French and held in Paris. Since 1949, the French had been experimenting with the system of final-four horse rotation in national championships. Very few nations took part in this edition, which attracted only nineteen riders. Francisco Goyoaga of Spain became the first World Champion with Quorum, after completing three perfect rounds riding the horses of his opponents Fritz Thiedemann, Pierre Jonquères d'Oriola, and Piero D'Inzeo.

FEI European Championships

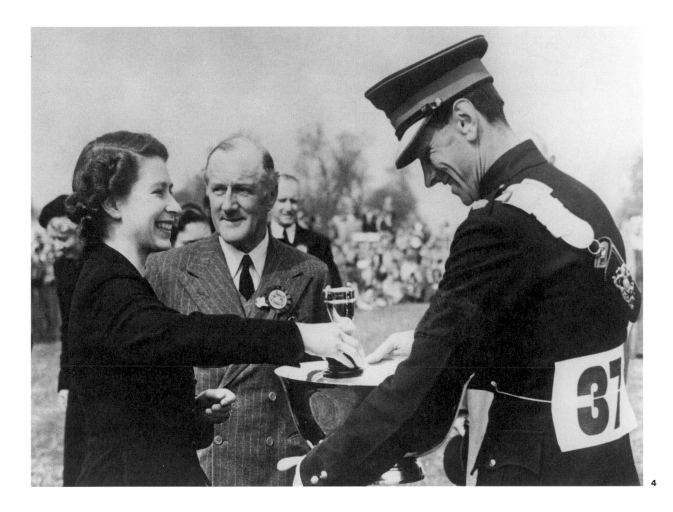

4

1. and **2.** F. Goyoaga, first world jumping champion, with Quorum.

3. P. Jonquères d'Oriola on Ali Baba.

4. A. Laurence Rook being congratulated by Queen Elizabeth II.

5. A. Laurence Rook, first European eventing champion, with Starlight.

— eventing

Badminton, United Kingdom
The Duke of Beaufort hosted this grand première of eventing on the extensive estate surrounding his imposing house. It was a genuinely festive occasion. Forty riders engaged in the competition, including twenty-eight British riders. Great Britain was the only nation to finish the team competition. Queen Elizabeth, Princess Anne, Princess Margaret, and Prince Philip were all in attendance. The Queen congratulated the first European eventing champion: the British rider Arthur Laurence Rook, riding Starlight.

5

1954—1955
FEI Championships

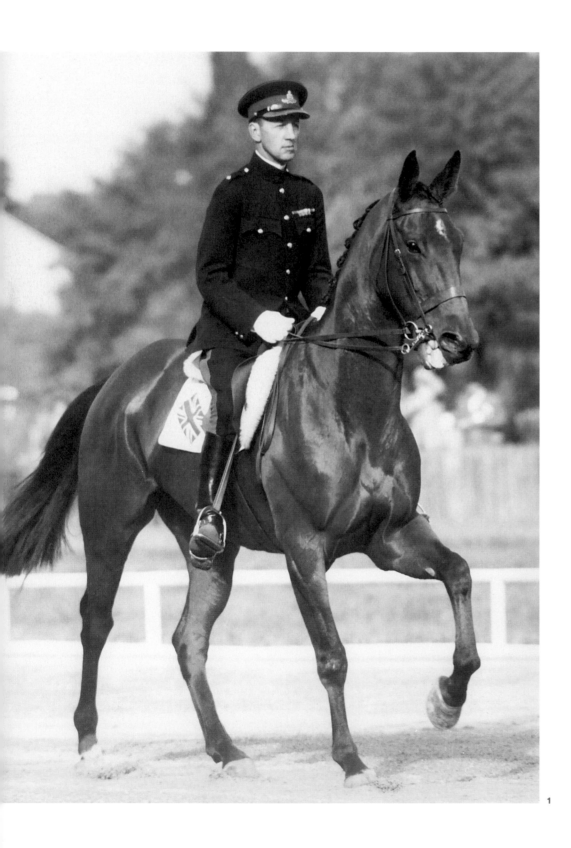

1954 — FEI World Championships

— jumping

Madrid, Spain
The FEI grappled with regulatory issues and decided that the champion was automatically qualified for the final. Francisco Goyoaga returned to the podium to collect the bronze medal, and Hans Günter Winkler, riding Halla, was crowned champion. The silver was awarded to Pierre Jonquères d'Oriola, riding Arlequin.

1954 — FEI European Championships

— eventing

Basel, Switzerland
Only two teams made it to the end of the competition, which included an endurance race of over 21¾ miles (35 km). Great Britain was again dominant in the discipline, coming in ahead of the West German team. Winners on the individual podium were all British. Albert "Bertie" Hill was first, riding Crispin, Frank Weldon came in second with Kilbarry, and Arthur Laurence Rook was third riding Starlight. Rook and Weldon had won gold and silver respectively at Badminton on the same horses the previous year.

1

1955 — FEI World Championships

Aachen, West Germany
The FEI abandoned its policy of allowing automatic qualification for the current holder of the title, but Hans Günter Winkler won it again, on his own, fair and square. However, the FEI's rules altered the results of the qualifying competitions. At the conclusion of these, Hans Günter Winkler, Pierre Jonquères d'Oriola, Raimondo D'Inzeo, and his brother Piero were in the lead, and should have qualified automatically. However, the rules allowed for only one rider per country in the final: Piero D'Inzeo was forced to accept fifth place, and Fritz Thiedemann, a compatriot of Winkler, also had to cede his position to Ronnie Dallas, a British rider. During the final-four

horse rotation, Jonquères d'Oriola was eliminated with Dallas's horse. Winkler and D'Inzeo were tied on penalties and had to proceed to a jump-off to break the tie. Winkler committed a fault with his own horse, Halla, but didn't knock down any bars with D'Inzeo's horse, Nadir, while D'Inzeo displaced a bar with every horse he rode. The German Winkler claimed his second world championship in two years.

1955 — FEI European Championships

Windsor, United Kingdom
Great Britain remained the uncontested master of the discipline, winning the team gold medal. Struggling valiantly, the Swiss managed to claim second place, but the other teams did not make it to the end of the competition. Frank Weldon earned the individual title on a podium that was once again occupied exclusively by British riders.

1. F. Weldon, with Kilbarry, ranked 2nd in eventing.

2. H. G. Winkler, world jumping champion, on Orient.

1956
Olympic Games, Stockholm

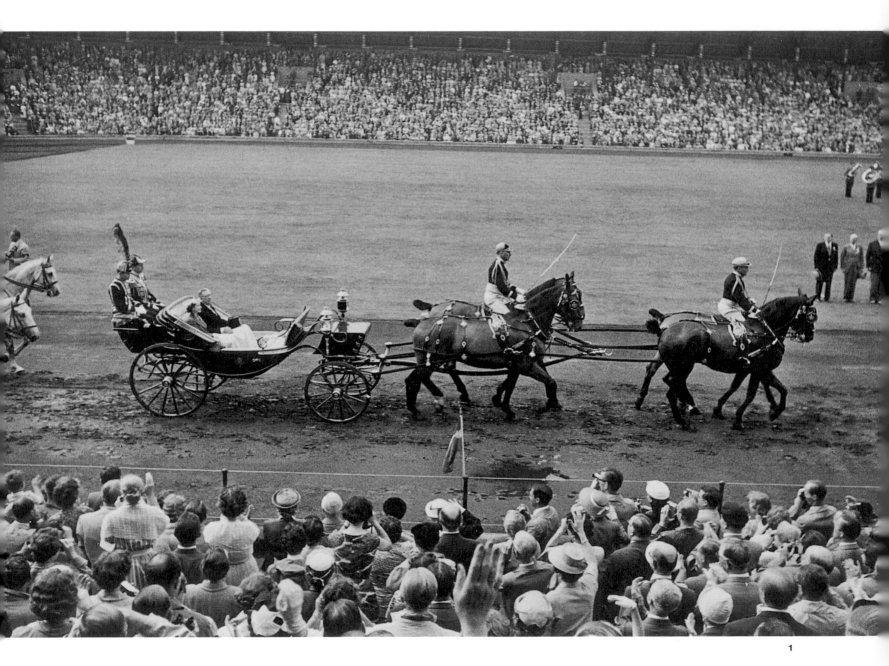

Australia, the host country of the twenty-sixth Olympiad in Melbourne, imposed a six-month quarantine period on animals. The International Olympic Committee (IOC) therefore decided to shift the equestrian events to Stockholm. King Gustaf VI and Queen Louise presided over the opening ceremony, which was also attended by Queen Elizabeth and Prince Philip from the UK. Twenty-nine countries were represented, Australia among them.

1. Queen Elizabeth II of the United Kingdom and King Gustaf VI of Sweden at the opening ceremony.

2. L. Hartel, silver medalist in dressage, on Jubilee.

2

The German and Swiss judges were suspended for each having ranked their own country's riders in the first, second, and third places. The IOC threatened to remove dressage from the Games. Sweden took the gold with the same team that had been awarded medals in 1948.

(The 1948 team had been disqualified the following year for having falsely represented Gehnäll Persson as a commissioned military officer, when in fact he had been promoted solely to qualify for the event.) Lis Hartel repeated her remarkable performance in the 1952 Games, winning a second silver medal.

Just four years after women first participated in the Olympic dressage event, two female riders won medals, Liselott Linsenhoff taking the silver for West Germany. Women constituted one-third of the riders.

3 >

— jumping

Women were allowed to take part for the first time, but only two of them participated: Great Britain's Pat Smythe, who came in tenth, and the Belgian Brigitte Schockaert, ranked thirty-fourth. The D'Inzeo brothers both earned recognition, winning places on the podium. Raimondo took the silver and Piero the bronze, coming in behind the world double champion Hans Günter Winkler.

— eventing

Obstacle 22 of this course, known as the "Trakener Ditch," proved an extremely tough test for the participants. A log placed above a ditch, it precipitated twelve falls, twenty-eight refusals, and three eliminations, including a fatal accident. Despite these difficulties, the three riders who were ahead after the cross-country phase maintained their respective places on the podium, each one knocking down two bars during the final show-jumping phase.

1. L. Linsenhoff, silver medalist in dressage.
2. The British rider P. Smythe on Flanagan.
3. Award ceremony for H. G. Winkler on Halla.

1

2 3 >

The 1950s

1956—1957
FEI Championships

1956 — FEI World Championships

jumping

Aachen, West Germany
The Italian rider Raimondo D'Inzeo became the world champion with his faithful Merano, the same horse that had helped him win the silver medal a month earlier at the Stockholm Olympics, when he came in just behind Hans Günter Winkler. But D'Inzeo wasn't able to take his revenge on the recently crowned German Olympic champion: Winkler missed the Aachen event owing to an injury he suffered in Stockholm.

1957 — FEI European Championships

jumping (men's)

Rotterdam, Netherlands
The first Jumping European Championships were created by the FEI to replace the World Championships, which had thus far been an annual event. It was now decided that the World Championships would be held only in Olympic years and organized on the same continent, as the FEI wished to encourage participation by distant countries. Hans Günter Winkler once again fared well in this competition. This type of competition with the final-four horse rotation seemed to highlight his riding skills and horsemanship.

eventing

Copenhagen, Denmark
August Lütke-Westhues, riding Franko for the GDR, took the lead after the dressage phase, closely followed by Sheila Willcox, the British rider of High and Mighty. Of the twenty-six initial participants, only nineteen remained after the endurance race. There were twenty falls and forty refusals. Just three riders completed the cross-country course without incident. Only Derek Allhusen and Laurien achieved a clear round on the show-jumping course, and all the other competitors knocked down at least two bars. Four years after the title of European champion was created, Sheila Willcox became the first woman to claim the honor. For this discipline, women continued to be excluded from the Olympics, however.

jumping (women's)

Spa, Belgium
Recognizing the growing number of women riding at international level, the FEI created a European Championship exclusively for them. The event was just like the men's: the four best riders had to compete—after three qualifying competitions—in a final-four horse rotation. At the conclusion of the final of four, Pat Smythe and Giulia Serventi were tied on penalties and had to break the tie with a final jump-off with a horse rotation. Each selected her reserve horse for the first round: Perseo for Serventi and Prince Hal for Smythe. Smythe had a clear round on her horse, while Serventi was penalized for one fault. But there was a dramatic reversal in the final round. Everyone had expected Smythe to be the victor, but she notched up three faults while riding the Italian rider's horse. After such a staggering upset, Serventi's triumph seemed inevitable. But the game wasn't over yet. Smythe's horse jumped so high and with such power that the Italian rider lost her balance. She ended her round with 18.5 penalties, conceding the title to her British rival.

(facing page)
Sheila Willcox and High and Mighty training in Windsor for the European Championships. Behind them are E. E. Marsh (Wild Venture), K. Tatham-Warter (Pampas Cat), G. Morrison (Benjamin Bunny).

1958
FEI European Championships

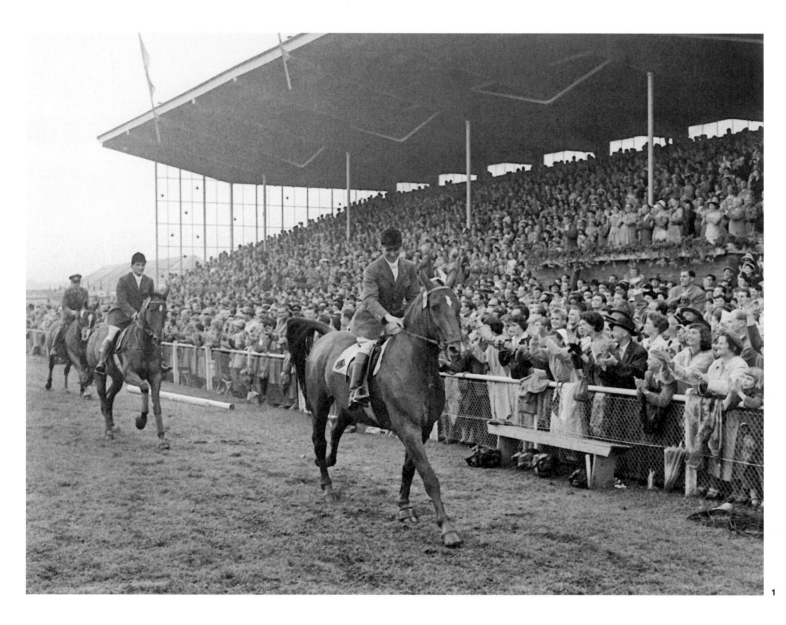

jumping (men's)

Aachen, West Germany
These championships were a huge success, attracting massive participation. The FEI once again changed the rules of play: they eliminated the final between the four best riders, as well as the horse rotation. The new formula became the standard, and consisted of four competitions. Fritz Thiedemann and Meteor won the title. Raimondo D'Inzeo had been wearing a cast on his arm since a fall in Lisbon. He wasn't in line for the championship, but that didn't prevent him from participating in the competitions organized alongside the main event— and winning one, despite his injury.

jumping (women's)

Palermo, Italy
The format of the competition was altered, and the new rules followed those of the men's European Championships. But the scheduling of this event conflicted with other major international equestrian events, and only thirteen participants attended. Giulia Serventi won the title in the absence of Pat Smythe, who chose to compete in an international show-jumping event in London instead.

1. and **2.** F. Thiedemann, European jumping champion, on Meteor.

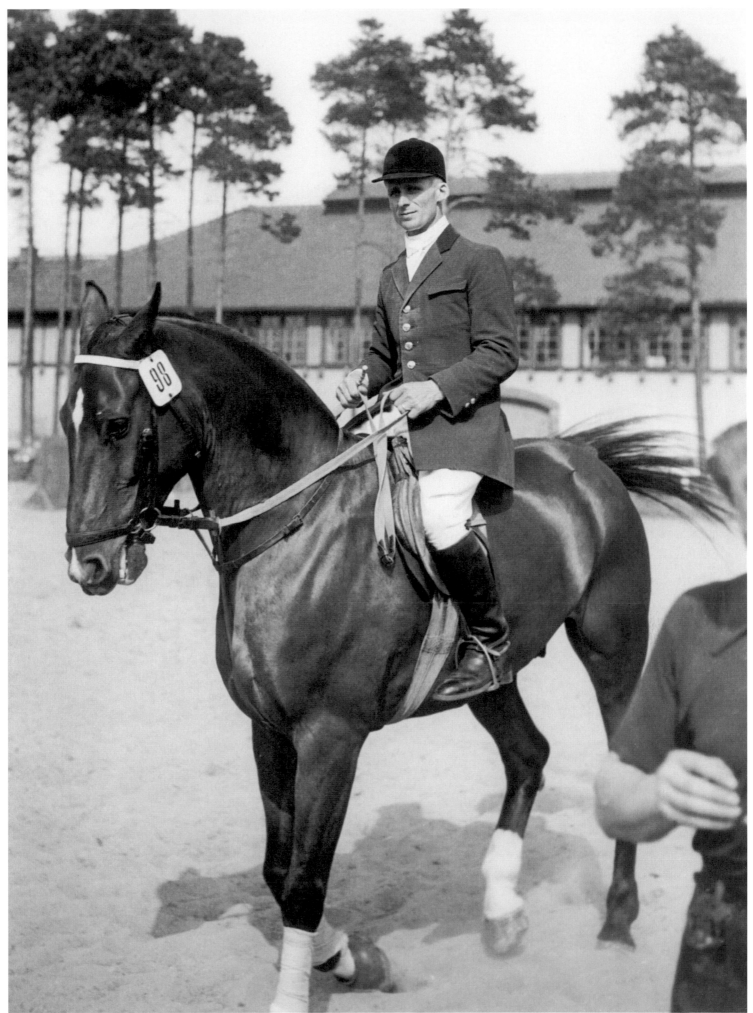

2

1959
FEI European Championships

1. and **2.** P. D'Inzeo,
European jumping
champion, on The
Quiet Man.

jumping (men's)

Paris, France
Once again, the rules changed for these championships, and the final with the horse rotation was revived. An array of impressive riders competed, including Jonquères d'Oriola, Winkler, Thiedemann, and Piero D'Inzeo. The final-four horse rotation highlighted the talents of the Italian rider, who won the title.

jumping (women's)

Rotterdam, Netherlands
Ann Townsend and Bandit IV won the competition, coming in ahead of the two previous holders of the title. Pat Smythe, the 1957 champion, finished second ahead of Giulia Serventi, winner in 1958. So there were two British riders on the podium, and it came as no surprise to see an all-woman national team competing in the next Olympic Games.

eventing

Harewood, United Kingdom
West Germany's victory in this competition marked the end of British supremacy in the discipline—and justly so: having grown accustomed to winning the gold every year since 1953, the team, although it was competing on its home turf, dropped to second place by less than a penalty. The top place on the individual podium also eluded the British riders, although they represented nearly half of all the participants.

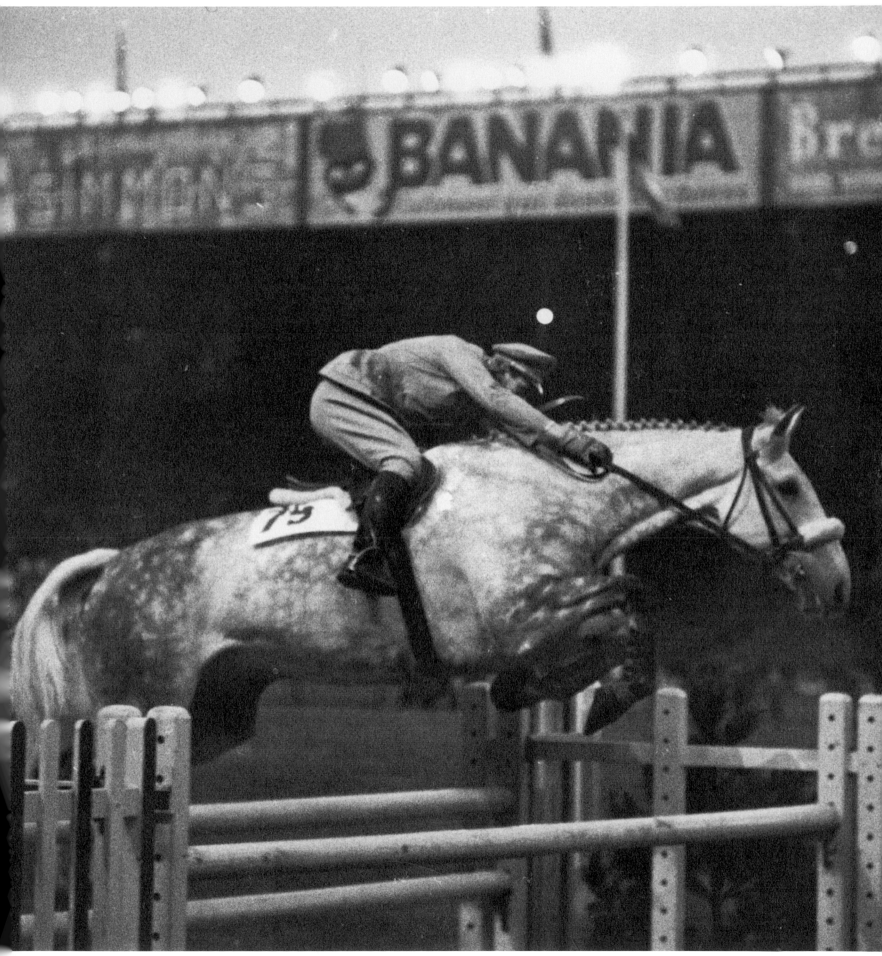

Hans Günter Winkler

An indefatigable horseman

Full of tragedies, joys, and international triumphs, there was nothing banal about Hans Günter Winkler's life. Born on July 24, 1926, in Barmen in northwestern Germany, Hans soon moved with his family to Frankfurt, where his father Paul managed a riding school. The family was devastated by the ravages of World War II. Winkler's father was enlisted into the army and was killed in the final weeks of the conflict. The family home was destroyed, and Hans, who had joined an anti-aircraft battalion, was taken prisoner. Released after the war ended, Hans became responsible for supporting his family. As a groom, he joined the staff of the stables of the Prince de Hesse in Kronberg im Taunus, which at the time was occupied by the American army. He was responsible for the day-to-day supervision of General Eisenhower's horses.

At the end of the Occupation in 1950, Hans joined Germany's national show-jumping team, a discipline in which he had already achieved considerable success. His supervisors asked him to train Halla, a young mare whose sire was a trotter, initially deemed unsuitable for show jumping. The horse and man formed a partnership and achieved success as a team. However, Hans, as a professional trainer, was not able to participate with her in 1952 at the Helsinki Olympics because the Games were restricted to amateur competitors.

Recognition came during the Melbourne Olympics in 1956, whose equestrian events took place in Stockholm owing to Australian quarantine regulations. During the first round, Halla had to make an extraordinary effort to clear the extremely difficult triple combination. Although the mare managed the jumps, Hans lost his balance, tearing an adductor muscle. Racked with pain, he kept going, but could not avoid a fault on the final obstacle. Two medals hung in the balance—but there was no way he would quit the competition. Spectators recall that during the second round the rider merely pointed Halla in the right direction, and the horse did the rest. They achieved a clear round, and were unforgettable Olympic champions in both

the individual and team competitions. Numerous other international triumphs followed, including a team gold medal in the Rome Olympic Games in 1960, the Tokyo Olympics in 1964, and the Munich Games in 1972.

The German hero retired at the peak of his accomplishments in 1986. After a final victory lap in Aachen, the mecca of German equestrian sports, he dedicated himself to training and managing his company, HGW Marketing, whose mission is to seek sponsors for riders and equestrian events.

The champion lived a hectic, nonstop life. Married four times, he fathered two children, Jorn Paul and Jytte Esther, from his second marriage to Marianne Gräfin Moltke. He experienced tragedy when Debby Malloy, whom he'd married in 1994, died after falling from her horse in 2011 at the age of fifty-one. Hans died at his home of a heart attack on July 9, 2018.

> "My father was a true horseman. Every one of his horses lived out its final years close to his home. He felt a deep affection for them and didn't want to let them go."
>
> — Jorn Paul Winkler

Jorn Paul Winkler remembers his father

Hans remained an exceptional performer throughout his career, riding many horses. He was undeniably blessed with an incredible talent, and diligence and perseverance did the rest. "My father was a hard worker, very demanding of himself and others. Most of his students would tell you that he was harsh. Many who tried to work with him soon threw in the towel! My father was a tough guy, and he would have done anything to win and support his team. When he tore an adductor muscle in Stockholm during the Olympics, he never for a moment considered quitting. He went back to the ring and did what he had to do. He would have had to be dead to give up!"

But that wasn't all, by any means. He genuinely loved horses. "My father was a true horseman. Every one of his horses lived out its final years close to his home. He felt a deep affection for them and didn't want to let them go. Of course, they were the tools of his trade, but they were also his friends. His professional success was based on his understanding of horses and the relationship that he developed with them. He listened to them, and he understood them. He was a true horse lover. There was nothing he enjoyed more than taking care of them."

Hans was tireless, constantly promoting his sport. "If my father were still alive today, he'd be attending a competition this weekend! He was a bit like an artist, fascinated by every aspect of what he did. When he retired from the competitive circuit, he certainly didn't stop riding or devoting time to equestrian sports. He yearned for the sport to be more accessible, and he wanted to get the next generation involved."

Hans passed his fierce determination to win and his sense of commitment on to his family. "My father taught me that you have to struggle to achieve a goal, and return again and again to learn from mistakes. I'm so fortunate that he taught me these lessons. At his funeral, I tried to reflect on my most precious recollection, and I realized that my entire life with him was really my best memory. All of it was great, from the high points to the everyday routine."

Career Highlights

Jumping

1954
Individual gold in the FEI World Championships in Madrid with Halla

1955
Individual gold in the FEI World Championships in Aachen with Halla and Orient

1956
Individual and team gold at the Melbourne (Stockholm) Olympic Games with Halla

1957
Individual gold in the FEI European Championships in Rotterdam with Halla

1960
Team gold at the Rome Olympic Games with Halla

1961
Individual bronze in the FEI European Championships in Aachen with Romanus

1962
Individual silver in the FEI European Championships in London with Romanus

1964
Team gold at the Tokyo Olympic Games with Fidelitas

1968
Team bronze at the Mexico City Olympic Games with Enigk

1969
Individual bronze at the FEI European Championships in Hickstead with Trophy

1976
Team silver at the Montreal Olympic Games with Trophy

1. Ceremony for Winkler's retirement from competition during the FEI World Championships, Aachen, 1986.

2. In the jumping competition, Stockholm, 1956.

Hans von Blixen-Finecke Jr.

Riding as an art

The life of Hans von Blixen-Finecke Jr. was profoundly influenced by the accomplishments of his father, who had won a bronze medal in dressage in the 1912 Olympics. Sadly, he never knew his father, who died in a plane crash when he was just a year old. Originally christened Nils Gustaf Fredrik Bror when he was born on July 20, 1916, in Linköping, Sweden, he was renamed Hans in his father's memory.

Hans Junior began to follow in his father's footsteps at an early age. He became a highly regarded cavalry officer and steeplechase and flat-course jockey, joining the Swedish cavalry regiment in 1937. From 1959 until 1965, he served as a colonel in the Swedish army's riding school in the Strömsholm Palace.

At the same time as he was pursuing a military career, Baron Hans von Blixen-Finecke Jr. was excelling as a steeplechase jockey, winning the Swedish amateur competitions in 1945 and 1946. He soon turned to the disciplines of dressage and eventing with equal success. During the 1952 Olympics in Helsinki, riding Jubal, he secured both the individual and team gold medals. In addition to this outstanding accomplishment, Hans achieved another rare success: his other horse, Master Rufus, won the individual Olympic championship in dressage. However, Henri Saint Cyr was in the saddle for this event, to avoid the then-existing ban on competing in two disciplines during a single Olympiad.

Hans ended his military career in 1964 and moved to the United Kingdom, leaving his wife and two sons in Sweden. He served as the British national trainer for several years until he was recruited by Canada. His time there was brief, and he returned to the UK, settling for good in Surrey in southeastern England, where he established a riding center.

Following retirement in the early 1970s, he resumed his coaching activities for a number of riders. In 1975, he began working with Jane and Christopher Bartle, who became prominent on the international circuits thanks to Hans's instruction.

Building on his success with the Bartle family, the former soldier acquired a distinguished reputation and traveled throughout the world to teach riding, passing on his technique to the next generation. Hans always considered the well-being of the horse, striving to help the horse through carefully structured training exercises. He was not satisfied with merely applying modern training techniques; he challenged accepted wisdom, ensuring that training practices were based on a clear understanding of the best way to help horses to achieve peak performance, taking both the mental and physical aspects into consideration.

Hans was a visionary who stood out among other professionals. He was committed to developing and enhancing the standards of international dressage, with an emphasis on respecting the integrity of the horse. His life was dedicated to disseminating these principles. Shortly after returning home from a dressage event in Stockholm in 2005, he died of influenza, aged eighty-nine, with his second wife, Anne Meriel, at his side.

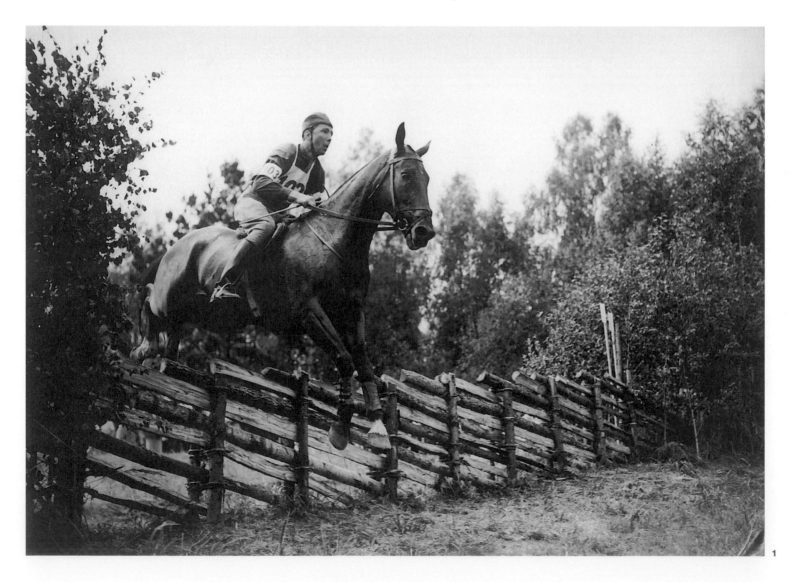

The 1950s

"He was constantly observing the horse's nature, He was a highly cerebral trainer, attentive to every detail."

— Christopher Bartle

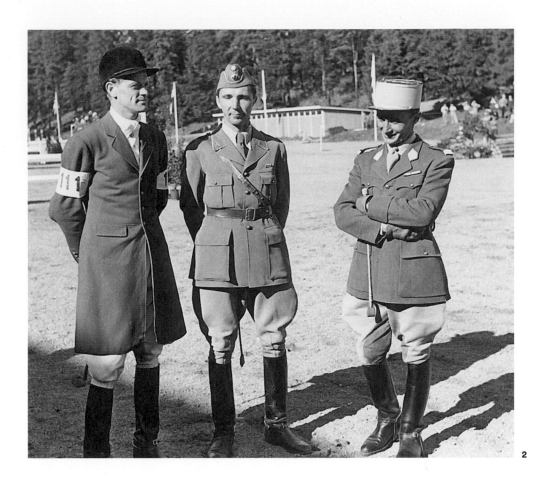

2

Christopher Bartle, dressage and eventing rider, and subsequently national trainer for Germany (2001–16) and the British team, remembers Hans

Although he had a military background, Hans van Blixen-Finecke Jr. did not apply rigid standards to his horses. He wanted to develop equestrian sports in a more natural direction, showing respect for the animal. "The Baron always asked himself 'Why?' He was constantly observing the horse's nature—the way the animal understood the rider's cues and responded to these various indications. He was a highly cerebral trainer, attentive to every detail."

Whether mounted or on foot, Hans Jr. applied his distinctive approach to training, and "that was what made him such a great horseman. He rode with awareness and feel. He paid close attention to his horse's every response and slightest movement, striving for maximum naturalness, particularly in terms of balance. Horses were at ease around him—they strove to give him the best of themselves."

Nevertheless, discipline was paramount, and Hans insisted on being heard—sometimes for long periods of time. "The Baron accepted and understood mistakes, but his views were very strongly held: they were the only correct ones, in his opinion. He never yelled; he'd ask us to stop and discuss, understand, and digest what he had to say before starting over and trying again and again. When we went to the Los Angeles Olympic Games in 1984, I asked just one thing of him: that he spare me his lengthy explanations until our time there was over. I wanted him to leave me on my own and let us analyze things after the fact."

Chris credits Hans as one of the key contributors to his own current success as a trainer. "He taught me a genuine philosophy of horses, and I shaped myself in his image. I was his protégé and am following in his footsteps. He was much more than a trainer for me; he was a spiritual father, a role model I strive to live up to. Unfortunately, I'll never achieve his greatness."

Career Highlight

Eventing

1952
Individual
and team gold medals
at the Helsinki
Olympics
with Jubal

1. In the individual eventing competition, Helsinki, 1952.

2. The three individual winners in 1952: (left to right) W. Büsing (Hubertus), H. von Blixen-Finecke Jr. (Jubal), G. Lefrant (Verdun).

Henri Saint Cyr

The gentleman competitor

1952
Individual
and team gold
in the Helsinki
Olympic Games
with Master Rufus

1953
Individual gold
in the FEI Grand
Prix, Wiesbaden,
with Master Rufus

1956
Individual
and team gold
in the Stockholm
Olympic Games
with Juli

1. On Master Rufus,
Helsinki, 1952.

2. On Juli, Stockholm,
1956.

1

Winner of four Olympic gold medals, Henri figures prominently among his nation's equestrian champions. He was born on March 15, 1902, in Stockholm and was twenty-two when he enlisted in the Swedish army. He had a distinguished military record, rising from the rank of major to squadron leader, and joining the army reserve forces in 1957. While serving in the military, he inaugurated his athletic career in show jumping and eventing. He represented Sweden in the eventing competition at the 1936 Berlin Olympics, where he was ranked twenty-third individually, riding a horse named Fun. Following an injury, Henri turned to dressage, a discipline in which he immediately excelled. He benefited from intensive training at the cavalry school in Saumur under the aegis of Lieutenant-Colonel Georges Margot. Henri became director of the institution in 1950 and obtained French citizenship, though he continued to compete for Sweden.

Henri was a member of the Swedish team that participated in the 1948 London Olympics, where he won fifth place mounted on Djinn. The Swedish threesome of Henri Saint Cyr, Gustaf Boltenstern, and Gehnäll Persson won the team gold, but this medal was rescinded the following year and awarded to France based on accusations of impropriety: at the time, participation in riding competitions was reserved for officers, and it was claimed that Gehnäll Persson had been promoted expressly for the occasion. He was subsequently demoted several weeks later.

This unfortunate episode did nothing to tarnish the quality of the Swedish riders. Four years later they proved themselves at the Helsinki Olympics, demonstrating the scope of their abilities and winning the dressage gold in strict compliance with the rules. On this occasion, Henri's mount was Master Rufus, a horse that was usually ridden by Hans von Blixen-Finecke. Hans was taking part in the eventing competition at these Games, and could not compete in dressage as well. He entrusted his fifteen-year-old chestnut to his fellow team member Henri.

The duo performed brilliantly together, and they were awarded the Olympic title despite the formidable challenge posed by the Danish rider Lis Hartel. This valiant sportswoman had been paralyzed below the knees by polio in 1944, yet continued to compete at the highest levels. Henri outperformed her by just a few points in a hard-fought competition, and a moving and inspirational page of Olympic lore was written at the conclusion of the event. Henri assisted his opponent to dismount and carried her to the podium, where he supported her as the medals were awarded. The audience was moved to tears by the spectacle. The French public celebrated this victory of sportsmanship, which they saw as a triumph of their country's equestrian tradition. The Germans, on the other hand, criticized the Swedish team, complaining that their horses were lacking impulsion and contact with the bit.

In any case, the Scandinavian nation's hegemony continued. The following year, Henri and Master Rufus were named champions at the FEI Grand Prix, Wiesbaden. In 1956, Henri was selected to recite the Olympic oath during the opening ceremony of the Stockholm Games. Riding in front of his fellow compatriots, mounted on Juli, he once again won the individual competition, coming in ahead of Lis Hartel. His performance was distinguished by seemingly effortless grace, despite the very bad footing following incessant rainstorms. Henri also contributed to another gold medal for the Swedish team. Impressed by his performance, Queen Elizabeth II invited Henri and his wife, Ruth, to meet the Duke of Beaufort at the eventing competition in Badminton.

Henri appeared again at the 1960 Olympics in Rome, where he was ranked fifth riding L'Étoile. This occasion marked Henri's final Olympic appearance. Four years later, he was the victim of an accident in Paris. Severely injured, he was unable to compete at the Tokyo Olympic Games. After a rapid recovery, he again distinguished himself in 1965, winning the legendary Aachen Grand Prix before finally retiring from his equestrian sporting career.

With a roster of four hundred victories in dressage, a French Legion of Honor medal, and comparable awards from Germany, Austria, and Belgium, Henri's career was the stuff of legend. He died on July 27, 1979, in Kristianstad.

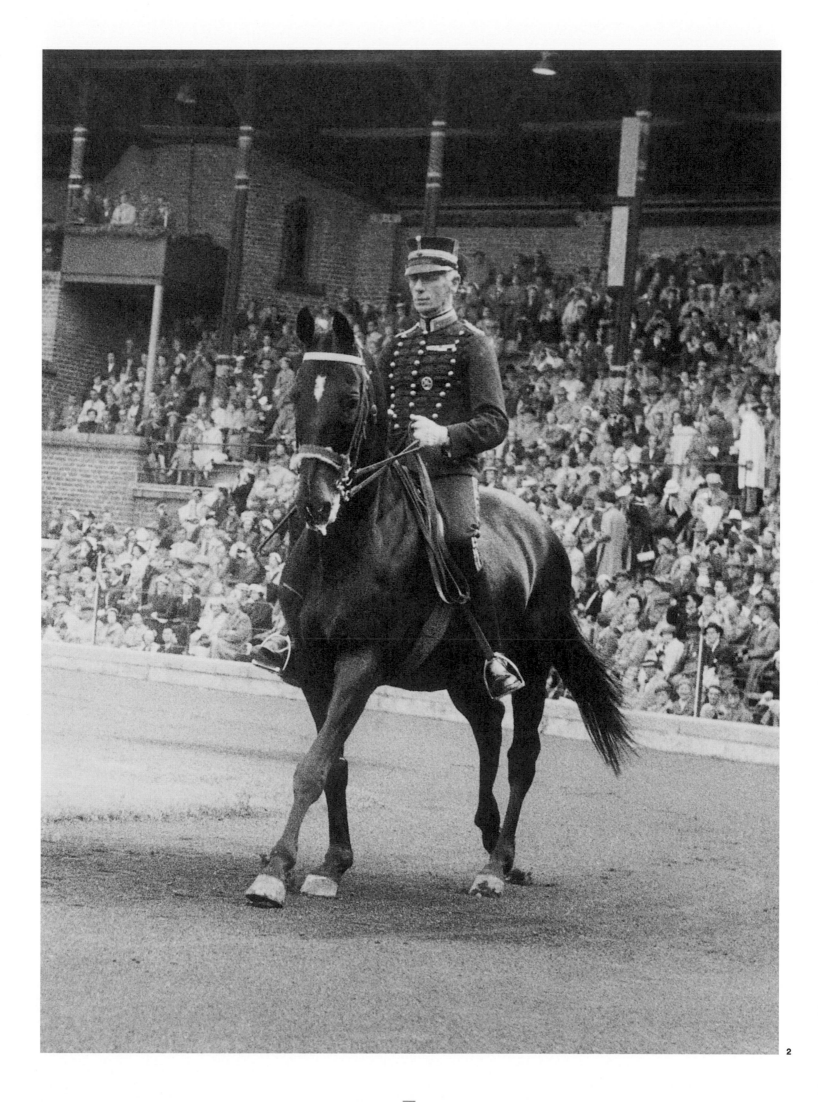

Jubilee

Generosity of spirit

Jubilee was born in Denmark in 1941 in the stables of Otto Viller Petersen; she was the offspring of the Thoroughbred Rockwood XX and an Oldenburg dam. The foal initially seemed unremarkable, giving no hint of her future starring role in the discipline of dressage. She was not a notably beautiful or elegant horse, and had a rather long back. Even later, when Jubilee's more fully developed musculature enhanced her appearance, she never impressed spectators with her physical presence: in fact, fans were often surprised when they saw her in the box.

The Holsts family purchased the young bay when she was four. Their daughter Lis (married name Hartel) was already an accomplished dressage rider who had won the 1943 and 1944 national championships mounted on Gigolo. Jubilee was intended to be a serviceable family horse, ridden by Lis's father and sister Tove, and used for simple dressage movements, recreational jumping, and casual rides.

A polio epidemic hit Denmark in 1944. Lis, who was pregnant at the time, was infected by the virus, which left her paralyzed below the knees. Doctors told her that her athletic career was over, offering only the tentative consolation that she

might one day manage to walk with the aid of crutches. Lis, then twenty-three, had her own, very different, plans. After spending four months in the hospital, she launched on a rehabilitation program to rebuild her muscular strength. Just one year later, despite some lingering weakness in her legs, she was once again in the saddle, with assistance in mounting and her horse led in hand. Her primary goal was to regain feeling in her legs. After numerous falls, Lis finally discovered the technique for maintaining her balance, and was once again able to work on her own. In 1945 she resumed dressage training. The Holsts family realized that Jubilee was the ideal partner for their daughter's endeavors.

Jubilee had a calm, docile, and generous nature. She needed to master the basics, both in the discipline of dressage and as a therapeutic horse. The bay mare soon learned to stand still as Lis hoisted herself into the saddle and quickly understood the new cues she had to respond to. A true partnership was inaugurated between horse and rider. In 1948 Lis began training with the renowned rider Gunnar Andersen, who helped Jubilee to build up her muscular strength and master the most challenging aspects of dressage. In 1949, the two companions were finally ready to begin competing at able-bodied competitions.

Lis and Jubilee soared through the rankings from their first intermediate level tests. By the following year, the bay had become invincible at this competitive level and moved ahead to the next. In their international debut in 1951, Jubilee and

Lis won the Prix St-Georges in Rotterdam, competing head to head with the many non-disabled riders. Despite the bay's mediocre piaffe, their Danish championship title qualified the pair for the Helsinki Olympics the following year.

Traveling by boat, the mare disembarked in Finland to make her partner's Olympic dreams a reality. Lis was apprehensive, but Jubilee delivered a brilliant performance; her flawless flying changes offset the weaknesses of her piaffe and won Lis the individual silver. The prize-giving ceremony was a moment of high emotion: the spectators became aware of the brilliant young competitor's disability only when the gold medalist of the competition, Henri Saint Cyr, carried her from her horse to the podium and helped her remain standing for the prize-giving ceremony.

After winning this title, Lis and Jubilee continued on the competitive circuit, still in quest of victories. They earned a place in the first FEI Dressage World Championships in 1954 in Aachen, where Jubilee triumphed. A transatlantic victory tour ensued, from London and Paris to New York and Toronto. Their final year of competition was in 1956. Having claimed their fifth national championship, Lis and Jubilee, flag-bearers for Denmark, were ranked among the favorites in the Stockholm Olympics. Captivating both the audience and the jury, the duo once again took the silver medal, to the dismay of many, who deplored a judging error: they believed that Lis and Jubilee should have won the Olympic title. The gold may have eluded them, but they had won over their admirers with their nobility, hope, perseverance, courage, and love.

Following the Olympics, Jubilee was retired from competitive riding, with plans for a new career as a brood mare. But, sadly, she soon fell ill and suffered severe damage to her leg. Despite the veterinarians' best efforts, nothing could be done, and in June 1957 Lis was forced to bid farewell to her beloved mare.

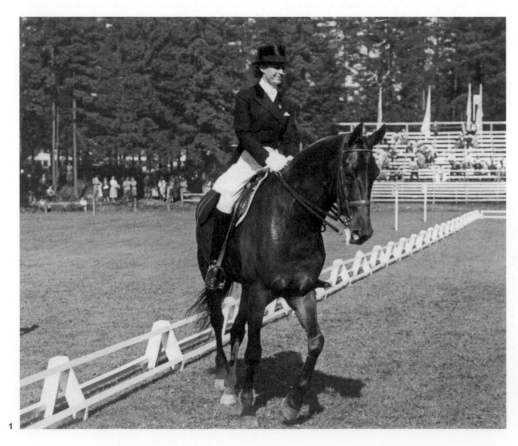

1

"The bay mare soon learned to stand still as Lis hoisted herself into the saddle and quickly understood the new cues she had to respond to."

Career Highlights

Dressage

1952
Individual silver
in the Helsinki
Olympics with
Lis Hartel

1956
Individual silver
in the Stockholm
Olympics with
Lis Hartel

1. and **2.** Jubilee
and L. Hartel,
Helsinki, 1952.

2

Women at the Olympic Games: The Path to Participation

Horse riding is clearly a mixed sport, but for many it is still considered an activity primarily for young girls. Horse riding is, however, the only Olympic sport in which women and men compete in the same contests on equal terms and share the same podiums. While this distinction seems today both a foregone conclusion and a point of pride for equestrian sports, women faced a long and arduous path before they were finally able to compete alongside male athletes.

There is evidence that women have been riding horses since earliest antiquity: some, including the Sauromatians and the Scythians, would have ridden into battle alongside men, for example. Likewise, in the Middle Ages the custom of women riding horses was widespread. Women came into close contact with horses when working in the fields or traveling, and, once again, there is evidence that women rode into combat: Joan of Arc is just one example among many warrior horse-women. Over time this tradition declined, however, and it became less and less accepted for women to ride on horseback in the same way as men.

Two factors explain this decline, and the difficulty women later had in riding at competition level. First, up until the development of the internal combustion engine horse riding was primarily a military pursuit, and as fewer and fewer women joined battle, so there were fewer opportunities for riding. Even during hunting expeditions, women usually followed behind in carriages. The second factor was the introduction of the side saddle in the Middle Ages. Women had been riding astride since the horse was domesticated, but by the eighteenth century they were obliged to ride side saddle for reasons of propriety; it meant that they could ride wearing a dress without showing their legs. At the same time, there arose the mistaken belief that riding would damage a woman's hymen, and thus it became associated with the loss of virginity.

Being able to sit astride was an important issue for women riders, but masculine resistance to it was stubborn: indeed, the famous French animal painter Rosa Bonheur, working in the second half of the nineteenth century, had to obey a ruling dating back to 1800 that obliged women to file cross-dressing requests every six months in order to be allowed to wear trousers when riding a horse. Similarly, in England, King George V forbade women from riding astride during the Olympia Horse Show in London in 1913. Women could find a measure of freedom in the circus world, however, and a few nineteenth-century female riders became world famous.

It was only in the twentieth century that women made their first forays into competition: the two world wars normalized their presence on horseback, emancipation movements removed the stigma against women riding astride, and horse riding became an official sport. However, even though women competed in different disciplines in country shows and fairs, there was great resistance to making these customs official. The history of the Olympic Games is a perfect illustration of this; indeed, the founding father of the modern Games, Pierre de Coubertin, considered "the female Olympian uninteresting, unsightly, and inappropriate."

Nonetheless, from 1900 onward women took part in the Games, participating in various disciplines without competing against men. Women's archery contests first appeared in 1904, skating in 1908, swimming in 1912, and athletics in 1918. However, the equestrian world was both closed and conservative, and contests remained reserved for military officers until 1952. Beyond the Olympic Games, the pressure from women who wanted to participate was so great that it was difficult for organizations to ignore, especially since the FEI was now advising the International Olympic Committee on which disciplines should be permitted to participate in the Olympics.

During the 1952 Helsinki Games, four women competed for the first time, alongside non-commissioned officers and civilians. Although their participation was restricted to the dressage competitions, this debut was highly symbolic. The Danish rider Lis Hartel took part with her horse Jubilee, despite having lost the use of her legs below the knee as a result of contracting polio in 1944. She won a silver medal in her debut competition and shared the podium with two soldiers, one of whom, the Swiss Henri Saint Cyr, helped her to the stand.

The way was clear, and subsequent Games saw women take their place beside men in all three equestrian disciplines. In 1956, in Stockholm, two women competed in the show-jumping classes for the first time: the British woman Pat Smythe, who finished tenth, and the Belgian Brigitte Schockaert. In 1964, the American rider Lana duPont was the first woman to take part in three-day eventing. By 1968 the figures had risen markedly, and there were thirteen women participating in the Mexican Olympic Games. Four years later, at the Munich Games, Liselott Linsenhoff won the Olympic crown in dressage. Although several of her colleagues went on to match her achievement during successive Olympic Games, to this day no woman has managed to bag an individual gold Olympic medal in show jumping or eventing.

At world championships, the Briton Mary Gordon-Watson won eventing titles from 1970 onward, and many women subsequently matched her achievement. The Canadian Gail Greenough won the show-jumping title in 1986, and her success was matched only in 2018 by German equestrian Simone Blum on DSP Alice.

The FEI staged the Women's European Championships for many years (1957–73), as well as three women's world championships (in 1965, 1970, and 1974), during which the best competitors—for example Pat Smythe, Marion Coakes, Kathy Kusner, and Janou Lefebvre—excelled themselves. These initiatives were quickly abandoned, however, as women preferred to compete against men and to participate in international competitions. And rightly so: doubters only have to look at the record of achievements over the past few decades to be convinced. The only sporting discipline in which men and women compete on an equal footing, thanks in no small part to these pioneering figures, horse riding has become a leading exponent of equality between the sexes in the field of sports. Many women occupy important positions in the FEI and the equestrian federations of individual countries.

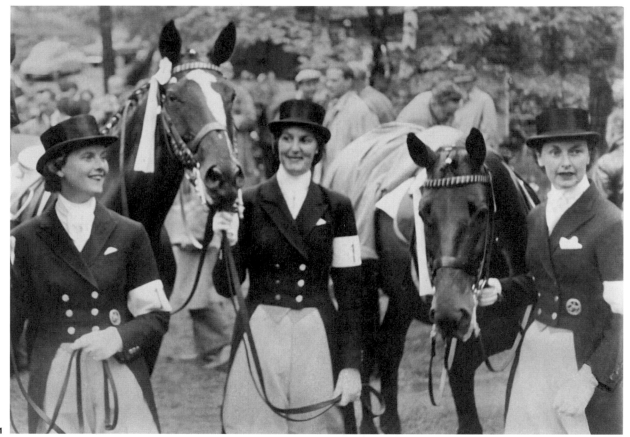

1. (from left to right)
H. Weygand,
L. Linsenhoff, and
L. Hartel at the Stockholm
Olympic Games, 1956.

2. Janou Lefebvre in 1974.

Janou Lefebvre

French show-jumping competitor Janou Lefebvre speaks openly about the 1960s and 1970s, when women first began to compete, saying that she did not find it a struggle. When asked about the 1964 Olympic Games selection process, she replied: "I wasn't in the team at the outset. I was lucky to come second in the Aachen Grand Prix in 1963, and the soldier who was team leader was forced to select me. He was not in favor of having women in his team, which amused and motivated me. It was up to me to prove them wrong." Once selected, Janou had no problem with the male riders. "They were old. They were never spiteful to me; we didn't see one another." At the age of nineteen, she was competing alongside Guy Lefrant, who was forty-one years old, and Pierre Jonquères d'Oriola, who was forty-four.

At the beginning of her career, Janou worked alone and got on well with American equestrian Kathy Kusner. "She came to my house when she was on tour in Europe, and she made me work. I learned a lot. The best way for me to learn was to invite her to my house every day and just watch her. I saw a different style of horse riding, and it was comforting to know that the great American champion was there. We became friends in the end."

For Janou, it was natural to hold mixed championships, because too few women were interested in competing, and because the women who did were used to standing up to the men. "All year round we would compete with the men, so the mixed championships were not a problem for me. Physical strength is not an issue on horseback, so there was no difference between men and women."

Nevertheless, there is one fundamental difference between the two sexes: one that pushed Lefebvre to retire suddenly from a sport in which she had had a great deal of success. "I stopped riding when I had a baby. I became less bothered about competitions and felt the need to stay home. My son was born on December 31, 1978, and I stopped straight away. I no longer felt passionate about it. I've never missed it; you don't miss something when you have a child."

The
1960s

RESULTS 1960–1969

1960
⚬⚬⚬ OLYMPIC GAMES, ROME

DRESSAGE
GOLD Sergei Filatov (URS) and Absent
SILVER Gustav Fischer (SUI) and Wald
BRONZE Joseph Neckermann (GER†) and Asbach

JUMPING
— *Individual*
GOLD Raimondo D'Inzeo (ITA) and Posillipo
SILVER Piero D'Inzeo (ITA) and The Rock
BRONZE David Broome (GBR) and Sunsalve
— *Team*
GOLD Germany†: Hans Günter Winkler (Halla), Fritz Thiedemann (Meteor), and Alwin Schockemöhle (Ferdl)
SILVER United States: Hugh Wiley (Master William), William Steinkraus (Riviera Wonder), and George Morris (Sinjon)
BRONZE Italy: Raimondo D'Inzeo (Posillipo), Piero D'Inzeo (The Rock), and Antonio Oppes (The Scholar)

EVENTING
— *Individual*
GOLD Lawrence Morgan (AUS) and Salad Days
SILVER Neale Lavis (AUS) and Mirrabooka
BRONZE Anton Bühler (SUI) and Gay Spark
— *Team*
GOLD Australia: Lawrence Morgan (Salad Days), Neale Lavis (Mirrabooka), William Roycroft (Our Solo), and Brian Crago (Sabre)
SILVER Switzerland: Anton Bühler (Gay Spark), Hans Schwarzenbach (Burn Trout), Rudolf Günthardt (Atbara), and Rolf Ruff (Gentleman)
BRONZE France: Jack Le Goff (Image), Guy Lefrant (Nicias), Jehan Le Roy (Garden), and Pierre Durand (Guiliano)

1960
🏆 FEI WORLD CHAMPIONSHIPS, VENICE

JUMPING
GOLD Raimondo D'Inzeo (ITA) and Gowran Girl
SILVER Carlos César Delia (ARG) and Huipil
BRONZE David Broome (GBR) and Sunsalve

1960
⚥ FEI EUROPEAN CHAMPIONSHIPS

JUMPING (WOMEN'S)
Copenhagen, Denmark
GOLD Susan Cohen (GBR) and Clare Castle
SILVER Dawn Wofford-Palethorpe (GBR) and Hollandia
BRONZE Anna Clement (FRG) and Nico

1961
⚥ FEI EUROPEAN CHAMPIONSHIPS

JUMPING (MEN'S)
Aachen, West Germany
GOLD David Broome (GBR) and Sunsalve (Silver Knight)
SILVER Piero D'Inzeo (ITA) and Pioneer (The Rock)
BRONZE Hans Günter Winkler (FRG) and Feuerdorn (Romanus)

JUMPING (WOMEN'S)
Deauville, France
GOLD Pat Smythe (GBR) and Scorchin (Flanagan)
SILVER Irene Jansen (NED) and Kairouan (Icare F)
BRONZE Michèle Cancre (FRG) and Océane (Jimmy B)

1962
⚥ FEI EUROPEAN CHAMPIONSHIPS

JUMPING (MEN'S)
London, United Kingdom
GOLD David Barker (GBR) and Mr. Softee (Franco)

SILVER Hans Günter Winkler (FRG) and Romanus (Feuerdorn)
BRONZE Piero D'Inzeo and Pioneer (The Rock)

JUMPING (WOMEN'S)
Madrid, Spain
GOLD Pat Smythe (GBR) and Flanagan
SILVER Helga Köhler (FRG) and Cremona
BRONZE Paolo Goyoaga-Elizalde (ESP) and Kif Kif

EVENTING
Burghley, United Kingdom
— *Individual*
GOLD James Templer (GBR) and M'Lord Connolly
SILVER German Gazyumov (URS) and Granj
BRONZE Jane Wykeham-Musgrave (GBR) and Ryebrooks
— *Team*
GOLD Soviet Union: German Gazyumov (Granj), Pavel Deev (Satrap), Lev Baklyshkin (Khirurg), and Saybaytol Mursalimov (Dzhigit)
SILVER Ireland: Anthony Cameron (Sam Weller), Harry Freeman-Jackson (St. Finbarr), Virginia Freeman-Jackson (Irish Lace), and Patrick Conolly-Carew (Ballyhoo)
BRONZE Great Britain: Frank Weldon (Young Pretender), Michael Bullen (Sea Breeze), Susan Fleet (The Gladiator), and Peter Welch (Mister Wilson)

1963
⚥ FEI EUROPEAN CHAMPIONSHIPS

DRESSAGE
Copenhagen, Denmark
GOLD Henri Chammartin (SUI) and Wolfdietrich
SILVER Harry Boldt (FRG) and Remus
BRONZE Henri Chammartin (SUI) and Woerman

JUMPING (MEN'S)
Rome, Italy
GOLD Graziano Mancinelli (ITA) and Rockette (The Rock)
SILVER Alwin Schockemöhle (FRG) and Freiherr (Ferdl)
BRONZE Harvey Smith (GBR) and O'Malley (War Paint)

JUMPING (WOMEN'S)
Hickstead, United Kingdom
GOLD Pat Smythe (GBR) and Flanagan (Scorchin)

SILVER Arline Givaudan (BRA) and Huipile (Caribe)
BRONZE Anneli Drummond-Hay (GBR) and Merely-a-Monarch (Tango)

1964
⚬⚬⚬ OLYMPIC GAMES, TOKYO

DRESSAGE
— *Individual*
GOLD Henri Chammartin (SUI) and Woerman
SILVER Harry Boldt (GER†) and Remus
BRONZE Sergei Filatov (URS) and Absent
— *Team*
GOLD United Team of Germany†: Harry Boldt (Remus), Reiner Klimke (Dux), and Josef Neckermann (Antoinette)
SILVER Switzerland: Henri Chammartin (Woerman), Gustav Fischer (Wald), and Marianne Grossweiler (Stephan)
BRONZE Soviet Union: Sergej Filatov (Absent), Ivan Kizimov (Ikhor), and Ivan Kalita (Moar)

JUMPING
— *Individual*
GOLD Pierre Jonquères d'Oriola (FRA) and Lutteur B
SILVER Hermann Schride (GER†) and Dozent II
BRONZE Peter Robeson (GBR) and Firecrest
— *Team*
GOLD United Team of Germany†: Hermann Schridde (Doznet II), Kurt Jarasinski (Torro), and Hans Günter Winkler (Fidelitas)
SILVER France: Pierre Jonquères d'Oriola (Lutteur B), Janou Lefebvre (Kenavo D), and Guy Lefrant (M. de Littry)
BRONZE Italy: Piero D'Inzeo (Sunbeam), Raimondo D'Inzeo (Posillipo), and Graziano Mancinelli (Rockette)

EVENTING
— *Individual*
GOLD Mauro Checcoli (ITA) and Surbean
SILVER Carlos Moratorio (ARG) and Chalan
BRONZE Fritz Ligges (GER†) and Donkosak
— *Team*
GOLD Italy: Mauro Checcoli (Surbean), Paolo Angioni (King), Giuseppe Ravano (Royal Love), and Alessandro Argenton (Scottie)

SILVER United States: Michael Page (Grasshopper), Kevin Freeman (Gallopade), John Michael Plumb (Bold Ministrel), and Lana duPont (Mr. Wister)
BRONZE United Team of Germany†: Fritz Ligges (Donkosak), Horst Karsten (Condora), Gerhard Schutlz (Balza), and Karl-Heinz Fuhrmann (Mohamet)

1965
🏆 FEI WORLD CHAMPIONSHIPS

JUMPING (WOMEN'S)
Hickstead, United Kingdom
GOLD Marion Coakes (GBR) and Stroller (Little Fellow)
SILVER Kathy Kusner (USA) and Untouchable (That's Right)
BRONZE Alison Westwood (GBR) and The Maverick

1965
⚥ FEI EUROPEAN CHAMPIONSHIPS

DRESSAGE
Copenhagen, Denmark
— *Individual*
GOLD Henri Chammartin (SUI) and Wolfdietrich
SILVER Harry Boldt (FRG) and Remus
BRONZE Reiner Klimke (FRG) and Arcadius
— *Team*
GOLD Federal Republic of Germany: Reiner Klimke (Arcadius), Harry Boldt (Remus), and Josef Neckermann (Antoinette)
SILVER Switzerland: Henri Chammartin (Wolfdietrich), Gustav Fischer (Wald), and Marianne Gossweiler (Stephan)
BRONZE Soviet Union: Ivan Kalita (Tariph), Ivan Kizimov (Ikhor), and Elena Petushkova (Pepel)

JUMPING
Aachen, West Germany
GOLD Hermann Schridde (FRG) and Kamerad (Dozent)
SILVER Nelson Pessoa (BRA) and Huipil (Gran Geste)
BRONZE Alwin Schockemöhle (FRG) and Exakt (Freiherr)

EVENTING
Moscow
— *Individual*
GOLD Marian Babirecki (POL) and Volt
SILVER Lev Baklyshkin (URS) and Evlon
BRONZE Horst Karsten (FRG) and Condora
— *Team*
GOLD Soviet Union: Valentin Gorelkin (Prikhod), Saybaytol Mursalimov (Dzhigit), Aleksandr Yevdokimov (Podarok), and Lev Baklyshkin (Evlon)
SILVER Ireland: Eddie Boylan (Durlas Eile), Penelope Moreton (Loughlin), Virginia Freeman-Jackson (Sam Wellere), and Anthony Cameron (Lough Druid)
BRONZE Great Britain: Derek Allhusen (Lochinvar), Richard Meade (Bareberry), Christine Sheppard (Fenjirao), and Reuben Jones (Master Bernard)

1966
🏆 FEI WORLD CHAMPIONSHIPS

DRESSAGE
Bern, Switzerland
— *Individual*
GOLD Josef Neckermann (FRG) and Mariano
SILVER Harry Boldt (FRG) and Remus
BRONZE Reiner Klimke (FRG) and Dux
— *Team*
GOLD Federal Republic of Germany: Josef Neckermann (Mariano), Reiner Klimke (Dux), and Harry Boldt (Remus)
SILVER Switzerland: Henri Chammartin (Wolfdietrich), Gustav Fischer (Wald), and Marianne Gossweiler (Stephan)
BRONZE Soviet Union: Ivan Kizimov (Ikhor), Elena Petushkova (Pepel), and Michael Kopeijkin (Korbel)

JUMPING
Buenos Aires, Argentina
GOLD Pierre Jonquères d'Oriola (FRA) and Pomone B.
SILVER José Álvarez de Bohórques (ESP) and Quizas
BRONZE Raimondo D'Inzeo (ITA) and Bowjak

EVENTING
Burghley House, United Kingdom
— *Individual*
GOLD Carlos Moratorio (ARG) and Chalan
SILVER Richard Meade (GBR) and Barberry
BRONZE Virginia Freeman-Jackson (IRL) and Sam Weller
— *Team*
GOLD Ireland: Virginia Freeman-Jackson (Sam Weller), Eddie Boylan (Durlas Eile), Penny Moreton (Loughlin), and Tommy Brennan (Kilkenny)
SILVER Argentina: Carlos Moratorio (Chalan), Roberto Pistarini (Desidia), Ludovico Fusco (Gatopardo), and Enrique Sztyrle (Hijo Manso)
Only two teams completed the competition.

1966
☗ FEI EUROPEAN CHAMPIONSHIPS

JUMPING (MEN'S)
Lucerne, Switzerland
GOLD Nelson Pessoa (BRA) and Huipil (Gran Geste)
SILVER Frank Chapot (USA) and Good Twist (San Lucas)
BRONZE Hugo Arrambide (ARG) and Chimbote

JUMPING (WOMEN'S)
Gijón, Spain
GOLD Janou Lefebvre (FRA) and Kenavo (Or Pailleur)
SILVER Monica Bachmann (SUI) and Sandro (Ibrahim)
BRONZE Lalla Novo (ITA) and Oxo Bob (Rahin)

1967
☗ FEI EUROPEAN CHAMPIONSHIPS

DRESSAGE
Aachen, West Germany
— *Individual*
GOLD Reiner Klimke (FRG) and Dux
SILVER Ivan Kizimov (URS) and Ikhor
BRONZE Harry Boldt (FRG) and Remus
— *Team*
GOLD Federal Republic of Germany: Reiner Klimke (Dux), Harry Boldt (Remus), and Josef Neckermann (Mariano)
SILVER Soviet Union: Mikhail Kopejkin (Korbey), Ivan Kizimov (Ikhor), and Elena Petushkova (Pepel)

BRONZE Switzerland: Henri Chammartin (Wolfdietrich), Marianne Gossweiler (Stephan), and Hansrüdi Thomi (Mecca)

JUMPING (MEN'S)
Rotterdam, Netherlands
— *Individual*
GOLD David Broome (GBR) and Mr. Softee (Top of the Morning)
SILVER Harvey Smith (GBR) and Harvester
BRONZE Alwin Schockemöhle (FRG) and Pesgö (Donald Rex)

JUMPING (WOMEN'S)
Fontainebleau, France
— *Individual*
GOLD Kathy Kusner (USA) and Untouchable (Aberali)
SILVER Lalla Novo (ITA) and Prédestiné
BRONZE Monica Bachmann (SUI) and Erbach (Dax)

EVENTING
Punchestown, Ireland
— *Individual*
GOLD Eddie Boylan (IRL) and Durlas Eile
SILVER Martin Whiteley (GBR) and The Poacher
BRONZE Derek Allhusen (GBR) and Lochinvar
— *Team*
GOLD Great Britain: Richard Meade (Barberry), Derek Allhusen (Lochinvar), Martin Whiteley (The Poacher), and Reuben Jones (Foxdor)
SILVER Ireland: Eddie Boylan (Durlas Eile), John Fowler (Dooney Rock), Lady Petersham (Sam Weller), and Bill Mullins (March Hawk)
BRONZE France: Jean-Jacques Guyon (Pitou), Daniel Lechevallier (Opéra), Henry Michel (Ouragan), and Michel Cochenet (Artaban)

1968
⠿ OLYMPIC GAMES, MEXICO

DRESSAGE
— *Individual*
GOLD Ivan Kizimov (URS) and Ikhor
SILVER Josef Neckermann (FRG) and Mariano
BRONZE Reiner Klimke (FRG) and Dux
— *Team*
GOLD West Germany: Josef Neckermann (Mariano), Reiner Klimke (Dux), and Liselott Linsenhoff (Piaff)

SILVER Soviet Union: Ivan Kizimov (Ikhor), Ivan Kalita (Absent), and Elena Petushkova (Pepel)
BRONZE Switzerland: Gustav Fischer (Wald), Henri Chammartin (Wolfdietrich), and Marianne Grossweiler (Stephan)

JUMPING
— *Individual*
GOLD William Steinkraus (USA) and Snowbound
SILVER Marion Coakes (GBR) and Stroller
BRONZE David Broome (GBR) and Mr. Softee
— *Team*
GOLD Canada: Jim Elder (The Immigrant), Jim Day (Canadian Club), and Tom Gayford (Big Dee)
SILVER France: Janou Lefebvre (Rocket), Marcel Rozier (Quo Vadis), and Pierre Jonquères d'Oriola (Nagir)
BRONZE Federal Republic of Germany: Alwin Schockemöhle (Donald Rex), Hans Günter Winkler (Enigk), and Hermann Schridde (Dozent)

EVENTING
— *Individual*
GOLD Jean-Jacques Guyon (FRA) and Pitou
SILVER Derek Allhusen (GBR) and Lochinvar
BRONZE Michael Page (USA) and Foster
— *Team*
GOLD Great Britain: Derek Allhusen (Lochinvar), Richard Meade (Cornishman V), Reuben Samuel Jones (The Poacher), and Jane Bullen (Our Nobby)
SILVER United States: Michael Page (Foster), James Wofford (Kilkenny), John Michael Plumb (Plain Sailing), and Kevin Freeman (Chalan)
BRONZE Australia: William Roycroft (Warrathoola), Brian Cobcroft (Depeche), Wayne Roycroft (Zhiwgo), and James Scanlon (Diambo de Nora)

1968
☗ FEI EUROPEAN CHAMPIONSHIPS

JUMPING (WOMEN'S)
Rome, Italy
GOLD Anneli Drummond-Hay (GBR) and Merely-a-Monarch (Xanthos)
SILVER Giulia Serventi (ITA) and Gay Monarch

BRONZE (JOINT) Marion Coakes (GBR) and Stroller
BRONZE (JOINT) Janou Lefebvre (FRA) and Rocket (Quitus)

1969
☗ FEI EUROPEAN CHAMPIONSHIPS

DRESSAGE
Wolfsburg, West Germany
— *Individual*
GOLD Liselott Linsenhoff (FRG) and Piaff
SILVER Ivan Kizimov (URS) and Ikhor
BRONZE Josef Neckermann (FRG) and Mariano
— *Team*
GOLD Federal Republic of Germany: Liselott Linsenhoff (Piaff), Reiner Klimke (Dux), and Josef Neckermann (Mariano)
SILVER Democratic Republic of Germany: Horst Köhler (Neuschnee), Wolfgang Müller (Marios), and Gerhard Brockmüller (Tristan)
BRONZE Soviet Union: Ivan Kalita (Tarif), Ivan Kizimov (Ikhor), and Elena Petushkova (Pepel)

JUMPING (MEN'S)
Hickstead, United Kingdom
GOLD David Broome (GBR) and Mr. Softee (Top of the Morning)
SILVER Alwin Schockemöhle (FRG) and Donald Rex (Wimpel)
BRONZE Hans Günter Winkler (FRG) and Enigk (Trophy)

JUMPING (WOMEN'S)
Dublin, Ireland
GOLD Iris Kellett (IRL) and Morning Light
SILVER Anneli Drummond-Hay (GBR) and Xanthos, (Merely-a-Monarch)
BRONZE Alison Westwood (GBR) and The Maverick

EVENTING
Haras du Pin, France
— *Individual*
GOLD Mary Gordon-Watson (GBR) and Cornishman V
SILVER Richard Walker (GBR) and Pasha
BRONZE Bernd Messmann (FRG) and Windspiel
— *Team*
GOLD Great Britain: Richard Walker (Pasha), Derek Allhusen (Lochinvar), Pollyann Hely Hutchinson (Count Jasper), and Reuben Jones (The Poacher)

SILVER Soviet Union: Aleksandr Yevdokimov (Farkhad), Kamo Zakarian (Fugas), Yulo Kepp (Hobot), and Yuri Solos (Fat)
BRONZE Federal Republic of Germany: Bernd Messmann (Windspiel), Kurt Mergler (Vaibel), Horst Karsten (Adajio), and Otto Ammermann (Alpaca)

† *Editor's Note: In the 1956, 1960, and 1964 Olympic Games, German athletes from both nations participated as a United Team of Germany.*

1960 Olympic Games, Rome

This was the first time that the Games were broadcast on live television throughout Europe.

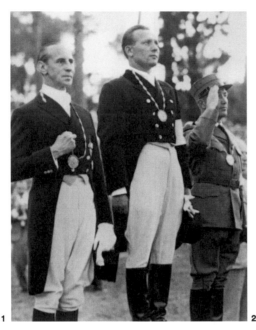

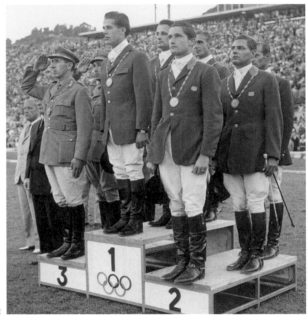

— dressage

In light of the inconsistent judging at the 1956 Games, the FEI took serious action: only two riders per country could participate; there was to be no team competition; the number of judges was reduced to three; and a discussion between the judges had to take place before the results were published.In order not to favor certain riders, judges of the same nationality as certain candidates who were medal contenders were not allowed to officiate, and the judges had to represent the different schools. . Finally, the competitors eligible for the ride-off had to constitute 25 percent of those who entered the Grand Prix. In the Grand Prix, the judges met for about 20 minutes after each test. The second round was filmed. No score was announced, and the results were revealed only three days after the competition, giving no details about the scores.

— jumping

Sixty-six riders and twenty-three nations competed for the individual title. In the event, the Italian brothers Raimondo et Piero D'Inzeo scooped gold and silver respectively—an extraordinary achievement. The team competition gave riders plenty of opportunity to come unstuck: eighteen teams of three riders took part, and after the first round nine of them had been eliminated. In order to guarantee the public a show worthy of the Olympic Games, the rules were adjusted and the eliminated teams were allowed to take part in the second round. Once again, three teams out of the nine first-round survivors did not qualify. Despite all their efforts, the final podium places were an exact reflection of the first-round results. Pat Smythe and Brigitte Schockaert were the only women to take part in the jumping competition.

— eventing

The Australian team took the lead after the endurance race, despite Bill Roycroft's fall at an obstacle made of concrete pipes. His horse bolted and Roycroft was stretchered off, but when he saw that his horse had been caught he got back on. The next day, with a dislocated shoulder and a fractured collarbone, he left hospital against medical advice. As one of the team's horses had failed the vet check, Roycroft had to finish the competition and complete the show-jumping phase, otherwise his team would be eliminated. He rode a clear round, with the result that Australia scooped its first team gold medal in the discipline. Reiner Klimke completed a clear cross-country round with 60 time penalties.

1. R. D'Inzeo, individual and team juming champion.

2. The individual dressage podium: (left to right) J. Neckermann, S. Filatov, G. Fischer.

3. The team jumping podium: (left to right) Italy, Germany, the United States.

4. The German jumping team: (left to right) A. Schockemöhle (Ferdl), H. Günter Winkler (Halla), F. Thiedemann (Meteor).

5. Neale Lavis, the Australian team gold medalist in eventing, on Mirrabooka.

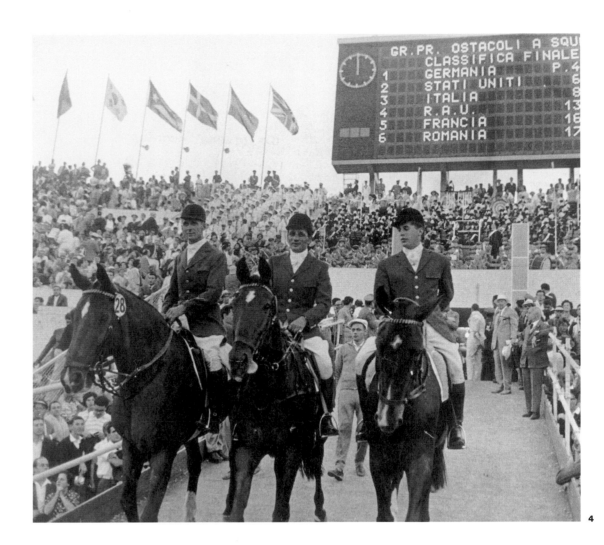

4

5

1960—1961
FEI Championships

1960 — FEI World Championships

— jumping (men's)

Venice, Italy
During the final-four horse rotation, Bill Steinkraus on Sunsalve, David Broome's horse, fell at the water jump. He was unable to get back on the horse and it rapidly became clear that he was suffering from concussion and a fractured collarbone. Raimondo D'Inzeo's mare, Gowran Girl, incurred a very heavy total of 48 penalties in the final-four rotation, but the Italian rider went on to take the world title. It was a great year for him, as he was also crowned Olympic champion in Rome.

1

2

1960 — FEI European Championships

— jumping (women's)

Copenhagen, Denmark
One British rider was clearly not enough: in the absence of Pat Smythe, her compatriot Susan Cohen scooped the gold medal.

1. R. D'Inzeo, world jumping champion, on Gowran Girl.

2. S. Cohen, European jumping champion, on Clare Castle.

3. D. Broome, European jumping champion, on Silver Knight.

4. The Aachen stadium.

1961 —
FEI European
Championships

— jumping (men's)

Aachen, West Germany
The first competition was scored under Table A against the clock followed by a puissance and a test of handiness, scored under Table C. The fourth competition of the championship was the most important as its score counted for 150 percent. With 4 penalties, Piero D'Inzeo, who was in the lead before the last of the four rounds, paid dearly as a result of this regulation, to the benefit of David Broome.

— jumping (women's)

Deauville, France
Eleven competitors lined up at the start of these championships. The riders had the right to compete with two horses. Pat Smythe, riding Scorchin and Flanagan, represented Great Britain and won with a significant 10 point penalty lead over Dutch horsewoman Irene Jansen.

3

4

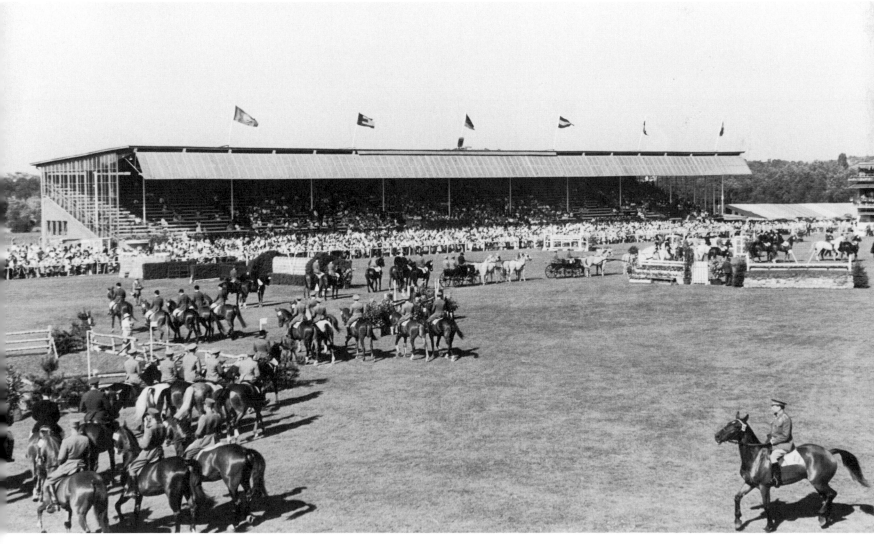

1962—1963
FEI Championships

1962
FEI European
Championships

— jumping (men's)

London, United Kingdom
As the FEI had given the British Equestrian Federation full rein to organize and govern this championship, the latter decided, contrary to expectations and despite custom and practice, to ban riders from non-European countries from competing. The British Federation also decided to change the way the title was awarded. There were still three qualifying competitions testing accuracy, power, and handiness. But these served only to identify the twelve best riders, who would take part in the two-round final in which the scoring started from scratch. This procedure was deeply unpopular with the French, who had instigated the final-four horse rotation in world championships. British rider David Barker won the title.

— jumping (women's)

Madrid, Spain
British rider Pat Smythe repeated her feat of 1961 and confirmed her status as the top European female rider. At this event she rode Flanagan.

— eventing

Burghley, United Kingdom
Only four teams were involved in this championship: the Soviet Union, Great Britain, Ireland, and France. The Soviets took the lead from the start of the competition and maintained it, despite a difficult cross-country course that saw twenty falls. The Soviets won the title by a comfortable margin. Jane Wykeham-Musgrave, riding Ryebrooks for Great Britain, was ahead after the cross country, but her two faults on the show-jumping course relegated her to third place. Her compatriot, James Templer riding M'Lord Connolly, took the title.

1. D. Barker, European jumping champion, 1962.

2. P. Smythe, European jumping champion, with Clare Castle, 1962.

3. G. Mancinelli,
European jumping
champion, on
Rockette, 1963.

1963
FEI European
Championships

— dressage

Copenhagen, Denmark
These were the first European
Championships in this discipline.
Until this point, the riders who
competed at the FEI Grand Prix
took part in the FEI Dressage
Championships and were
considered the European
champions. For this first-ever
event, there were sixteen
competitors and no team
competition, owing to a lack
of entrants.

— jumping (men's)

Rome, Italy
Surprisingly, the D'Inzeo brothers
did not attend these European
Championships: Piero was
reportedly in dispute with the
Italian Federation, and Raimondo
competed only in the Nations
Cup. In their absence, Graziano
Mancinelli took advantage of
this opportunity to scoop the title
riding The Rock, Piero's D'Inzeo's
former mount.

— jumping (women's)

Hickstead, United Kingdom
Pat Smythe took her fourth title
riding Flanagan and Scorchin on
home turf. The individual bronze
medal went to British rider Anneli
Drummond-Hay on Merely-a-
Monarch and Tango. Most unusually,
Anneli had won Badminton the
previous year, the most important
eventing competition in the world,
partnering the same horse, Merely-
a-Monarch.

1964
Olympic Games, Tokyo

For the first time, most of the horses arrived by air transport.

— dressage

The Grand Prix test lasted 12 minutes 30 seconds, and the scores were announced after each competitor finished. For the Grand Prix Special, which lasted 6 minutes 30 seconds and was filmed, the results were announced two hours after the end of the competition. The training methods of the Soviet riders attending the event were revealed, including those of Sergei Filatov, with whom communication was complicated for linguistic reasons. It emerged that, with calm horses, they taught the passage from the piaffe, and when the horses were more energetic the piaffe was taught from the passage.

1. The individual dressage podium: (left to right) H. Bolt, H. Chammartin, S. Filatov.

2. S. Filatov, bronze medalist in dressage, on Absent.

3. P. Jonquères d'Oriola, gold medalist in jumping, on Lutteur B.

— jumping

Emperor Hirohito was in the audience when Frenchman Pierre Jonquères d'Oriola achieved the feat of winning a second individual Olympic gold medal, following his Helsinki gold in 1952. On this occasion, he rode Lutteur B. France won team silver.

— eventing

Twenty-seven-year-old American rider Lana duPont was the first woman to compete in an Olympic eventing competition. Italy took gold in both individual and team competitions. Held approximately 90 miles (150 km) northeast of Tokyo, the cross-country phase was unusual in several respects: it took place in the grounds of a hotel complex in Kuruizawa, at an altitude of 3,280 ft. (1,000 m), and was overlooked by the active Asama volcano. Most competitors considered the cross-country course to be not very selective. Nonetheless, some, like the Australians, who had neglected dressage during their preparation, found themselves in difficulty. It was thought that Richard Meade, who led after the dressage phase and had won the endurance race, would emerge from this competition sporting the gold medal. However, the 36 penalties he incurred during the final phase of show jumping determined otherwise, and underlined the importance of the discipline of eventing.

< 1

3

1965
FEI World Championships

— jumping (women's)

Hickstead, United Kingdom
The FEI decided to create a women's world championship, although this inaugural event attracted only eight competitors. The British rider Marion Coakes became the first world champion, riding Stroller, a pony of just 14.2 hands (1.44 m). She beat American rider Kathy Kusner on Untouchable.

1. M. Coakes, first world jumping champion, on Stroller.

2. K. Kusner, ranked second, on Untouchable.

3. H. Schridde, European jumping champion, on Dozent.

FEI European Championships

— dressage

Copenhagen, Denmark
This time the teams were complete, and individual and team European champion titles could be awarded. Winner of the title in 1963 but absent the following year in Tokyo, Henri Chammartin of Switzerland won gold on Wolfdietrich. West Germany was the first team champion.

— jumping

Aachen, West Germany
In the last round of the individual competition, the two Tokyo rivals Hermann Schridde and Pierre Jonquères d'Oriola were once again neck and neck. While the German rode a clear round, the French rider jumped an obstacle that was not part of the course and was eliminated as a result.

— eventing

Moscow, USSR
The Irish rider Virginia Freeman-Jackson and her horse Sam Weller won the cross-country phase, but her positive scores were not enough to make up for her deficiencies in the dressage phase (multiplied by a coefficient of 1.5). Ultimately, she did not reach the podium.

1966
FEI World
Championships

— dressage

Bern, Switzerland
West Germany crushed its opponents as they won the competition by a wide margin, taking the three top places and scooping the team title. Josef Neckermann won the individual medal.

3

— jumping

Buenos Aires, Argentina
Some big names featured in the final-four horse rotation. Nelson Pessoa (Huipil), Raimondo D'Inzeo (Bowjak), José Álvarez de Bohórquez (Quizas), and Pierre Jonquères d'Oriola (Pomone B) were in contention. After three rounds, it was Jonquères d'Oriola's turn to ride Quizas, who had already sustained more than 37¾ penalties with the other riders. Refusing to ease up, and incurring 4 penalties at the water jump, Jonquères d'Oriola took the title of world champion, two years after winning his Olympic title in Tokyo on his seven-year-old mare.

— eventing

Burghley, United Kingdom
Of the five nations to enter the team competition only two finished. Ireland was the gold medalist, while Argentina won silver.

1. J. Neckermann, world dressage champion, on Mariano.

2. The German gold medal dressage team: (left to right) J. Neckermann (Mariano), R. Klimke (Dux), H. Boldt (Remus).

3. Carlos Moratorio, individual gold medalist in eventing, on Chalan.

1966
FEI European Championships

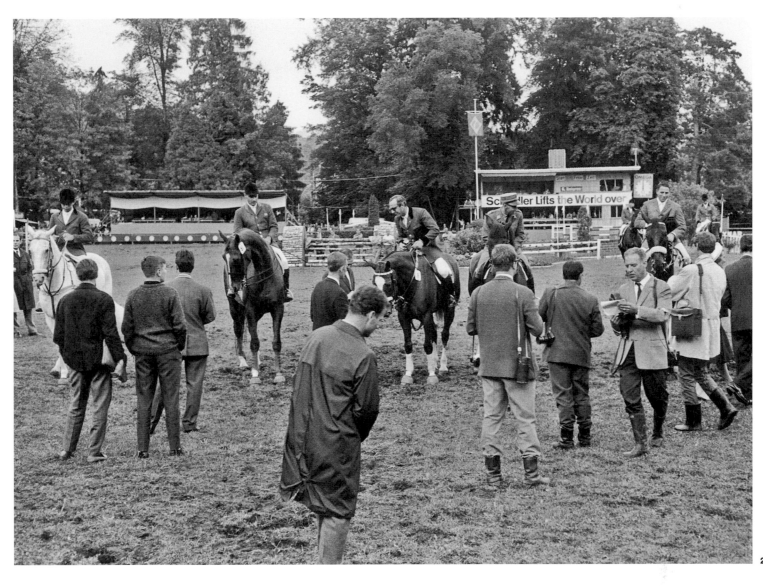

2

jumping (men's)

Lucerne, Switzerland
As surprising as it may seem today, the podium at these European Championships was not very European. Nelson Pessoa, a Brazilian, occupied the top step, while on the second stood American Frank Chapot, and, even more unusually, the third step was occupied by the Argentinian Hugo Arrambide.

jumping (women's)

Gijón, Spain
The job of the winner, Janou Lefebvre, had not been very difficult, and the notable absence of the main countries such as Great Britain made victory even easier for her.

1. N. Pessoa, European jumping champion, on Gran Geste.

2. Awards ceremony for the men's individual prizes in Lucerne.

3. J. Lefebvre, European jumping champion.

3

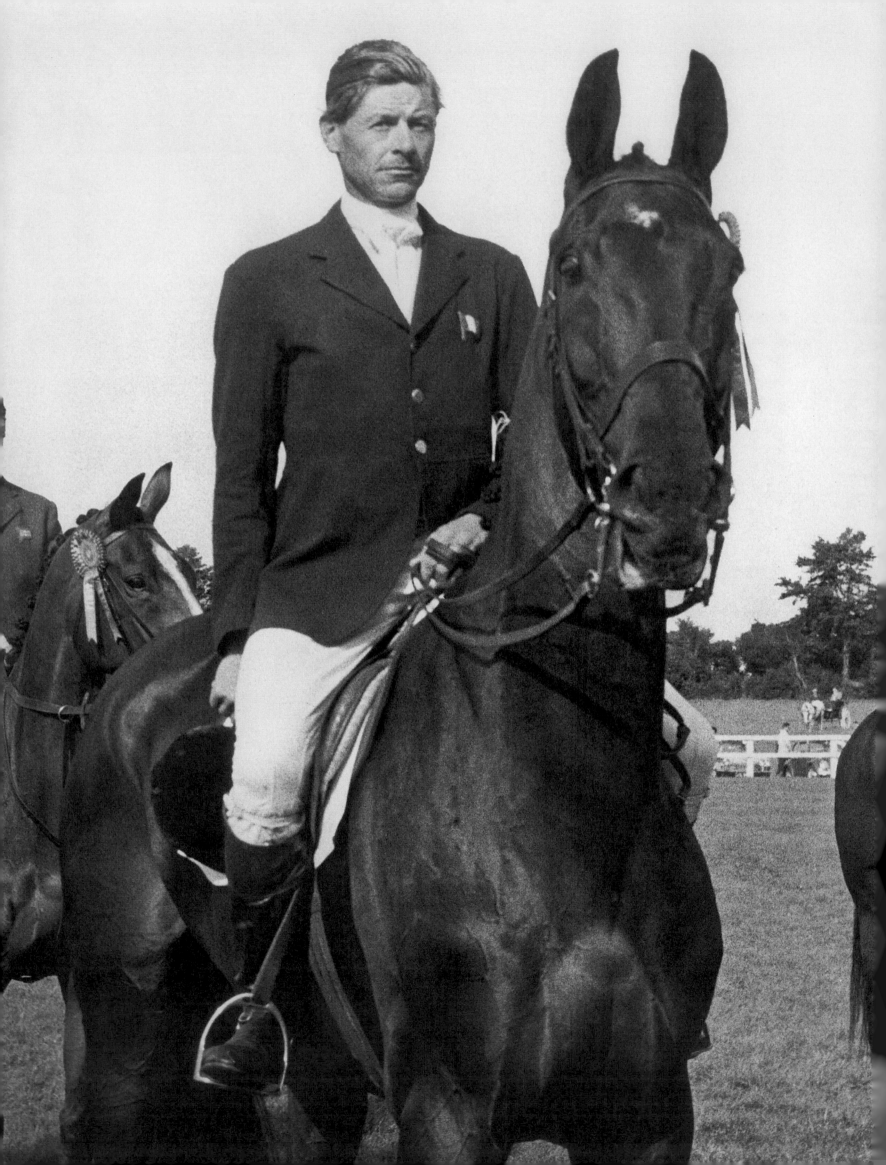

1967
FEI European Championships

— dressage

Aachen, West Germany
This was a tussle between the Soviet rider Ivan Kizimov and the German Reiner Klimke: the former won the Grand Prix on Ikhor, while the latter triumphed in the ride-off on Dux. With a mere four-point advantage, Klimke won the individual European title, as well as sharing in West Germany's team trophy.

— jumping (men's)

Rotterdam, Netherlands
David Broome became European champion for the second time, on this occasion riding Mr. Softee. His compatriot Harvey Smith riding Harvester joined him on the podium to receive a silver medal, while the bronze medal went to Alwin Schockemöhle riding Pesgö.

— jumping (women's)

Fontainebleau, France
The world's best women riders, with just a few exceptions, attended Fontainebleau: Kathy Kusner, Monica Bachmann, Lalla Novo, Marion MacDowell, and Anneli Drummond-Hay. The title holder, Janou Lefebvre, was absent, claiming a problem with her arm that some journalists questioned. She was not able to defend her title, but she was delighted to see the victory of Kathy Kusner, her friend and role model.

— eventing

Punchestown, Ireland
The difficulties of the steeplechase and the cross-country course caused havoc among the teams, but the British horses displayed an impressive gallop that outclassed the other teams' horses. Feeling relaxed on home turf, Eddie Boylan and Durlas Eile made light work of the traps to win the European title. Only twenty-eight out of forty-one horses made it to the finish line, with only six clear show-jumping rounds. Four out of eight teams were eliminated. Among the unfortunate competitors was Marietta Fox-Pitt, mother of a certain William Fox-Pitt.

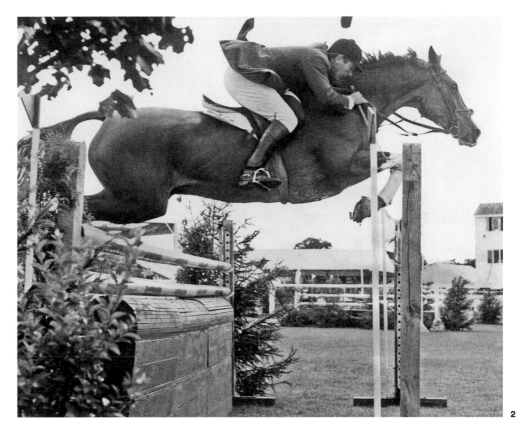

2

1. E. Boylan, European eventing champion, on Durlas Eile.

2. D. Broome, European jumping champion, on Mr. Softee.

< 1

1968
Olympic Games, Mexico

At the end of the first round, West German rider Josef Neckermann enjoyed a significant lead over the Soviet competitor, Ivan Kizimov. But the second round took a dramatic turn: as a result of noise in the stands, Neckermann's horse lost concentration. His dressage test was catastrophic, relegating him to last place in this round and costing him the gold medal, which went to Kizimov. The revelation of these Games was the entire Soviet dressage team, which had made enormous progress since Tokyo: Ivan Kizimov riding Ikhor took first place, Ivan Kalita on Absent was fourth, and Elena Petushkova on Pepel was sixth. In the final rankings, the Soviets ran the superlative West German team a very close second.

1. J. Neckermann, silver medalist in dressage, on Mariano.

2. B. Steinkraus, gold medalist in jumping, on Snowbound.

3. A cross-country obstacle after torrential rainstorms.

The individual competition was held over two rounds. With a 2,460 ft. (750 m) long course, the first round was a way of selecting the eighteen best riders for a second-round with a jump-off. The second round, with a 1,345 ft. (410 m) long course, was a puissance featuring an oxer 5 ft. 7 in. (1.7 m) high and 7 ft. 2½ in. (2.2 m) wide. There was no mystery as to who would take gold, as Bill Steinkraus, riding Snowbound, was the only rider with 4 penalties. Marion Coakes was the only competitor with 8 penalties and won silver with Stroller, a 14.1 hand (1.43 m) horse. There was a jump-off for the bronze medal, as Great Britain's David Broome, Frank Chapot of the USA, Hans Günter Winkler of West Germany, and Jim Elder of Canada were tied on 12 penalties. All four scored clear rounds in the jump-off, but the fastest was David Broome, so he claimed the bronze. Steinkraus's individual victory left a bitter taste since Snowbound sprained a tendon and was not able to participate in the team competition.

2

The cross country turned into a nightmare for some horses, who were exhausted before they even started. The first competitors started out in temperatures of about 104° F (40° C), and in the middle of the competition tropical rainstorms completely transformed the course. At Obstacle 22, the riders had to jump a log forming the edge of a small stream, but in the heavy rain the obstacle became an absolute torrent over 40 ft. (12 m) wide. Marcel Rozier, riding in the French jumping team, remembered seeing his compatriot Jean Sarazin disappear under the water with his horse, Job 5; several people had to jump into the water to rescue them. Others were less fortunate, and two horses died on the course, overcome by the altitude and extreme conditions. Richard Meade was the only rider to complete the course after the rain, and the only one to appear among the top ten in the final rankings.

3

1969
FEI European Championships

— dressage

Wolfsburg, West Germany
This was the first time that the East German team took part in any European Championships. They finished in second place and took silver, almost two hundred points separating them from the victorious West German team, which also had two riders on the individual podium: Liselott Linsenhoff and Piaff took gold, while Josef Neckermann and Mariano were in bronze position.

— jumping (men's)

Hickstead, United Kingdom
David Broome scooped his third European gold. Unruffled, he went to take a two-hour nap in his trailer before entering the arena to defend his double crown. He beat Alwin Schockemöhle, Hans Günter Winkler, Pierre Jonquères d'Oriola, and Raimondo D'Inzeo.

— jumping (women's)

Dublin, Ireland
With only six entrants, this championship did not attract many riders. Local rider Iris Kellett won the competition ahead of the talented Anneli Drummond-Hay.

— eventing

Haras du Pin, France
Mary Gordon-Watson took the individual gold medal riding Cornishman V. She was not one of the riders selected to represent Great Britain in the team event, but the British won the title nevertheless.

1. D. Broome, three-time European jumping champion, on Mr. Softee.

2. M. Gordon-Watson, European individual eventing champion, on Cornishman V.

3. A. Schockemöhle, silver medalist in jumping, on Wimpel.

Raimondo D'Inzeo

A down-to-earth legend

Raimondo has become the stuff of legend because his sporting success was combined with great humility. Born on February 8, 1925, at Poggio Mirteto, north of Rome, he was introduced to horse riding at a young age by his father, Carlo, an instructor in an Italian cavalry regiment, just as his elder brother, Piero, had been before him. Jealous of the relationship his brother had with their father, Raimondo stuck with riding, although at first it had terrified him; he would ultimately become passionate about it.

The young prodigy cut his teeth at the riding school at La Farnesina where he made his competitive debut in eventing and show jumping, and where he also tried his hand at racing. After several years at Milan University studying engineering, he persuaded his father to let him become a professional rider. At the same time, and aged only twenty, he launched his career in the 4th Carabinieri Cavalry Regiment, and he and his horses joined the army's riding school in Rome. Barely three years later, in 1948, he launched himself into his first Olympic Games, in London, in eventing. He subsequently took part in every single Olympic Games until 1976—eight consecutive Games—which is a world record matched only by the Canadian Ian Millar.

Events conspired to push Raimondo toward show jumping. He won two silver

1

medals, for individual and team, which he won thanks to Merano at the 1956 Melbourne Olympics (the equestrian events were held in Stockholm for quarantine reasons). In 1960, in front of an audience from his home town, Raimondo took the Olympic title with Posillipo, whom he had trained entirely by himself, relegating his brother Piero to second place. In the same year he executed a masterstroke by winning the Venice FEI World Championships with Gowran Girl, a title that he had already taken four years earlier with Merano. He went on to add to his medal record two group bronze medals in 1964 and 1972 at the Tokyo and Munich Olympics, carrying the Italian flag at the latter. He owed his success to his innate talent, determination, and tenacity, as well as his unorthodox style of riding and handling horses, which made him a very popular trailblazer.

With six Olympic medals and numerous international victories under his belt, and forced to miss out on his ninth Olympiad at Moscow in 1980 because of the boycott, the champion felt that this was the right time to retire, although he went on to become the Italian show-jumping team's trainer before retiring entirely. Many years of travel, and the tragedy of his daughter Alessandra's death at the age of twelve in a skiing accident in 1966, prompted him to appreciate time with his wife, Giuliana Mazzetti di Pietralata, his son, Guido Andrea, and his daughter, Susanna, as well as her children, Andrea and Raimonda Spalletti Trivelli. Throughout his life he was able to build relationships with horses based on attentiveness and trust; and horses were never far, since he continued to ride at La Farnesina with his granddaughter. After many years of ill health, Raimondo passed away on November 15, 2013, at the age of eighty-eight.

2

Susanna D'Inzeo, Raimondo's daughter, on her father

Despite having won six Olympic medals, Raimondo remained down to earth and very popular with everyone: "My father was very humble in both victory and defeat. When he saw a winner go wild with joy he used to say that the winner wasn't well brought up! On the day of his burial, when my daughter saw all the people crowding in to pay their respects, she realized that her grandfather was a legend. He adored his public, and at competitions signed thousands of autographs."

Throughout his career, Raimondo competed against talented riders, including his elder brother, the fiercest competitor of them all: "Piero was both his team member and his rival. At one time they were the two best riders in the world, so obviously they were rivals. However, outside of sport there was no rivalry."

As a bon viveur, Raimondo was a fish out of water in the military elite into which he was born. "My father never really fitted in with the army and that's probably why he never had a great military career. He loved life, loved laughing, having fun.... He had a strong character and could come across as domineering, but most of the time he was a really friendly person who we had great fun with."

The champion with a big heart and a wicked sense of humor made an impression on everyone he met. "Living by my father's side was incredible. He leaves a great void behind him. He always had a witty comment. On my wedding day, for example, when everybody was waiting for us at the church, we stopped on the way to smoke a cigar. Once we'd arrived at the church, he told me over and over that I mustn't fall, and in the end it was he who almost fell over. And when we were walking down the aisle, he told me that if I wanted, we could turn around. We walked the whole way down the aisle laughing our heads off. When he was overcome with emotion he would make jokes to hide his feelings. The most important thing he taught me was humility, to stay humble and respectful of everybody, without discriminating. He taught us to believe in what's important in life, such as family."

"My father was very humble in both victory and defeat."

— Susanna D'Inzeo

1. R. D'Inzeo and Litargirio at the Helsinki Olympics, 1952.

2. P. and R. D'Inzeo at the Rome Olympics, 1960.

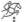

Lawrence Morgan

Always more, always better

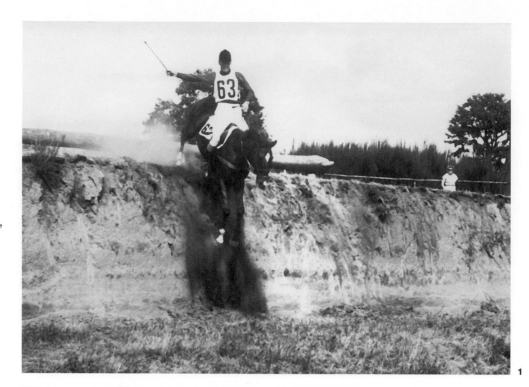

1

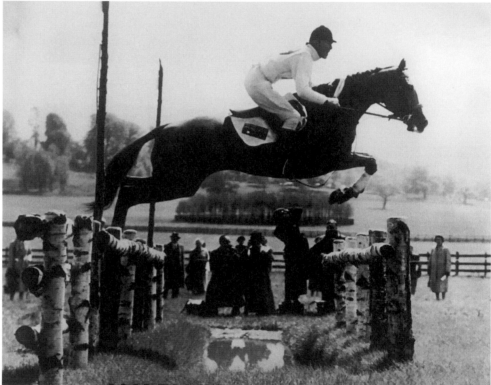

2

Lawrence "Laurie" Morgan became a legend through hard work, not good luck. He was born in 1915 in Yea, northeast of Melbourne, in an era when horses were utilized for agricultural labor and basic transport. But Laurie had a taste for a more refined approach to horses and attended a riding school. A multitalented sportsman, he was a highly disciplined athlete who engaged in show jumping and horse racing, soccer (he joined the Fitzroy Football Club, one of Victoria's top teams), boxing at the police training school (he became the national champion in the heavyweight category), and even rowing for the national team.

In 1953, Laurie decided to commit himself exclusively to equestrian sports, which were becoming increasingly popular in Australia. Ambitious and determined to make a name for himself, he traveled by cargo ship to England, accompanied by his wife, Anne, his son, Warwick, and his horse Gold Ross, a steeplechase and eventing winner. But his initial experience competing in the UK came as a complete shock. Everything seemed more intimidating, more demanding, more professional. Laurie was an intrepid competitor, however, and— undaunted— he persevered, in 1955 coming fourth in the European Championship in Greenwich Park, mounted on Gold Ross. The horse and rider also joined the British polo team at about the same time.

In 1956, when the Melbourne Olympics were relocated to Stockholm because of quarantine regulations, Australia organized its first team of riders. The country was determined to demonstrate that it was a fertile breeding ground for courageous young riders. Lawrence was not among those selected: at the age of thirty, he was deemed too old. This initial policy was later changed, however, and national team membership was opened to all ages.

Lawrence returned to Australia in 1957 with an excellent grasp of the situation in Europe, the best-qualified man in the country to select and train the equestrian team. He became the national trainer and captain of the Australian team, and rode in it himself. In 1959, he took off again for England to prepare for the Rome Olympics with his team. Their strategy was simple, and it paid off: leaving aside dressage and taking advantage of the horses' physical condition, they rode the cross-country course as fast as possible. At that time, the cross-country

phase was a test against the clock. Mounted on Salad Days, Lawrence became individual and team Olympic champion in Rome, although he ranked only eleventh in dressage. He subsequently took up steeplechasing and won many victories as a jockey.

A devotee of hunting and the great outdoors, Laurie was a self-made man, realizing his dream of becoming an Australian landowner in 1961. Over a period of two decades, Morgan and his son created a successful business on a tract of territory once inhabited by cattle and wild horses. Starting life with nothing, this indomitable rider achieved many successes before he died in 1997 at the age of eighty-two.

1. In the eventing competition in Rome, 1960.

2. In the FEI European Championships, 1955.

3. L. Morgan (on foot) and his son Warwick on Salad Days.

"There's no doubt that his personality explained his success. He always pushed the limits of what's possible."

— Warwick Morgan

Warwick Morgan remembers his father

Lawrence was an amazing horseman with a rare gift that was largely unrecognized by the public. "He had an extraordinary ability to evaluate other people's horses as well as the competence of various riders. When he left England in 1957, he was familiar with all the strengths and weaknesses of the horse-and-rider teams that had participated in the Melbourne Olympics in 1956. He knew exactly what was needed to create a team in Australia."

Undeniably a champion, Laurie was a tough character who was very clear on what he wanted and how to get it. "He always insisted that we do more, and do it better. That was his approach to his professional life, and to his personal life too. He actually left my mother for a younger woman. He wasn't an easy man to live with. He decided on everything, and everything had to be just the way he wanted it. There's no doubt that his personality explained his success. He always pushed the limits of what's possible."

Laurie could be abrasive, but this champion also knew how to charm his audience. "Young women all found him irresistible. He had plenty of charisma. Even the Queen of England, who attended a number of dinners and gatherings with him, thought he was terrific; she genuinely admired him. He actually offered to give her Salad Days as a gift 'from one friend to another' before we left for Australia."

Despite his successful career and roster of prizes, Lawrence regretted that he hadn't received more appreciation at home. "My father wasn't recognized in his own country during his lifetime because he had performed in Europe rather than Australia. Australian media didn't take much notice of equestrian sports. They thought riders were all rich men's sons. It wasn't the kind of story that appealed to them. But my father was a completely self-made man. The only way we were able to travel to Europe was thanks to a €6,000 bank loan. It was an advance on the proceeds of wool sales from the sheep on his farm!"

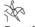

3

Ivan Kizimov

A master of many disciplines

Ivan was born on April 28, 1928, in Novotcherkassk, a town in the southwest of the Soviet Union. He became fascinated by horses at a very young age. His career began in horse racing, particularly in the steeplechase competitions that were popular at the time. In 1947 he received his diploma from the national school of apprentice jockeys and immediately launched himself into eventing as well,

practicing both disciplines with a horse named Satrap. The very survival of this horse was a small miracle. Retired from racing competitions and about to be shipped off to the slaughterhouse, he was purchased at the last moment—along with three other fortunate Trakehner horses—by Victor Ilyasov, director of the Rostov Riding School, who wanted to fill up his stables. The advent of World War II forced Ilyasov to abandon his school in Rostov, and he and his horses moved to Novotcherkassk, where Ivan made them welcome.

Ivan and Victor became a team. Working with Satrap, the two friends enjoyed many victories in eventing competitions. Their success culminated with winning individual and team championships in the USSR club games in 1957. One of their fellow riders, Pavel Deev, was just fifteen years old at the time; he went on to ride Satrap in the 1964 Olympics. Along with his activities as an eventing competitor, Ivan served as dressage trainer for the seniors in the national riding school in Leningrad from 1957 until 1961, the year when he bought Ikhor, his partner in many triumphs.

Initially, the bay horse did not seem destined for greatness. Ikhor was a Ukrainian saddle horse, purchased at the age of two by Ivan as one in a lot of eight horses he bought from a neighboring breeder, all for the equivalent of just $1,800. Already experienced in dressage, the rider focused on training his brilliant young protégé, and by the age of four the horse had already mastered piaffe and passage. Taking advantage of his young mount's skills, Ivan focused increasingly on the discipline of dressage.

Ikhor participated in his first Grand Prix at the age of five. Today it would be an incredible feat, but it was not all that exceptional at the time. He finished fourth in the national championship and took off for the 1964 Olympics in Tokyo when he was just six. The duo finished tenth in the individual rankings and shared in the Soviet team bronze medal.

Ikhor's performance continued to improve as he matured under the tutelage of his talented rider. Ivan was already embracing the beginnings of modern equestrianism; it was an approach that was more natural and respectful of the animal—

1

2

1. In the dressage
competition
in Munich, 1972.

2. The Soviet gold medal
dressage team: (left
to right) I. Kalita (Tarif),
E. Petushkova (Pepel),
I. Kizimov (Ikhor).

less military, in short. Crowned USSR
champions in 1967 and 1968, and European
runner-up in Aachen in 1967, the duo
arrived in Mexico for the Olympics full of
confidence. They carried off the top
individual prize and took the team silver
as well. Collecting national titles in 1969,
1970, and 1972, and winning medals at
every European edition, they were not
on the podium in Munich in 1972 but they
shared the team gold. Ivan and Ikhor made
a final push in 1973 in Aachen, where they
finished seventh in individual rankings
and won a team silver. The magnificent
bay lived out his retirement years in the
comfort of Ivan's stables, where he died
of a heart attack on June 21, 1981, at the
age of twenty-three.

After 1973, Ivan pursued his career
riding Rebus. They went to the 1976
Olympics in Montreal and were ranked
in sixteenth place in individual and fourth
in team competitions. Ivan decided to retire
from competitive riding and devoted
himself to training activities, including
serving as head of the national team
between 1985 and 1990. Very committed
to sharing his expertise, Ivan remained
in charge of the Saint Petersburg Riding
School until 2012 and directed numerous
training courses. He shared his vision of
dressage with his son Mikhail, and they
coauthored the book *Secrets of Excellence*.
Ivan continued to ride well past his
eightieth birthday.

Absent

Pride of the Soviets

A true hero of the former USSR, Absent impressed fans with the splendor of his presence and his panoply of titles. He was born in 1952 on a national stud farm in Dzhambul, a town now known as Taraz, in Kazakhstan. The black foal's sire was Arab, an Akhal-Teke gray stallion, and his dam was named Baccara. The young horse was soon moved to the famed Lugovskoi stables, where all the state's Akhal-Teke horses were transferred in 1955. Absent dazzled everyone with the beautiful sheen of his ebony coat, set off by white socks and a white star on his forehead. His training was concentrated on show jumping, but he was also drilled in dressage, where he demonstrated impressive ability.

In 1958, this magnificent horse was assigned to Sergei Filatov, a talented member of the 1956 Olympic team. Their goal was to qualify to compete in dressage in the 1960 Games in Rome. Although success did not seem guaranteed, Filatov worked tirelessly to achieve this objective, believing his protégé had genuine championship potential. Absent was a good student, improving rapidly. His innate star qualities soon became evident—he demonstrated suppleness, lightness, and ground-covering ability, whether at the trot or canter. Their progress continued, and the duo won the Soviet dressage championship in 1959. In the qualifying competitions held in St. Gallen for the Italian Olympics, Sergei and his horse came in second, easily gaining access to the Games in Rome and demonstrating remarkable success with just two years of preparation.

Sergei relied upon his capacity for invention to accomplish so much so quickly. Initially, Absent was unable to lift his legs and position his feet properly for the passage. Sergei fashioned a training device, using a long stick with a hard piece attached to the end. This contraption allowed Sergei, while mounted in the saddle, to train Absent to lift his knees. The horse soon understood what was expected of him and mastered passage.

After a long and difficult voyage to Rome, during which Absent had to transfer from train to ship and then back to train, the duo was ready to shine in the Grand Prix on the Piazza di Siena. The audience turned up en masse to see the stars in action. Absolute silence reigned during their performance, and, as soon as it concluded, the stadium was filled with wild applause celebrating Sergei's breathtaking performance. They were awarded the individual Olympic title. Affirming their talent four years later in the Tokyo Olympics, they took third place on the podium, winning both individual and team bronze medals for the Soviets, thus earning an honored place in the pantheon of Olympic champions.

After these glorious years of collaboration with Sergei, Absent was acquired by Ivan Kalita, a highly regarded dressage rider. They represented the Soviet Union in 1968 in the Mexico Olympics, where they missed out on a medal in the individual competition but won the team silver.

After this remarkable competitive career, the quadruple medal-winner turned to a more tranquil way of life on a stud farm, siring over seventy foals. Among them was Abakan, the great international competitor ridden by the champion Elena Petushkova. Absent, known as the "Black Swan" by his admirers, died in 1975 at the age of twenty-three.

Career Highlights

Dressage

1960
Individual gold
in the Rome Olympics
with Sergei Filatov

1964
Individual
and team bronze
in the Tokyo Olympics
with Sergei Filatov

1968
Team silver
in the Mexico
Olympics with
Ivan Kalita

1

1. In Mexico
with I. Kalita, 1968.
2. In Rome with
S. Filatov, 1960.

2

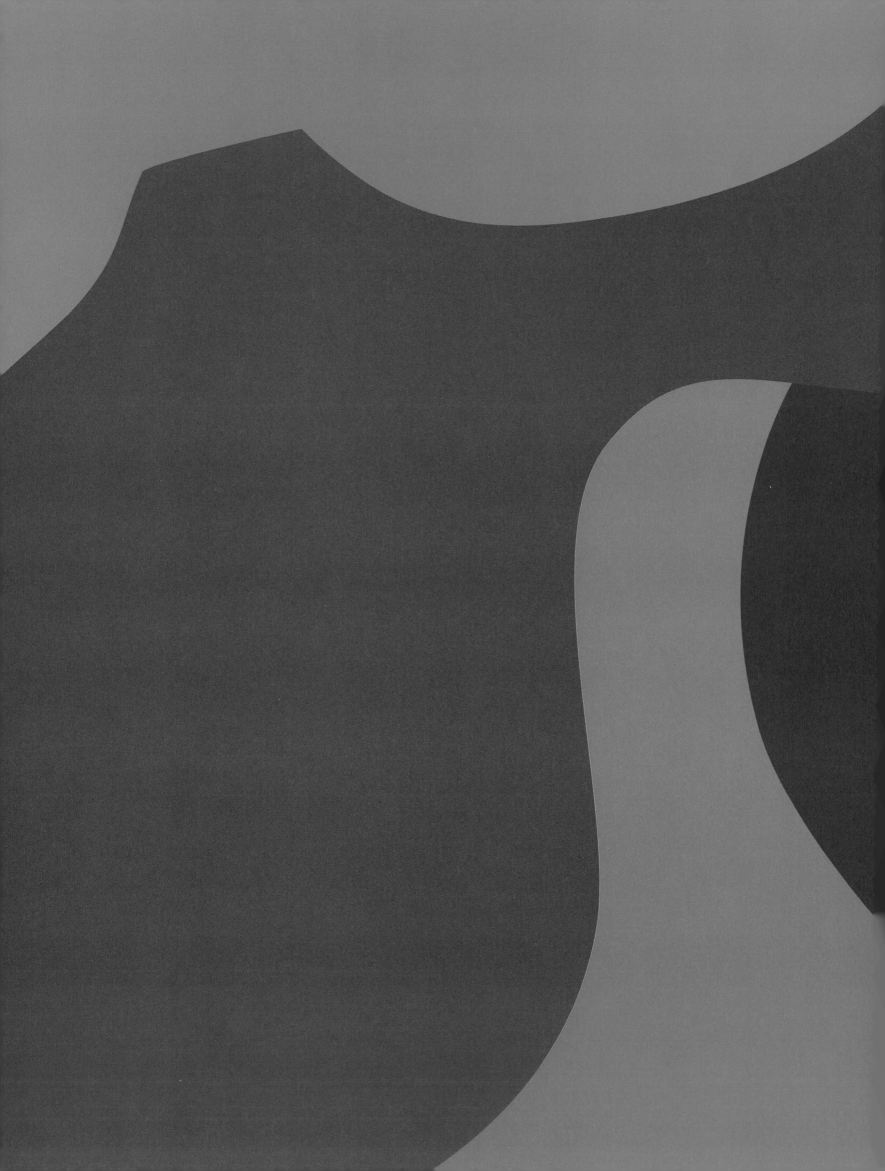

The
1970s

RESULTS 1970–1979

1970

🏆 FEI WORLD CHAMPIONSHIPS

DRESSAGE
Aachen, West Germany
— Individual
GOLD Elena Petushkova (URS) and Pepel
SILVER Liselott Linsenhoff (FRG) and Piaff
BRONZE Ivan Kizimov (URS) and Ikhor
— Team
GOLD Soviet Union: Elena Petushkova (Pepel), Ivan Kizimov (Ikhor), and Ivan Kalita (Tarif)
SILVER Federal Republic of Germany: Liselott Linsenhoff (Piaff), Josef Neckermann (Mariano), and Harry Boldt (Remus)
BRONZE Democratic Republic of Germany: Horst Köhler (Neuschnee), Wolfgang Müller (Marios), and Gerhard Brockmüller (Liostro)

JUMPING (MEN'S)
La Baule, France
GOLD David Broome (GBR) and Beethoven
SILVER Graziano Mancinelli (ITA) and Fidux
BRONZE Harvey Smith (GBR) and Mattie Brown

JUMPING (WOMEN'S)
Copenhagen, Denmark
GOLD Janou Lefebvre (FRA) and Rocket (Troubadour)
SILVER (JOINT) Marion Mould-Coakes (GBR) and Stroller (Daddy's Girl)
SILVER (JOINT) Anneli Drummond-Hay (GBR) and Merely-a-Monarch (Xanthos)

EVENTING
Punchestown, Ireland
— Individual
GOLD Mary Gordon-Watson (GBR) and Cornishman V
SILVER Richard Meade (GBR) and The Poacher
BRONZE James Wofford (USA) and Kilkenny
— Team
GOLD Great Britain: Mary Gordon-Watson (Cornishman V), Richard Meade (The Poacher), Mark Phillips (Chicago III), Stuart Stevens (Benson)
SILVER France: Michel Cochenet (Quaker), Dominique Bentejac (Trou Normand), Dominique Flament (Qui Dit Mieux), and Henri Michel (Ouragan)
Only two teams completed the competition.

1971

🏅 FEI EUROPEAN CHAMPIONSHIPS

DRESSAGE
Wolfsburg, West Germany
— Individual
GOLD Liselott Linsenhoff (FRG) and Piaff
SILVER Josef Neckermann (FRG) and Van Eick
BRONZE Ivan Kizimov (URS) and Ikhor
— Team
GOLD Federal Republic of Germany: Liselott Linsenhoff (Piaff), Reiner Klimke (Mehmed), and Josef Neckermann (Van Eick)
SILVER Soviet Union: Ivan Kalita (Tarif), Ivan Kizimov (Ikhor), and Elena Petushkova (Pepel)
BRONZE Sweden: Maud von Rosen (Lucky Boy), Ulla Håkanson (Ajax), and Anders Lindgren (Eko)

JUMPING (MEN'S)
Aachen, West Germany
GOLD Hartwig Steenken (FRG) and Simona (Kosmos)
SILVER Harvey Smith (GBR) and Evan Jones (Mattie Brown)
BRONZE Paul Weier (SUI) and Wulf (Donauschwalbe)

JUMPING (WOMEN'S)
St. Gallen, Switzerland
GOLD Ann Moore (GBR) and Psalm (April Love)
SILVER Alison Dawes-Westwood (GBR) and The Maverick (Meridian)
BRONZE Monika Leitenberger (AUT) and Limbara (Gioiosa de Nora)

EVENTING
Burghley, United Kingdom
— Individual
GOLD HRH Princesse Anne (GBR) and Doublet
SILVER Debbie West (GBR) and Baccarat
BRONZE Stuart Stevens (GBR) and Classic Chips
— Team
GOLD Great Britain: Debbie West (Baccarat), Richard Meade (The Poacher), Mary Gordon-Watson (Cornishman V), and Mark Phillips (Great Ovation)
SILVER Soviet Union: Aleksandr Yevdokimov (Farkhad), Vladimir Soroka (Obzor), Sergin Muchin (Resfeder), and Yuri Solos (Rashod)
BRONZE Ireland: William McLernon (Ballangarry), Diana Wilson (Broken Promise), William Powell-Harris (Smokey VI), and Ronnie McMahon (San Carlos)

1972

⚫ OLYMPIC GAMES, MUNICH

DRESSAGE
— Individual
GOLD Liselottt Linsenhoff (FRG) and Piaff
SILVER Elena Petushkova (URS) and Pepel
BRONZE Josef Neckermann (FRG) and Venetia
— Team
GOLD Soviet Union: Elena Petushkova (Pepel), Ivan Kizimov (Ikhor), and Ivan Kalita (Tarif)
SILVER Federal Republic of Germany: Liselottt Linsenhoff (Piaff), Josef Neckermann (Venetia), and Karin Schlüter (Liostro)
BRONZE Sweden: Ulla Håkanson (Ajax), Ninna Swaab (Casanova), and Maud von Rosen (Lucky Boy)

JUMPING
— Individual
GOLD Graziano Mancinelli (ITA) and Ambassador
SILVER Ann Moore (GBR) and Psalm
BRONZE Neal Shapiro (USA) and Sloopy
— Team
GOLD Federal Republic of Germany: Fritz Ligges (Robin), Gerd Wiltfang (Askan), Hartwig Steenken (Simona), and Hans Günter Winkler (Trophy)
SILVER United States: William Steinkraus (Main Spring), Neal Shapiro (Sloopy), Kathy Kusner (Fleet Apple), and Frank Chapot (White Lightning)
BRONZE Italy: Vittorio Orlandi (Fulmer Feather Duster), Raimondo D'Inzeo (Fiorello II), Graziano Mancinelli (Ambassador), and Piero D'Inzeo (Easter Light)

EVENTING
— Individual
GOLD Richard Meade (GBR) and Laurieston
SILVER Alessandro Argenton (ITA) and Woodland
BRONZE Jan Jönsson (SWE) and Sarajevo
— Team
GOLD Great Britain: Richard Meade (Laurieston), Mary Gordon-Watson (Cornishman V), Bridget Parker (Cornish Gold), and Mark Phillips (Great Ovation)
SILVER United States: Kevin Freeman (Good Mixture), Bruce Davidson (Plain Sailing), John Michael Plumb (Free-and-Easy), and Jimmy Wofford (Kilkenny)
BRONZE Federal Republic of Germany: Harry Klugmann (Christopher Robert), Ludwig Gössing (Chicago), Karl Schultz (Pisco), and Horst Karsten (Sioux)

1973

🏅 FEI EUROPEAN CHAMPIONSHIPS

DRESSAGE
Aachen, West Germany
— Individual
GOLD Reiner Klimke (FRG) and Mehmed
SILVER Elena Petushkova (URS) and Pepel
BRONZE Ivan Kalita (URS) and Tarif
— Team
GOLD Federal Republic of Germany: Reiner Klimke (Mehmed), Karin Schlüter (Liostro), and Liselott Linsenhoff (Piaff)
SILVER Soviet Union: Ivan Kalita (Tarif), Elena Petushkova (Pepel), and Ivan Kizimov (Ikhor)
BRONZE Switzerland: Christine Stückelberger (Merry Boy), Marita Aeschbacher (Charlamp), and Hermann Dür (Sod)

JUMPING (MEN'S)
Hickstead, United Kingdom
GOLD Paddy McMahon (GBR) and Penwood Forge Mill (Millbridge)
SILVER Alwin Schockemöhle (FRG) and The Robber (Weiler)
BRONZE Hubert Parot (FRA) and Tic (Port Royal)

JUMPING (WOMEN'S)
Vienna, Austria
GOLD Ann Moore (GBR) and Psalm (April Love)

EVENTING
— Individual
GOLD Alexander Jewdokimow (URS) and Jeger
SILVER Herbert Blöcker (FRG) and Albrant
BRONZE Horst Karsten (FRG) and Sioux
— Team
GOLD Federal Republic of Germany: Kurt Mergler (Vaibel), Herbert Blöcker (Albrant), Harry Klugmann (El Paso), and Karsten Horst (Sioux)
SILVER Soviet Union: Aleksandr Yevdokimow (Jeger), Soroka (Obzor), Salnikov (Goodwill), and Valentin Gorelkin (Rock)
BRONZE Great Britain: Richard Meade (Wayfarer II), Lucinda Prior-Palmer (Be Fair), Janet Norton Hodgson (Larkspur), and Debbie West (Baccarat)

1974

🏆 FEI WORLD CHAMPIONSHIPS

DRESSAGE
Copenhagen, Denmark
— Individual
GOLD Reiner Klimke (FRG) and Mehmed
SILVER Liselott Linsenhoff (FRG) and Piaff
BRONZE Elena Petushkova (URS) and Pepel
— Team
GOLD Federal Republic of Germany: Reiner Klimke (Mehmed), Liselott Linsenhoff (Piaff), and Karin Schlüter (Liostro)
SILVER Soviet Union: Elena Petushkova (Pepel), Ivan Kalita (Tarif), and Ivan Kizimov (Ikhor)
BRONZE Switzerland: Christine Stückelberger (Granat), Hermann Dür (Sod), and Regula Pfrunder (Merry Boy)

JUMPING (MEN'S)
Hickstead, United Kingdom
GOLD Hartwig Steenken (FRG) and Simona
SILVER Eddie Macken (IRL) and Pele
BRONZE Hugo Simon (AUT) and Lavendel

EVENTING
Kiev, USSR
— Individual
GOLD Alexander Jewdokimow (URS) and Jeger

1975

🏅 FEI EUROPEAN CHAMPIONSHIPS

DRESSAGE
Kiev, USSR
— Individual
GOLD Christine Stückelberger (SUI) and Granat
SILVER Harry Boldt (FRG) and Woycek
BRONZE Karin Schlüter (FRG) and Liostro
— Team
GOLD Federal Republic of Germany: Harry Boldt (Woycek), Karin Schlüter (Liostro), and Ilsebill Becher (Mitsouko)
SILVER Soviet Union: Ivan Kalita (Tarif), Mikhail Kopejkin (Torpedist), and Elena Petushkova (Pepel)
BRONZE Switzerland: Christine Stückelberger (Granat), Ulrich Lehmann (Widin), and Doris Ramseier (Roch)

Caroline Bradley / Eventing — Kiev (col. 5)
SILVER Caroline Bradley (GBR) and True Lass (New Yorker)
BRONZE Monica Weier-Bachmann (SUI) and Erbach (Vasall)

JUMPING (WOMEN'S)
La Baule, France
GOLD Janou Tissot-Lefebvre (FRA) and Rocket (Alterline)
SILVER Michele McEvoy (USA) and Mr. Muskie (Sundancer)
BRONZE Barbara Simpson-Kerr (CAN) and Magnor (Australis)

EVENTING
Burghley, United Kingdom
— Individual
GOLD Bruce Davidson (USA) and Irish Cap
SILVER John Michael Plumb (USA) and Good Mixture
BRONZE Hugh Thomas (GBR) and Playamar
— Team
GOLD United States: Bruce Davidson (Irish Cap), John-Michael Plumb (Good Mixture), Edward Emerson (Victor Darkin), and Donald Sachey (Plain Sailing)
SILVER Great Britain: Richard Meade (Wayfarer II), Bridget Parker (Cornish Gold), Christopher Collins (Smokey VI), and Mark Phillips (Columbus)
BRONZE Federal Republic of Germany: Martin Plewa (Virginia), Herbert Blöcker (Albrant), Horst Karsten (Sioux), and Kurt Mergler (Vaibel)

JUMPING
Munich, West Germany
— *Individual*
GOLD Alwin Schockemöhle (FRG) and Warwick Rex
SILVER Hartwig Steenken (FRG) and Erle
BRONZE Sönke Sönksen (FRG) and Kwept
— *Team*
GOLD Federal Republic of Germany: Alwin Schockemöhle (Warwick Rex), Hartwig Steenken (Erle), and Sönke Sönksen (Kwept)
SILVER Switzerland: Paul Weier (Wulf), Walter Gabathuler (Butterfly), and Bruno Candrian (Golden Shuttle)
BRONZE France: Marcel Rozier (Bayard de Maupas), Gilles Bertran de Balanda (Bearn), and Michel Roche (Un Espoir)

EVENTING
Luhmühlen, West Germany
— *Individual*
GOLD Lucinda Prior-Palmer (GBR) and Be Fair
SILVER Princess Anne (GBR) and Goodwill
BRONZE Pyotr Gornushko (URS) and Gusar
— *Team*
GOLD Soviet Union: Pyotr Gornushko (Gusar), Viktor Kalinin (Araks), Vladimir Lanugin (Reflex), and Vladimir Tizhkin (Flot)
SILVER Great Britain: Lucinda Prior-Palmer (Madrigal), Princesse Anne (Goodwill), Sue Benson (Harley), and Janet Norton Hodgeson (Larkspur)
BRONZE Federal Republic of Germany: Kurt Mergler (Vaibel), Herbert Blöcker (Albrant), Harry Klugmann (Veberod), and Horst Karsten (Sioux)

1976
OLYMPIC GAMES, MONTREAL

DRESSAGE
— *Individual*
GOLD Christine Stückelberger (SUI) and Granat
SILVER Harry Boldt (FRG) and Woycek
BRONZE Reiner Klimke (FRG) and Mehmed
— *Team*
GOLD West Germany: Harry Boldt (Woycek), Reiner Klimke (Mehmed), and Gabriela Grillo (Ultimo)
SILVER Switzerland:

Christine Stückelberger (Granat), Ulrich Lehmann (Widin), and Doris Ramseier (Roch)
BRONZE United States: Hilda Gurney (Keen), Dorothy Morkins (Monaco), and Edith Master (Dahlwitz)

JUMPING
— *Individual*
GOLD Alwin Schockemöhle (GER) and Warwick Rex
SILVER Michel Vaillancourt (CAN) and Branch County
BRONZE François Mathy (BEL) and Gai Luron
— *Team*
GOLD France: Hubert Parot (Rivage), Marcel Rozier (Bayard de Maupas), Marc Roguet (Belle-de-Mars), and Michel Roche (Un Espoir)
SILVER West Germany: Alwin Schockemöhle (Warwick Rex), Hans Günter Winkler (Trophy), Sönke Sönksen (Kwept), and Paul Schockemöhle (Agent)
BRONZE Belgium: Eric Wauters (Gute Sitte), François Mathy (Gai Luron), Henry-Edgar Cuepper (Le Champion), and Stanny van Paesschen (Porsche)

EVENTING
— *Individual*
GOLD Edmund "Tad" Coffin (USA) and Bally Cor
SILVER John Michael Plumb (USA) and Better and Better
BRONZE Karl Schultz (FRG) and Madrigal
— *Team*
GOLD United States: Edmund Coffin (Bally Cor), John Michael Plumb (Better and Better), Bruce Davidson (Irish Cap), and Mary-Anne Tauskey (Marcus Aurelius)
SILVER West Germany: Karl Schultz (Madrigal), Herbert Blöcker (Albrant), Helmut Rethemeier (Pauline), and Otto Ammermann (Volturno)
BRONZE Australia: Wayne Roycroft (Laurenson), Mervyn Bennett (Regal Reign), William Roycroft (Version), and Denis Pigott (Hillstead)

1977
FEI EUROPEAN CHAMPIONSHIPS

DRESSAGE
St. Gallen, Switzerland
— *Individual*

GOLD Christine Stückelberger (SUI) and Granat
SILVER Harry Boldt (FRG) and Woycek
BRONZE Uwe Schulten-Baumer (FRG) and Slibowitz
— *Team*
GOLD Federal Republic of Germany: Harry Boldt (Woycek), Gabriela Grillo (Ultimo), and Uwe Schulten-Baumer (Slibowitz)
SILVER Switzerland: Christine Stückelberger (Granat), Ulrich Lehmann (Widin), and Claire Koch (Scorpio)
BRONZE Soviet Union: Irina Karacheva (Said), Mikhail Kopejkin (Aspect), and Wera Misevitch (Plot)

JUMPING
Vienna, Austria
— *Individual*
GOLD Johan Heins (NED) and Seven Valleys
SILVER Eddie Macken (IRL) and Kerrygold
BRONZE Anton Ebben (NED) and Jumbo Design
— *Team*
GOLD Netherlands: Harry Wouters (Salerno), Anton Ebben (Jumbo Design), Henk Nooren (Pluco), and Johan Heins (Seven Valleys)
SILVER Great Britain: Derek Ricketts (Hydrophane Coldstream), Debbie Johnsey (Moxy), Harvey Smith (Olympic Star), and David Broome (Philco)
BRONZE Federal Republic of Germany: Norbert Koof (Minister), Lutz Merkel (Salvaro), Paul Schockemöhle (Agent), and Gerd Wiltfang (Davos)

EVENTING
Burghley, United Kingdom
— *Individual*
GOLD Lucinda Prior-Palmer (GBR) and George
SILVER Karl Schultz (FRG) and Madrigal
BRONZE Horst Karsten (FRG) and Sioux
— *Team*
GOLD Great Britain: Lucinda Prior-Palmer (George), Jane Holderness-Roddam (Warrior), Christopher Collins (Smokey VI), and Clarissa Strachan (Merry Sovereign)
SILVER Federal Republic of Germany: Karl Schultz (Madrigal), Horst Karsten (Sioux), Hanna Huppelsberg-Zwöck (Aksent), and Harry Klugmann (El Passo)

BRONZE Ireland: John Watson (Cambridge Blue), Eric Horgan (Pontoon), Patsy Maher (Bellagarry), and Norman van de Vater (Blue Tom Tit)

1978
FEI WORLD CHAMPIONSHIPS

DRESSAGE
Goodwood, United Kingdom
— *Individual*
GOLD Christine Stückelberger (FRG) and Granat
SILVER Uwe Schulten-Baumer (FRG) and Slibowitz
BRONZE Jennie Loriston-Clarke (GBR) and Madras
— *Team*
GOLD Federal Republic of Germany: Uwe Schulten-Bauer (Slibowitz), Harry Boldt (Woycek), and Gabriella Grillo (Galapagos)
SILVER Switzerland: Christine Stücklerberger (Granat), Ulrich Lehmann (Widin), and Claire Koch (Scorpio)
BRONZE Soviet Union: Irina Karacheva (Said), Victor Ugriumov (Shkval), and Elena Petushkova (Abakan)

JUMPING
Aachen, West Germany
— *Individual*
GOLD Gerd Wiltfang (FRG) and Roman
SILVER Eddie Macken (IRL) and Boomerang
BRONZE Michael Matz (USA) and Jet Run
— *Team*
GOLD Great Britain: Derek Ricketts (Hydrophane Coldstream), Caroline Bradley (Tigre), Malcolm Pyrah (Law Court), and David Broome (Philco)
SILVER Netherlands: Henk Nooren (Pluco), Dick Wieken (Sil Z), Anton Ebben (Jumbo Design), and Johan Heins (Pandur Z)
BRONZE United States: Conrad Homfeld (Balbuco), Dennis Murphy (Tuscaloosa), Buddy Brown (Viscount), and Michael Matz (Jet Run)

EVENTING
Lexington KY, United States
— *Individual*
GOLD Bruce Davidson (USA) and Might Tango

SILVER John Watson (IRL) and Cambridge Blue
BRONZE Helmut Rethemeier (FRG) and Ladalco
— *Team*
GOLD Canada: Mark Ishoy (Law and Order), Juliet Bishop (Sumatra), Elizabeth Ashton (Sunrise), and Cathy Wedge (Abracadabra)
SILVER Federal Republic of Germany: Helmut Rethemeier (Ladalco), Otto Ammermann (Volturno), Harry Klugmann (Veberot), and Herbert Blöcker (Albrant)
BRONZE United States: Bruce Davidson (Might Tango), Jimmy Woffort (Carawich), Edmund "Tad" Coffin (Bally Cor), and John Michael Plumb (Laurenson)

1979
FEI EUROPEAN CHAMPIONSHIPS

DRESSAGE
Aarhus, Denmark
— *Individual*
GOLD Elisabeth Theurer (AUT) and Mon Cherie
SILVER Christine Stückelberger (SUI) and Granat
BRONZE Harry Boldt (FRG) and Woycek
— *Team*
GOLD Federal Republic of Germany: Gabriela Grillo (Ultimo), Harry Boldt (Woycek), and Uwe Schulten-Baumer (Slibowitz)
SILVER Soviet Union: Viktor Ugriumov (Shkval), Irina Karacheva (Said), and Elena Petushkova (Abakan)
BRONZE Switzerland: Amy-Catherine de Bary (Aintree), Christine Stückelberger (Granat), and Ulrich Lehmann (Widin)

JUMPING
Rotterdam, Netherlands
— *Individual*
GOLD Gerd Wiltfang (FRG) and Roman
SILVER Paul Schockemöhle (FRG) and Deister
BRONZE Hugo Simon (AUT) and Gladstone
— *Team*
GOLD Great Britain: Malcolm Pyrah (Law Court), Derek Ricketts (H Coldstream), Caroline Bradley (Law Court), and David Broome (Queensway B.Q.)

SILVER Federal Republic of Germany: Heinrich-Wilhelm Johannsmann (Sarto), Peter Luther (Livius), Paul Schockemöhle (Deister), and Gerd Wiltfang (Roman)
BRONZE Ireland: John Roche (Maigh Cuillin), Gerry Mullins (Ballinderry), Con Power (Rockbarton), and Eddie Macken (C. Boomerang)

EVENTING
Luhmühlen, West Germany
— *Individual*
GOLD Nils Haagensen (DEN) and Monaco
SILVER Rachel Bayliss (GBR) and Gurgle The Greek
BRONZE Rüdiger Schwarz (FRG) and Power Game
— *Team*
GOLD Ireland: John Watson (Cambridge Blue), David Foster (Inis Mean), Alan Lillingston (Seven Up), and Helen Cantillon (Wing Forward)
SILVER Great Britain: Clarissa Strachan (Merry Sovereign), Lucinda Prior-Palmer (Killaire), Sue Benson (Monocle Li), and Christopher Collins (Gamble)
BRONZE France: Thierry Touzaint (Gribouille C), Armand Bigot (Gamin du Bois), Thierry Lacour (Sertorius), and Edouard Decharme (Frisson A)

1979
FEI WORLD CUP

JUMPING
Gothenburg, Sweden
GOLD Hugo Simon (AUT) and Gladstone
SILVER Katie Monahan-Prudent (FRA) and The Jones Boy
BRONZE (JOINT) Norman Dello Joio (USA) and Allegro
BRONZE (JOINT) Eddie Macken (IRL) and Carolls of Dundalk

1970
FEI World Championships

1

2

— dressage

Aachen, Germany
Liselott Linsenhoff scooped the Grand Prix ahead of Russian rider Elena Petushkova, with Russia winning the team gold. The next day, on her way to the ride-off, Liselott was involved in a car accident. She rushed back to the competition and managed to be on her horse in time. However, she was shaken up and incurred one fault in the test. When Elena Petushkova entered the arena on Pepel, she produced a spectacular performance, which the judges rightly commended as worthy of a world champion.

— jumping (men's)

La Baule, France
During the final qualifying round, when David Broome had just completed a clear round, unrest emerged among the officials and spread to the riders. Broome's mount, Mattie Brown, was said to have hit the rail of the water jump. The Duke of Gor, president of the Spanish Federation and the water jump judge, had not indicated a fault.

— jumping (women's)

Copenhagen, Denmark
Clearly, the design of the obstacles was not worthy of a world championships, as some seemed unstable while others appeared sturdy. It did not take much for the young French rider Janou Lefebvre, to pay the price: when Rocket jumped the wall, the cup supporting the pole became detached without either the pole or the cup falling. The British team lodged a protest in favor of Marion Mould-Coakes but this was rejected, since no part of the obstacle had fallen, and Janou Lefebvre was crowned world champion.

3

— eventing

Punchestown, Ireland

Twenty-two-year-old Mary Gordon-Watson became world champion on Cornishman V, the horse she had ridden the year before when she won her European title. Almost half of the competitors were eliminated during the cross-country course. Only two of the six starting teams, Great Britain and France, made it to the podium. The horse ridden by Michel Cochenet, the French chef d'équipe, suffered a fall at Obstacle 23, and rolled over his rider who got hit in the head by the horse's foot. A German rider near the water jump managed to catch the horse and helped Cochenet back into the saddle.

1. E. Petushkova, world dressage champion, on Pepel.

2. J. Lefebvre, world jumping champion, on Troubadour.

3. M. Gordon-Watson, individual world eventing champion, on Cornishman V.

1971
FEI European Championships

— dressage

Wolfsburg, West Germany
A clash of two opposing traditions was reflected in the judges' scoring. Some preferred the elevated head carriage and the artistic lightness of Russian equestrianism, while others focused more on the technique, rigor, and precision of German equestrianism.

— jumping (men's)

Aachen, West Germany
Torrential rain made the footing so treacherous that some top horses were excluded right from the outset, while others that competed were injured. The course designer was forced to adapt his courses to take account of the very poor quality of the footing, meaning that the design of the courses no longer met championship standards in either terms of distance or the number and height of the jumps.

— jumping (women's)

St. Gallen, Switzerland
Only ten riders from six different nations competed for the title. Unsurprisingly, one of the two British riders won, with Ann Moore outperforming fellow British compatriot Alison Dawes-Westwood.

1

Burghley, United Kingdom
Leading her fellow Briton and rival Debbie West by more than 40 penalties, Princess Anne became European champion. The tabloid press was already concerned about her participation in the Munich Olympic Games and her ability to represent her country. While some attributed her victory to trainer Alison Oliver and the exceptional qualities of Doublet, others noted that many well-trained riders with good horses had been unsuccessful on the Burghley cross-country course.

1. A. Moore, European jumping champion, on April Love.

2. Princess Anne, European eventing champion, on Doublet.

2

1972
Olympic Games, Munich

These Games were marked by the terrorist attack on the Israeli team's accommodation in the Olympic Village. The Palestinian collective known as "Black September" took hostages, resulting in a heavy toll of eleven dead.

1

— dressage

For the first time, judges' boxes were placed at B and at E. The rules had changed once again, with five judges appointed. Patrick Le Rolland's horse, Cramique, was lame right from the beginning, when he proceeded in trot at X, when walking, and even when cantering. The president of the jury, Gustaf Nyblaeus, chair of the FEI Dressage Committee, should have warned Mr. Le Rolland that he was eliminated. Since he did not, all the judges acted as if nothing had happened. Liselott Linsenhoff was the first woman to become Olympic dressage champion.

— jumping

After the individual competition, it was clear which riders would be on the podium, but not which color medal they would be wearing around their necks. Three riders were tied: Ann Moore for Great Britain, Neal Shapiro for the United States, and Graziano Mancinelli for Italy. A jump-off would decide the placings: Mancinelli rode a clear round and was top of the podium, Moore incurred three faults to take the silver medal, and, with 8 penalties, Neal Shapiro had to console himself with bronze.

— eventing

At the end of the first phase, the dressage, Great Britain was in fourth place while Switzerland took the lead. The British demonstrated how to master the tricky cross-country course, enhancing their reputation by moving impressively ahead of the competition. For the first time in their history, they won double Olympic gold in eventing.

1. L. Linsenhoff, first Olympic dressage champion, on Piaff.

2. G. Mancinelli, gold medalist in jumping, on Ambassador.

2 >

1973
FEI European Championships

— dressage

Aachen, West Germany
The East German sports authorities decided that their riders would no longer take part in championships or Olympic Games in the discipline of dressage. Reiner Klimke dominated, winning his third European title on Mehmed.

— jumping (men's)

Hickstead, United Kingdom
British rider Paddy McMahon won the title on Penwood Forge Mill, the horse belonging to Mr. Fred Hartill, who the previous year had turned down an offer of £100,000 to buy him. At that time, the horse was called Plonk and, in the Hartill tradition, was renamed with the stable name of Penwood.

— jumping (women's)

Vienna, Austria
Ann Moore scored a double triumph, winning the last women's European Championships in history.

— eventing

Kiev, USSR
As announced in advance, every horse taking part in the competition was subject to an anti-doping test in the form of a saliva sample. The results were published the same day and there was nothing to report. Many officials at the championships were reassured to see the excess energy shown by the horses during the dressage phase, evidence that no sedatives had been used. Princess Anne attended to defend her title, but the pitfalls of this extremely difficult course thwarted her ambitions from Obstacle 2 onward. At the start, Goodwill fell at this particularly nasty obstacle that caught out several other horses and riders. In total, there were more than sixty falls and over twenty eliminations, among other incidents.

1

1. P. McMahon, European jumping champion, on Penwood Forge Mill.

2. R. Klimke, European dressage champion, on Mehmed.

1974
FEI World Championships

— dressage

Copenhagen, Denmark
After taking the 1973 European title in Aachen, Reiner Klimke and Mehmed won their first world title. It was a double victory, since Germany also won team gold.

— jumping (men's)

Hickstead, United Kingdom
In the final-four round (a new addition to the championships), after the horse rotation, Germany's Hartwig Steenken and Irishman Eddie Macken, now back on their own horses, had to compete in a jump-off for the gold medal. Steenken won with 4 penalties, and Macken, with 8 penalties, had to settle for silver. Frank Chapot for the United States and Hugo Simon for Austria were also tied with 8 penalties and should have entered a jump-off for third place. However, this did not take place as the organizers declared a tie.

— jumping (women's)

La Baule, France
Out of the three women's World Championships in the history of equestrian sports, Janou Tissot-Lefebvre won two, the first championships of 1968 having been won by Marion Coakes. From this point on, the championships would be mixed.

1. The German world dressage champion team: (left to fight) K. Schlüter (Liostro), R. Klimke (Mehmed), L. Linsenhoff (Piaff).

2. E. Macken, silver medalist in jumping, on Iris Kellett's Pele.

3. The jumping gold medalist H. Steenken on Simona.

4. M. Phillips in the eventing competition on Columbus.

5. B. Davidson, world eventing champion, on Irish Cap.

— eventing

Burghley, United Kingdom

The 1970s was a decade made famous by the exploits of the British royal couple. At Burghley, Captain Mark Phillips rode Columbus, a horse from the royal stables. After a faultless cross-country course, which took him from tenth to first place, Queen Elizabeth's aide-de-camp did not take the beautiful gray to the vet check: having hit Obstacle 26, the "Trout Hatchery," with his hind legs, Columbus was unable to complete the competition. A former French cavalry officer and rider in the French Olympic team, Jack Le Goff had been training the US eventing team since 1970, with great success, and at Burghley they won gold. In the individual competition, Americans Bruce Davidson on Irish Cap and John Michael Plumb on Good Mixture finished first and second respectively.

1975
FEI European Championships

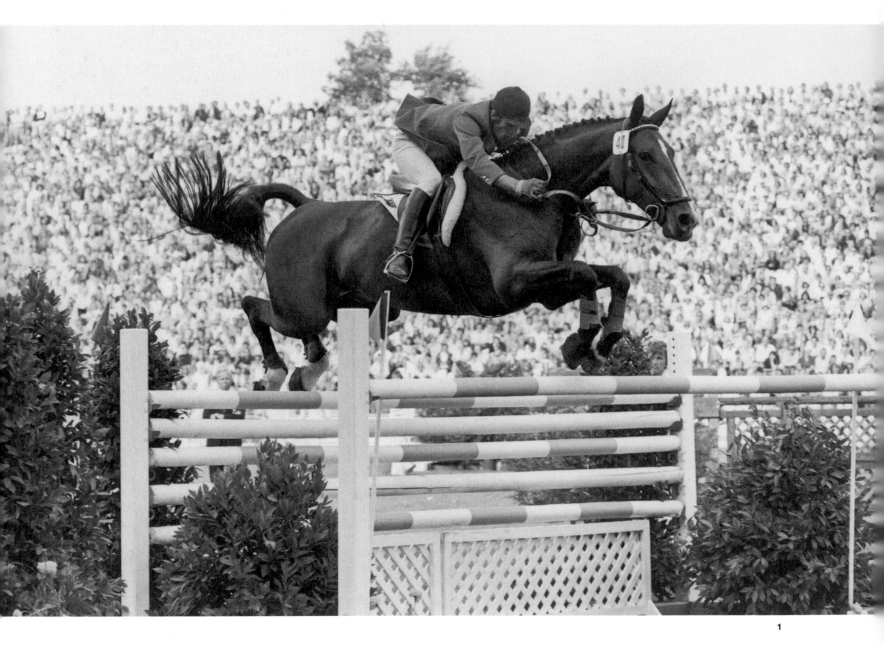

1

— dressage

Kiev, USSR
Christine Stückelberger of
Switzerland, riding Granat, who had
twice beaten Reiner Klimke and
Mehmed at the Aachen international
championships that same year,
continued her run of good form and
put an end to the German dominance
of European competitions.

— jumping

Munich, West Germany
Sixth time lucky! Alwin
Schockemöhle had mounted
the podium of the European
Championships on five successive
occasions but without ever
securing the gold. This time,
riding Warwick Rex, he became
European champion.

2

Luhmühlen, West Germany
The prize-giving ceremony could have taken place after the dressage phase, as the top three maintained their rankings until the end of the competition. The queen of this championship was Lucinda Prior-Palmer, riding Be Fair.

Appropriately, Princess Anne with Goodwill was European silver medalist. Third place went to Soviet rider Pyotr Gornushko.

1. A. Schockemöhle, European jumping champion, on Warwick Rex.

2. Princess Anne leading Goodwill to a veterinary appointment the day of the finals.

1976
Olympic Games, Montreal

Strict rules regarding horses that tested positive for piroplasmosis (a parasitic disease caused by ticks) undermined the composition of some teams.

— dressage

Germany reigned supreme: the Federal Republic took team gold, and in the individual competition they monopolized the top two steps of the podium. But it was not only on the podium that Germany excelled. The skills of the German trainers were highly sought after, as were their horses: out of twenty-seven competitors, eleven rode German warmblood horses, such as Granat, the mount of new Olympic champion Christine Stückelberger. The price of some horses was already in excess of $200,000.

1. C. Stückelberger, gold medalist in dressage, on Granat.

2. The individual jumping podium: (left to right) M. Vaillancourt (Branch County), A. Schockemöhle (Warwick Rex), F. Mathy (Gai Luron).

4

— jumping

In the individual competition that took place under torrential rain in Bromont, Alwin Schockemöhle finished with two clear rounds. Moreover, he was the only rider to do so. Three of his rivals were on 12 penalties and had to enter a jump-off for the other two podium places. Young Debbie Johnsey, the British representative, finished in fourth place.

— eventing

Forty-nine riders began the endurance race, and the statistics speak for themselves: thirteen riders were eliminated and six were unable to participate in the last phase of the event. There were forty falls and forty-six refusals, not counting the eliminated riders. Of the twelve participating teams, six were eliminated, including Great Britain and France.

3. A. Schockemöhle on Warwick Rex.

4. Bruce Davidson and Irish Cap, members of the US champion eventing team.

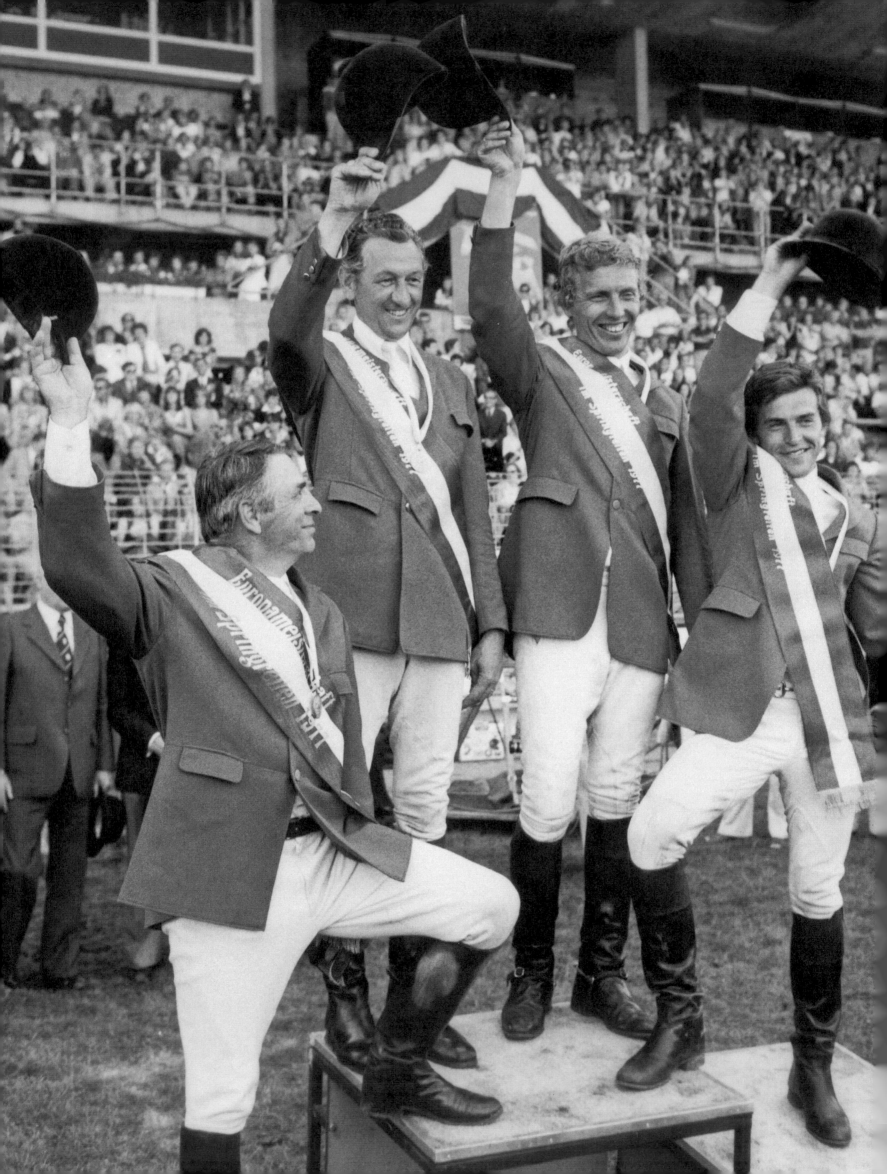

1977
FEI European Championships

— dressage

St. Gallen, Switzerland
Christine Stückelberger won her second successive title with Granat. The Grand Prix Special was introduced in place of the ride-off.

— jumping

Vienna, Austria
The British took it down to the wire: Great Britain lost the chance of facing the Netherlands in a jump-off for gold by just a quarter of a time penalty.

— eventing

Burghley, United Kingdom
The "Trout Hatchery" and the "Turkey House" were quirky names given to obstacles on this very tricky course, which only the British rider Chris Collins managed to complete without incident.

1. The Dutch European jumping champion team: (left to right) A. Ebben (Jumbo Design), H. Wouters (Salerno), J. Heins (Seven Valleys), H. Nooren (Pluco).

2. C. Stückelberger, European dressage champion, on Granat.

3. L. Prior-Palmer (far left) and some members of the gold-medal British eventing team: (left to right) C. Strachan (Merry Sovereign), J. Holderness-Roddam (Warrior), C. Collins (Smokey VI).

<1

2

3

1978
FEI World Championships

1

— dressage

Goodwood, United Kingdom
Jury president Gustaf Nyblaeus
gave Christine Stückelberger and
Granat an additional twenty-six
points, while the other judges
tended to put young rider Uwe
Schulten-Baumer on Slibowitz
in the lead. Officials and spectators
were impressed by Schulten-
Baumer's tests, while the dressage
movements of Stückelberger,
a very experienced rider, included
numerous faults.

— jumping

Aachen, West Germany
These championships saw many
changes, since the competitions
became mixed and now offered
the opportunity of a team medal.
Completing four clear rounds,
Ireland's Eddie Macken won
the silver medal by a quarter
of a time penalty. Germany's
Gerhard Wiltfang, with four clear
rounds, scooped gold, while
Michael Matz had to make do with
a frustrating bronze medal, clocking
up 4 penalties on his own horse.

1. U. Schulten-Baumer,
silver medalist in
dressage, on Feudal.

2. Runner-up E. Macken
(left; on Boomerang)
congratulating jumping
world champion
G. Wiltfang (on Roman).

2

3

3. B. Davidson and Might Tango, world individual eventing champions, attending a veterinary appointment.

eventing

Lexington KY, USA
Horses that tested positive for piroplasmosis were forbidden from setting hoof on American soil, a country that was not affected by the disease. There would be no French representative in Kentucky, as four of the team's five horses tested positive. "The Snake", a combination of Obstacles 23, 24, and 25, decimated the British team, which had started out as favorites. Two of the three riders who fell at this obstacle were eliminated: the British did not make it onto the podium.

1979
FEI European
Championships

Aarhus, Denmark
Young Austrian rider Elisabeth Theurer, who was initially criticized during the Grand Prix for smiling at the judges, achieved the highest score in the Grand Prix Special, snatching the title from Christine Stückelberger and Uwe Schulten-Baumer, who were regarded as favorites.

Rotterdam, Netherlands
Only one woman, Great Britain's Caroline Bradley, entered this competition. There were only six full teams. Half of the competitors in the hunting competition were penalized for exceeding the time allowed. A new regulation had to be created, enabling the course designer and the president of the jury to modify the time allowed in light of the rounds completed by several competitors.

Luhmühlen, West Germany
The technical difficulties of the cross-country course and the extremely hard ground caused a great deal of trouble. The Soviet team was eliminated because only one combination managed to complete the cross-country course. Lucinda Prior-Palmer's horse, a victim of the poor ground quality, did not pass the vet check.

2

3

1. E. Theurer, European dressage champion, on Mon Cherie.

2. G. Wiltfang, European individual jumping champion, on Roman.

3. N. Haagensen, European individual eventing champion, on Monaco.

Alwin Schockemöhle

A German prodigy

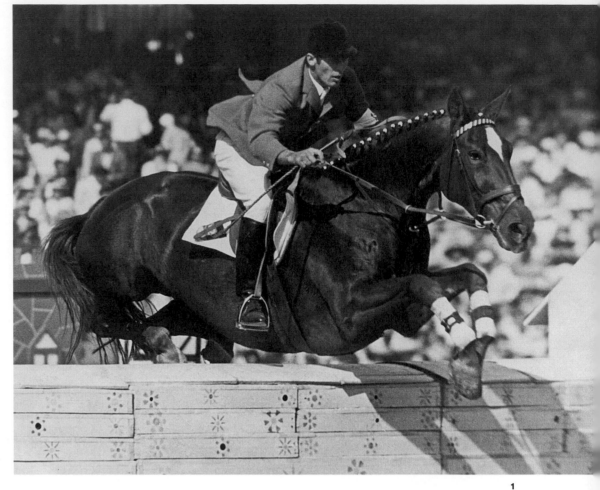

Alwin was born into a farming family in Meppen, Lower Saxony, Germany, on May 29, 1937. His parents were knowledgeable about horses, and they conveyed their enthusiasm to their three sons. Like Alwin, his younger brothers Paul and Werner also made their careers in the equestrian world. After succeeding as a show jumper, Paul became a respected horse dealer, while Werner bred numerous starring horses in Oldenburg.

Alwin discovered the joys of pony riding at the age of ten and immediately began to take part in local competitions with his friends from the nearby riding school. He tried eventing at national and then international level, eventually qualifying for the 1956 Olympics, but in the end he was considered too young for the Games that year. Frustrated by this experience, Alwin decided to turn his attention to show jumping, where his talent created an immediate sensation. He was inspired to devote himself exclusively to this discipline, and the idea of becoming a professional began to take root.

Alwin's grandmother died when he was twenty. He returned to her farm in Mühlen, taking charge of the family business and putting it on a sound financial footing by selling his star mare Anaconda to an American rider. Alwin never moved away from the family property, and his stud farm is still there today. With unwavering determination, extraordinary innate talent (particularly in flat work), abundant sound judgment, and respect for others, Alwin surrounded himself with top-notch collaborators. They contributed to his peak performance and helped him win the team gold for Germany in the 1960 Olympics in Rome. This triumph marked the inauguration of a successful fifteen-year career, during which he collected several national titles, team bronze in the 1968 Mexico Olympics, and numerous European successes.

Alwin's career peaked in Montreal in 1976. He competed brilliantly and won the individual Olympic title, mounted on Warwick Rex, and was runner-up in the team competition together with his brother Paul. Ironically, Alwin had almost missed out on these Olympics. Initially, the German Olympic Committee did not choose him for the team lineup, despite his impressive roster of titles and tremendous talent, but favorable recommendations flowed in to overturn their decision and Alwin was offered a place. Alwin's pride had been stung, however: he was at first reluctant to accept, but eventually yielded. He did not disappoint, executing two clear rounds, a feat not achieved since the 1928 Games. He said later, "Winning those medals was the greatest moment of my career. I'm proud of everything I've accomplished. I had a lot of good luck. I'd never have been able to do it without the people around me who give their support." Returning from his Olympic triumph, he was hailed as a hero, and the church bells of his village rang in his honor.

After an impressive riding career, Alwin was forced to retire in 1976 owing to recurring back problems. He decided to experiment with breeding trotters on his family farm. Devoting himself to raising top performers, he became one of the most highly regarded European breeders of trotters. His stallion Diamond Way was the European trotting champion, and another

of his protégés, Abano AS, won the 2003 Prix d'Amérique, the world's most prestigious harness-racing competition. "I won everything there was to win, first in show jumping and then in harness racing. I'm a proud professional."

Today, Alwin continues to manage his breeding business personally. Show-jumping horses have returned to his farm at the instigation of his daughter Vanessa, who is very active in the family business. She is from Alwin's second marriage, to Rita Schockemöhle, and the couple also has another daughter, Christina. With his first wife, Gaby, Alwin has a daughter, Alexandra, and two sons, Christoph and Frank. Still suffering from serious back problems, Alwin no longer rides as he used to, but he has happily embarked on his new vocation as a grandfather: "Watching the Formula 1 races and spending time with my grandson Leon are now my favorite activities!"

Inducted into the German Sports Hall of Fame in 2016, Alwin has become a legend in the world of equestrian sports.

"He loathed failure. He worshipped success, but defeat brought out his inner strength and resources."

— Dieter Ludwig

Dieter Ludwig, a long-standing friend, on Alwin

Ever since their first meeting, AFP journalist Dieter Ludwig has admired Alwin's success. "I respect him as a person and as a brilliant show jumper. Alwin has a winning, appealing personality that caught the attention of the great French show jumper Janou Lefebvre. I believe he was actually engaged to her at one point! Ever since I've known him, he's been competing at the highest level. His horses were always perfectly trained, thanks to regular gymnastic exercises and his incredible flat work, which comes from his background in eventing. No one else handles the reins with such mastery, and he never goes against the horse's natural movements."

Dieter was at Alwin's side during many championships and observed his reactions. "He loathed failure. He worshipped success, but defeat brought out his inner strength and resources. Alwin always understood what he knew how to do and what he could do. He focused on the highest standards and strove for perfection. I was with him at Hickstead in 1973, where he finished European silver medalist for the third time. He was considered the unofficial champion, and he didn't care for that—until Montreal!"

Dieter emphasizes Alwin's kindness as well as his riding skills. "Alwin is a person who gives more than he receives. He's generous, compassionate, and socially committed. For example, he hired paroled prisoners to help them reintegrate into society."

1. In Mexico on Donald Rex, 1968.

2. In Montreal on Warwick Rex, 1976.

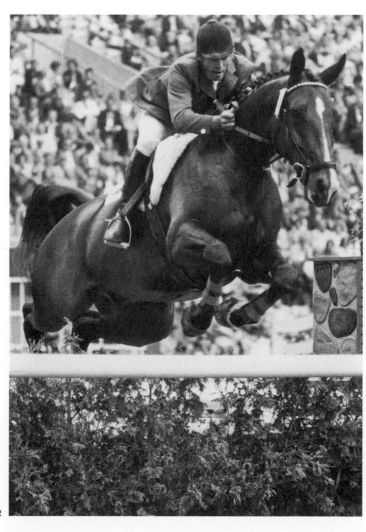

2

Career Highlights

Jumping

1960
Team gold in the Rome Olympics with Ferdl

1963
Individual silver in the FEI European Championships in Rome with Ferdl

1965
Individual bronze in the FEI European Championships in Aachen with Exakt (Freiherr)

1967
Individual bronze in the FEI European Championships in Rotterdam with Donald Rex

1968
Team bronze in the Mexico Olympics with Donald Rex

1969
Individual silver in the FEI European Championships in Hickstead with Donald Rex

1973
Individual silver in the FEI European Championships in Hickstead with The Robber

1975
Individual and team gold in the FEI European Championships in Munich with Warwick Rex

1976
Individual gold and team silver in the Montreal Olympics with Warwick Rex

Richard Meade

A rider who brought out the best in his horses

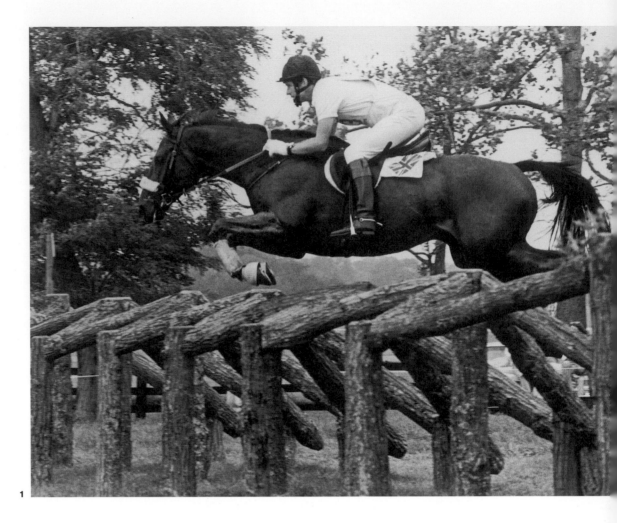

1

Relying on neither a horse nor famous stables, Richard Meade was architect of his own success. He was born on December 4, 1938, in the Welsh town of Chepstow, into an equestrian family; his parents, John and Phyllis, were joint masters of the hunt and had established the first Connemara pony stud in Great Britain. From an early age, Richard followed in their footsteps before moving into classical riding, helped by the famous show jumper Harry Llewellyn. Alongside a brilliant career as an engineering student at Cambridge University, Richard perfected his equestriain skills.

In 1960, at the age of twenty-two and at the end of his military service with the 11th Hussars, the future champion drove across Europe in a caravan with his sisters Sarah and Jane to attend the Olympic Games in Rome. Camping alongside the cross-country course, Richard was captivated by the intensity and beauty of eventing, and he decided to compete in the next Olympics, to be held in Tokyo. He began searching for the ideal partner and set his sights on Barberry, a four-year-old horse that he trained for four years before trying his luck in the qualifying competitions, at the time an obligatory step before selection. Things did not go as planned, and Richard fell in the first two competitions. The national coach then said he was interested in the horse—which he tried to buy—but not in the rider. Richard remained unruffled by these stinging words,

and gave his all during the final round in Burghley, which he won. The pair thus secured their ticket to Japan, where they finished eighth.

There followed numerous successes at the highest level, making Richard a linchpin of the British squad. Lacking a horse on the eve of the Mexico Games in 1968, he benefited from the misfortune of his injured teammate Mary Gordon-Watson, who lent him her mount, Cornishman V, for the occasion. In Mexico, in torrential rain and with the obstacles barely visible, the new pair rode an incredible clear round in a fast time that allowed Great Britain to win gold. Fourth in the individual competition, Richard did not miss the opportunity to improve at the Munich Games of 1972, becoming Olympic champion in both individual and team competitions. This time he rode the temperamental eight-year-old Laurieston, who had previously given many riders a hard time—the horse had an unfortunate tendency to jump the fence of the dressage arena. This victory was not the only example of Richard's incredible talent.

While looking for a horse for the 1976 Olympics in Montreal, Richard tried out on Jacob Jones, who was known to dislike jumping ditches. Despite his colleagues' derision, Richard began training by taking Jacob Jones out with the Berkeley Hunt, which was famous for jumping the widest ditches in Britain. The strategy worked, and

the pair took fourth place at the Games, even thought the British team did not finish the competition. A member of the 1981 European Championships' winning team, Richard scooped one last notable victory in 1982 at Badminton, riding Speculator III.

In 1984, after more than twenty-one years in the national team and with three Olympic titles, Richard bowed out and devoted himself to the development of the sport he loved so much. He was appointed President of the British Equestrian Federation, founded the British Horse Foundation in 1991, was in charge of improving and promoting breeding, and joined various FEI committees. Ultimately, he became a trainer, judge, and course designer.

In 1977, Richard married Angela Dorothy Farquhar. They lost their first son, Charles, in 1979 at the age of seven months, but went on to have three other children: James, Harry, and Lucy. Richard regularly attended competitions with Harry, himself an eventing rider whom his father supported passionately. Richard died of cancer on January 8, 2015.

Harry Meade, an international eventing rider, talks about his father

Blessed with an extraordinary talent, Richard always ensured that he got the best out of every horse. "My father possessed real horsemanship and was very good at understanding how to ride each horse. At his funeral, Hugh Thomas, one of his teammates, said he was more talented than the horses he had been associated with."

Although he took his riding seriously, Richard also liked to have fun once out of the saddle. "He had a very professional manner in his approach to horses and competitions, but there was also a side of him that remained the enthusiastic amateur who loved the atmosphere and the post-competition celebrations more than the victory itself!"

Harry has chosen to follow in his father's footsteps. "He gave me an unparalleled sense of what horsemanship means, but he also gave me the skills needed to create a top-level horse and bring out the best in him. He also taught me how to choose my goals, not to want to win everything, and to prepare for certain incidents. He came with me to every competition and offered me his expertise. I think he was the best in the world at walking a cross-country course. He could see the course through the eyes of the horse that was going to ride it. If you had a particular horse, he would identify a route that no one else had considered, but one that would make the horse comfortable. So many times I was presented with strategies that were different from those of the other riders, but he was never wrong. If he had died a few years earlier, I think I would have felt lost. Now I can see things as he did, as if he were still there by my side."

Richard was not only a horseman. "He was not defined by competition. He was not just a rider, he was so much more. He was interested in a huge number of things. During his whole time in top-level competition, he carried on his job in London, where he worked for an insurance company, and he rode every evening after he left the office."

1. At the World Championships in Lexington KY, 1978.
2. At the Munich Olympic Games, 1972.

"I think he was the best in the world at walking a cross-country course. He could see the course through the eyes of the horse that was going to ride it."

— Harry Meade

2

Career Highlights

Eventing

1966
Individual silver at the FEI World Championships in Burghley with Barberry

1968
Team gold at the Mexico Olympics with Cornishman V

1970
Individual silver and team gold at the FEI World Championships in Punchestown with The Poacher

1971
Team gold at the FEI European Championships in Horsens with The Poacher

1972
Individual and team gold at the Munich Olympics with Laurieston

1973
Team bronze at the FEI European Championships in Kiev with Wayfarer II

1974
Team silver at the FEI World Championships in Burghley with Wayfarer II

1981
Team gold at the FEI European Championships in Horsens with Kilcashel

1982
Team gold at the FEI World Championships in Luhmühlen with Kilcashel

Christine Stückelberger

A lifetime of dedication

Not many people are able to devote their entire lives to one passion, but Christine is among those lucky few.

She was born on May 22, 1947, in Bern in Switzerland and grew up in a family that had little interest in equestrian sports. Her mother had ridden during the 1930s but stopped with her first pregnancy; her father, a doctor who ran a clinic, was frankly afraid of horses. Although Christine was drawn to riding at a very young age, her parents apparently hadn't noticed, and Christine pursued a traditional academic curriculum. Her love of horses had no identifiable origin but manifested itself very early in her childhood. "When I was two, on a picnic in the country with my parents, I ran off to visit the horses in the stable on the other side of the road. My parents searched for me for hours and finally found me trying to get on to the back of a pony by climbing up its tail."

The young riding enthusiast took charge of her destiny when she was about ten years old. One of her aunts was a student at the Spanish Riding School of Vienna, which had moved to Switzerland for the duration of World War II and was open to civilians. While her aunt was visiting Christine's family, the child badgered her to be taught how to ride a horse. "So she sat me down on a kitchen chair and got me started. I practiced by myself every day until my aunt came back again, and when she finally returned, I proudly showed her my progress. As my reward, she treated me to ten lessons at the nearby riding school." This is where Christine first encountered Georg Wahl, a dressage rider and horse trainer, who was to become her professional partner. Christine had natural ability combined with powerful determination, and her skills developed rapidly. Although she devoted a great deal of time to horses, the notion of becoming a professional rider didn't cross her mind for quite some time. She was busy pursuing her studies and began to work as a secretary

in an insurance company. However, when she was eighteen, Christine decided to return to "Herr Wahl," as she continued to call him, at the Spanish Riding School in Vienna, where she made her debut in the dressage competition riding Merry Boy.

The duo experienced immediate success in their first year of competing; a season highlight was winning second place in her first international competition in 1967 in Aachen. Christine's meteoric rise continued when she and Merry Boy tried their luck in the Grand Prix and earned a place in the Swiss team's squad of reservists for the Mexico Olympics. Christine won her first medal on the international stage at the FEI European Championships in Aachen in 1973, having been ranked among the top ten Europeans between 1969 and 1971. At this point, Christine was preparing to compete with Granat, a horse purchased at the age of four in 1969. Blind in his right eye, Granat sometimes reacted unpredictably and was difficult to control. "We had a limited budget so we settled on Granat. He wasn't the handsomest horse, and he hadn't accomplished much so far. We later found out that he'd been worked for an hour before we arrived for the try-out so that he wouldn't act completely crazy." With practice, the bay's behavior improved. Christine rode him in his first competition, and they won it together.

Christine and Merry Boy were selected for the 1972 Olympics in Munich. She also decided to take Granat along to expose him

to the atmosphere of a high-level event. The horse worried other competitors who saw him at work, and his Swiss trainer decided to enter him in the competition, against the advice of both Christine and Georg Wahl. The duo came in fifteenth at the conclusion of their first Grand Prix. Granat was better prepared when he arrived at the FEI World Championships in Copenhagen two years later, coming in second in the Grand Prix and fourth in the Special. This triumph marked the beginning of his long-standing dominance in the discipline, and Christine and Granat remained unsurpassed for over four and a half years in international competitions. Between 1975 and 1978 they claimed two European titles, a world title, and an Olympic gold. "During the World Championships in Lausanne in 1982, I was diagnosed with Hepatitis B, and I could barely get on a horse. I went from my bed to my saddle and back. I won the Grand Prix, but during the Grand Prix Special I was completely done in and we finished in second place. Following Lausanne, Granat retired at the age of eighteen." He was finally put down at the age of twenty-six, stricken by several brain seizures.

Christine continued on the international circuit, riding a number of champion horses including Diamond, Tansanit, and Achat, before Gauguin de Lully appeared on the scene. Although it took a while for horse and rider to get accustomed to each other, they eventually came to a meeting of minds.

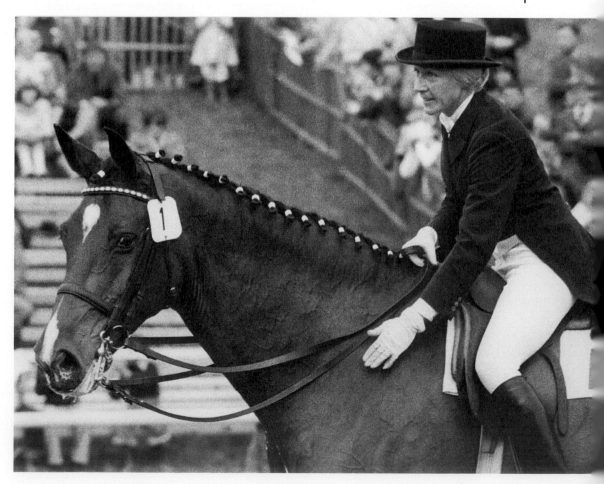

The 1970s

Christine continued to add to her vast collection of victories and medals. However, the pair's stunning pre-eminence came to an abrupt halt when Christine had a serious accident in 1989. Barely escaping complete paralysis, she courageously managed to get back into the saddle through sheer force of will. She began to compete again at the highest level with the giant Aquamarin, although she didn't go on to win any additional medals. "The first time I got on a horse after my accident, I rode two circles around the arena in the walk and had to dismount because I was feeling really dreadful. But I thought things over during the night and tried again the following day. Gauguin gave me the confidence to try again—it worked, and I kept going."

Christine was classified among the top five in her discipline in the year 2000, but she was ranked twenty-second in the Sydney Olympics following questionable and scandalous judging. "Aquamarin gave his best Grand Prix performance ever in Sydney, but Nadine Capellman, whose horse had his tongue hanging out, finished second and I was twenty-sixth. I asked for some explanation from the chief judge, but in vain. Apparently I had insulted the judges beforehand, claiming they were stupid. In reality, it was actually my fellow team-member Daniel Ramseier, who didn't want me to beat him once again, who had started this rumor. Riders from all the disciplines and many other witnesses came forward to speak in my defense. They told me I should hire a lawyer and write to the FEI. But I didn't have the heart to do that—I was just too traumatized by the whole situation." Distressed by the malice that had overtaken her sport, she ended her competitive career.

Since that time, and despite the death of her lifelong partner and mentor Georg Wahl in 2013, Christine has dedicated herself to training young riders and giving clinics all over the world. She is also breeding future dressage champions at Haras Hasenberg, near St. Gallen, and continues to ride one or two horses on a daily basis.

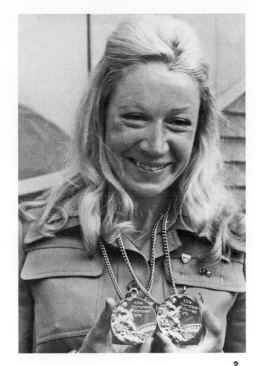

2

1. With Granat at the FEI World Championships in Goodwood, 1978.

2. Gold and silver medalist at the Montreal Olympic Games, 1976.

"The first time I got on a horse after my accident, I rode two circles around the arena in the walk and had to dismount because I was feeling really dreadful. But I thought things over during the night and tried again the following day. Gauguin gave me the confidence to try again— it worked, and I kept going."

— Christine Stückelberger

Career Highlights

Dressage

1973
Team bonze in the FEI European Championships in Aachen with Merry Boy

1974
Team bronze in the FEI World Championships Copenhagen with Granat

1975
Individual gold and team bronze in the FEI European Championships in Kiev with Granat

1976
Individual gold and team silver in the Montreal Olympics with Granat

1977
Individual gold and team silver in the FEI European Championships in St. Gallen with Granat

1978
Individual gold at the FEI World Championships at Goodwood with Granat

1979
Individual silver and team bronze in the FEI European Championships in Aarhus with Granat

1981
Individual and team silver in the FEI European Championships in Laxenbourg with Granat

1982
Individual and team silver in the FEI World Championships in Lausanne with Granat

1983
Team bronze in the FEI European Championships in Aachen with Achat

1984
Team silver in the Los Angeles Olympics with Tansanit

1986
Individual silver and team bronze in the FEI World Championships in Cedar Valley with Gauguin de Lully

1987
Team silver in the FEI European Championships in Goodwood with Gauguin de Lully

1988
Individual bronze and team silver in the Seoul Olympics with Gauguin de Lully

1990
Team bronze in the FEI World Equestrian Games in Stockholm with Gauguin de Lully

Cornishman V

Athlete, hunter, and movie star

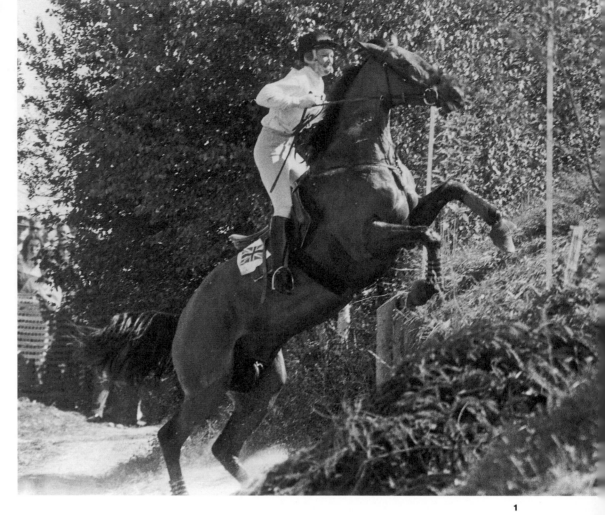

1

Born in Cornwall in 1959, Cornishman V was the offspring of the Thoroughbred Golden Surprise and a mare named Polly IV. The young bay grew up in the peaceful meadows of southwestern England and was purchased at the age of four by the father of Mary Gordon-Watson for the modest sum of £500 (about £11,000 today, or $14,000). Mary was fifteen at the time, and it was Cornishman's face—he had not yet been started—that appealed to the young rider's father, who had initially intended to purchase a different horse. In his early years, the gelding went hunting with the Watson parents as well as competing in a few horse-racing events. Mary was riding a pony at that time, but she loaned it to her brother Alexander when he was old enough to begin riding. This generosity left her without a mount for her qualifying test at the pony riding school, the final hurdle before entering into adult competitions. Her parents agreed to allow her to ride Cornishman, who was to become her future boon companion.

Cornishman had never been taught to do flat work. The training course for the qualifying test proved to be more challenging than anticipated owing to his rather volatile personality. The Olympic rider Ben Jones, who was the trainer at the time, recognized the horse's potential for eventing and encouraged Mary and Cornishman to try their luck in this discipline. The duo seized the opportunity with enthusiasm and took center stage in their first amateur competitions. They progressed so rapidly that they moved up from novice to advanced level in just two competitions, an incredible achievement given the technical gap between these two levels. Babe Moseley, the national eventing recruiter at the time, had the ambition to see Mary and her horse venture into the legendary Badminton CCI competition in the 1968 Olympic year. Many observers thought the idea was absurd, but

Mary directed laser-like focus and fanatical commitment to the training program required. Things did not go smoothly when they arrived in Badminton, however. They launched themselves into the cross-country phase with undue haste, and Mary initially demanded too much of Cornishman. The horse tired quickly and failed to clear the coffin, three obstacles before the finish line, unseating his rider. The handsome bay was clearly not yet prepared for this level of competition.

Later that year, Mary broke her leg. Her father was besieged by requests from the national British staff, who wanted to rent Cornishman to compete in the Mexico Olympics. Originally destined for Ben Jones, who had just lost his own longtime mount, the bay was ultimately assigned to Richard Meade, the great British champion. The duo participated in the prizewinning achievements of the UK team, to the profound gratification of the horse's owners. Mary recovered her trusty Cornishman the following year, taking the individual gold in the FEI European Championships in Haras du Pin. Buoyed by this success, Mary and Cornishman went to the 1970 FEI World Championships in Punchestown. They continued to dominate the field, claiming both the individual and team titles. The duo repeatedly gave outstanding performances in the months

that followed, claiming a place in the 1972 Munich Olympics. They won Olympic team gold and came in fourth place individually in this high-profile event.

Following this achievement, Mary decided to retire her fourteen-year-old protégé from sporting competitions in 1973. Cornishman was suffering from a severe cough. At the age of seven, he had had an operation for a laryngeal hemiplegia, an advanced form of respiratory cartilage obstruction, and experienced ongoing throat problems. He nevertheless continued to hunt with his partner for several years, and even embarked upon an acting career in later life. In 1974 he appeared in the film *Dead Cert*, adapted from a novel by Dick Francis, where he was ridden by jockey John Oaksey in a scene where the horse bounds over a car. Cornishman subsequently featured in the film *International Velvet* in 1978. He died in 1986.

1. At the Munich Olympics with M. Gordon-Watson, 1972.

2. In Mexico with R. Meade, 1968.

"We ultimately developed an incredibly close connection despite my small size and limited strength, and that relationship allowed us to understand each other."

— Mary Gordon-Watson

Mary Gordon-Watson, Cornishman V's rider and owner, remembers

Cornishman V was a powerful horse who used his strength in favor of his rider. "At first, I could only jump obstacles at a trot because his galloping stride was too big. Since I couldn't collect him, I didn't have any control. We ultimately developed an incredibly close connection despite my small size and limited strength, and that relationship allowed us to understand each other. He obeyed my voice commands and always understood what I wanted him to do. Despite his height, massive build, and power, Cornishman could maneuver his way through any situation that arose in the cross-county course; he knew how to manage every single obstacle. He could even shorten his stride to pony length to tackle a difficult jump. And he had extraordinary courage."

Although he was a formidable competitor, Cornishman retained youthful fears even as a mature champion. "Cornishman had some bad experiences with men. For his entire life, it was impossible for a man to catch him in a pasture. A slight young woman named July looked after him for practically his entire life. He trusted her absolutely, and she could get him to do whatever she wanted. Cornishman was a real warrior in certain regards, but in other areas—especially situations involving people on foot—he was easily spooked. And he wasn't a friendly horse who'd make the first overture to you—you had to go to him."

An eventing champion, Cornishman nevertheless preferred some activities to others. "Cornishman didn't really enjoy dressage. He didn't understand the point or interest of this discipline. He did it because he had to, but often with no enthusiasm whatsoever, and that was obvious in the arena! On the other hand, he loved cross country and performed beautifully on wet ground, unlike most horses. But he didn't like hard grounds, and we always tried to spare him from those."

Career Highlights

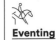

Eventing

1968
Team gold
in the Mexico
Olympics with
Richard Meade

1969
Individual gold
in the FEI European
Championships
in Haras du Pin
with Mary
Gordon-Watson

1970
Individual
and team gold
in the FEI World
Championships
in Punchestown with
Mary Gordon-Watson

1971
Team gold
in the FEI European
Championships
in Burghley with
Mary Gordon-Watson

1972
Team gold
in the Munich
Olympics with
Mary Gordon-Watson

2

The History of Para-Equestrian Sports

The origins of the Paralympic Games, which paved the way for all disability sports can be traced back to 1944, when the British government asked Dr. Ludwig Guttmann to develop sporting activities for wounded veterans at the rehabilitation center of Stoke Mandeville Hospital, located northwest of London. On July 29, 1948, the day of the opening ceremony of the London Olympics, the neurologist organized an archery competition for wheelchair-bound participants, christening it the "Stoke Mandeville Games." This event assumed an international dimension four years later when a Dutch team came to compete against the British patients. In the post-war world, countless victims of the conflict embraced the development of sports as a therapeutic aid to recovery; as early as 1945, Austrian and German medical advisers recommended skiing practice for wounded and disabled soldiers.

The first official Paralympic Games were organized in Rome alongside the 1960 Summer Olympics. Initially, only wheelchair-bound athletes were authorized to participate. Gradually, others began to compete, including, for example, those with a visual impairment in 1976, and those with cerebral palsy in 1980. The International Paralympic Committee (IPC) was created in 1989 to address the increasing breadth of the movement and to regulate its practices. By 1992, all participants were ranked according to their condition to assure the fairest possible standards for the competitions.

The physicians of the ancient world were well aware of the health benefits of horse riding, but it was only in the nineteenth century that the first medical studies on the subject were published. Various therapeutic practices began to appear—pony-riding schools for the blind opened in Berlin in 1888, for example. But it was not until the 1960s, inspired by the Shetland-pony-riding schools established for the education of children with disabilities in Illinois and Kansas, that the Bargteheide Therapeutic Riding School in Germany and M. Genêt's Institute for the Blind based in Romainville, France, were opened. The establishment of riding as a distinct sport for those with disabilities took years, however. In 1952, the Danish rider Lis Hartel, who was paralyzed below the knee, competed in the Helsinki Games alongside able-bodied riders. She won the silver medal, becoming the first woman to claim an Olympic prize in equestrian sports.

Riding was among a number of disciplines included in the first World Games for disabled athletes, held in 1970, in which over eight hundred individuals from twenty-one countries participated. Twelve Spanish riders with visual impairments rode a dressage test on this occasion. It was in 1996 that para-equestrian dressage made its first appearance in the tenth edition of the Paralympic Games in Atlanta. In the interest of fairness, the competitors were classified according to the extent of their disabilities in "grades" ranging from I to IV. Sixty-one riders from sixteen countries participated in this first edition, with the competitors riding horses that had been loaned to them. During the 2000 Paralympic Games in Sydney, seventy-two riders from twenty-four countries took part, again on borrowed horses. It was not until the 2004 Olympics in Athens that the athletes rode their own horses, which somewhat reduced the number of participants.

In order to uphold the standard of fairness among various degrees of disability, a reform was instituted for the 2008 Paralympics in Beijing. The ranking according to grades was modified: Grade I was divided into two subcategories, and in 2017 the grades themselves were renamed, now extending from Grade I to Grade V. Three criteria were evaluated for the classification of riders: muscle strength, joint mobility, and coordination. These classifications remain in effect today.

During para-equestrian competitions, riders are required to perform an established Grand Prix test and a Freestyle to Music test. For Grade I riders, the movements are basically done at a walk, while trot work is included for Grade II. For Grade III canter is allowed in

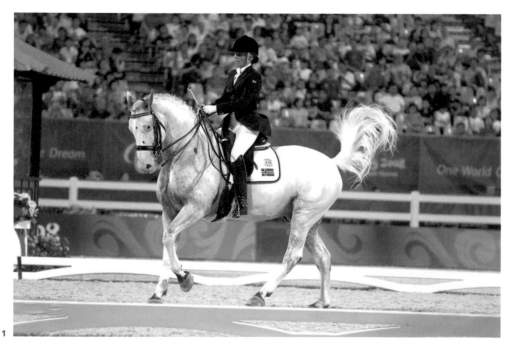

1. The Norwegian Ann Cathrin Lubbe, gold medalist at Athens and silver medalist at Hong Kong, on Zanko.

2. Closing ceremony of the London Paralympics, 2012.

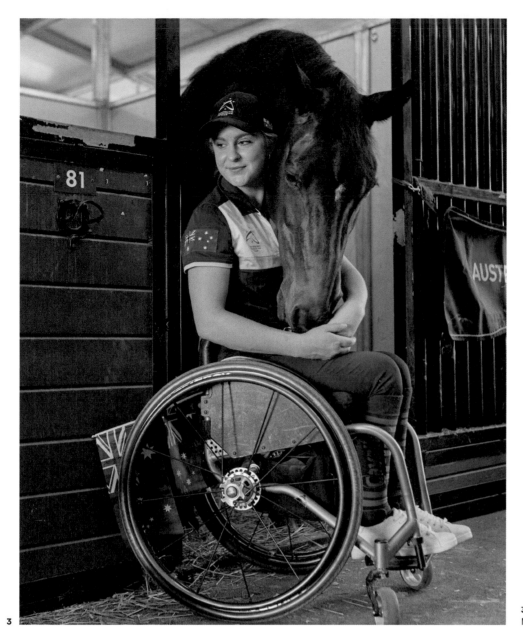

3. Emma Booth with Movelgangs Zidane.

the Freestyle to Music. For Grade IV, the test includes all three paces, with lateral work in the Freestyle. The Grade V test includes all three paces, with half-pirouettes, lateral work, and flying changes every three or four strides, in a rectangular arena measuring 196 × 65 ft. (60 × 20 m). In Paralympic events, team competitions are required to include three-member teams, with at least one member belonging to Grade I, II, or III.

The FEI has been responsible for para-equestrian sports since 2006. The first FEI World Championships for para-equestrian dressage were held in 2007, and in 2010 para-equestrian dressage was incorporated in the FEI World Equestrian Games in Lexington. European championships would follow. An international circuit has thus been established, offering an increasing number of opportunities for riders to compete. Fans followed the competitions and the para-equestrian riders enthusiastically, particularly during the 2012 Paralympics in London. Almost eighty riders attended from twenty-seven countries where riding is an integral part of the culture. Great

Britain has always claimed the gold in the team Paralympic competitions, with five of the eleven gold medals distributed in London awarded to British recipients. They claimed seven in Rio in 2016, including the team gold, coming ahead of the German and Dutch teams. The skill of these para-equestrian riders made them stars within their disciplines and in their homelands, and numerous other national federations followed. Today, however, new champions are mounting the podiums, including Rodolpho Riskalla, who won a silver medal for Brazil at the most recent FEI World Equestrian Games in Tryon in 2018, where some sixty riders from over twenty countries participated. The roster of winners from this movement continues to grow: new riders from all over the world are beginning take part, hailing from South Africa, the US, Germany, and Singapore, for instance. During the 2018 FEI World Equestrian Games, the Dutch took the gold—the first time any team other than Great Britain has done so in the history of para-equestrian dressage. It is worth noting that women are claiming the lioness's share of the medals.

The
1980s

RESULTS 1980–1989

1980
⚜ OLYMPIC GAMES, MOSCOW

DRESSAGE
— Individual
GOLD Elisabeth Theurer (AUT) and Mon Cherie
SILVER Yury Kovshov (URS) and Igrok
BRONZE Viktor Ugriumov (URS) and Shkval
— Team
GOLD Soviet Union: Yury Kovshov (Igrok), Viktor Ugriumov (Shkval), and Vera Misevich (Plot)
SILVER Bulgaria: Petar Mandajiev (Chtchibor), Svetoslav Ivanov (Aleko), and Guergui Gadjev (Unimatelen)
BRONZE Romania: Anghelache Donescu (Dor), Dumitru Velicu (Dezebal), and Petr Rosca (Derbist)

JUMPING
— Individual
GOLD Jan Kowalczyk (POL) and Artemor
SILVER Nikolay Korolkov (URS) and Espadron
BRONZE Joaquin Perez (MEX) and Alymony
— Team
GOLD Soviet Union: Viatcheslav Chukanov (Gepatit), Viktor Poganovsky (Topky), Viktor Asmaev (Reis), and Nicolai Korolkov (Espadron)
SILVER Poland: Jan Kowalczyk (Artemor), Wieslaw Hartmann (Norton), Marian Kozicki (Bremen), and Janusz Bobik (Szampan)
BRONZE Mexico: Joaquin Perez (Alymony), Alberto Valdes (Lady Mirka), Gerardo Tazzer (Karibe), and Jesus Gomez Portugal (Massacre)

EVENTING
— Individual
GOLD Euro Federico Roman (ITA) and Rossinan
SILVER Aleksandr Blinov (URS) and Galzun
BRONZE Yury Salnikov (URS) and Pintset
— Team
GOLD Soviet Union: Aleksandr Blinov (Galzun), Yury Salnikov (Pintset), Valery Volkov (Tzhetti), and Sergei Rogozhin (Gelespont)
SILVER Italy: Euro Federico Roman (Rossinan), Anna Casagrande (Daleye), Mauro Roman (Dourakine), and Marina Sciocchetti (Rohan de Lechère)
BRONZE Mexico: Manuel Mendivil Yocupicio (Remember), David Barcena Rios (Bonbona), José Luis Soto Perez (Quelite), and Fabian Vazquez Lopez (Cocaleco)

1980
🏆 FEI WORLD CUP

JUMPING
Baltimore MD, United States
GOLD Conrad Homfeld (USA) and Balbuco
SILVER Melanie Smith (FRA) and Calypso
BRONZE Paul Schockemöhle (FRG) and Deister

1981
⚜ FEI EUROPEAN CHAMPIONSHIPS

DRESSAGE
Laxenburg, Austria
— Individual
GOLD Uwe Schulten-Baumer (FRG) and Madras
SILVER Christine Stückelberger (SUI) and Granat
BRONZE Gabriela Grillo (FRG) and Galapagos
— Team
GOLD Federal Republic of Germany: Uwe Schulten-Baumer (Madras), Gabriela Grillo (Galapagos), and Reiner Klimke (Ahlerich)
SILVER Switzerland: Christine Stückelberger (Granat), Amy-Catherine de Bary (Aintree), and Ulrich Lehmann (Widin)
BRONZE Soviet Union: Yuri Kovshov (Igrok), Vera Misevitch (Plot), and Tatiana Nenakhova (Garun)

JUMPING
Munich, West Germany
— Individual
GOLD Paul Schockemöhle (FRG) and Deister
SILVER Malcolm Pyrah (GBR) and Towerlands Anglezarke

BRONZE Bruno Candrian (SUI) and Van Gogh
— Team
GOLD Federal Republic of Germany: Norbert Koof (Fire II), Peter Luther (Livius), Gerd Wiltfang (Roman), and Paul Schockemöhle (Deister)
SILVER Switzerland: Willi Melliger (Trumpf Burr), Walter Gabathuler (Harley), Thomas Fuchs (Willora Carpets), and Bruno Candrian (Van Gogh)
BRONZE Netherlands: Emile Hendrix (Livius), Rob Ehrens (Koh-I-Noor), Henk Nooren (Opstalan), and Johan Heins (Larramy)

EVENTING
Horsens, Denmark
— Individual
GOLD Hansueli Schmutz (SUI) and Oran
SILVER Helmut Rethemeier (FRG) and Santiago 31
BRONZE Brian McSweeney (IRL) and Inis Meain
— Team
GOLD Great Britain: Lizie Purbrick (Peter the Great), Sue Benson (Gemma Jay), Richard Meade (Killcashel), and Virginia Holgate (Priceless)
SILVER Switzerland: Joseph Burger (Beaujour de Mars), Josef Räber (Benno II), Hansueli Schmutz (Oran), and Ernst Baumann (Baron)
BRONZE Poland: Miroslaw Slusarszyk (Ekran), Krzysztof Rafalak (Djak), Jan Lipczynski (Elektron), and Miroslaw Szlapka (Erywan)

1981
🏆 FEI WORLD CUP

JUMPING
Birmingham, United Kingdom
GOLD Michael Matz (USA) and Jet Run
SILVER Donald Cheska (USA) and Southside
BRONZE Hugo Simon (AUT) and Gladstone

1982
🏆 FEI WORLD CHAMPIONSHIPS

DRESSAGE
Lausanne, Switzerland
— Individual
GOLD Reiner Klimke (FRG) and Ahlerich

SILVER Christine Stückelberger (SUI) and Granat
BRONZE Uwe Schulten-Baumer (FRG) and Madras
— Team
GOLD Federal Republic of Germany: Reiner Klimke (Ahlerich), Gabriella Grillo (Galapagos), and Uwe Schulten-Baumer (Madras)
SILVER Switzerland: Christine Stückelberger (Granat), Claire Koch (Beau Geste), and Doris Ramseier (River King)
BRONZE Denmark: Anne-Grethe Jensen (Marzog), Finn Saksö-Larsen (Coq d'Or), and Tove Jorck-Jorckston (Lazuly)

JUMPING
Dublin, Ireland
— Individual
GOLD Norbert Koof (FRG) and Fire II
SILVER Malcolm Pyrah (GBR) and Towerlands Anglezarke
BRONZE Michel Robert (FRA) and Idéal de la Haye
— Team
GOLD France: Michel Robert (Idéal de la Haye), Patrick Caron (Eole IV), Frédéric Cottier (Flambeau C), and Gilles Bertran de Balanda (Galoubet A)
SILVER Federal Republic of Germany: Norbert Koof (Fire II), Peter Luther (Livius), Gerd Wiltfang (Roman), and Paul Schockemöhle (Deister)
BRONZE Great Britain: John Whitaker (Ryan's Son), Nick Skelton (If Ever), Malcolm Pyrah (Towerlands Anglezarke), and David Broome (Mr. Ross)

EVENTING
Luhmühlen, West Germany
— Individual
GOLD Lucinda Green (GBR) and Regal Realm
SILVER Helmut Rethemeier (FRG) and Santiago
BRONZE Kim Walnes (USA) and The Grey Goose
— Team
GOLD Great Britain: Lucinda Green (Regal Realm), Richard Meade (Kilcashel), Virginia Holgate (Priceless), and Rachel Bayliss (Mystic Minstrel)
SILVER Federal Republic of Germany: Helmut Rethemeier (Santiago), Rudiger Schwarz (Power Game), Herbert Blöcker (Ladad), and Dietmar Hogrefe (Foliant 6)

BRONZE United States: Kim Walnes (The Grey Goose), Nancy Bliss (Cobblestone), Torrance Watkins Fleischmann (Southern Comfort), and John Michael Plumb (Blue Stone)

1982
🏆 FEI WORLD CUP

JUMPING
Gothenburg, Sweden
GOLD Norman Dello Joio (USA) and I Love You
SILVER Hugo Simon (AUT) and Gladstone
BRONZE Mélanie Smith (USA) and Calypso

1983
⚜ FEI EUROPEAN CHAMPIONSHIPS

DRESSAGE
Aachen, West Germany
— Individual
GOLD Anne-Grethe Jensen (DEN) and Marzog
SILVER Reiner Klimke (FRG) and Ahlerich
BRONZE Uwe Sauer (FRG) and Montevideo
— Team
GOLD Federal Republic of Germany: Uwe Sauer (Montevideo), Uwe Schulten-Baumer (Madras), Hergert Krug (Muscadeur), and Reiner Klimke (Ahlerich)
SILVER Denmark: Anne-Grethe Jensen (Marzog), Finn Saksö-Larsen (Coq d'Or), Torben Ulso-Olsen (Patricia), and Renee Igelski (Baloo)
BRONZE Switzerland: Otto Hofer (Limandus), Claire Koch (Beau Geste), Christine Stückelberger (Achat), and Amy-Catherine de Bary (Aintree)

JUMPING
Hickstead, United Kingdom
— Individual
GOLD Paul Schockemöhle (FRG) and Deister
SILVER John Whitaker (GBR) and Ryan's Son
BRONZE Frédéric Cottier (FRA) and Flambeau C
— Team
GOLD Switzerland: Walter Gabathuler (Beethoven), Heidi Robbiani (Jessica), Willi Melliger (Van Gogh), and Thomas Fuchs (Willora Swiss)

SILVER Great Britain: Harvey Smith (Sanyo Video), David Broome (Mr. Ross), John Whitaker (Ryan's Son), and Malcolm Pyrah (Towerlands Anglezarke)
BRONZE Federal Republic of Germany: Achaz von Buchwaldt (Wendy), Michael Rüping (Caletto), Gerd Wiltfang (Goldika), and Paul Schockemöhle (Deister)

EVENTING
Frauenfeld, Switzerland
— Individual
GOLD Rachel Bayliss (GBR) and Mystic Minstrel
SILVER Lucinda Green (GBR) and Regal Realm
BRONZE Christian Persson (SWE) and Joel
— Team
GOLD Sweden: Christian Paersson (Joel), Göran Breisner (Ultimus), Sven Ingvarsson (Doledo), and Jeanette Ullsten (Noir)
SILVER Great Britain: Lucinda Green (Regal Realm), Virginia Holgate (Night Cap), Lorna Clarke (Danville), and Diana Clapham (Windjammer II)
BRONZE France: Pascal Morvillers (Gulliver B), Thierry Lacour (Hymen de la Cour), Marie-Christine Duroy (Harley), and Patrick Marquebielle (Flamenco III)

1983
🏆 FEI WORLD CUP

JUMPING
Vienna, Austria
GOLD Norman Dello Joio (USA) and I Love You
SILVER Hugo Simon (AUT) and Gladstone
BRONZE Melanie Smith (USA) and Calypso

1984
⚜ OLYMPIC GAMES, LOS ANGELES

DRESSAGE
— Individual
GOLD Reiner Klimke (FRG) and Ahlerich
SILVER Anne-Grethe Jensen (DEN) and Marzog
BRONZE Otto Hofer (SUI) and Limandus

— Team
GOLD Federal Republic of Germany: Reiner Klimke (Ahlerich), Uwe Sauer (Montevideo), and Herbert Krug (Muscadeur)
SILVER Switzerland: Otto Hofer (Limandus), Christine Stückelberger (Tansanit), and Amy-Catherine de Bary (Aintree)
BRONZE Sweden: Ulla Håkanson (Flamingo), Ingamay Bylund (Aleks), and Louise Nathhorst (Inferno)

JUMPING
— Individual
GOLD Joe Fargis (USA) and Touch of Class
SILVER Conrad Homfeld (USA) and Abdullah
BRONZE Heidi Robbiani (SUI) and Jessica
— Team
GOLD United States: Joe Fargis (Touch of Class), Conrad Homfeld (Abdullah), Leslie Burr-Howard (Albany), and Melanie Smith (Calypso)
SILVER Great Britain: Michael Whitaker (Overton Amanda), John Whitaker (Ryan's Son), Steven Smith (Shining Example), and Tim Grubb (Linky)
BRONZE West Germany: Paul Schockemöle (Deister), Peter Luther (Livius), Franke Sloothaak (Farmer), and Fritz Ligges (Ramzes)

EVENTING
— Individual
GOLD Mark Todd (NZL) and Charisma
SILVER Karen Stives (USA) and Ben Arthur
BRONZE Virginia Holgate (GBR) and Priceless
— Team
GOLD United States: John Michael Plumb (Blue Stone), Karen Stives (Ben Arthur), Torrance Watkins-Fleischmann (Finvarra), and Bruce Davidson (J. J. Babu)
SILVER Great Britain: Virginia Holgate (Priceless), Lucinda Green (Regal Realm), Ian Stark (Oxford Blue), and Diana Clapham (Windjammer II)
BRONZE West Germany: Dietmar Hogrefe (Foliant), Bettina Overesch (Peacetime), Claus Erhorn (Fair Lady), and Burkhard Tesdorpf (Freedom)

1984
🏆 FEI WORLD CUP

JUMPING
Gothenburg, Sweden
GOLD Mario Deslauriers (CAN) and Aramis
SILVER Norman Dello Joio (USA) and I Love You
BRONZE Nelson Pessoa (BRA) and Moët et Chandon Laramy

1985
🎖 FEI EUROPEAN CHAMPIONSHIPS

DRESSAGE
Copenhagen, Denmark
— Individual
GOLD Reiner Klimke (FRG) and Ahlerich
SILVER Otto Hofer (SUI) and Limandus
BRONZE Anne-Grethe Jensen (DEN) and Marzog
— Team
GOLD Federal Republic of Germany: Reiner Klimke (Ahlerich), Tilmann Meyer zu Erpen (Tristan), Uwe Sauer (Montevideo), and Uwe Schulten-Baumer (Madras)
SILVER Denmark: Anne-Grethe Jessen (Marzog), Ernst Jessen (Why Not), Torben Ulsö-Olsen (Patricia), and Jesper Frisman (Clermont)
BRONZE Soviet Union: Olga Klimko (Babaris), Elena Petushkova (Hevsur), Yuri Kovshov (Ruch), and Vladimir Lanugin (Kuznets)

JUMPING
Dinard, France
— Individual
GOLD Paul Schockemöhle (FRG) and Deister
SILVER Heidi Robbiani (SUI) and Jessica
BRONZE John Whitaker (GBR) and Hopscotch
— Team
GOLD Great Britain: Nick Skelton (St. James), Michael Whitaker (Warren Point), Malcolm Pyrah (Towerlands Anglezarke), and John Whitaker (Hopscotch)
SILVER Switzerland: Philippe Guerdat (Pybalia), Heidi Robbiani (Jessica), Walter Gabathuler (The Swan), and Willi Melliger (Beethoven II)
BRONZE Federal Republic of Germany: Franke Sloothaak (Walido), Michael Rüping (Silbersee), Peter Luther

(Livius), and Paul Schockemöhle (Deister)

EVENTING
Burghley, United Kingdom
— Individual
GOLD Virginia Leng (GBR) and Priceless
SILVER Lorna Clarke (GBR) and Myross
BRONZE Ian Stark (GBR) and Oxford Blue
— Team
GOLD Great Britain: Lorna Clarke (Myross), Ian Stark (Oxford Blue), Virginia Leng (Priceless), and Lucinda Green (Regal Realm)
SILVER France: Jean Teulère (Godelureau), Vincent Berthet (Kopino), Marie-Christine Duroy (Harley), and Pascal Morvilliers (Gulliver B)
BRONZE Federal Republic of Germany: Christoph Wagner (Philip), Jürgen Blum (Frosty Bay), Ralf Ehrenbrink (Bettina 26), and Claus Erhorn (Fair Lady 54)

1985
🏆 FEI WORLD CUP

JUMPING
Berlin, West Germany
GOLD Conrad Homfeld (USA) and Abdullah
SILVER Nick Skelton (GBR) and Everest
BRONZE Pierre Durand (FRA) and Jappeloup

1986
🏆 FEI WORLD CHAMPIONSHIPS

DRESSAGE
Cedar Valley, Canada
— Individual
GOLD Anne-Grethe Jensen (DEN) and Marzog
SILVER Christine Stückelberger (SUI) and Gauguin de Lully
BRONZE Johann Hinnemann (FRG) and Ideaal
— Team
GOLD Federal Republic of Germany: Gina Capellmann (Ampère), Johann Hinnemann (Ideaal), Reiner Klimke (Pascal), and Herbert Krug (Dukat)
SILVER Netherlands: Tineke Bartels (Olympic Duco), Bert Rutten (Robby), Annemarie Sanders (Amon), and

Helene Aubert-Pen (Mr. X)
BRONZE Switzerland: Daniel Ramseier (Orlando), Ulrich Lehmann (Xanthos), Christine Stückelberger (Gauguin de Lully), and Doris Ramseier (Rochus)

JUMPING
Aachen, West Germany
— Individual
GOLD Gail Greenough (CAN) and Mr. T
SILVER Conrad Homfeld (USA) and Abdullah
BRONZE Nick Skelton (GBR) and Raffles Apollo
— Team
GOLD United States: Michael Matz (Chef), Conrad Homfeld (Abdullah), Katie Monahan (Amadia), and Katharine Burdsall (The Natural)
SILVER Great Britain: Nick Skelton (Apollo), Michael Whitaker (Next Warren Point), Malcolm Pyrah (Towerlands Anglezarke), and John Whitaker (Next Hopscotch)
BRONZE France: Frédéric Cottier (Flambeau C), Michel Robert (La Fayette), Patrice Delaveau (Laeken), and Pierre Durand (Jappeloup de Luze)

EVENTING
Gawler, Austria
— Individual
GOLD Virginia Leng (GBR) and Priceless
SILVER Trude Boyce (NZL) and Mossman
BRONZE Lorna Clarke (GBR) and Myross
— Team
GOLD Great Britain: Virginia Leng (Priceless), Lorna Clarke (Myross), Ian Stark (Oxford Blue), and Clarissa Strachan (Delphy Dazzle)
SILVER France: Marie-Christine Duroy (Harley), Armand Bigot (Jacquou du Bois), Thierry Touzaint (Gardenia III), and Vincent Berthet (Jupille)
BRONZE Australia: Barry Roycroft (Last Tango), Scott Keach (Trade Commissioner), Wayne Roycroft (Valdez), and Andrew Hoy (Just James)

1986
🏆 FEI WORLD CUP

JUMPING
Gothenburg, Sweden
GOLD Leslie Burr (USA) and Mclain

SILVER Ian Millar (CAN) and Big Ben
BRONZE Conrad Homfeld (USA) and Maybe

1987
🎖 FEI EUROPEAN CHAMPIONSHIPS

DRESSAGE
Goodwood, United Kingdom
— Individual
GOLD Margit Otto-Crépin (FRA) and Corlandus
SILVER Ann-Kathrin Linsenhoff (FRG) and Courage
BRONZE Johann Hinnemann (FRG) and Ideaal
— Team
GOLD Federal Republic of Germany: Ann-Kathrin Linsenhoff (Courage), Johann Hinnemann (Ideaal), Herbert Krug (Floriano), and Gina Capellmann (Ampere)
SILVER Switzerland: Daniel Ramseier (Orlando), Otto Hofer (Limandus), Ulrich Lehmann (Xanthos), and Christine Stückelberger (Gauguin de Lully)
BRONZE Netherlands: Anne Marie Sanders (Amon 5), Hélène Aubert (Mr. X), Tineke Bartels (Duco), and Bert Rutten (Garibaldi)

JUMPING
St. Gallen, Switzerland
— Individual
GOLD Pierre Durand (FRA) and Jappeloup
SILVER John Whitaker (GBR) and Milton
BRONZE Nick Skelton (GBR) and Apollo
— Team
GOLD Great Britain: Nick Skelton (Apollo), Michael Whitaker (Amanda), Malcolm Pyrah (Towerlands Anglezarke), and John Whitaker (Milton)
SILVER France: Philippe Rozier (Jiva), Pierre Durand (Jappeloup), Frédéric Cottier (Flambeau C), and Michel Robert (La Fayette)
BRONZE Switzerland: Philippe Guerdat (Lanciano V), Markus Fuchs (Shandor), Walter Gabathuler (The Swan), and Willi Melliger (Corso)

EVENTING
Luhumühlen, West Germany
— Individual
GOLD Virginia Leng (GBR) and Night Cap II

SILVER Ian Stark (GBR) and Sir Wattie
BRONZE Claus Erhorn (FRG) and Justyn Thyme
— Team
GOLD Great Britain: Rachel Hunt (Aloaf), Ian Stark (Sir Wattie), Virginia Leng (Night Cap II), and Lucinda Green (Shannagh)
SILVER Federal Republic of Germany: Wolfgang Mengers (Half Moon Bay), Ralf Ehrenbrink (Uncle Todd), Claus Erhorn (Justyn Thyme), and Jürgen Blum (Frosty Bay)
BRONZE France: Thierry Lacour (Hymen de la Cour), Didier Séguret (Jovial E), Vincent Berthet (Jet Crub), and Pascal Morvillers (Jacquet)

1987
🏆 FEI WORLD CUP

JUMPING
Paris, France
GOLD Katharine Burdsall (USA) and The Natural
SILVER Philippe Rozier (FRA) and Malesan Jiva
BRONZE Lisa Ann Jacquin (USA) and For the Moment

1988
🏅 OLYMPIC GAMES, SEOUL

DRESSAGE
— Individual
GOLD Nicole Uphoff (FRG) and Rembrandt
SILVER Margit Otto-Crépin (FRA) and Corlandus
BRONZE Christine Stückelberger (SUI) and Gauguin de Lully
— Team
GOLD Federal Republic of Germany: Nicole Uphoff (Rembrandt), Monica Theodorescu (Ganimedes), Ann-Kathrin Linsenhoff (Courage), and Reiner Klimke (Ahlerich)
SILVER Switzerland: Christine Stückelberger (Gaugin de Lully), Otto Hofer (Andiamo), Daniel Ramseier (Random), and Samuel Schatzmann (Rochus)
BRONZE Canada: Cynthia Ishoy (Dynasty), Ashley Nicoll (Reipo), Gina Smith (Malte), and Eva-Maria Pracht (Emirage)

JUMPING

— Individual
GOLD Pierre Durand (FRA) and Jappeloup
SILVER Greg Best (USA) and Gem Twist
BRONZE Karsten Huck (FRG) and Nepomuk

— Team
GOLD Federal Republic of Germany:
Ludger Beerbaum (The Freak), Wolfgang Brinkmann (Pedro), Dirk Hafemeister (Orchidee), and Franke Sloothaak (Walzerkönig)
SILVER United States:
Joe Fargis (Mill Pearl), Greg Best (Gem Twist), Lisa Jacquin (For the Moment), and Anne Kursinske (Starman)
BRONZE France:
Pierre Durand (Jappeloup), Michel Robert (La Fayette), Frédéric Cottier (Flambeau C), and Hubert Bourdy (Morgat)

EVENTING

— Individual
GOLD Mark Todd (NZL) and Charisma
SILVER Ian Stark (GBR) and Sir Wattie
BRONZE Virginia Leng (GBR) and Master Craftsman

— Team
GOLD Federal Republic of Germany: Claus Erhorn (Justyn Thyme), Matthias Baumann (Shamrock), Thies Kaspareit (Sherry), and Ralf Ehrenbrink (Uncle Todd)

SILVER Great Britain:
Ian Stark (Sir Wattie), Virginia Leng (Master Craftsman), Karen Straker (Get Smart), and Mark Phillips (Cartier)
BRONZE New Zealand:
Mark Todd (Charisma), Tinks Pottinger (Volunteer), Andrew Bennie (Grayshott), and Marges Knighton (Entreprise)

1988

🏆 FEI WORLD CUP

JUMPING
Gothenburg, Sweden
GOLD Ian Millar (CAN) and Big Ben
SILVER Pierre Durand (FRA) and Jappeloup
BRONZE Philippe Lejeune (BEL) and Nistria

1989

🥇 FEI EUROPEAN CHAMPIONSHIPS

DRESSAGE
Mondorf-les-Bains, Luxembourg
— Individual
GOLD Nicole Uphoff (FRG) and Rembrandt
SILVER Margit Otto-Crépin (FRA) and Corlandus
BRONZE Ann-Kathrin Linsenhoff (FRG) and Courage
— Team
GOLD Federal Republic of Germany: Ann-Kathrin Linsenhoff (Courage),

Monica Theodorescu (Ganimedes), and Nicole Uphoff (Rembrandt)
SILVER Soviet Union:
Nina Menkova (Dikson), Yuri Kovshov (Buket), and Olga Klimko (Shipovnik)
BRONZE Switzerland:
Daniel Ramseier (Random), Otto Hofer (Andiamo), and Samuel Schatzmann (Rochus)

JUMPING
Rotterdam, Netherlands
— Individual
GOLD John Whitaker (GBR) and Milton
SILVER Michael Whitaker (GBR) and Mon Santa
BRONZE Jos Lansink (NED) and Felix
— Team
GOLD Great Britain: Nick Skelton (Apollo), Michael Whitaker (Mon Santa), John Whitaker (Milton), and Jozsef Turi (Kruger)
SILVER France: Hervé Gogignon (La Belletière), Philippe Rozier (Oscar Minotière), Michel Robert (La Fayette), and Pierre Durand (Jappeloup)
BRONZE Switzerland:
Walter Gabathuler (The Swan), Markus Fuchs (Shandor), Willi Melliger (Corso), and Thomas Fuchs (Dollar Girl)

EVENTING
Burghley, United Kingdom
— Individual
GOLD Virginia Leng (GBR) and Master Craftsman
SILVER Jane Thelwall (GBR) and King's Jester

BRONZE Lorna Clarke (GBR) and Fearliath Mor
— Team
GOLD Great Britain:
Rodney Powell (The Irishman II), Ian Stark (Glenburnie), Virginia Leng (Master Craftsman), and Lorna Clarke (Fearliath Mor)
SILVER Netherlands:
Eddy Stibbe (Autumn Fantasy), Fiona Van Tuyll (Just A Gamble), and Mandy Stibbe-Jeakins (Autumn Bronze)
BRONZE Ireland:
Melanie Duff-O'Brien (Rathlin Roe), Olivia Holohan (Rusticus), Eric Horgan (Homer), and Joe McGowan (Private Deal)

1989

🏆 FEI WORLD CUP

DRESSAGE
Gothenburg, Sweden
GOLD Margit Otto-Crépin (FRA) and Corlandus
SILVER Christine Stückelberger (SUI) and Gaugin de Lully
BRONZE Nina Menkova (URS) and Dikson

JUMPING
Tampa FL, United States
GOLD Ian Millar (CAN) and Big Ben
SILVER John Whitaker (GBR) and Milton
BRONZE George Lindemann (USA) and Jupiter

1980 Olympic Games, Moscow

With the Cold War at its height, these Games were notable for being boycotted by fifty-one countries protesting against the Soviet invasion of Afghanistan.

1. The jumping stadium.

2. E. Theurer, gold medalist in dressage, on Mon Cherie.

— dressage

Although all the best riders in the world decided to take part in an alternative competition, the International Dressage Festival at Goodwood in England, Austrian rider Elisabeth Theurer opted for the Olympic Games, where she emerged as victor. Controversial in Austria, this decision forced the president of the Austrian Federation to resign. The winners of the alternative competition were the Federal Republic of Germany, Switzerland, and Denmark, while in Moscow the results were more surprising, with the Soviets, Bulgaria, and Romania reaching the podium.

3

 jumping

In Moscow, the individual competition took place in the Games' main venue, the Central Lenin Stadium. Polish rider Jan Kowalczyk took gold, and the team competition was won by the Soviet Union. In response, it was decided that the best riders in the world would gather at the Rotterdam Show Jumping Festival, where the Austrian rider Hugo Simon won the individual competition, while Canada won the Nations Cup.

— eventing

Italy was the only country taking part with any real experience in the discipline, and Federico Roman won the individual gold medal. In the team competition, seven nations took part, including India—a first in this discipline. The best riders met at Fontainebleau for the "Alternative Olympic Games." France won the team competition with Danish rider Nils Haagensen taking the individual honors.

3. F. Roman, gold medalist in individual eventing, on Rossinan.

1981
FEI European
Championships

— dressage —

Laxenburg, Austria
Once again, Colonel Nyblaeus courted controversy. He awarded fifty-three fewer points than the other judges to the French rider Margit Otto-Crépin. Uwe Schulten-Baumer, riding Slibowitz, exacted his revenge on Christine Stückelberger and Granat, who had beaten him during the last World Championships at Goodwood.

— jumping —

Munich, West Germany
As the gold-winning-team whose four members were among the twenty (out of forty-one) riders qualifying for the last individual round, Germany's dominance was overwhelming.

— eventing —

Horsens, Denmark
Great Britain became European champions, while the French team lagged behind Poland and Russia. British rider Richard Meade caused a sensation during the cross country when he opted for the "jump of death," the direct route that even his fellow team members did not dare tackle; they preferred to play safe and take the longer option rather than attempt this technically challenging water jump.

P. Schockemöhle, European individual jumping champion, on Deister.

1982
FEI World
Championships

— dressage

Lausanne, Switzerland
Despite faults in his dressage test, Reiner Klimke became world champion for the second time, having first won in 1974. He also won gold as part of the German team. Switzerland managed to reach second place thanks to the performance of Christine Stückelberger, who also won the individual silver medal.

— jumping

Dublin, Ireland
When the Veterinary Committee examined the horses in competition, seven of them were not "sound"— in other words, they were lame. The vets decided to see them again twelve hours later. Some horses were reinspected the next day, and Everest If Ever and Trumpf Buur, ridden by Nick Skelton and Willi Melliger respectively, were withdrawn from the competition, before the Appeal Committee swiftly authorized the two riders to compete. Competing in the victorious French team were two famous stallions, Galoubet A, ridden by Gilles Bertran de Balanda, and Flambeau C, with Frédéric Cottier in the saddle.

— eventing

Luhmühlen, West Germany
The British team was not on home ground but clearly felt at ease, winning gold with a team composed of three women and one man, Richard Meade. And as if that weren't enough, Lucinda Green, already European champion in 1975 and 1977, became world champion. The competition, which promised to be a great success, was marred by the death of Swiss rider Ernst Baumann after he fell from his horse.

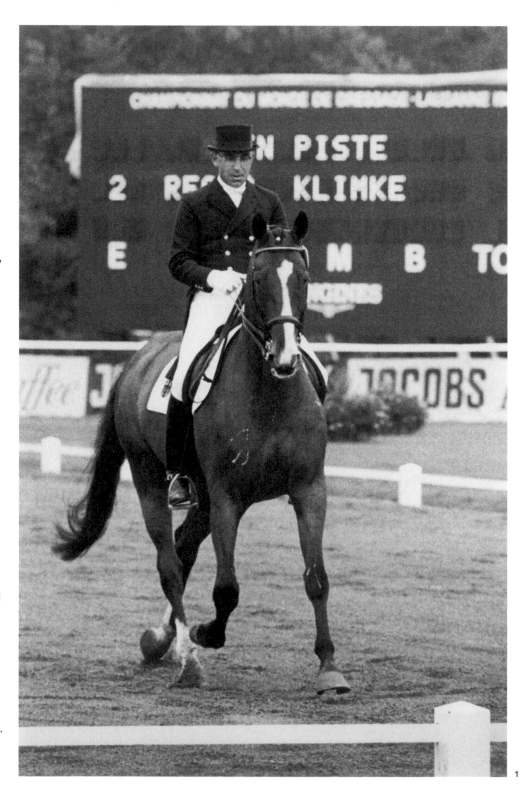

2

1983
FEI European
Championships

— dressage

Aachen, West Germany
This was a first for the Lipizzaner horses from Lipica. Representing Slovenia, they finished sixth out of the eleven teams that entered this championship, which was won by West Germany.

— jumping

Hickstead, United Kingdom
At last, Switzerland scooped its first European title, with Thomas Fuchs, Willi Melliger, Heidi Robbiani, and Walter Gabathuler comprising the winning team. Paul Schockemöhle, riding Deister, gained his second individual title.

— eventing

Frauenfeld, Switzerland
Once again, two British riders occupied the top two steps of the podium, with Rachel Bayliss winning gold and Lucinda Green (née Prior-Palmer) the silver. The team competition was won by a large contingent from Sweden, while the British team, which was exclusively female, came second.

1. A.-G. Jensen, European individual dressage champion, on Marzog.

2. L. Green, silver medalist in the eventing competition, on Regal Realm.

3. R. Bayliss, European eventing champion, on Mystic Minstrel.

1984 Olympic Games, Los Angeles

**These Games were boycotted
by Eastern-bloc countries, in retaliation
for the boycott of the 1980 Moscow Games.**

— dressage

Germany won both team and individual medals in this discipline. Reiner Klimke scooped the first individual Olympic medal of his career.

— jumping

For the first time in their history, the Japanese, coached by Henk Nooren, made it to the final of the Olympic team competition. The course was designed by Bertalan de Nemethy, and the individual competition saw two jump-offs. The winner was the American Joe Fargis, riding Touch of Class. He competed for the gold with his compatriot and partner Conrad Homfeld, who rode Abdullah. Fargis completed a clear round and claimed the top prize, while Homfeld, with 8 penalties, had to settle for the silver. At the end of the second round, three riders were tied on 8 penalties. They faced a second jump-off to determine who would win the bronze. The Swiss rider Heidi Robbiani delivered the only perfect performance in this challenge, coming in ahead of Mario Deslauriers with 4 penalties for Canada and Bruno Candrian with 8 penalties for Switzerland.

— eventing

Course designer Neil Ayer was accused of revealing details of his course before the authorized date, having provided information to reporters along with the details needed for a technical understanding of the course. An important milestone was achieved with the first female soldier taking part in the competition, riding under the Mexican flag: Sandra del Castillo, who competed in uniform.

(pages 152–53)

1. K. Stives, team
gold medalist
and individual silver
medalist in eventing,
on Ben Arthur.

2. R. Klimke, gold
medalist in dressage,
on Ahlerich.

3. S. del Castillo
on Alegre, ranked
34th in the eventing
competition.

4

The 1980s

4. Cross-country Obstacle 14 was notable for its representation of an Old West mining town.

5. The US Olympic champion jumping team: J. Fargis (Touch of Class), C. Homfeld (Abdullah), L. Burr-Howard (Albany), M. Smith (Calypso).

5

1985
FEI European Championships

Copenhagen, Denmark
At this time, it was not uncommon for judges to be biased toward riders from their own country. They also often formed alliances with co-panelists that reflected military pacts between their countries of origin, a fact that was reflected in their scoring. In terms of equestrian skill, the piaffes and passages were generally mediocre. The German school was still lagging in this discipline, while the Russian riders distinguished themselves in Haute Ecole movements. Their performance earned them a team bronze medal.

Dinard, France
After the first two rounds, the scores were very close and the competition wide open: Paul Schockemöhle, lying fourth before the last round, managed to claim first place. He won his third individual title, with four bars knocked down.

1. R. Klimke, European dressage champion, on Ahlerich.

2. P. Schockemöhle, European jumping champion, on Deister.

3. The British team came first in jumping, and the atmosphere during the press conference was boisterous: (left to right) M. Pyrah, N. Skelton, J. Whitaker, M. Whitaker.

1

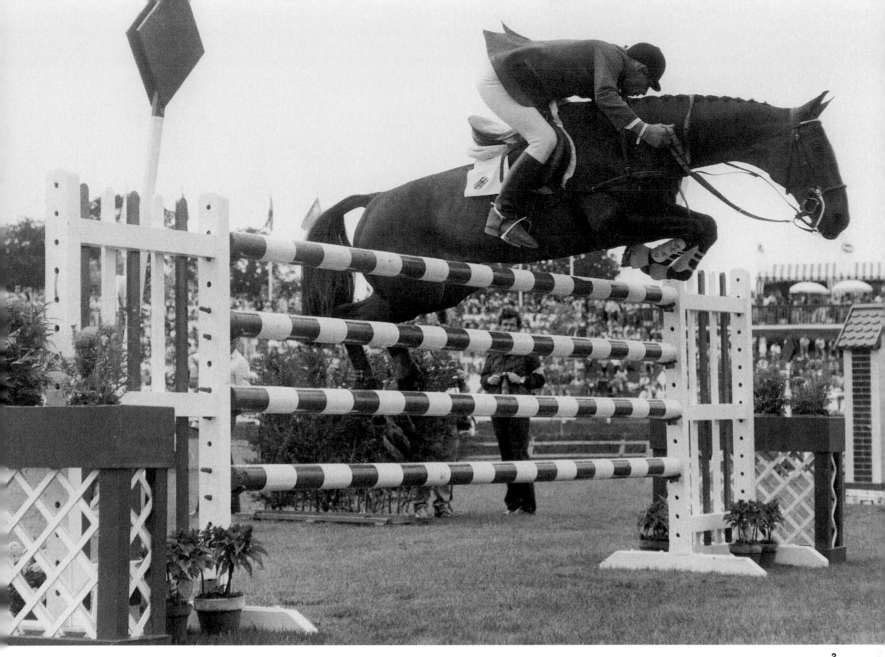

3

— eventing

Burghley, United Kingdom
The Polish team was completely decimated at Obstacle 5, the water jump, when four riders fell, ending Poland's hopes of a European title. The final vet check proved devastating, putting an end to the adventure not only for the Italian team, but also for the German Werner Koch, who was nevertheless placed fifth in the provisional rankings, and Briton Andy Griffiths, who was placed seventh.

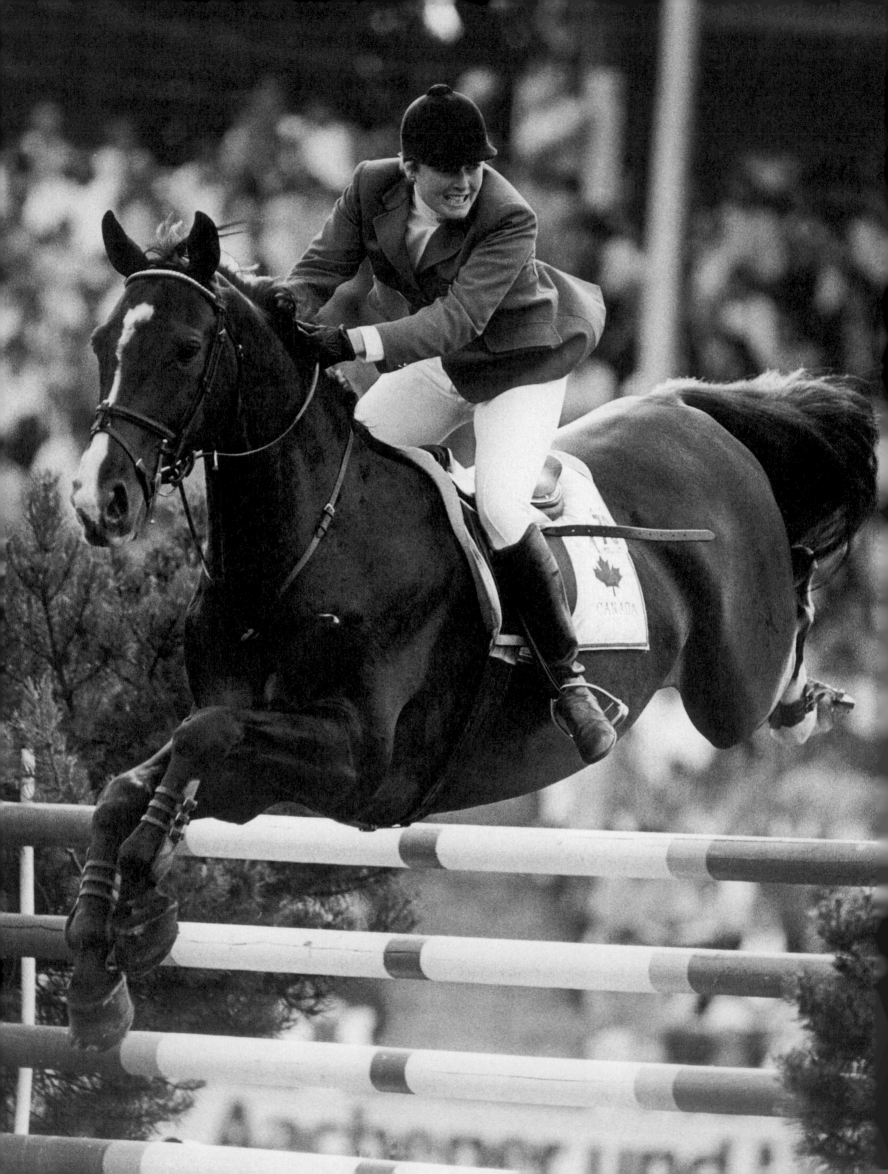

1986 FEI World Championships

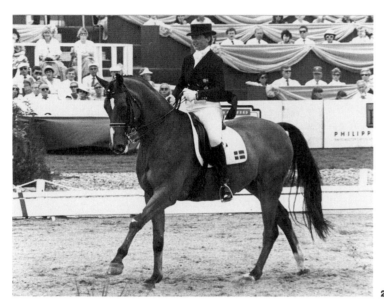

Cedar Valley, Canada
These championships were held in the Canadian facilities of Evi (Eva-Maria) Pracht. She was the daughter of the German rider Joseph Neckermann, a double team Olympic champion in 1964 and 1968, and the individual world dressage champion in 1966. The European horses had difficulty adapting to the taste of the local water, which contained more chlorine than they were used to. The riders attempted to tackle this problem by adding apple juice to the drinking water. Several riders had horses suffering from a variety of gastric ailments.

Aachen, West Germany
Twelve years after the end of the women's World Championships, Gail Greenough, the Canadian rider who rode Mr. T, became the first woman in history to win this title.

Gawler, Austria
Representing France with her horse Harley, Marie-Christine Duroy was astonished—on the evening of the cross-country phase, which was still a combination of roads and tracks and steeplechase—to see how the Australian riders managed their horses' recovery in preparation for the vet check the following day. While the French team and many others made sure they walked their horses, and applied ice and bandages on their legs, the Australians rugged their horses and turned them all out in the same paddock for the night, even though they were shod behind. In the individual competition, the podium was an all-female affair, with Virginia Leng, Trudy Boyce, and Lorna Clarke.

1. G. Greenough, world jumping champion, on Mr. T.

2. A.-G. Jensen, world dressage champion, on Marzog.

3. V. Leng, world eventing champion, on Priceless.

1987
FEI European Championships

— dressage

Goodwood, United Kingdom
Margit Otto-Crépin brought a ray of sunshine to the dressage event, putting an end to the eternal battle between Reiner Klimke and Anne-Grethe Jensen. The podium saw new occupants, with medals for Ann-Kathrin Linsenhoff and Johann Hinnemann. With a shortfall of three paltry points, the Swiss team failed to topple the Federal Republic of Germany, whose saving grace was judge Maria Günther.

— jumping

St. Gallen, Switzerland
The British were indisputably ahead of the pack, winning this championship six bars ahead of the French. Germany came in fifth, much to the despair of Paul Schockemöhle, who thought the quality of the footing was not good enough and tried by every means possible to move the date of the Nations Cup. At the prize-giving ceremony, the two exceptional horses, Jappeloup and Milton, stood side by side as their riders, Pierre Durand and John Whitaker, occupied the top two steps of the podium.

— eventing

Luhmühlen, West Germany
Virginia ("Ginny") Leng won her third successive title. Although fourteen-year-old her horse, Night Cap II, was still on good form, she decided to take early retirement to take up fox hunting. After the Sunday vet check, all three leading teams were down to three team members, so there was no room for error: a fall or an elimination would result in disqualification for the team.

1. J. Whitaker, European jumping silver medalist, on Milton.

2. P. Durand, European jumping champion, on Jappeloup.

3. V. Leng, European eventing champion, on Night Cap II.

3 >

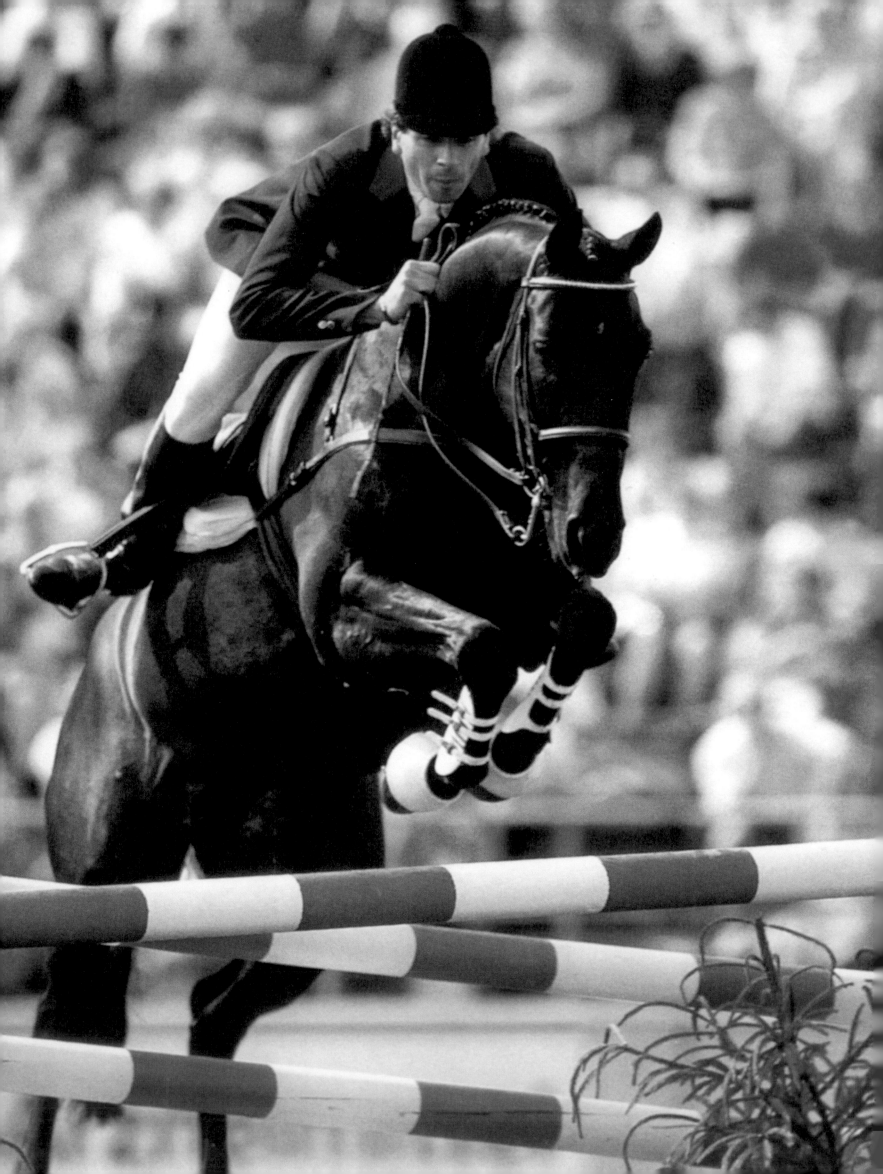

1988 Olympic Games, Seoul

dressage — The Grand Prix provided the scores for the team medals to be awarded, and only the eighteen best riders qualified for the individual competition. The rules also stated that only three riders per team could qualify for the last round. Reiner Klimke came in seventh, but as he was the lowest-ranked of the German team on overall points, he was unable to defend his title.

jumping — Everardo Hegewisch represented Mexico. His horse Pepito boasted an incredible story. Purchased in 1987 in Germany, the Westphalian horse survived an airplane crash. On July 30, 1987, the Boeing in which Pepito was traveling with the horses, riders, and staff of the junior Mexican show-jumping team, and some horses in the senior team, crashed and burst into flames immediately after take-off. Seven people survived, including Mexican jumping rider Federico Fernandez. The next day, thinking he had lost everything, Everardo received a phone call from a friend telling him to watch a news report that a horse affected by burns had been found not far from the accident site. Everardo recognized Pepito: his mane and his tail would never grow back, but he was there, at the Olympic Games, a year after the tragedy.

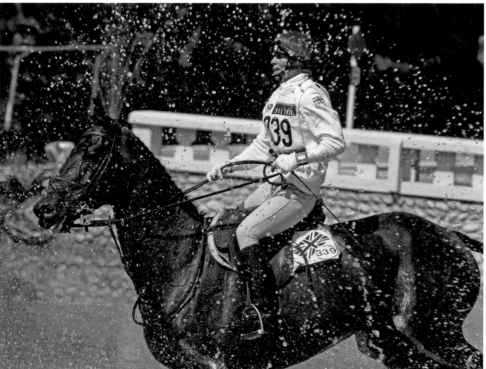

2

eventing — The final vet check took place amid an atmosphere of extreme tension. Ralf Ehrenbrink's horse failed the vet check because of a large bruise in the girth area. Ehrenbrink was determined to ride bareback. Paul Schockemölhe lodged a protest, but nothing was done. It was a close call for the British rider Virginia Leng and her ambitions to claim the individual bronze medal. Princess Anne was among the spectators when Leng presented her horse Master Craftsman; the animal displayed signs of stiffness. The fate of Her Majesty's team rested on Leng's shoulders: without her presence, the entire British team would have been eliminated, and they would not have been in the lineup for the show-jumping competition, the final phase. A palpable sense of relief spread through the ranks when the judge tipped his hat as an indication of approval.

1. P. Durand, gold medalist in individual jumping, on Jappeloup.
2. V. Leng, bronze medalist in eventing, on Master Craftsman.

< 1

1989
FEI European Championships

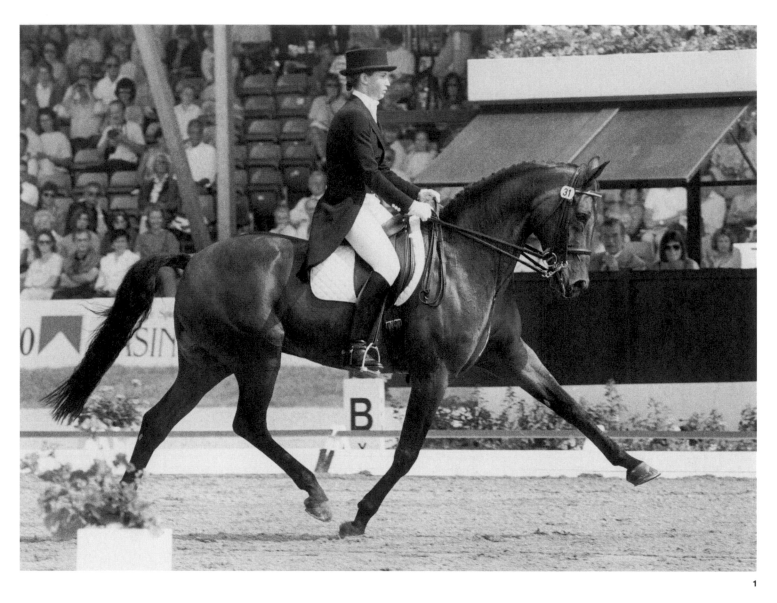

— dressage

Mondorf-Les-Bains, Luxembourg
At a press conference, FEI Dressage Committee Chair Wolfgang Niggli announced the decision to revise the qualification conditions for the Grand Prix Special. As was the case for the Olympic Games, only the top three riders from each team would be selected for the test. The fourth, even if their scores were higher than those of other competitors, could not be selected. The committee thus sought to allow more countries to take part in the rest of the competition. If the discipline wanted to remain an active force at the Olympic Games, it had to become more open.

1. N. Uphoff, European individual dressage champion, on Rembrandt.

2. The Whitaker brothers on the first two steps of the jumping podium.

3. Jappeloup (left) and Milton (right), both international jumping legends of their day, presented respectively by French rider P. Durand and British rider J. Whitaker.

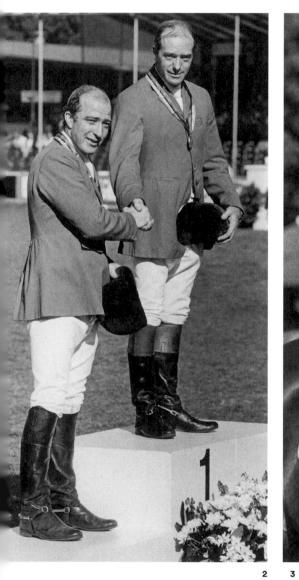

2 3

jumping

Rotterdam, Netherlands
The Whitaker brothers scooped the first two places. Riding his famous horse Milton, John captured gold while Michael took silver. The latter was only a reserve rider but, when David Broome's horse was injured, he had to compete on Mon Santa.

eventing

Burghley, United Kingdom
The British team could not have performed any better. In addition to the team medal, the team occupied all three podium places in the individual competition. Team member Ian Stark made a bet with course designer Mark Phillips that he would meet Obstacle 28 head on while all the other competitors took the "chicken way" (the longer but less challenging option)—and Stark won the bet.

Joe Fargis

Giving his personal best

Joseph was born on April 2, 1948, in New York. Nothing in his family background suggested that he was destined for a career in the international equestrian world. He recalls, however, that "There was a riding school near us in Vienna, Virginia. It was within walking distance of my house, and that's where I spent my free time from the age of seven." Jane Dillon taught him the basics and conveyed her vision of the ideal approach to riding, one that was respectful of the animal and its natural inclinations. When he was eighteen, Joe went to work for Frances Rowe at Foxwood Farm in Crozier, Virginia, where he remained for twelve years. "Some of her competitive riders had been injured, and that gave me the chance to begin competing. After demonstrating my ability, I was able to participate in more important competitions and ride more horses." Joe's career progressed, and he joined the national team.

He represented the United States for the first time in 1970 at the FEI Nations Cup in Lucerne, Switzerland, riding the national team's horses. Following this victory, the team continued on its European tour, visiting legendary venues including Aachen and La Baule. A high-stakes performer, Joe turned in a distinguished performance at the Pan American Games in Mexico that contributed to the American team's victory. He continued to work hard but without setting any clear objectives. "My development wasn't driven by a hunger for competition. I loved to ride, but I never really dared to hope that I'd be part of the national team or go to the Olympics. I simply gave the best of myself throughout this adventure. My skills improved over the years. As I had more horses to ride, and more sponsors, I could aim for more important competitions. It was nothing I really planned—it just happened." His career took off, and Joe racked up victories riding Touch of Class and Mill Pearl.

In 1978, Joe entered into a partnership with Conrad Homfeld, another brilliant American rider. They established Sandron Farm in Virginia, where they trained high-level horses and welcomed riders and their mounts. On the strength of this partnership,

they accumulated wins in North America and Europe, qualifying for the 1984 Olympics in Los Angeles. Touch of Class was selected for the event, and her performance won Joe individual and team Olympic gold, with only one fault during the entire competition. "I never dreamt of winning an Olympic medal—I simply wanted to do my best. I seized the moment, but I didn't put too much pressure on myself. It was an enormous surprise to achieve that. Touch of Class deserves a lot of credit. Good horses make for good riders!" His partner Conrad Homfeld carried off the silver in these Games.

Joe continued to perform at his peak for several years, riding Touch of Class and

Mill Pearl, who was his mount for the bronze medal won by the United States at the 1988 Olympic Games in Seoul. He also rode Mill Pearl in his final championship in 1990 at the FEI World Equestrian Games in Stockholm, where he finished fourth in the team competition.

Joe decided to embark upon the next phase of his career, becoming a trainer. "I hadn't really made a conscious decision to stop participating in high-level competitions, but the horses did it for me—none of them were up to the challenge. I never really missed those major competitions. Life is like that—it picks you up and moves you around, first in one direction, then another.

"Joe is thoughtful, meticulous, maybe a little tense sometimes, but extremely funny."

— Kathy Kusner

Kathy Kusner, a prominent international American rider and friend, on Joe

Joe's success is based on his unswerving determination to do things correctly, following clearly stated principles. Kathy recalls an episode that's a perfect illustration of this aspect of his character. "I was with Conrad and Joe at the Los Angeles Olympics in 1984. Frank Chapot was chef d'équipe at the time. He had a powerful personality and wanted to call the shots on everything. Joe and Conrad had designed a practice course that was simple and intelligently laid out to prepare their horses in the best way possible. Frank Chapot came along, absolutely furious, and asked them if they knew what they were doing. They didn't say a word, but I piped up: 'Yeah, they know!' In the end, they helped to win the Americans' team gold. Joe won the individual Olympic championship, and Conrad was runner-up. I guess they really did know what they were doing!"

In the arena as in life, the champion lives up to his own high standards—he's straightforward, fair, persistent, and universally respected. "Joe is thoughtful, meticulous, maybe a little tense sometimes, but extremely funny. He always has a smile and never complains. When he was preparing for the Olympics in Los Angeles, his determination and focus were incredible; he anticipated every last detail and made sure that he was at his best at critical moments. He's a consummate professional."

Despite his success, Joe's tastes remain simple, and it doesn't take much to make him happy. "We went on a trip in 1978 to see Conrad Homfeld compete at Hickstead and in Aachen. Before we left, one of our joint owners offered Joe and me a nice travel allowance. When he found out we were going to Europe, he gave us a little bonus so we could treat ourselves a bit. Joe was always very careful how he spent money. Conrad and I wanted to travel everywhere by taxi, but Joe was always saying, 'No, let's take the bus.' Although he's frugal, he can be very generous as well. When we were in Aachen, he had to return to the United States sooner than expected because one of his clients needed him at a competition. He gave me the money he had left, and that made it possible for me to visit Scandinavia before returning to the USA. Joe's always generous with the people around him. He doesn't care about the frills—he likes the genuinely good things in life. He always chooses less expensive restaurants, for example. He doesn't need material things to make him happy, and when you're with him, you don't need anything other than Joe for entertainment."

Career Highlights

Jumping

1984
Individual and team gold in the Los Angeles Olympics with Touch of Class

1988
Team silver in the Seoul Olympics with Mill Pearl

1. With Abdullah, Conrad Homfeld's mount, at the FEI World Championships in Aachen, 1986.

2. At the Los Angeles Olympics on Touch of Class, 1984.

What I love most about teaching is encouraging people to treat their horses well, use them correctly, and give them the respect they deserve." Conrad has now completely retired, but Joe is still on the go and has no plans to bow out any time soon. "My goal for the future—staying alive! I'm seventy years old now, and I picture myself doing exactly the same thing when I'm eighty. I like being outdoors with the horses all day long. I also serve on a number of committees for the federation and for various competitions. I'm committed to improving the sport and instilling respect for the horses. I'd like that to be my legacy."

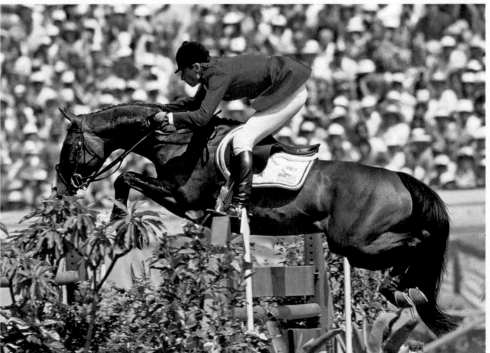

Mark Todd

A giant with an indomitable spirit

Frequently lionized, sometimes ridiculed, Mark Todd never lets up: he strives relentlessly to achieve his goals. He was born on March 1, 1956, in Cambridge, New Zealand. At a very young age, Mark was captivated by a pony belonging to his grandfather's neighbor. Impressed by his grandson's enthusiasm, the indulgent granddad bought the boy his own pony, and Mark rode him every two weeks at the local riding school. At the age of fifteen, with driving license in hand, the young rider graduated to a horse and purchased a small horse truck to enable his independence. Constrained by the very limited number of eventing competitions in New Zealand, he focused primarily on show jumping. But in 1977, Top Hunter appeared on the scene, and Lockie Richards started coaching the New Zealand team. The trainer decided that a foursome should attend the 1978 World Championships in Lexington, and Mark was one of the participants in this historic event, the first time a Kiwi team entered the championship. "It was my first international experience and my second time riding in an eventing competition."

Following this success, Mark sold Top Hunter and moved to the United Kingdom to ride for a horse dealer, staying there almost two years. He bought Southern Comfort in late 1979, and in 1980 the pair began competing at an exalted level, winning at the legendary Badminton Horse Trials. Although they were in forty-fifth place at the conclusion of the dressage phase, the duo was one of only three pairs who achieved a clear cross-country round. Mark spent the next two years working flat out, and then decided it was time for him to pursue a more "normal" way of life. "I felt I'd come to the end of that career path. It was time to go home and find a real job. I got a position working on a farm that belonged to one of my father's friends. I stayed there until 1984, when I finally decided that I really wanted to be an eventing rider."

So it was off to England again, this time with Charisma. This horse was his partner in his second victory in Badminton as well as his amazing Olympic title in Los Angeles later that year. The star duo repeated their feat, and they were again crowned Olympic champions in Seoul in 1988. Mark was also a member of the show-jumping team. "The first medal was incredible because I wasn't expecting it at all! Winning again four years later when my horse was sixteen and a lot of people thought he was too old—that was terrific! I even became the second rider in history to take two Olympic golds in a row."

Although Mark experienced some bad luck in the championships, he won Badminton again in 1994 and 1996, and racked up five victories in Burghley between 1987 and 1999. The phenomenal athlete made his grand return to the winners' podium at the 1998 FEI World Equestrian Games in Rome, winning the silver medal while the New Zealand team took the championship. At the Sydney Games two years later, he won the bronze. But allegations made by the *Sunday Mirror*, a notorious British tabloid, somewhat tarnished this win by publishing a damaging report on his personal life. Despite his many medals, Mark decided to distance himself from the sport and return to New Zealand. "I'd pretty much accomplished what I'd set out to do as a rider, and I'd lost some of my motivation." Also a horse-racing enthusiast, Mark embarked on breeding and training Thoroughbreds, achieving Group 1 status.

It wasn't until 2008, following a bet, that the man who had been named "the

> "He was riding Southern Comfort, and he survived a cross-country course that was incredibly challenging because the terrain was so treacherous. It was a remarkable and astounding performance."

— Lucinda Green

2

best rider of the twentieth century" by the FEI agreed to return to the saddle for the Beijing Olympics. "During a night out with friends, I told them that if they could find me a horse I'd go, thinking that would be the end of the matter. A month later they turned up with Gandalf! One of the owners I'd been training horses for became my sponsor and I was off." Mark returned to the UK and qualified for Beijing. He finished seventeenth and recovered his appetite for eventing. Divorced in 2009 from his wife, who had decided to remain in New Zealand, Mark resumed his successful career. He won in Badminton again in 2011, and earned selections on the national team. He took the team bronze in the 2012 Games in London and ended up in seventh place in Rio de Janeiro with NZB Campino in 2016.

Meanwhile, this amiable giant had remarried Carolyn in 2014, with their two children serving as the only witnesses. "I really don't set myself goals anymore. I live from day to day. I don't know whether I'll go to the Tokyo Olympics—we'll see. I'd be thrilled to earn another title, but if that doesn't work out, it's not a problem. Ten years from now I'd like to be lounging on a beach somewhere and owning a few luxury hotels!"

Lucinda Green, an international rider and friend, looks back

Mark Todd arrived at the 1978 FEI World Equestrian Games in Lexington as a complete unknown, but Lucinda remembers recognizing his potential very quickly. "He's always been incredibly talented. We first saw him riding Top Hunter—a pretty average, rather awkward horse—and Mark had those incredibly long legs. It didn't make a great impression. No one really paid any attention to him. It was in Badminton, in 1980, that I really thought he must be an extraterrestrial being. He was riding Southern Comfort, and he survived a cross-country course that was incredibly challenging because the terrain was so treacherous. It was a remarkable and astounding performance."

Life has not always been kind to Mark, and Lucinda hails his courage in the face of adversity. "Mark has been through some rough times, but he always manages to pick himself up and get through them without being overwhelmed. He's strong but very sensitive, and he's charismatic without being extroverted. You're never bored in his company—he's a funny, genuine, candid, and very interesting guy. He tells things as they are, even if they're tough to hear. Seeing how he got through his wife's illness really made an impression on me. He was her rock—he was there for her day in, day out, always with the same spirit and joie de vivre. Their story, with all its ups and downs, is inspirational."

Lucinda recalls an incident that's typical of her friend. "Mark is very considerate. During those years he was divorced from Carolyn, he'd take me out for dinner on my birthday because it was one of the few occasions when we could spend time together. Unfortunately I was cooped up in the hospital because a horse had stepped on my foot. Mark came to visit me, sat down on my bed, and burst out laughing: 'I've waited all these years for this!'"

1. At the Los Angeles Olympics on Charisma, 1984.

2. With his wife and daughter, 2017.

Career Highlights

Eventing

1984
Individual gold in the Los Angeles Olympics with Charisma

1988
Individual gold and team bronze in the Seoul Olympics with Charisma

1990
Team gold in the Stockholm FEI World Equestrian Games with Bahlua

1992
Team silver in the Barcelona Olympics with Welton Greylag

1998
Individual silver and team gold in the Rome FEI World Equestrian Games with Broadcast News

2000
Individual bronze in the Sydney Olympics with Eyespy II

2010
Team bronze in the Lexington FEI World Equestrian Games with Grass Valley

2012
Team bronze in the London Olympics with NZB Campino

Reiner Klimke

The lawyer who became a top Olympic medalist

Reiner was born in Münster during the Third Reich, on January 14, 1936. His father was a psychologist and neurologist; his mother, a true horse lover, introduced him to equestrian sports at a young age. Despite the considerable difficulty involved, Reiner traveled many miles by bicycle to reach the riding school in the neighboring village. He was allowed to train there in exchange for helping with chores. At the end of the World War II, Reiner, as committed as ever, enrolled in Stecken's Westfalian riding school in Münster. As a teenager, he left for Warendorf, the headquarters of the German Equestrian Federation, where he perfected his eventing techniques. His roommate was Alwin Schockemöhle, who let him ride his horse Lausbub; the duo won the team silver in eventing at the European Championships in 1957.

Despite Reiner's success, his father remained opposed to his riding career. The young prodigy therefore continued his studies, became a judge, and established a law office in Münster. But he could not stay away from riding. While continuing with his professional activities, he also kept about fifteen horses at the Reiterverein St Georg riding school in Münster, and rode them whenever he was able, outside office hours. It took strict discipline and an entourage of capable support staff to handle the organization and scheduling required to do this. But, fortunately for Reiner, he had the encouragement of his wife, Ruth, who was also a rider, and the support of his law partners. Reiner was well aware that if he wished to pursue his sport, he would have to work very hard to cover his expenses.

Training for eventing was very time-consuming. Reiner therefore focused his attention on dressage, while still retaining great affection for the diversity of the challenges involved in eventing. Committed to the physical and mental well-being of his horses, he oversaw every aspect of their training, making sure that they spent plenty of their workout time outdoors. His closeness to his horses undoubtedly contributed to his five Olympic team golds, and the top individual title in the 1984 Los Angeles Olympics with Ahlerich, not to mention many additional European and international medals. As the flag-bearer for the German delegation at the Seoul Olympics in 1988, he marched beneath the proud gaze of his wife and three children, Rolf, Ingrid, and Michael, who followed and encouraged him every step of the way.

An indefatigable worker, Reiner culminated his extraordinary career by winning a double gold medal in Los Angeles. He then dedicated his time to training young horses to compete at the highest level. He took joy in riding until the end of his life. Always a lively companion, he relished every experience and frequently mentioned how important it was to savor every moment. He suffered a massive and fatal heart attack at his home in Münster on August 17, 1999, when he was just sixty-three.

> "My father was generous and authoritarian in equal parts; he enjoyed telling us what we should do and how we should do it, but he had a big heart."
>
> — Ingrid Klimke

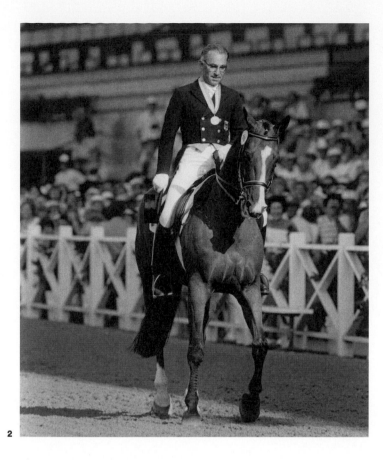

2

Ingrid Klimke, multiple medalist in international eventing, remembers her father

Nothing ever fazed Reiner. He had his feet on the ground and didn't much care what people said about him. It wasn't all that easy for the daughter of a multi-medalist to get her own start in riding, but he saw to it that his children could stand on their own. "If I performed well when I was young, people said, 'Well, obviously, she's Klimke's daughter—it's easy for her.' If I made a mistake, they'd say, 'Klimke's daughter should do better than that!' When I was very young, my father told me not to worry about what other people thought—just to concentrate on my performance and my horses. He was always telling me I should be riding for my own pleasure, not anyone else's."

Like most champions, Reiner had a strong personality, and his entourage had to deal with that. "My father was generous and authoritarian in equal parts; he enjoyed telling us what we should do and how we should do it, but he had a big heart. He was an optimist: he loved life and celebrated it every single day. Our household was always open, and on good days anybody and everybody was welcome. On the other hand, on bad days he just wanted to be with his family. We all had to be there—nobody was excused. Everything had to be just the way he wanted it, and I think that's why it took me so long to decide to become a professional rider. He wanted me to remain amateur and have a more normal life."

He was a true father figure, demanding and encouraging in equal measure, and his death left an immense void. "He was an incredible inspiration for our family—the way he treated horses and people, the way he loved life and always found the solution to every problem. His death was an enormous blow to all of us. I miss him tremendously. It was his dream that one of his children would participate in the Olympics. He died in 1999, and I entered my first Olympics in 2000. It was my way of honoring his memory. I believe he's always somehow close to me and that I manage to perform thanks to his presence. I never forget his motto: 'Always give your best effort and challenge yourself. Never punish or blame the horse.'"

Career Highlights

Dressage

1964
Team gold
in the Tokyo Olympics
with Dux

1965
Individual bronze
and team gold
in the FEI European
Championships
in Copenhagen
with Arcadius

1966
Individual bronze
and team gold
in the FEI World
Championships
in Bern with Dux

1967
Individual
and team gold
in the FEI European
Championships
in Aachen with Dux

1968
Individual bronze
and team gold
in the Mexico
Olympics with Dux

1969
Team gold in the
FEI European
Championships
in Wolfsburg with Dux

1971
Team gold in the
FEI European
Championships
in Wolfsburg
with Mehmed

1973
Individual
and team gold
in the FEI European
Championships
in Aachen with
Mehmed

1974
Individual
and team gold
in the FEI World
Championships
in Copenhagen
with Mehmed

1976
Individual bronze
and team gold in the
Montreal Olympics
with Mehmed

1981
Team gold
in the FEI European
Championships
in Luxembourg
with Ahlerich

1982
Individual
and team gold
in the FEI World
Championships
in Lausanne
with Ahlerich

1983
Individual silver
and team gold in the
Aachen FEI European
Championships
with Ahlerich

1984
Individual
and team gold
in the Los Angeles
Olympics
with Ahlerich

1985
Individual
and team gold
in the FEI European
Championships
in Copenhagen
with Ahlerich

1986
Team gold
in the FEI World
Championships
in Cedar Valley
with Pascal

1988
Team gold in the
Seoul Olympics
with Ahlerich

Eventing

1957
Team silver
in the FEI European
Championships
in Copenhagen
with Lausbub

1959
Team gold
in the FEI European
Championships
in Harewood
with Fortunat

1. At the Montreal Olympics on Mehmed, 1976.

2. At the Los Angeles Olympics on Ahlerich, 1984.

3. With his daughter, Ingrid.

Milton

An equine genius

"He loved going to competitions, and if the truck left without him he would bang his stable door, wanting to be taken along! He preferred the major events, where the tension was highest."

— John Whitaker

Born Marius Silver Jubilee on February 16, 1977, at John Harding-Rolls's stud farm near Oxford, England, this gray ultimately took Milton as his professional name. The famous British show jumper Caroline Bradley set her sights on the future champion simply because he was sired by Marius, a stallion she had partnered to her top-level successes. The foal joined the Bradley family stables for the modest sum of £1,000. Besotted with the young gray, Caroline told her family and friends that Milton would be her next Olympic mount and she focused on his training, entering him for competitions when he was just four years old. Tragedy struck, and Caroline died of a heart attack during a competition in 1983, leaving her protégé an orphan.

Caroline's parents sold the rest of their horses, but they could not bring themselves to part with Milton, despite the offers that poured in. They decided to contact John Whitaker, Great Britain's show-jumping prospect, whose riding technique and philosophy Caroline was so fond of. Away at a competition in Scotland, John could not respond, so instead the Bradleys approached Steven Hadley—who would go on to become a famous show-jumping commentator on FEI TV—who rode Milton for a while. Unfortunately, this exceptional horse sustained a tendon injury the following year, and was dropped from competition for a year and a half. Milton returned in the summer of 1985, now ridden by John Whitaker, who had used the time to get the champion back in shape through intensive work on the flat and outdoors.

"From my very first jump on Milton, I immediately realized that he was a very good horse. After completing two or three courses, I discovered that he was absolutely outstanding." Very successful from the start, the pair entered the FEI World Cup event in Berlin, where the gelding, then just eight years old, finished third in the Small Grand Prix. It was the start of a long career

punctuated by international successes, which would make Milton the first horse outside horse racing to total over £1 million in winnings. European champion in 1989, winner of the FEI World Cup Final in 1990 and 1991, and individual silver medalist at the World Championships in 1990, Milton, who often ended his rounds with a buck, had never been given the chance to win an Olympic medal, however. The Bradleys believed that their daughter Caroline had been unjustly deprived of Olympic selection, and so had made it a condition that their horse should not take part in the Olympic Games.

The owners changed their minds eventually, and finally gave Milton his opportunity at the 1992 Olympic Games in Barcelona; but now aged fifteen, the horse suffered from the heat. While he was in the lead before the final, a stop during this last competition destroyed any hopes of a medal and he plummeted to fourteenth place. In 1993, the champion horse began to suffer health problems, and he was absent from competitions for nearly ten months before returning to win a last few victories. He bade farewell to his public in 1994 at the Olympia Horse Show, London.

Milton enjoyed a well-deserved retirement at the Whitaker stables in Yorkshire with Hopscotch, John's other preferred equine partner. Suffering from colic in 1998, he managed to recover, but he died on July 4 of the following year, at the age of twenty-two, following another massive attack of colic. He is buried on John's estate.

Milton's rider, John Whitaker, remembers his horse

While other horses have enjoyed many victories during their careers, few are as famous Milton. For John, it derived from his attitude. "For the public, Milton was a true legend because he was something special. He had real charisma and a character all of his own. The crowds loved him, and he loved them in return. His white coat and his style of jumping were eye-catching, and he won everything, which really left an impression on everyone. His rivalry with Jappeloup was a bit of a media invention, but it created something good— the competition between us was friendly, though! Sometimes we won, sometimes it was Jappeloup and Pierre [Durand], but we were always good sports."

Milton also charmed the public through his obvious qualities as an individual, which were immediately clear to his rider. "Milton had incredible abilities, but most of all he wanted to be a champion, and he always did his best. He loved going to competitions, and if the truck left without him he would bang his stable door, wanting to be taken along! He preferred the major events, where the tension was at its highest. He didn't really have any weaknesses. However, I had to adapt to his style because his technique was a little different from that of other horses. He was a bit slow and took his time folding his front legs. Once I understood that, he began to improve and picked up speed."

Milton was also endowed with a personality all of his own, a personality that is the very essence of a champion. "He was lovely to take care of. On the other hand, he annoyed my wife enormously because he was in the habit of pulling his rugs off and throwing them on the floor before ripping them up. She kept telling me that it was a bit of luck that he was a good horse and won a lot of money, because he cost us plenty in rugs every week. He was very curious and interested in everything. He used to watch it all. He was just a very cheerful horse."

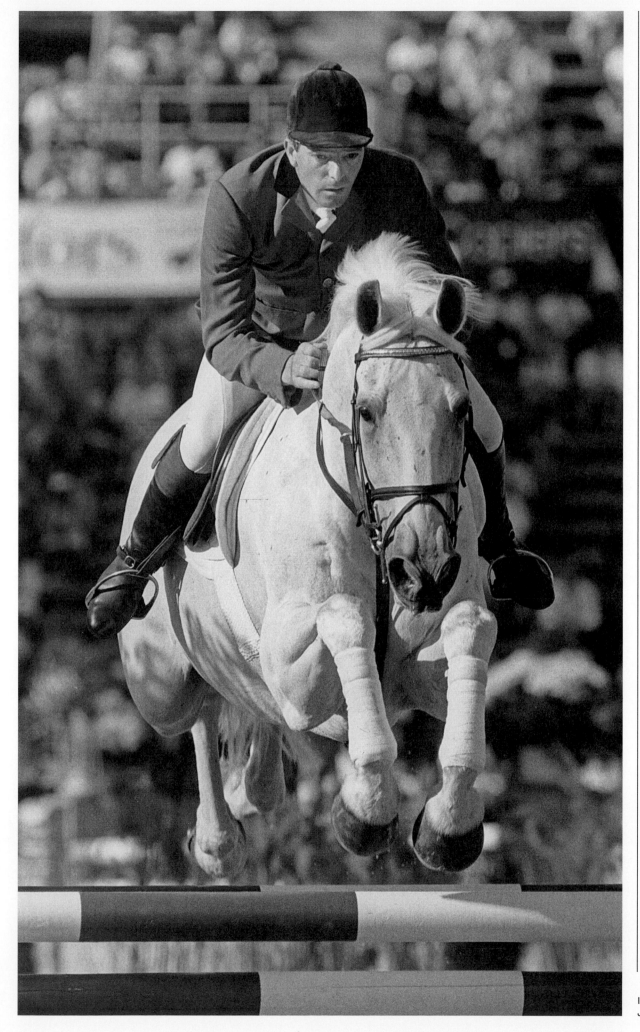

1987
Individual silver medal
at the FEI European
Championships
in St. Gallen with
John Whitaker

1989
Individual and
team gold medal
at the FEI European
Championships
in Rotterdam with
John Whitaker

1990
Individual silver and
team bronze medals
at the FEI World
Equestrian Games
in Stockholm with
John Whitaker

1990
Winner of the FEI
World Cup Final
in Dortmund with
John Whitaker

1991
Winner of the FEI
World Cup Final
in Gothenburg
with John Whitaker

In Stockholm with
J. Whitaker, 1990.

The 1990s

RESULTS 1990–1999

1990
🏆 FEI WORLD EQUESTRIAN GAMES, STOCKHOLM

DRESSAGE
— *Individual*
GOLD Nicole Uphoff (FRG) and Rembrandt
SILVER Kyra Kyrklund (FIN) and Matador
BRONZE Monica Theodorescu (FRG) and Ganimedes
— *Team*
GOLD Federal Republic of Germany: Sven Rothenberger (Ideaal), Ann-Kathrin Linsenhoff (Golfstrom), Monica Theodorescu (Ganimedes), and Nicole Uphoff (Rembrandt)
SILVER Soviet Union: Nina Menkova (Dikson), Valery Tishkov (Kholst), Olga Klimko (Shipovnik), and Yuri Kovshov (Bouket)
BRONZE Switzerland: Daniel Ramseier (Random), Silvia Iklé (Spada), Christine Stückelberger (Gauguin de Lully), and Sam Schatzmann (Rochus)

JUMPING
— *Individual*
GOLD Éric Navet (FRA) and Quito de Baussy
SILVER John Whitaker (GBR) and Milton
BRONZE Hubert Bourdy (FRA) and Morgat
— *Team*
GOLD France: Éric Navet (Quito de Baussy), Hubert Bourdy (Morgat), Roger-Yves Bost (Norton de Rhuys), and Pierre Durand (Jappeloup)
SILVER Federal Republic of Germany: Karsten Huck (Nepomuk), René Tebbel (Borsu Urchin), Otto Becker (Optiebeurs Pamina), and Ludger Beerbaum (Almox Gazelle)
BRONZE Great Britain: Nick Skelton (Alan Paul Grand Slam), Michael Whitaker (Mon Santa), David Broome (Lannegan), and John Whitaker (Milton)

EVENTING
— *Individual*
GOLD Blyth Tait (NZL) and Messiah

SILVER Ian Stark (GBR) and Murphy Himself
BRONZE Bruce Davidson (USA) and Pirath Lion
— *Team*
GOLD New Zealand: Andrew Nicholson (Spinning Rhombus), Andrew Scott (Umptee), Blyth Tait (Messiah), and Mark Todd (Bahlua)
SILVER Great Britain: Karen Straker Dixon (Get Smart), Rodney Powell (The Irishman II), Virginia Leng (Griffin), and Ian Stark (Murphy Himself)
BRONZE Federal Republic of Germany: Edith Beine (Kyang), Matthias Baumann (Alabaster), Marina Loheit (Sundance Kid), and Herbert Blöcker (Feine Dame)

1990
🏆 FEI WORLD CUP

JUMPING
Dortmund, West Germany
GOLD John Whitaker (GBR) and Milton
SILVER Pierre Durand (FRA) and Jappeloup
BRONZE Franke Sloothaak (FRG) and Walzekönig

1991
⚲ FEI EUROPEAN CHAMPIONSHIPS

DRESSAGE
Donaueschingen, Germany
— *Individual*
Grand Prix Special
GOLD Isabell Werth (GER) and Gigolo
SILVER Nicole Uphoff (GER) and Rembrandt
BRONZE Margit Otto-Crépin (FRA) and Corlandus
Freestyle Musical Dressage
GOLD Sven Rothenberger (GER) and Andiamo
SILVER Klaus Balkenhol (GER) and Goldstern
BRONZE Nina Menkova (URS) and Dixon
— *Team*
GOLD Germany: Sven Rothenberger (Andiamo), Isabell Werth (Gigolo), and Nicole Uphoff (Rembrandt)

SILVER Soviet Union: Nina Menkova (Dixon), Olga Klimko (Shipovnik), and Yuri Kovshov (Buket)
BRONZE Netherlands: Anky van Grunsven (Bonfire), Tineke Bartels (Duphar), and Elle Bontje (Larius II)

JUMPING
La Baule, France
— *Individual*
GOLD Éric Navet (FRA) and Quito de Baussy
SILVER Franke Sloothaak (FRG) and Walzerkönig
BRONZE Jos Lansink (NED) and Egano
— *Team*
GOLD Belgium: Jos Lansink (Egano), Ludo Philippaerts (Darco), and Evelyn Blaton (Careful)
SILVER Netherlands: Piet Raymakers (Ratina Z), Jan Tops (Top Gun), and Emile Hendrix (Aldato)
BRONZE Great Britain: Nick Skelton (Phoenix Park), Michael Whitaker (Mon Santa), and John Whitaker (Milton)

EVENTING
Punchestown, Ireland
— *Individual*
GOLD Ian Stark (GBR) and Glenburnie
SILVER Richard Walker (GBR) and Jacana
BRONZE Karen Starker (GBR) and Get Smart
— *Team*
GOLD Great Britain: Richard Walker (Jacana), Ian Stark (Glenburnie), Karen Starker (Get Smart), and Mary Elizabeth Thomson (King William)
SILVER Ireland: Sonya Duke (Bright Imp), Olivia Holohan (Rustikus), Jeremy Spring (Holly Smoke), and Fiona Wentges (Oliver)
BRONZE France: Jean-Jacques Boisson (Oscar de la Loge), Didier Mayoux (Maryland II), Jean Teulère (Orvet de Bellaing), and Didier Séguret (Newlot)

1991
🏆 FEI WORLD CUP

JUMPING
Gothenburg, Sweden
GOLD John Whitaker (GBR) and Milton
SILVER Nelson Pessoa (BRA) and Special Envoy
BRONZE Roger-Yves Bost (FRA) and Norton de Rhuys

1992
OLYMPIC GAMES BARCELONA

DRESSAGE
— *Individual*
GOLD Nicole Uphoff (GER) and Rembrandt
SILVER Isabell Werth (GER) and Gigolo
BRONZE Klaus Balkenhol (GER) and Goldstern
— *Team*
GOLD Germany: Nicole Uphoff (Rembrandt), Isabell Werth (Gigolo), Klaus Balkenhol (Goldstern), and Monica Theodorescu (Grunox)
SILVER Netherlands: Anky van Grunsven (Olympic Bonfire), Ellen Bontje (Olympic Larius), Tineke Bartels (Olympic Courage), and Annemarie Sanders (Olympic Montreux)
BRONZE United States: Carol Lavell (Gifted), Charlotte Bredahl (Monsieur), Robert Dover (Lectron), and Michael Poulin (Graf George)

JUMPING
— *Individual*
GOLD Ludger Beerbaum (GER) and Classic Touch
SILVER Piet Raymakers (NED) and Ratina Z
BRONZE Norman Dello Joio (USA) and Irish
— *Team:*
GOLD Netherlands: Jos Lansink (Egano), Piet Raymakers (Ratina Z), Jan Tops (Top Gun), and Bert Romp (Waldo)
SILVER Austria: Thomas Frühmann (Genius), Hugo Simon (Apricot D), Jörg Müntzner (Graf Grande), and Boris Boor (Love Me Tender)
BRONZE France: Hervé Godignon (Quidam de Revel), Hubert Bourdy (Razzia du Poncel), Éric Navet (Quito de Baussy), and Michel Robert (Nonix)

EVENTING
— *Individual*
GOLD Matthew Ryan (AUS) and Kibah Tic Toc
SILVER Herbert Blöcker (GER) and Feine Dame
BRONZE Blyth Tait (NZL) and Messiah
— *Team*
GOLD Australia: Matthew Ryan (Kibah Tic Toc), Andrew Hoy (Kiwi), Gillian Rolton (Peppermint Grove), and David Green (Duncan II)
SILVER New Zealand: Blyth Tait (Messiah), Vicky Latta (Chief), Andrew Nicholson

(Spinning Rhombus), and Mark Todd (Welton Greylag)
BRONZE Germany: Herbert Blöcker (Feine Dame), Ralf Ehrenbrink (Kildare), Cord Mysegaes (Ricardo), and Matthias Baumann (Alabaster)

1992
🏆 FEI WORLD CUP

JUMPING
Del Mar CA, United States
GOLD Thomas Frühmann (AUT) and Genius
SILVER Lesley McNaught-Mändli (SUI) and Pirol
BRONZE Markus Fuchs (SUI) and Shandor

1993
⚲ FEI EUROPEAN CHAMPIONSHIPS

DRESSAGE
Lipica, Slovak Republic
— *Individual*
Grand Prix Special
GOLD Isabell Werth (GER) and Gigolo
SILVER Monica Theodorescu (GER) and Grunox
BRONZE Emile Faurie (GBR) and Virtu
Freestyle Musical Dressage
GOLD Nicole Uphoff (GER) and Grand Gilbert
SILVER Sven Rothenberger (GER) and Andiamo
BRONZE Gyula Dallos (HON) and Aktion
— *Team*
GOLD Germany: Monica Theodorescu (Grunax Tecrent), Nicole Uphoff (Grand Gilbert), Isabell Werth (Gigolo FRH), and Klaus Balkenhol (Goldstern)
SILVER Great Britain: Ferdinand Eilberg (Arun Tor), Richard Davison (Master JCB), Laura Fry (Quarryman), and Emile Faurie (Virtu)
BRONZE Netherlands: Jeannette Haazen (Windsor JH), Leida Strijk (Wempe Jewel), Suzanne van Cuyk (Mr. Jackson), and Gonnelien Rothenberger (Ideaal)

JUMPING
Gijón, Spain
— *Individual*
GOLD Willy Melliger (SUI) and Quinta C.
SILVER Michel Robert (FRA) and Miss San Patrignano

BRONZE Michael Whitaker (GBR) and Midnight Madness
— *Team*
GOLD Switzerland: Lesley McNaught-Mändli (Pirol IV), Stefan Lauber (Lugana II), and Willi Melliger (Quinta C.)
SILVER Great Britain: Nick Skelton (Dollar Girl), Michael Whitaker (Midnight Madness), Mark Armstrong (Corella), and John Whitaker (Gammon)
BRONZE France: Hubert Bourdy (Razzia du Poncel), Michel Robert (Miss San Patrignano), Hervé Godignon (Twist du Valonà), and Éric Navet (Quito de Baussy)

EVENTING
Achselschwang, Germany
— *Individual*
GOLD Jean-Lou Bigot (FRA) and Twist La Beige
SILVER Kristina Gifford (GBR) and Song And Dance
BRONZE Eddy Stibbe (NED) and Bahlua
— *Team*
GOLD Sweden: Lars Christensson (Hydro One Way), Fredrik Bergendorff (Michaelmas Day), Erik Duvander (Right On Time), and Anna Hermann (Mr. Punch)
SILVER France: Jean Teulère (Orvet de Bellaing), Michel Bouquet (Newport), Didier Séguret (Newlot), and Jean-Lou Bigot (Twist La Beige)
BRONZE Ireland: Susan Shortt (Menana), Sonia Rowe (Bright Imp), Sally Corscadden (Cageadore), and Eric Smiley (Enterprise)

1993
🏆 FEI WORLD CUP

JUMPING
Gothenburg, Sweden
GOLD Ludger Beerbaum (GER) and Ratina Z
SILVER John Whitaker (GBR) and Grannush (Milton)
BRONZE Michael Matz (USA) and Rhum

1994

🏆 FEI WORLD EQUESTRIAN GAMES, THE HAGUE

DRESSAGE
— Individual
Grand Prix Special
GOLD Isabell Werth (GER) and Gigolo
SILVER Nicole Uphoff (GER) and Rembrandt
BRONZE Sven Rothenberger (NED) and Dondolo
Freestyle Musical Dressage
GOLD Anky van Grunsven (NED) and Olympic Bonfire
SILVER Klaus Balkenhol (GER) and Goldstern
BRONZE Karin Rehbein (GER) and Donnerhall
— Team
GOLD Germany: Nicole Uphoff (Rembrandt), Klaus Balkenhol (Goldstern), Isabell Werth (Gigolo), and Karin Rehbein (Donnerhall)
SILVER Netherlands: Sven Rothenberger (Dondolo), Ellen Bontje (Heuriger N), and Anky van Grunsven (Olympic Bonfire)
BRONZE United States: Kathleen Raine (Avontuur), Robert Dover (Devereaux), Gary Rockwell (Suna), and Carol Lavell (Gifted)

JUMPING
— Individual
GOLD Franke Sloothaak (GER) and San Patrignano Weihaiwej
SILVER Michel Robert (GER) and Miss San Patrignano
BRONZE Sören van Rönne (GER) and Taggi
— Team
GOLD Germany: Franke Sloothaak (San Patrignano Weihaiwej), Sören von Rönne (Taggi), Dirk Hafemeister (PS Priamos), and Ludger Beerbaum (Ratina Z)
SILVER France: Roger-Yves Bost (Souviens Toi III), Philippe Rozier (Baiko Rocco V), Éric Navet (Quito de Baussy), and Michel Robert (Miss San Patrignano)
BRONZE Switzerland: Thomas Fuchs (Major AC Folien), Stefan Lauber (Lugana II), Markus Fuchs (Interpane Goldlights), and Lesley McNaught-Mändli (Pirol IV)

EVENTING
— Individual
GOLD Vaughn Jefferis (NZL) and Bounce

SILVER Dorothy Trapp (USA) and Molokai
BRONZE Karen Dixon (GBR) and Get Smart
— Team
GOLD Great Britain: Karen Dixon (Get Smart), Mary Thomson (King William), Charlotte Bathe (The Cool Customer), and Kristina Gifford (General Jock)
SILVER France: Jean-Lou Bigot (Twist La Beige), Jean Teulère (Rodosto), Marie-Christine Duroy (Summersong), and Didier Séguret (Cœur de Rockeur)
BRONZE Germany: Bettina Overesch (Watermill Stream), Cord Mysegaes (Ricardo), Peter Thomsen (White Girl), and Ralf Ehrenbrink (Kildare)

1994

🏆 FEI WORLD CUP

JUMPING
's-Hertogenbosch, Netherlands
GOLD Jos Lansink (BEL) and Libero H
SILVER Franke Sloothaak (GER) and Dorina (San Patrignano Weihaiwej)
BRONZE Michael Whitaker (GBR) and Midnight Madness

1995

FEI EUROPEAN CHAMPIONSHIPS

DRESSAGE
Mondorf-les-Bains, Luxembourg
— Individual
GOLD Isabell Werth (GER) and Gigolo
SILVER Anky van Grunsven (NED) and Bonfire
BRONZE Sven Rothenberger (NED) and Bo
— Team
GOLD Germany: Martin Schaudt (Durgo), Nicole Uphoff (Rembrandt), Isabell Werth (Gigolo), and Klaus Balkenhol (Goldstern)
SILVER Netherlands: Tineke Bartels (Barbria), Ellen Bontje (Silvano N), Sven Rothenberger (Bo), and Anky van Grunsven (Bonfire)
BRONZE France: Dominique Brieussel (Akazie), Dominique d'Esme (Arnoldo Thor), Margit Otto-Crépin (Lucky Lord), and Marie-Hélène Syre (Marlon)

EVENTING
— Individual
GOLD Vaughn Jefferis (NZL) and Bounce

JUMPING
St. Gallen, Switzerland
— Individual
GOLD Peter Charles (IRL) and La Ina
SILVER Michael Whitaker (GBR) and Everest Two Step
BRONZE Willi Melliger (SUI) and Calvaro V
— Team
GOLD Switzerland: Lesley McNaught-Mändli (Dönhoff), Stefan Lauber (Bay Networks Escado), Willi Melliger (Calvaro V), and Thomas Fuchs (Major A. C. Folien)
SILVER Great Britain: Nick Skelton (Dollar Girl), Michael Whitaker (Everest Two Step), Alison Bradley (Endeavour), and John Whitaker (Welham)
BRONZE France: Jean-Maurice Bonneau (Urleven Pironnière), Alexandra Ledermann (Rochet M), Hervé Godignon (Unic du Perchis), and Roger-Yves Bost (Souviens Toir III)

EVENTING
Pratoni del Vivaro, Italy
— Individual
GOLD Lucy Thompson (IRL) and Welton Romance
SILVER Marie-Christine Duroy (FRA) and Ut du Placineau
BRONZE Mary King (GBR) and King William
— Team
GOLD Great Britain: Charlotte Bathe (The Cool Customer), Kristina Gifford (Midnight Blue), William Fox-Pitt (Cosmopolitan II), and Mary King (King William)
SILVER France: Gilles Pons (Ramdame), Rodolphe Scherer (Uran des Pins), Didier Willefert (Seducteur Biolay), and Jean-Lou Bigot (Twist La Beige)
BRONZE Ireland: Lucy Thompson (Welton Romance), Mark Barry (Vagabond Collongues), Virginia McGrath (Yellow Earl), and Eric Smiley (Enterprise)

1995

🏆 FEI WORLD CUP

JUMPING
Gothenburg, Sweden
GOLD Nick Skelton (GBR) and Dollar Girl
SILVER Lars Nieberg (GER) and For Pleasure
BRONZE Lesley McNaught-Mändli (SUI) and Barcelona SVH (Dönhoff)

1996

⚫⚫⚫ OLYMPIC GAMES, ATLANTA

DRESSAGE
— Individual
GOLD Isabell Werth (GER) and Gigolo
SILVER Anky van Grunsven (NED) and Bonfire
BRONZE Sven Rothenberger (GER) and Weyden
— Team
GOLD Germany: Isabell Werth (Gigolo), Monica Theodorescu (Grunox), Klaus Balkenhol (Goldstern), and Martin Schaudt (Durgo)
SILVER Netherlands: Anky van Grunsven (Bonfire), Sven Rothenberger (Weyden), Tineke Bartels (Barbria), and Gonnelien Rothenberger (Dondolo)
BRONZE United States: Michelle Gibson (Peron), Guenter Seidel (Graf George), Steffen Peters (Udon), and Robert Dover (Metallic)

JUMPING
— Individual
GOLD Ulrich Kirchhoff (GER) and Jus de Pomme
SILVER Willi Melliger (SUI) and Calvaro V
BRONZE Alexandra Ledermann (FRA) and Rochet M
— Team
GOLD Germany: Ludger Beerbaum (Ratina Z), Ulrich Kirchhoff (Jus de Pomme), Lars Nieberg (For Pleasure), and Franke Sloothaak (Joly)
SILVER United States: Peter Leone (Legato), Anne Kursinski (Eros), Michael Matz (Rhum), and Leslie Burr-Howard (Extreme)
BRONZE Brazil: Rodrigo Pessoa (Tomboy), Luiz Felipe de Azevedo (Cassiana), Alvaro de Miranda Neto (Aspen), and André Johannpeter (Calei)

EVENTING
— Individual
GOLD Blyth Tait (NZL) and Ready Teddy
SILVER Sally Clark (NZL) and Squirrel Hill
BRONZE Kerry Millikin (USA) and Out And About
— Team
GOLD Australia: Wendy Schaeffer (Sunburst), Phillip Dutton (True Blue Girdwood), Andrew Hoy (Darien Power), and Gillian Rolton (Peppermint Grove)
SILVER United States: David O'Connor (Giltedge),

Bruce Davidson (Heyday), Karen O'Connor (Biko), and Kill Henneberg (Nirvana)
BRONZE New Zealand: Blyth Tait (Chesterfield), Vaughn Jefferis (Bounce), Andrew Nicholson (Jagermeister II), and Vicky Latta (Broadcast News)

1996

🏆 FEI WORLD CUP

JUMPING
Geneva, Switzerland
GOLD Hugo Simon (AUT) and ET
SILVER Willi Melliger (SUI) and Calvaro
BRONZE Nick Skelton (GBR) and Dollar Girl

1997

🐴 FEI EUROPEAN CHAMPIONSHIPS

DRESSAGE
Verden an der Aller, Germany
— Individual
GOLD Isabell Werth (GER) and Gigolo
SILVER Anky van Grunsven (NED) and Bonfire
BRONZE Karin Rehbein (GER) and Donnerhall
— Team
GOLD Germany: Isabell Werth (Gigolo), Karin Rehbein (Donnerhall), Ulla Salzgeber (Rusty 47), and Nadine Capellmann (Gracioso)
SILVER Netherlands: Sven Rothenberger (Jonggor's Weyden), Gonnelien Rothenberger (Bo), Anky van Grunsven (Bonfire), and Ellen Bontje (Gestion Silvan N)
BRONZE Sweden: Jan Brink (Kleber Martini), Louise Nathhorst (LRF Walk on Top), Annette Solmell (Flyinge Strauss 689), and Ulla Håkanson (Flyinge Bobby)

JUMPING
Mannheim, Germany
— Individual
GOLD Ludger Beerbaum (GER) and Ratina Z
SILVER Hugo Simon (AUT) and ET
BRONZE Willi Melliger (SUI) and Calvaro V
— Team
GOLD Germany: Lars Nieberg (For Pleasure), Markus Beerbaum

(Lady Weingard), Ludger Beerbaum (Ratina Z), and Markus Merschformann (Ballerina)
SILVER Netherlands: Emile Hendrix (Finesse), Bert Romp (Mr. Blue), Jan Tops (Top Gun), and Jos Lansink (Calvaro Z)
BRONZE Great Britain: Michael Whitaker (Ashley), Geoff Billington (It's Otto), Robert Smith (Tees Hanauer), and John Whitaker (Welham)

EVENTING
Burghley, United Kingdom
— Individual
GOLD Bettina Overesch-Boker (GER) and Watermill Stream
SILVER William Fox-Pitt (GBR) and Cosmopolitan II
BRONZE Kristina Gifford (GBR) and General Jock
— Team
GOLD Great Britain: Christopher Bartle (Word Perfect II), Ian Stark (Arakai), William Fox-Pitt (Cosmopolitan II), and Mary King (Star Appeal)
SILVER Sweden: Sivert Jonsson (Jumping Jet Pack), Magnus Österlund (Master Mind), Paula Tornyvist (Monaghan), and Anna Hermann (Home Run II)
BRONZE France: Jean Teulère (Rodosto), Frédéric de Romblay (Rosendael HN), Marie-Christine Duroy (Summer Song), and Jean-Lou Bigot (Twist La Beige*HN)

1997

🏆 FEI WORLD CUP

DRESSAGE
's-Hertogenbosch, Netherlands
GOLD Anky van Grunsven (NED) and Bonfire
SILVER Sven Rothenberger (NED) and Jonggor's Weyden
BRONZE Louise Nathhorst (SWE) and Walk on Top

JUMPING
Gothenburg, Sweden
GOLD Hugo Simon (AUT) and ET
SILVER John Whitaker (GBR) and Grannush (Welham)
BRONZE Franke Sloothaak (GER) and San Patrignano Joly

1998

🏆 FEI WORLD EQUESTRIAN GAMES, ROME

DRESSAGE
— Individual
GOLD Isabell Werth (GER) and Gigolo
SILVER Anky van Grunsven (NED) and Gestion Bonfire
BRONZE Ulla Salzgeber (GER) and Rusty
— Team
GOLD Germany: Isabell Werth (Gigolo), Karin Rehbein (Donnerhall), Nadine Capellmann (Gracioso), and Ulla Salzgeber (Rusty)
SILVER Netherlands: Anky van Grunsven (Gestion Bonfire), Coby van Baalen (Ferro), Ellen Bontje (Gestion Silvano N.), and Gonnelien Rothenberger (Dondolo)
BRONZE Sweden: Louise Nathhorst (Walk on Top), Ulla Håkanson (Flyinge Bobby), Annette Solmell (Flyinge Strauss 689), and Jan Brink (Bjorsell's Fontana)

JUMPING
— Individual
GOLD Rodrigo Pessoa (BRA) and Lianos

SILVER Thierry Pomel (FRA) and Thor des Chaines
BRONZE Franke Sloothaak (GER) and San Patrignano Joly
— Team
GOLD Germany: Lars Nieberg (Esprit FRH), Markus Beerbaum (Lady Weingard), Franke Sloothaak (San Patrignano Joly), and Ludger Beerbaum (PS Priamos)
SILVER France: Alexandra Ledermann (Rochet M), Roger-Yves Bost (Airborne Montecillo), Éric Navet (Atout d'Isigny), and Thierry Pomel (Thor des Chaînes)
BRONZE Great Britain: Diane Lampard (Abbervail Dream), Geoff Billington (It's Otto), Nick Skelton (Hopes Are High), and John Whitaker (Heyman)

EVENTING
— Individual
GOLD Blyth Tait (NZL) and Ready Teddy
SILVER Mark Todd (NZL) and Broadcast News
BRONZE Paula Tornquist (SWE) and SAS Monaghan
— Team
GOLD New Zealand: Blyth Tait (Ready Teddy), Mark Todd (Broadcast News), Vaughn Jefferis (Bounce), and Sally Clark (Squirrel Hill)

SILVER France: Marie-Christine Duroy (Summersong), Rodolphe Scherer (Bambi de Brière), Jean-Lou Bigot (Twist La Beige*HN), and Philippe Mull (Viens du Frêne*ENE-HN)
BRONZE United States: David O'Connor (Giltedge), Keey Millikin (Out And About), Bruce Davidson (Heyday), and Karen O'Connor (Prince Panache)

1998

🏆 FEI WORLD CUP

JUMPING
Helsinki, Finland
GOLD Rodrigo Pessoa (BRA) and Baloubet du Rouet
SILVER Lars Nieberg (GER) and Esprit
BRONZE Ludger Beerbaum (GER) and PS Priamos

1999

🏅 FEI EUROPEAN CHAMPIONSHIPS

DRESSAGE
Arnhem, Netherlands
— Individual
GOLD Anky van Grunsven (NED) and Bonfire

SILVER Ulla Salzgeber (GER) and Rusty 47
BRONZE Arjen Teeuwissen (NED) and Goliath
— Team
GOLD Germany: Nadine Capellmann (Gacioso 008), Alexandra Simons de Ridder (Chacomo 003), Ulla Salzgeber (Rusty 47), and Isabell Werth (Antony FRH)
SILVER Netherlands: Ellen Bontje (Gestion Silvano N), Coby van Baalen (Olympic Ferro), Arjen Teeuwissen (Yakumo 39), and Anky van Grunsven (Bonfire)
BRONZE Denmark: Jon D. Pedersen (Esprit 39), Lone Jörgensen (FBW Kennedy), Lars Petersen (Blue Hors Cavan), and Anne van Olst-Kolch (Any How)

JUMPING
Hickstead, United Kingdom
— Individual
GOLD Alexandra Ledermann (FRA) and Rochet M.
SILVER Markus Fuchs (SUI) and Tinka's Boy
BRONZE Lesley McNaught-Mändli (SUI) and Dulf Z

— Team
GOLD Germany: Carsten-Otto Nagel (L'Eperon), Meredith Michaels-Beerbaum (Stella), Marcus Ehning (For Pleasure), and Ludger Beerbaum (Champion du Lys)
SILVER Switzerland: Lesley McNaught-Mändli (Dulf Z), Markus Fuchs (Tinka's Boy), Beat Mändli (Pozitano), and Willi Welliger (Calvaro)
BRONZE Netherlands: Emile Hendrix (Finesse), Jeroen Dubbeldam (De Sjiem), Jan Tops (Montemorelos), and Jos Lansink (Carthago Z)

EVENTING
Luhumühlen, Germany
— Individual
GOLD Pippa Funnell (GBR) and Supreme Rock
SILVER Linda Algotsson (SWE) and Stand By Me
BRONZE Paula Törnqvist (SWE) and Monaghan
— Team
GOLD Great Britain: Kristina Gifford (The Gangster), Jeanette Brakewell (Over To You), Ian Stark (Jaybee), and Pippa Funnell (Supreme Rock)

SILVER Germany: Peter Thomsen (Warren Gorse), Herbert Blöcker (Mobilcom Chicoletto), Nele Hagnener (Little McMuffin), and Bodo Battenberg (Sam The Man)
BRONZE Belgium: Virginie Caulier (Kiona), Kurt Heyndricks (Archimedes), Carl Bouckaert (Welton Molecule), and Constantin Van Rijckevorsel (Otis)

1999

🏆 FEI WORLD CUP

JUMPING
Gothenburg, Sweden
GOLD Rodrigo Pessoa (BRA) and Baloubet du Rouet
SILVER Trevor Coyle (IRL) and Cruising
BRONZE René Tebbel (UKR) and Radiator

1990
FEI World Equestrian Games, Stockholm

Under the impetus of the Duke of Edinburgh, who was president of the FEI from 1964 to 1986, the FEI World Championships for all three Olympic disciplines were held in the same venue alongside the non-Olympic disciplines of the FEI. This innovation gave rise to the FEI World Equestrian Games.

1. N. Uphoff, individual and team gold medalist in dressage, on Rembrandt.

— dressage

It was a competition of miracles. Nicole Uphoff, recovering from a fractured left arm, won the individual gold while wearing a splint. Moreover, as a result of her injury, she had been forced to entrust Rembrandt's preparation to Harry Boldt. Finnish rider Kyra Kyrklund, a silver medalist, achieved a place on the podium with her horse Matador, which had undergone an operation for colic and whose sporting career was thought to be over. Lastly, Christine Stückelberger returned to competitive riding after narrowly escaping paralysis following a very serious fall from her horse. The riders all remembered their surprise on seeing the arenas: as an experiment, the sand had been dyed green.

1

— jumping

At the conclusion of a nail-biting four-way finale, Éric Navet took the individual title with Quito de Baussy. The horse, just eight years old, had been bred by Navet's father, Alain, on the Baussy stud farm in the heart of Normandy. Éric and Quito also won the team title, along with their comrades Hubert Bourdy, Roger-Yves Bost, and Pierre Durand. The Schockemöhle scandal, involving questionable training techniques, weighed heavily on these first FEI World Equestrian Games and affected German team morale.

— eventing

Memories of this event included a particularly challenging, winding, very uneven cross-country course, with a significant number of uphill and downhill banks. With temperatures reaching 86° F (30° C), many horses completed the course in an unacceptable state of fatigue. Only three riders finished without incident and in the time allowed: the New Zealanders Blyth Tait and Andrew Nicholson, and the Frenchman Didier Seguret. By the evening of the cross-country phase, they topped the rankings. The show-jumping course was equally discriminating, with only Blyth Tait managing to retain a podium place. Didier Seguret fell in the ranking, with six bars down.

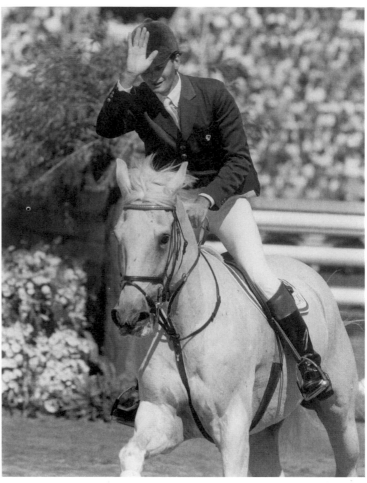

2

2. É. Navet, gold medalist in individual and team jumping, shown here on Gem Twist.

3. B. Tait, gold medalist in eventing, on Messiah.

4. B. Davidson and Pirath Lion winning the bronze medal for individual eventing.

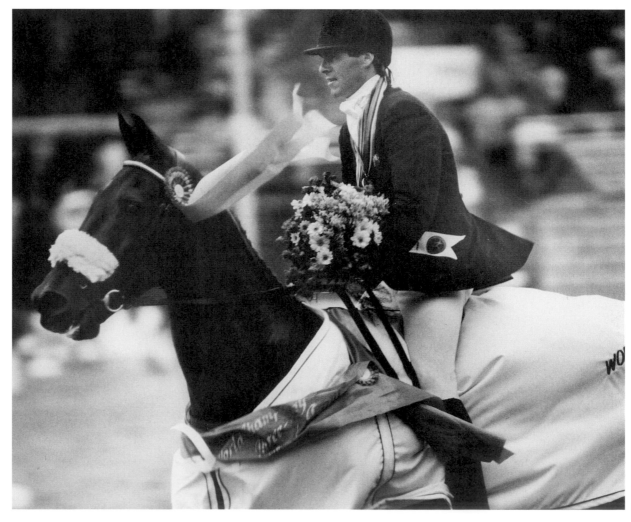

3 4 >

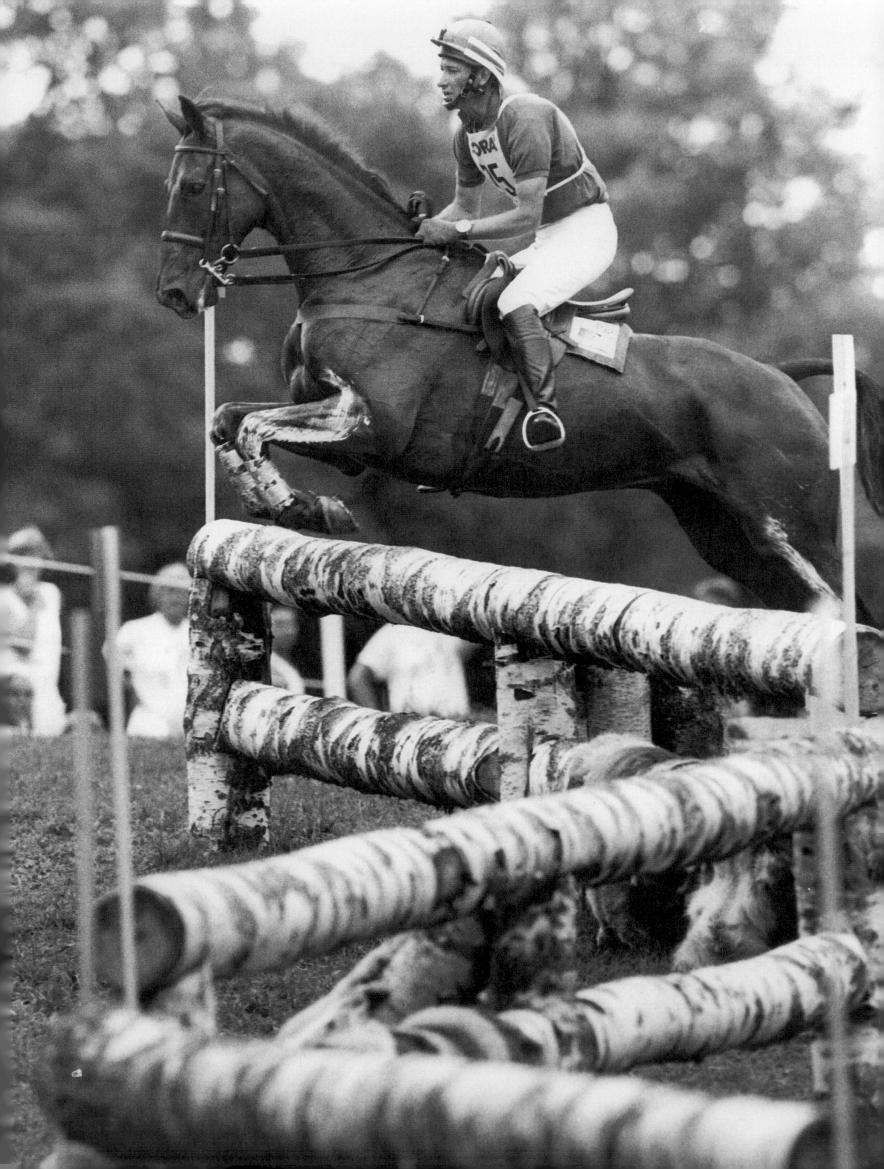

1991
FEI European Championships

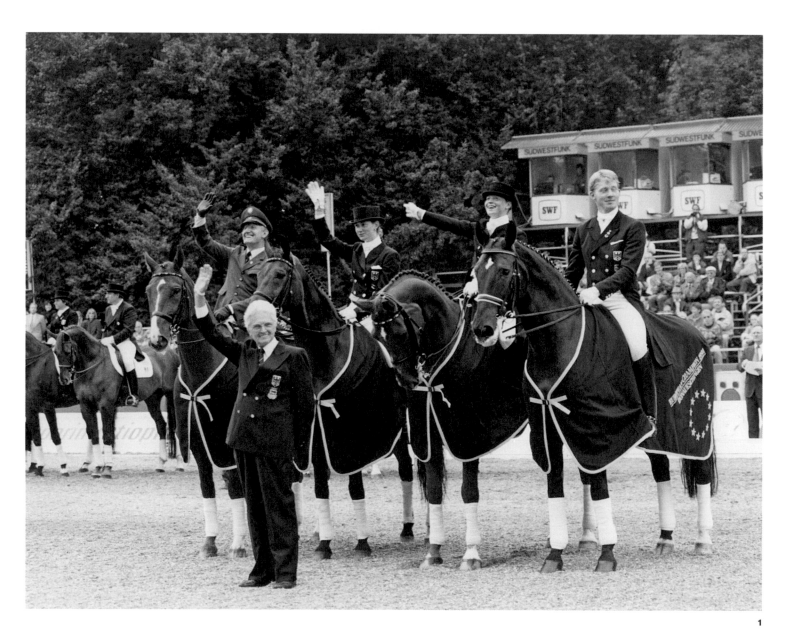

1

— dressage

Donaueschingen, Germany
The dressage freestyle or "Kür" was introduced into the European Championships, and henceforth a second European Championship title was awarded for this test. However, some officials considered the judges and riders not yet ready: the riders did not know how to synchronize the movements and

paces to the music, while the judges floundered amid what seemed to be a random scoring system. For twenty-two-year-old Isabell Werth, this was her first event and first title: she won the Grand Prix Special.

1. The German team, European dressage champions: (left to right) K. Balkenhol (Goldstern), N. Uphoff (Rembrandt), I. Werth (Gigolo), S. Rothenberger (Andiamo).

2. É. Navet, European jumping champion, on Quito de Baussy.

— jumping

La Baule, France
In this competition, Ratina Z was ridden by Dutch rider Piet Raymakers; Milton went down with 8 penalties, and the magnificent Quito de Baussy delivered the gold medal to the 1990 FEI World Champion, Frenchman Éric Navet.

— eventing

Punchestown, Ireland
As in 1989, the British scooped all the individual medals and the team gold. Richard Walker won the silver medal, as in 1969.

1992
Olympic Games, Barcelona

— dressage

In the first surprise of these Games, Margit Otto-Crépin's sixteen-year-old horse Corlandus did not pass the initial vet check. The Germans dominated the rankings and won the team gold medal by scooping the first four places in the Grand Prix. The chief of the Düsseldorf mounted police, Klaus Balkenhol, took third place on the podium with his police horse, Goldstern.

1

— jumping

In Barcelona, the FEI changed the qualification rules for the individual final, demanding three qualifying rounds before the individual final: the first two would be team competition rounds with the third taking place after they were completed, so technically not necessary. Only forty-four out of eighty-six riders completed the course as they sought to preserve their horses, which as a result was underwhelming for the extremely disappointed audience. The furor caused by this incident forced Princess Anne, president of the FEI, to hold a memorable press conference. When a journalist asked her how she accounted for this disaster, she replied that earthquakes and tsunamis might be considered disasters, but not this.

2

1. K. Balkenhol, team gold medalist in dressage and individual bronze medalist, on Goldstern.

2. Princess Anne at a press conference.

3. and **4.** A. Hoy on Kiwi (top) and D. Green on Duncan II (bottom), members of the winning Australian eventing team.

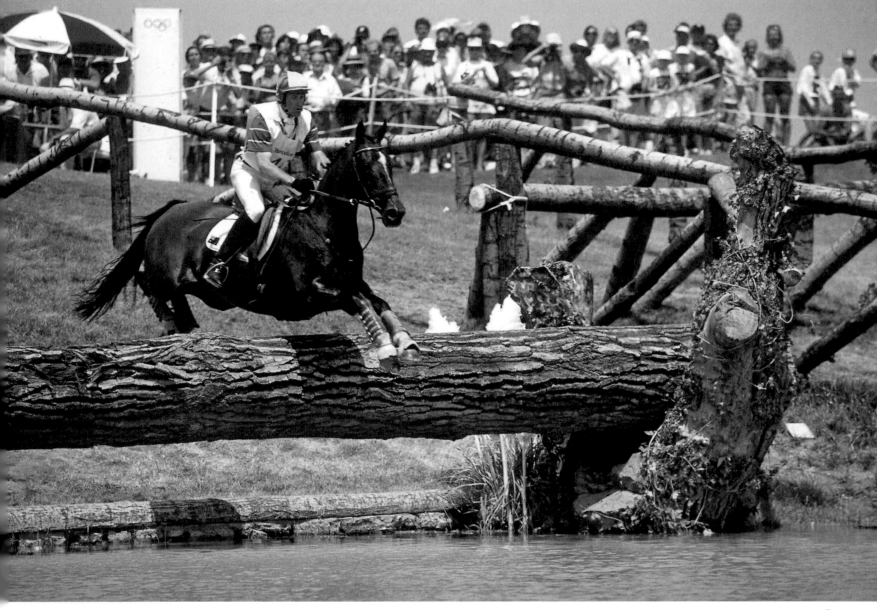

3

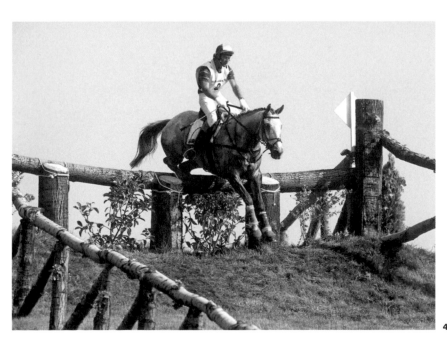

4

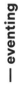

The cross-country course took the riders by surprise. A whole house had been built on the course, and choosing the slower option to the water jump meant going through it. The drop into the water was so high that a ladder had been installed so that riders walking the cross-country course could make their way down this impressive step. Only Belgian rider Karen Donkers tackled this extremely challenging course choosing the straight route. The other riders chose the slower option to make sure they completed it without incident, at the risk of incurring a few time penalties.

1993
FEI European Championships

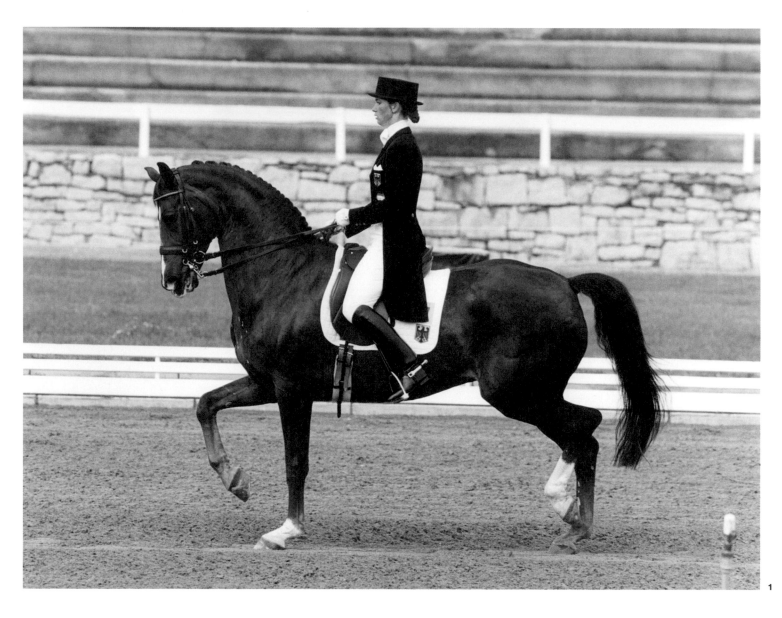

1

Lipica, Slovak Republic
The Kür (from the German *kür*, meaning "show"), which for the second time took place to music, became known as the Freestyle to Music, or simply "Freestyle." The German rider Nicole Uphoff was awarded excessive points despite a mediocre piaffe, winning the test on Grand Gilbert. The British team finished with its first-ever silver medal.

1. N. Uphoff, European dressage champion, on Grand Gilbert.

2. On the individual jumping podium: (left to right) French rider M. Robert, Swiss rider W. Melliger, British rider J. Whitaker.

3. J.-L. Bigot, European eventing champion, on Twist La Beige.

4. W. Melliger, European jumping champion, on Quinta C.

Gijón, Spain
In Spain, Spaniard Nicolás Álvarez de Bohórquez, who was unanimously praised for the quality and progressive challenges of his courses, was hired as designer. However, he had been widely criticized for the extreme difficulty of his courses at the 1992 Olympic Games in Barcelona.

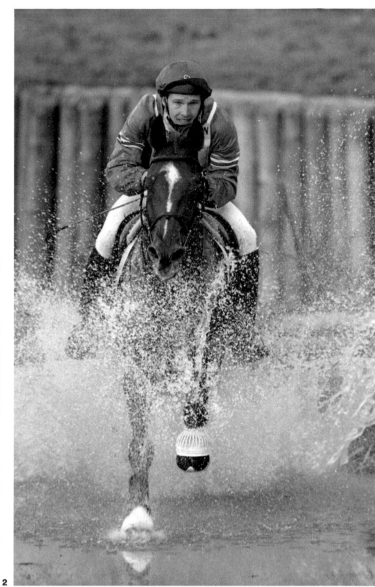

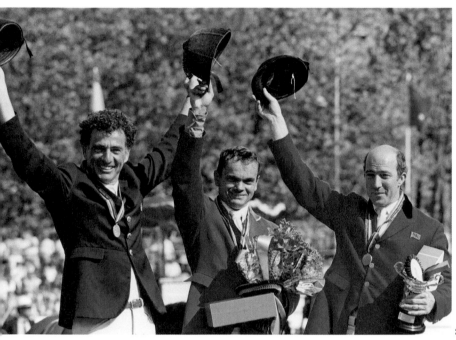

2

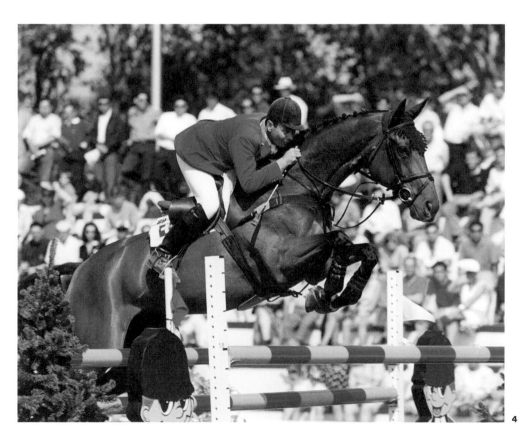

4

Achselschwang, France
When he presented himself for the dressage test in the pouring rain, Frenchman Jean-Lou Bigot was asked by the jury to go back and take shelter in the stables. However, this did not affect the young rider's concentration, because after this incident and a very difficult cross-country course in which no rider finished in the time allowed, Bigot won the European title— a first for France.

1994
FEI World Equestrian Games, The Hague

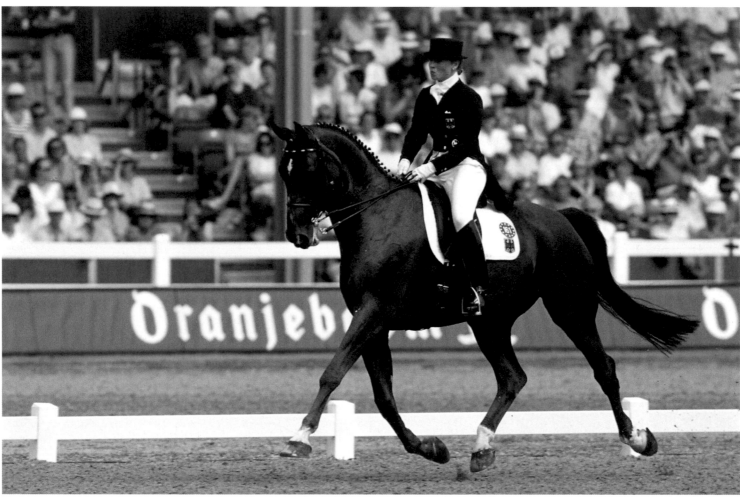

— dressage

Despite the legitimacy of the Freestyle to Music being constantly called into question, twenty thousand spectators crowded into the stadium to watch. The judging puzzled some professionals, who did not understand why some riders were scored so badly. The Russian riders Svetlana Kirjazeva and Mina Menkova were relegated to the bottom of the rankings, although they performed magnificently in both piaffe and passage.

— jumping

Watching from the edge of the arena as other riders performed better than he did, French rider Éric Navet, the 1990 world champion, realized that all his medal hopes were lost. David Broome, who had experienced this same situation, gave him a congratulatory hug for having been a great world champion.

— eventing

The riders who made up the gold-medal-winning British team were all female—Karen Dixon, Mary Thomson, Charlotte Bathe, and Kristina Gifford—and all eventing legends.French judge Jack Le Goff's harshness toward his compatriots was hard to explain. His scores differed by 20 penalties from the other judges, to the detriment of several French riders.

1. I. Werth, gold medalist
in individual dressage
(Grand Prix Special)
and team gold medalist,
on Gigolo.

2. The British team,
victors in eventing:
(left to right) K. Dixon
(Get Smart), M. Thomson
(King William), C. Bathe
(The Cool Customer),
K. Gifford (General Jock).

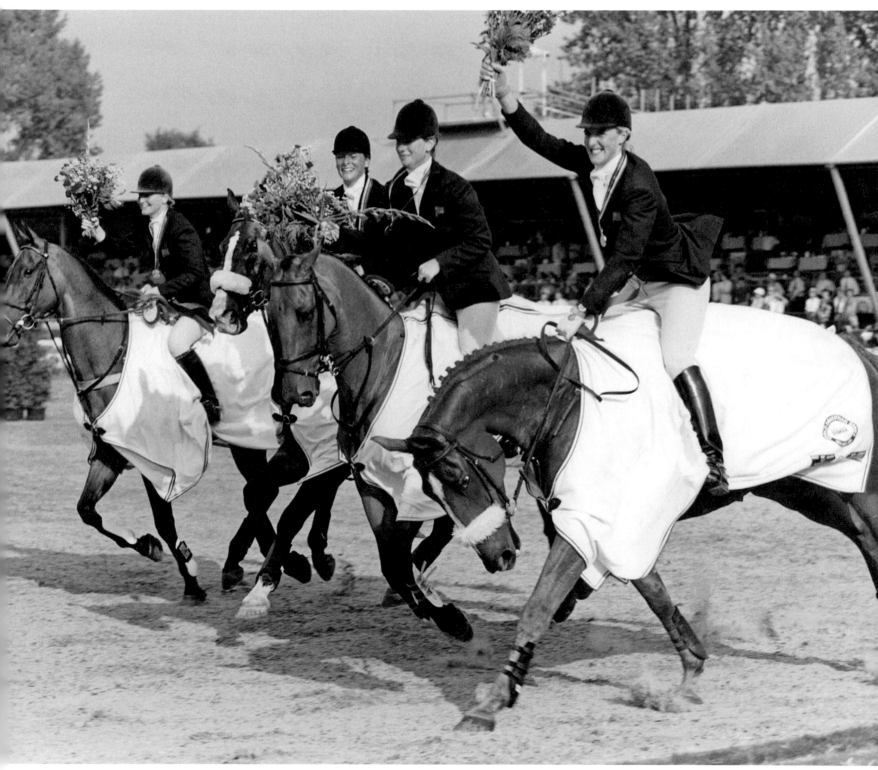

2

1995
FEI European Championships

— dressage

Mondorf-Les-Bains, Luxembourg
The individual title was contested over three competitions: the Grand Prix, the Grand Prix Special, and the Freestyle to Music. The percentages of these three tests were added up and the individual medals awarded accordingly. French rider Dominique Brieussel, riding Akasie, found himself in an awkward situation during this event. The mare's co-owner, who lived next door to the venue, threatened to take the horse home to rest. Akasie was padlocked every time she was returned to the stables, and Brieussel's mount was kept under tight surveillance.

— jumping

St. Gallen, Switzerland
Individual gold medalist Peter Charles and his mare, La Ina, both had atypical careers. Although he was representing Ireland in St. Gallen, until 1992 Charles had competed for Great Britain. His mare had belonged to Francisco Goyoaga's son. This sensitive horse had been bought to be trained and resold, with no one imagining that she might go on to win a European title.

— eventing

Pratoni del Vivaro, Italy
The British rider Mary King (née Thomson) announced a happy event: she was five months pregnant when she took part in these championships.

1

1. The French team, bronze medalists in dressage: (left to right) M. Otto-Crépin, D. d'Esme, M.-H. Syre, D. Brieussel.

2. The individual jumping podium: (left to right) British rider M. Whitaker, Irish rider P. Charles, Swiss rider W. Melliger.

2

1996
Olympic Games, Atlanta GA

— dressage

1. Anky van Grunsven, silver medalist in dressage, on Bonfire.

Nicole Uphoff's excellent horse, Rembrandt, was forced to retire after the final horse inspection. Anky van Grunsven's Bonfire was also close to being eliminated but would go on to win the silver medal after the three tests, a questionable result in the eyes of some. On the eve of the event, the Spanish reserve rider Luis Lucio, whose horse was stabled three hours away from the venue, was nominated to open the dressage event, as the judges needed to see a rider to adjust their scoring. But the terrorist attack of July 27 had just plunged the Olympic Games into mourning, disrupting its program. The truck carrying Luis's horse got stuck in traffic, and the competition was constantly delayed. Despite these uncertainties, Luis rode "the test of his life," beating his personal record by two points.

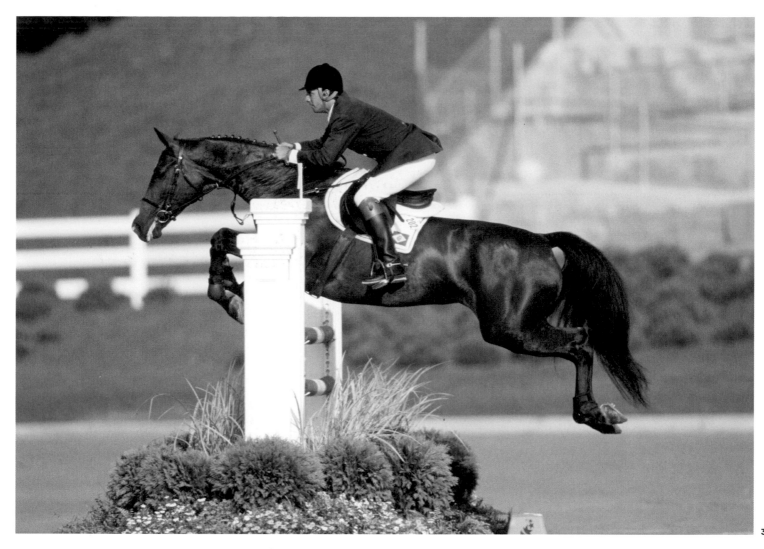

— jumping

It was not luck that took Brazil to the podium to take the bronze medal: in charge of training was Nelson Pessoa, known as "Neco" or "the Wizard." On the financial side, André Johannpeter, a generous investor and a wealthy steel magnate, added his support. As a rider, he was also a member of this medal-winning team.

— eventing

Prior to these Olympic Games, the IOC announced that it wanted to remove eventing from the equestrian events, citing as their reason that two medals could not be awarded for the same effort. The FEI's proposal to hold two separate competitions for individual and team medals was accepted and implemented. Some riders took part on two different horses, such as Blyth Tait with Ready Teddy, on which he scooped the individual gold, and Chesterfield, on which he won the team bronze.

2. and **3.** A. Johannpeter, a member of the bronze-winning Brazilian team, on Calei.

4. B. Tait and Chesterfield.

4

1997
FEI European Championships

Verden, Germany
At the prize-giving ceremony, Ignacio Rambla, director of the Royal Andalusian School of Equestrian Art, and his faithful mount Evento performed a memorable Spanish walk.

Mannheim, Germany
Ludger Beerbaum and Ratina Z won individual and team medals. This was Beerbaum's first individual medal in the championships since his Olympic title in Barcelona in 1992.

Burghley, United Kingdom
Although Bettina Overesch-Böker's horse, Watermill, was not accepted at the first vet check, it was finally passed, and the German rider went on to become European champion. She had prepared for the event with Australian competitor Andrew Hoy, her future husband, and was trained by Mark Phillips at the royal stables.

1. L. Beerbaum, European individual and team jumping champion, on Ratina Z.
2. B. Overesch-Böker, European eventing champion, on Watermill.

1

2 >

1998
FEI World Equestrian Games, Rome

— dressage

Tired of seeing Germany triumph every year, some specialists proposed the introduction of a final with a horse rotation change, as was the case in show jumping, which would also make the discipline more dramatic—but to no avail. The majority of the riders were reluctant, as they had been at the time of the introduction of the Freestyle to Music to championships.

1. I. Werth, gold medalist in dressage, on Gigolo.

2. M. Todd, individual silver and team gold medalist in eventing, on Broadcast News.

3. B. Tait, occupying the top step of the individual eventing podium, once again putting New Zealand at center stage. The nation also claimed the team prize.

1

— jumping

The moment of the final-four horse rotation arrived. Willi Melliger for Switzerland, Thierry Pommel for France, Franke Sloothaak for Germany, and Rodrigo Pessoa for Brazil were in contention. None of the riders managed four clear rounds. The Brazilian rider came top with 4 penalties, one penalty ahead of the Frenchman.

— eventing

Carried away with enthusiasm, rider Philippe Mull, who opened for the French team, fulfilled his role perfectly. He did not realize that on the cross-country course he had overtaken the Argentinian Edouardo Ojeda. The Hungarian Tibor Hercegfalvi finished the cross-country phase with a few refusals, by choosing all the longer options and exceeding the time allowed by twenty-two minutes.

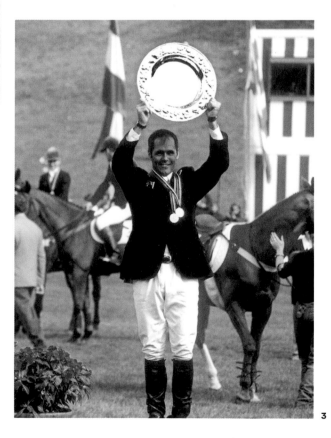

3

1999
FEI European Championships

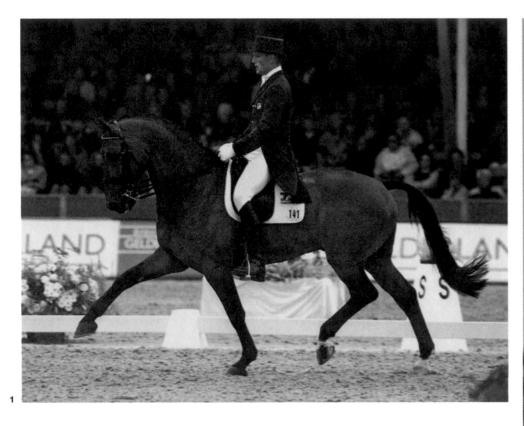

1

— dressage

Arnhem, Netherlands
In the absence of Isabell Werth, Anky van Grunsven scooped the gold. Her life partner and coach, Sjef Janssen, achieved more than satisfactory results, and Arjen Teeuwissen, who trained with her, rode to bronze on Goliath.

— jumping

Hickstead, United Kingdom
In this legendary British venue, the European Championships, as a mixed event, finally saw the first show-jumping victory by a woman: French rider Alexandra Ledermann on Rochet M.

— eventing

Luhmühlen, Germany
Two key points in the regulations were changed. In dressage, coefficients were removed, and the importance of the dressage phase was reduced in favor of the cross-country phase, in which one second over the time allowed incurred 1 penalty instead of 0.4. This regulation encouraged riders to go faster and take certain risks.

1. A. Ledermann,
European jumping
champion, on Rochet M.

2. A. Teeuwissen, bronze
medalist in dressage,
on Goliath.

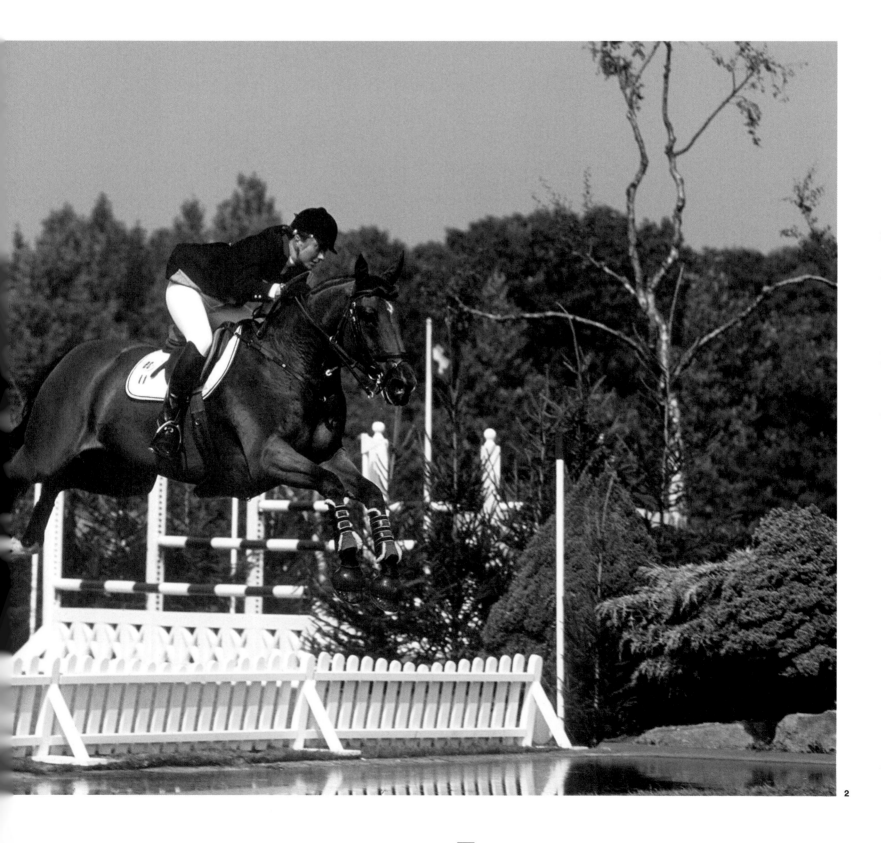

2

Ludger Beerbaum

A "Kaiser" hungry for success

Diligence, perseverance, and humility: these are the three watchwords of the "Kaiser." Ludger was born on August 26, 1963, in Detmold, northwestern Germany. His father was a farmer and his mother a teacher. Horses frightened him as a child, but he took up riding seriously at the age of eight, encouraged by a school friend, and began to enter competitions when he was about eleven. Ludger was already hoping to pursue an equestrian career, but his parents insisted that he first complete his education. Performing strongly in young rider competitions with the mare Wetteifernde, Ludger enjoyed great success. At the age of twenty, he decided to put his degree in economics at the University of Göttingen on hold and try his luck as a professional. "My parents gave me a year to make it work; after that, they said they wouldn't support me further, and I'd have to return to university. That was the deal."

Ludger began training with the respected German rider Hermann Schridde and won two bronze medals (individual and team) at the 1984 FEI European Championships for Young Riders. He then joined the stables of Paul Schockemöhle, the German rider and horse dealer. Ludger stayed with him for four years and took part in his first Olympic Games in 1988 in Seoul. There, he competed for the Mannschaft gold medal, riding The Freak, a horse that belonged to a fellow team member, Dirk Hafemeister, borrowed at the last minute as a substitute for his own injured horse, Landlord. Two years later, Ludger joined the Munich stables of Alexander Moksel, a businessman who offered him sponsorship. He began to work with Classic Touch, the horse that was to be his partner in the 1992 Barcelona Olympics. "The competition got off to a very bad start. During the first team round, when we were still a long way off, I had to get off my mare because a rein broke. Three days later I became Olympic champion with the only double clear round in the final. It was incredibly intense emotionally."

Several dismaying mishaps occurred at subsequent Olympic events, however. Ludger again won the team gold in Atlanta in 1996 but, with his mount Ratina Z injured, he had to withdraw from the individual competition. In Sydney in 2000, the German team was again outstanding, but the scores of the Kaiser and Goldfever 3 were scrubbed. Then, with the German team at its peak in 2004, Goldfever 3 tested positive for betamethasone, a substance that was banned at the time but is now permitted. "That was the toughest period of my career. I'd been named the German flag-bearer for these Games. I'd won my fifth Olympic gold medal, my horse was at the top of his form—he'd completed two clear rounds—and I had to hand back the medal. The team was downgraded to third place. I had to defend and explain myself to everyone. It was tough, but I had nothing to hide."

Since then, Ludger has won a total of thirty-two medals in championships, not counting his victories in numerous Grand Prix events and the years he dominated in world rankings. After taking the team bronze medal in the 2016 Olympic Games in Rio de Janeiro, Ludger bade farewell to his red riding jacket. He has since dedicated more of his time to his company, which encompasses a riding center offering competitions and clinics, a stud, and a competition yard where some of the world's finest riders, including

Philipp Weishaupt, Henrik von Eckermann, Marco Kutscher, and Christian Kukuk, have trained. Ludger also sells horse feeds and sports horses. He divides his time between his roles as rider and a businessman, and continues to train and coach. He also participated in the Longines World Equestrian Academy to promote show jumping in China.

Ludger's family provides unstinting support. "My wife, Arundell, rides two horses competitively and works at the stables. My son, Alexander [from a first marriage], is twenty-five now and also works with us. My daughters, Cecilia and Mathilde, are nine and seven. They ride, but it's too soon to say whether they'll take it up seriously. If they want to go professional, I'd support them so long as they pass all their school exams. Anyway, they have to do something else on the side—not just horse riding."

A modest man, Ludger would never have envisioned such a career for himself. "Everything just came naturally. As a young man, I never would have imagined all this. I just wanted to achieve something and offer the best of myself. Maybe I dreamed of someday participating in the Olympics, but that was all. You always wonder whether you could have done things differently or better, but in the end I'm satisfied with what I've accomplished."

Susanne Strübel, press officer at the Beerbaum stables, describes Ludger's career

Susanne first met Ludger in 1988 when she was a journalist for the *Frankfurter Allgemeine Zeitung*, but it was during a marketing campaign in 1993 that their active collaboration began. "He was then, and still is now, a regular guy with no pretensions."

No frills for the Kaiser: the sport is what counts. "His objectives have always been concentrated on the sport; he wants to win, and he's done so countless times. He's very focused, always thinking about how to improve his riding and create the best collaboration possible with his horse." It's this tenacity, this ability to reflect and analyze, that allows him to raise questions, progress, and rise to a still higher level of performance. "At first, he wanted to shape horses to his own mold. He changed as the years went by, as the sport and approach to training evolved. That was particularly obvious with Ratina Z. When she arrived, she had already won second in the Barcelona Olympics with Piet Raymakers. Ludger was under a lot of pressure, and it took some time for them to become an effective team. The key was to let her have some freedom and give her the maximum support possible."

Ludger is respectful of his horses, just as he is in his daily dealings with co-workers. He surrounds himself with a team of people, with whom he achieves results. "Working with Ludger is fascinating, never a dull moment. He aims to be your colleague, not your boss. He's always clear: 'yes' means 'yes,' and 'no' means 'no.' He'll listen; he's open to discussion, and never hesitates to ask for advice when things aren't turning out as expected or when he needs to make a decision."

At the Barcelona Olympics on Classic Touch, 1992.

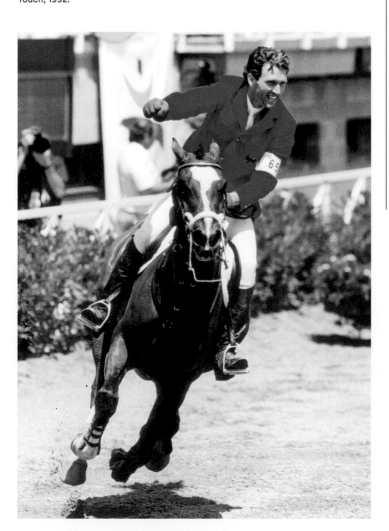

Career Highlights

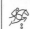

Jumping

1988
Team gold in the Seoul Olympics with The Freak

1990
Team silver in the FEI World Equestrian Games in Stockholm with Almox Gazelle

1992
Individual gold in the Barcelona Olympics with Classic Touch

1994
Team gold in the FEI World Equestrian Games in The Hague with Ratina Z

1996
Team gold in the Atlanta Olympics with Ratina Z

1997
Individual and team gold in the FEI European Championships in Mannheim with Ratina Z

1998
Team gold in the FEI World Equestrian Games in Rome with PS Priamos

1999
Team gold in the FEI European Championships at Hickstead with Champion du Lys

2000
Team gold in the Sydney Olympics with Goldfever 3

2001
Individual gold and team bronze in the FEI European Championships in Arnhem with Gladdys S

2003
Individual and team silver in the FEI European Championships in Donaueschingen with Goldfever 3

2004
Team bronze in the Athens Olympics with Goldfever 3

2006
Team bronze in the FEI World Equestrian Games in Aachen with L'Espoir

2007
Individual bronze and team silver in the FEI European Championships in Mannheim with Goldfever 3

2010
Second in the FEI World Cup Final in Geneva with Gotha FRH

2011
Team gold in the FEI European Championships in Madrid with Gotha FRH

2013
Team silver in the FEI European Championships in Herning with Chiara 222

2015
Team silver in the FEI European Championships in Aachen with Chiara 222

2016
Team bronze at the Rio de Janeiro Olympics with Casello

"It's this tenacity, this ability to reflect and analyze, that allows him to raise questions, progress, and rise to a still higher level of performance."

— Susanne Strübel

Blyth Tait

An unassuming champion

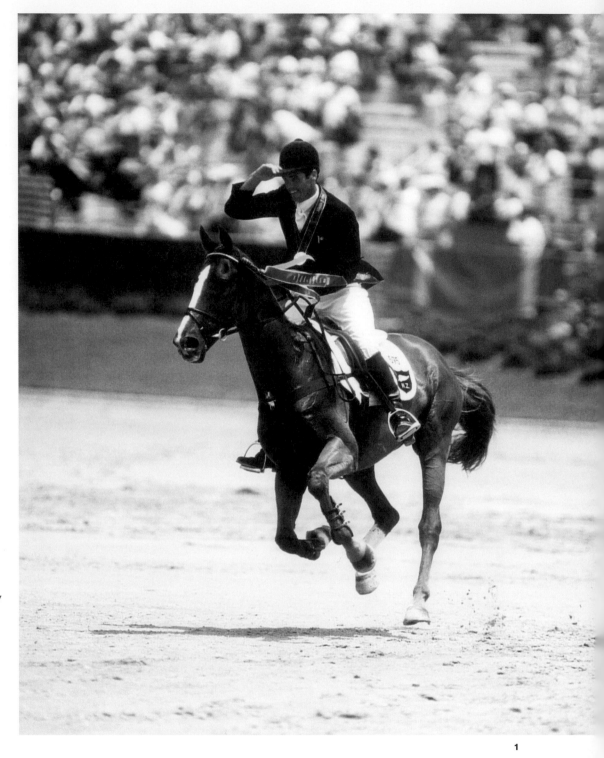

Blyth was born on May 10, 1961, in Whangarei, New Zealand. His father, a successful real estate executive who was fascinated by horse racing, introduced his son to riding. The boy took his first gallops across the meadows of the family farm and soon joined the local pony club. He began show jumping when he was just ten, but ultimately decided to focus on eventing. "Eventing wasn't yet very well established in New Zealand. The FEI World Championships organized in Gawler, Australia, in 1986 were the first edition held in the southern hemisphere. That made me want to try my luck, and I was chosen for the team. Sadly, my horse Rata died just before training began."

Despite this heartbreaking setback, the future champion did not give up. He began training on Messiah, and that gave him hope he might qualify for the 1990 FEI World Equestrian Games in Stockholm. To focus exclusively on his preparation, Blyth left his job pre-training race horses and left for the United Kingdom. He joined Bill Noble, the British rider who became New Zealand's dressage team trainer. It proved to be a fruitful alliance: Blyth and Messiah were crowned double world champions in Stockholm. "I hadn't planned to remain in the UK—I'd expected to return home after the World Equestrian Games. Those two gold medals changed my mind, and I decided to try my luck as a professional rider." An optimist at heart, Blyth assumed that sponsors would be quick to back him, but it took almost six months before he managed to obtain his first partnership deal.

He pursued his endeavors, winning the individual bronze and team silver with Messiah in the 1992 Olympics. Blyth knew he was a talented rider and had no intention of stopping in the midst of such a promising career. Four years later, he was back in the saddle riding Ready Teddy, and winning the individual Olympic medal in Atlanta. "I wasn't expecting a performance like that. Ready Teddy was only eight years old, and I was just a reserve rider. Unfortunately, Mark Todd's horse was injured on the trip, and I was lucky enough to get to the starting line!" In 1998, Blyth and Ready Teddy won a new and final title, claiming the individual gold in the FEI World Equestrian Games in Rome.

But life became more complicated. He was flag-bearer for the New Zealand team in the 2000 Sydney Olympics but was unable to complete the course; he was eliminated in the 2002 FEI World Equestrian Games in Jérez de la Frontera; and he was ranked eighteenth in the 2004 Olympics in Athens. At this point,

he decided to end his competitive career. "I missed my family, and I wanted to get back to my roots. I just didn't have the drive I used to feel." Returning to New Zealand, Blyth rediscovered his youthful passion for flat racing. He trained and raised horses, including Nashville, a Group 1 winner.

After six years away from competitions, Blyth missed the excitement and returned to the saddle in 2011 in the UK. He initially rode Santos, but kept the horse only briefly owing to his fragile health. "I began working with young horses again, training them up to the CCI 4* level." He had to wait until 2016 to return to the highest competitive level; in 2018 he once again represented New Zealand colors at the world championships. Blyth flew to

"He's incredibly talented and knows how to train horses at the very highest level."

— Jonelle Price

Jonelle Price, fellow team member and friend, on Blyth

Blyth is unpretentious, honest, and incredibly modest. "He simply doesn't realize all that he's achieved and just makes light of it. He's one of the people who encouraged me to pursue my own career. When I was still in New Zealand, I'd get up in the middle of the night to watch him on television—along with Mark Todd and Andrew Nicholson—participating in major competitions. They were a tremendous inspiration to me and motivated me to dream big."

Jonelle wasn't with Blyth at the peak of his career, and she regrets it. "I'm really sorry not to have known him back then. He hasn't hit those heights again since we've been together in the sport, and I'd really love to see him win another major title. No matter what happens, though, he can be incredibly proud of what he's accomplished already."

Jonelle doesn't need to have seen him on the podium to admire his riding skills. "He's a great competitor, who brings terrific experience and the sense of assurance that comes with that. I was very fortunate to ride with him. He's incredibly talented and knows how to train horses at the very highest level. He's a tremendously gifted show jumper and always gives an exemplary performance. He's confident, with a great sense of humor, and he knows how to speak his mind. He's a truly fine person."

Career Highlights

Eventing

1990
Individual and team gold in the Stockholm FEI World Equestrian Games with Messiah

1992
Individual bronze and team silver in the Barcelona Olympics with Messiah

1996
Individual gold and team bronze in the Atlanta Olympics with Ready Teddy and Chesterfield

1998
Individual and team gold in the FEI World Equestrian Games in Rome with Ready Teddy

1. At the Atlanta Olympics on Ready Teddy, 1996.

2. At the Barcelona Olympics on Messiah, 1992.

Tryon for the 2018 FEI World Equestrian Games to ride Dasset Courage. Unfortunately they were eliminated during the cross-country phase. "Every defeat is a disappointment, but you have to learn to accept it and work even harder to do better the next time."

Blyth lives day by day and currently has no fixed plans for the future. "It's an expensive sport. I'm renting my stables here and I don't have any promising young horses at the moment. Right now I'm working on developing my skills as a cross-country course designer. It's a new challenge, and I think that with my experience as a competitive rider I have something to contribute. As I get older, it will be a good way for me to stay active in the sport."

2

Isabell Werth

Driven by passion

Passion, talent, and hard work—these are the secrets of Isabell Werth's success. She was born on July 21, 1969, in Sevelen in West Germany, and grew up in Rheinberg. Her parents, Heinrich and Brigitte, were farmers and dedicated horse lovers. They welcomed retired sports horses, which were set free to graze in the pastures of their farm. "I grew up with horses and began riding at a very young age, almost before I could walk," Isabell remembers. She honed her skills in a nearby riding school where she began to participate in show jumping and eventing competitions.

At the age of seventeen Isabell caught the eye of Uwe Schulten-Baumer, a neighbor and prominent figure in German dressage, who was looking for a temporary replacement rider: "I was asked to lend him a hand for four weeks, but I ended up staying there for sixteen years." She initially worked with young horses alongside Nicole Uphoff, a star in the dressage world, who was in charge of the top-level ones. Isabell gradually began to train real champions as well, one of whom was Gigolo. This remarkable horse was her longtime partner, sharing in Isabell's many early triumphs, including the individual gold in the 1996 Atlanta Olympics. Meanwhile, Isabell continued her law studies and joined the law firm Oexamm as an attorney in 2000. She then turned her attention and talents to marketing for her sponsor Karstadt Warenhaus, an online retailer. "I thought I'd remain an amateur, but in the end I decided to make a career commitment to my passion. Still, I'm very glad to have a backup in case something ever goes wrong for me in riding."

At that point Isabell received the support of the Winter-Schulzes, a husband-and-wife team. Madeleine is herself a former rider. They invested in horses for Isabell, and she left her mentor Uwe Schulten-Baumer in 2001 to join their stables in Mellendorf. "I spent a year there before I was able to return to the family farm in Rheinberg, which had been restored." Encouraged and supported by Madeleine Winter-Schulze, and embraced as a member of the family, Isabell oversaw the growth of her stables, which today house approximately fifty horses and four riders.

Following the retirement of Gigolo and the loss of Absinth, Isabell took some time off from top-level competitions. In 2006 she came back stronger than ever, mounted on Satchmo 78; they won the individual and team gold medals in the FEI World Equestrian Games in Aachen. She's been on the winners' podium ever since, repeatedly delivering victories with a variety of different mounts, highlighting her extraordinary talents. There was just one dark interlude: she was suspended in 2013 after a banned

substance was detected in El Santos during the Rhineland Championships in 2012. After a four-month hiatus, Isabell returned to competitive riding and resumed her prizewinning feats.

Isabell knows how to surmount challenges. She patiently bided her time for almost four years before she was able to ride Bella Rose again. This legendary horse had been injured and forced to abandon the 2014 FEI World Equestrian Games in Normandy after winning a team title. After two triumphant CDI 4* events, Bella Rose outdid the competition in Tryon in September 2018 with exceptional scores, once again bringing Isabell success. "I was shaking with emotion. Riding that horse again after four years— what a happy ending! We resumed exactly where we'd left off, but with a bit more polish. Bella Rose is the mare that's closest to my heart, and it's wonderful to see her excelling and performing so beautifully."

Isabell intends to pursue her passion— training horses and paying attention to every last detail of the process—for as long as she

possibly can. "It's thrilling to see how far you can take them. You put your heart into teaching them how to excel and succeed." Isabell emphasizes that she owes these achievements to her family. They've always provided unstinting support, following her career and sustaining her since the beginning. She credits her success to her parents, her sister Claudia, her partner, Wolfgang Urban, her son Frederik (who was born in 2009), and, of course, Madeleine Winter-Schulz.

Devoted to her horses and committed to her sport, Isabell begins every morning with the same resolve. "I have the good fortune to do what I love day after day. To me, that's an enormous privilege, even more important than my career or any medal that I've won."

1. At the Normandy World Equestrian Games on Bella Rose 2, 2014.

2. At the awards ceremony for the World Cup Final.

3. With M. Winter-Schulze.

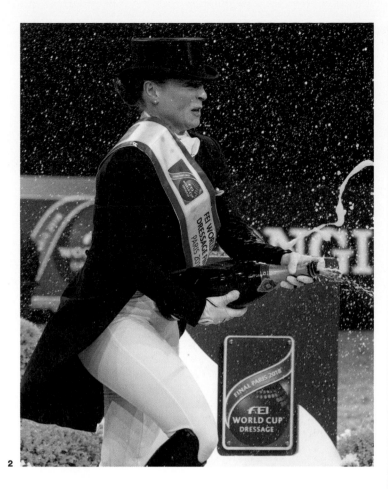

2

Career Highlights

Dressage

1991
Individual gold
in the Grand Prix
Special and team gold
in the FEI European
Championships
in Donaueschingen
with Gigolo

1992
Individual silver
and team gold in the
Barcelona Olympics
with Gigolo

1993
Individual gold
in the Grand Prix
Special and team gold
in the FEI European
Championships
in Lipica with Gigolo

1994
Individual gold
in the Grand Prix
Special and team
gold in the FEI
World Equestrian
Games in The Hague
with Gigolo

1995
Individual and team gold
in the FEI European
Championships in
Mondorf with Gigolo

1996
Individual and team
gold in the Atlanta
Olympics with Gigolo

1997
Individual and
team gold in the
FEI European
Championships
in Verden with Gigolo

1998
Individual and team
gold in the FEI World
Equestrian Games
in Rome with Gigolo

1999
Team gold
in the FEI European
Championships
in Arnhem
with Anthony

2000
Individual silver
and team gold
in the Sydney
Olympics with Gigolo

2001
Team gold
in the FEI European
Championships
in Verden with Anthony

2003
Team gold
in the FEI European
Championships
in Hickstead
with Satchmo

2006
Individual and team
gold in the Grand Prix
Special and individual
bronze in the Freestyle
to Music in the FEI
World Equestrian
Games in Aachen
with Satchmo

2007
Individual gold
in the Grand Prix
Special, individual
silver in the Freestyle
to Music, and team
silver in the FEI
European
Championships
in La Mandria
with Satchmo

2008
Individual silver
and team gold in
the Beijing Olympics
with Satchmo

2010
Team bronze in the
FEI World Equestrian
Games in Lexington
with Warum Nicht

2011
Team silver
in the FEI European
Championships
in Rotterdam
with El Santo

2013
Team gold
in the European
Championships
in Herning
with Don Johnson

2014
Team gold in the FEI
World Equestrian
Games in Normandy
with Bella Rose 2

2015
Team bronze
in the FEI European
Championships
in Aachen with
Don Johnson

2016
Individual silver and
team gold in the Rio
de Janeiro Olympics
with Weihegold

2017
Individual gold
in the Grand Prix
Special and Freestyle
to Music, and team
gold in the FEI
European
Championships
in Gothenburg
with Weihegold

2018
Individual gold
in the Grand Prix
Special and team
gold in the FEI
World Equestrian
Games in Tryon
with Bella Rose 2

**Madeleine Winter-Schulze, horse owner
and close friend, on Isabell Werth**

Madeleine Winter-Schulze observes that Isabell's success is not due to good luck, and that she demonstrated tenacity and perseverance from the start. "She's always been very motivated and determined. I have complete confidence in Isabell—she has carte blanche with my horses. The stable's pretty far away from my own home, so I often spend the night. I love waking up there. I head over right away to join Isabell in the stables and watch her ride. She always has plenty to show me, and she gives me her honest opinions on the horses."

Hard work is not the only key to her success. The level of intelligence she applies to the process allows her to understand her horses and bring out the best in them. "Isabell adapts her training approach to each horse. She's often told me how important it is to take extra time with certain horses because they're more sensitive. She's never wrong—she has an incredible instinct. You won't ever hear her blame the horse if there's a problem. She takes the time to analyze the situation, figuring out what she could have done to perform at a higher level. She's always challenging herself."

Isabell makes a point of surrounding herself with a close-knit, accomplished team. Their mutual commitment is based on understanding and loyalty. "Isabell is part of my family. She was with me when my husband died. She knew he wasn't doing well, and even though she had to leave for a competition in Frankfurt the next day, she came to my house that evening to see him. She was there for me when I needed her at a very difficult time, and that strengthened our relationship even further. We call each other every day to talk about the horses, but we discuss our lives and daily issues too. I broke my leg in Tryon waiting to congratulate her at the end of her test. I had to be taken to the hospital and wasn't able to be there for the prize-giving ceremony. A few hours later, Isabell turned up at my bedside with their gold medal in hand—it was a fantastic moment. She's very generous with the people around her and does everything in her power to help them out. She's a truly remarkable individual." 3

Rembrandt

A champion with a stormy temperament

Born in 1977 on Herbert de Baey's farm in Hamminkeln, Germany, Rembrandt was descended from championship stock. His sire was Romadour II, a Westphalian stallion highly regarded during the 1970s. His dam was Adone, the sister of Ahlerich, a many-time Olympic medalist ridden by Reiner Klimke. Despite his enviable pedigree, which must have impressed a number of fans, several potential riders passed on this horse in his early years because of his Thoroughbred appearance.

In 1981, the gelding caught the eye of Jürgen Uphoff, whose fourteen-year-old daughter Nicole was eager to begin learning the elements of dressage. The family was not initially enthusiastic, but Rembrandt immediately captivated the girl, although he was obviously difficult to control. The first years of training were indeed a challenge. Rembrandt was very sensitive and unpredictable; he was so easily spooked that he could be dangerous. Nicole's parents wanted to sell the horse, but when they presented him for conformation and paces competitions, they realized that he had championship potential in dressage. His young rider persevered and had some success in taming her talented but tempestuous mount. By the age of five, Rembrandt had participated in several competitions and was beginning to make progress. Still, he was often erratic and uncontrollable, scoring last in rankings.

Nicole experienced yet another disastrous performance with Rembrandt when the gelding was nine, and Uwe Schulten-Baumer volunteered to provide some assistance, seeing genuine potential in her difficult protégé. Nicole accepted his offer and embarked upon a very stressful period of training. She struggled with every session, but finally discovered the secret to mastering her horse. She had to create an environment of absolute calm to bring out his best qualities, and to be as discreet as possible with her cues. Once that understanding was established, the duo's performance improved rapidly. In 1987, at the age of ten, Rembrandt participated in his first Grand Prix in Münster, but the competition

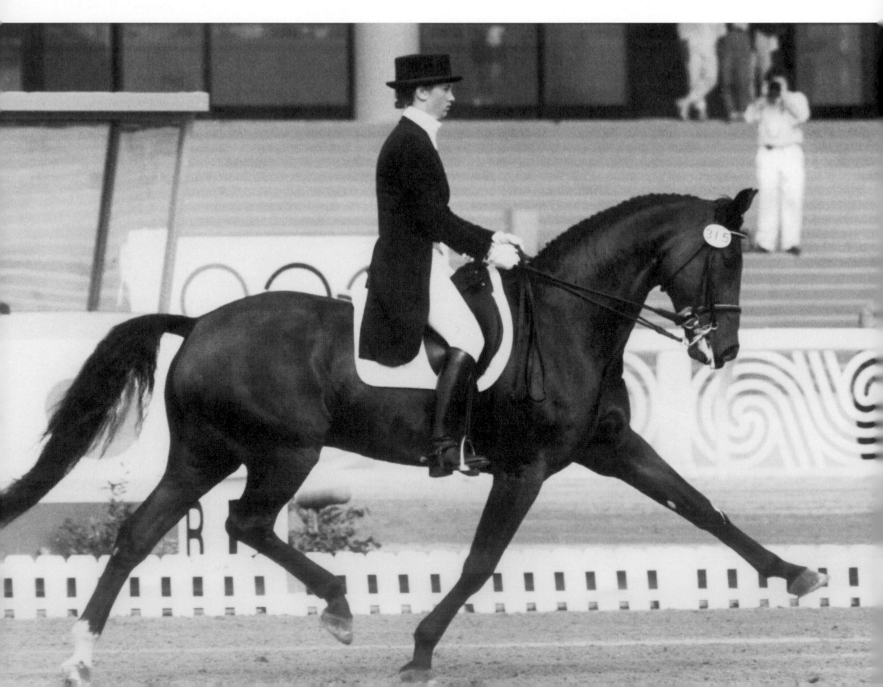

"The first years of training were indeed a challenge. Rembrandt was very sensitive and unpredictable; he was so easily spooked that he could be dangerous."

proved to be yet another disappointment. They finished last, and then second to last in the next Grand Prix—but only because another duo abandoned the competition. However, they eventually achieved some respectable results, and their competitive career was launched.

In their first trip abroad in 1987, Nicole and Rembrandt came in third in the Grand Prix in Lausanne. Spectators were impressed by this newly discovered partnership, seemingly come out of nowhere. Nicole and Rembrandt even had the honor of competing against the former Olympic champion Christine Stückelberger in the Grand Prix Special. Win followed win, and this succession of triumphs secured their selection for the FEI European Championships in the young riders category in Cervia, Italy, where they were awarded both individual and team gold.

The next year, Rembrandt's performance earned Nicole a place in the highly anticipated Seoul Olympics. The duo went to train at the national riding school in Warendorf, working under the supervision of Harry Boldt, the great champion and trainer of the German team. The early months in this unfamiliar environment were challenging. Rembrandt was still apprehensive, and Nicole couldn't figure out how to calm him down. She was close to giving up and returning home, but Reiner Klimke forestalled her departure and promoted her abilities to the rest of the team, many of whom were very skeptical. His confidence was well placed, however: in defiance of their detractors,

Rembrandt and Nicole became double Olympic champions in South Korea in both the individual and team events. After winning these titles, the duo were unbeatable, claiming gold medals in the European and World Championships. In 1992, they repeated their Olympic performance in Barcelona, where they were once again double champions.

An accident the following year abruptly halted this meteoric trajectory. While prizes were being awarded for the German championship, Rembrandt was kicked by another horse, breaking his leg. Following an operation and the insertion of two pins, Rembrandt had to undergo an almost yearlong period of recovery. When he returned to competition in Hagen, the delirious spectators crowded around, creating such a mêlée that the show-jumping competition going on at the same time had to be postponed. Nicole and Rembrandt finished third in the Grand Prix and resumed their victorious career. In 1996, after two additional years of success and medals, Nicole decided to retire "Remmi," as she affectionately nicknamed her horse. They embarked on a memorable farewell tour, during which the nineteen-year-old champion received the plaudits of his fans for the final time. Rembrandt spent his remaining days happily in the Uphoff stables, and Nicole continued to ride him until he was twenty-two. Sadly, Rembrandt suffered from severe arthritis that gradually paralyzed his legs, forcing Nicole to have him put down in 2001.

(facing page)
At the Seoul Olympics with N. Uphoff, 1988.

Career Highlights

Dressage

1988
Individual and team gold in the Seoul Olympics with Nicole Uphoff

1989
Individual and team gold in the FEI European Championships in Mondorf-les-Bains with Nicole Uphoff

1990
Individual and team gold in the FEI World Equestrian Games in Stockholm with Nicole Uphoff

1991
Individual silver and team gold in the FEI European Championships in Donaueschingen with Nicole Uphoff

1992
Individual and team gold in the Barcelona Olympics with Nicole Uphoff

1994
Individual silver and team gold in the FEI World Equestrian Games in The Hague with Nicole Uphoff

1995
Team gold in the FEI European Championships in Mondorf-les-Bains with Nicole Uphoff

The
2000s

RESULTS 2000–2009

2000
🏅 OLYMPIC GAMES, SYDNEY

DRESSAGE
— *Individual*
GOLD Anky van Grunsven (NED) and Bonfire
SILVER Isabell Werth (GER) and Gigolo
BRONZE Ulla Salzgeber (GER) and Rusty
— *Team*
GOLD Germany: Isabell Werth (Gigolo), Nadine Capellmann (Farbenfroh), Alexandra Simons de Ridder (Chacomo 003), and Ulla Salzgeber (Rusty)
SILVER Netherlands: Anky van Grunsven (Bonfire), Coby van Baalen (Ferro), Arjen Teeuwissen (Goliath), and Ellen Bontje (Silvano)
BRONZE United States: Christine Traurig (Etienne), Susan Blinks (Flim Flam), Guenter Seidel (Aragon), and Robert Dover (Ranier)

JUMPING
— *Individual*
GOLD Jeroen Dubbeldam (NED) and De Sjiem
SILVER Albert Voorn (NED) and Lando
BRONZE Khaled Al-Eid (KSA) and Khashm Al-Aan
— *Team*
GOLD Germany: Otto Becker (Cento), Marcus Ehning (For Pleasure), Lars Nieberg (Esprit FRH), and Ludger Beerbaum (Goldfever 3)
SILVER Switzerland: Willi Melliger (Calvaro V), Beat Mändli (Pozitano), Markus Fuchs (Tinka's Boy), and Lesley McNaught-Mändli (Dulf Z)
BRONZE Brazil: Rodrigo Pessoa (Baloubet du Rouet), Luiz Felipe de Azevedo (Ralph), Alvaro de Miranda Neto (Aspen), and André Johannpeter (Calei)

EVENTING
— *Individual*
GOLD David O'Connor (USA) and Custom Made
SILVER Andrew Hoy (AUS) and Swizzle In
BRONZE Mark Todd (NZL) and Eyespy II

— *Team*
GOLD Australia: Stuart Tinney (Jeepster), Andrew Hoy (Darien Power), Matt Ryan (Kibah Sandstone), and Phillip Dutton (House Doctor)
SILVER Great Britain: Pippa Funnell (Supreme Rock), Leslie Law (Shear L'Eau), Jeanette Brakewell (Over To You), and Ian Stark (Jaybee)
BRONZE United States: Karen O'Connor (Prince Panache), David O'Connor (Giltedge), Nina Fout (3 Magic Beans), and Linden Wiesman (Anderoo)

2000
🏆 FEI WORLD CUP

DRESSAGE
's-Hertogenbosch, Netherlands
GOLD Anky van Grunsven (NED) and Bonfire
SILVER Coby van Baalen (NED) and Ferro
BRONZE Arjen Teeuwissen (NED) and Goliath T

JUMPING
Las Vegas NV, United States
GOLD Rodrigo Pessoa (BRA) and Baloubet du Rouet
SILVER Markus Fuchs (SUI) and Tinka's Boy
BRONZE Beat Mändli (SUI) and Pozitano

2001
🥇 FEI EUROPEAN CHAMPIONSHIPS

DRESSAGE
Verden an der Aller, Germany
— *Individual*
GOLD Ulla Salzgeber (GER) and Rusty 47
SILVER Arjen Teeuwissen (NED) and Goliath T
BRONZE Nadine Capellmann (GER) and Farbenfroh
— *Team*
GOLD Germany: Nadine Capellmann (Farbenfroh), Heike Kemmer (Albano 7), Ulla Salzgeber (Rusty 47), and Isabell Werth (Anthony)

SILVER Netherlands: Anky van Grunsven (Gestion Idool), Ellen Bontje (Gestion Silvano N), Arjen Teeuwissen (Gestion Goliath T), and Gollenien Rothenberger-Gordijn (Jonggor's Weyden)
BRONZE Denmark: Lone Jörgensen (Kennedy), Lars Petersen (Blue Hors Cavan), Jon D. Pedersen (Esprit de Valdemar), and Nathalie Sayn-Wittgenstein (Fantast S)

JUMPING
Arnhem, Netherlands
— *Individual*
GOLD Ludger Beerbaum (GER) and Gladdys S
SILVER Ludo Philippaerts (BEL) and Verelst Otterongo
BRONZE Rolf-Göran Bengtsson (SWE) and Pialotta
— *Team*
GOLD Ireland: Kevin Babington (Carling King), Jessica Kürten (Bonita 38), Peter Charles (Traxdata Corrada), and Dermott Lennon (Liscalgot)
SILVER Sweden: Malin Baryard-Johnsson (Butterfly Flip), Helena Lundbäck (Utfors Mynta), Rolf-Göran Bengtsson (Pialotta), and Peter Eriksson (Cardenta 933)
BRONZE Germany: Sören von Rönne (Chandra), Otto Becker (Cento), Lars Nieberg (Esprit FRH), and Ludger Beerbaum (Gladdys S)

EVENTING
Pau, France
— *Individual*
GOLD Pippa Funnell (GBR) and Supreme Rock
SILVER Inken Johanssen (GER) and Brillante
BRONZE Enrique Sarasola (ESP) and Dopé Doux
— *Team*
GOLD Great Britain: Leslie Law (Shear L'Eau), Jeanette Brakewell (Over To You), William Fox-Pitt (Stunning), and Pippa Funnell (Supreme Rock)
SILVER France: Rodolphe Scherer (Quack), Denis Mesples (Vampire), Frédéric Aronio de Romblay (Baba Au Rhum), and Didier Courrèges (Débat d'Estruval)
BRONZE Italy: Fabio Fani Ciotti (Down Town Brown), Andrea Verdina (Donnizzetti), Marco Biasia (Ecu), and Fabio Magni (Cool)

2001
🏆 FEI WORLD CUP

DRESSAGE
Aarhus, Denmark
GOLD Ulla Salzgeber (GER) and Rusty 47
SILVER Isabell Werth (GER) and Antony
BRONZE Rudolf Zeilinger (GER) and Livijno

JUMPING
Gothenburg, Sweden
GOLD Markus Fuchs (SUI) and Tinka's Boy
SILVER Rodrigo Pessoa (BRA) and Baloubet du Rouet
BRONZE Michael Whitaker (GBR) and Händel II

2002
🥇 FEI WORLD EQUESTRIAN GAMES, JÉREZ DE LA FRONTERA

DRESSAGE
— *Individual*
GOLD Nadine Capellmann (GER) and Farbenfroh
SILVER Beatriz Ferrer-Salat (ESP) and Beauvalais
BRONZE Ulla Salzgeber (GER) and Rusty 47
— *Team*
GOLD Germany: Nadine Capellmann (Farbenfroh), Ulla Salzgeber (Rusty 47), Klaus Husenbeth (Piccolino), and Ann-Kathrin Linsenhoff (Renoir)
SILVER United States: Debbie McDonald (Brentina), Lisa Wilcox (Relevant), Susan Blinks (Flim Flam), and Günter Seidel (Nikolaus 7)
BRONZE Spain: Beatriz Ferrer-Salat (Beauvalais), Rafael Soto Andrade (Invasor), Juan Antonio Jimenez Cobo (Guizo), and Ignacio Rambla Algarin (Granadero)

JUMPING
— *Individual*
GOLD Dermott Lennon (IRL) and Liscalgot
SILVER Éric Navet (FRA) and Dollar du Mûrier
BRONZE Peter Wylde (USA) and Fein Cera
— *Team*
GOLD France: Éric Levallois (Diamant de Semilly), Reynald Angot (Tlaloc M.), Gilles Bertran de Balanda (Crocus Graverie), and Éric Navet (Dollar du Mûrier)
SILVER Sweden: Peter Eriksson (VDL Cardento 933), Royne

Zetterman (Richmont Park), Helena Lundbäck (Utfors Mynta), and Malin Baryard (H&M Butterly Flip)
BRONZE Belgium: Philippe Lejeune (Nabab de Rêve), Stanny van Paesschen (O de Pomme), Peter Postelmans (Oleander), and Jos Lansink (AK Caridor Z)

EVENTING
— *Individual*
GOLD Jean Teulère (FRA) and Espoir de la Mare
SILVER Jeanette Brakewell (GBR) and Over To You
BRONZE Piia Pantsu (FIN) and Ypäjä Karuso
— *Team*
GOLD United States: John Williams (Carrick), Kimberley Vinoski (Winsome Adante), David O'Connor (Giltedge), and Amy Tryon (Poggio II)
SILVER France: Cédric Lyard (Fine Merveille), Jean Teulère (Espoir de la Mare), Jean-Luc Force (Crocos Jacob), and Didier Courrèges (Free Style ENE-HN)
BRONZE Great Britain: Jeanette Brakewell (Over To You), Pippa Funnell (Supreme Rock), William Fox-Pitt (Tamarillo), and Leslie Law (Shear L'Eau)

2002
🏆 FEI WORLD CUP

DRESSAGE
's-Hertogenbosch, Netherlands
GOLD Ulla Salzgeber (GER) and Rusty 47
SILVER Lars Petersen (DEN) and Blue Hors Cavan
BRONZE Beatriz Ferrer-Salat (ESP) and Beauvalais

JUMPING
Leipzig, Germany
GOLD Otto Becker (GER) and Dobel's Cento
SILVER Ludger Beerbaum (GER) and Gladdys S.
BRONZE Rodrigo Pessoa (BRA) and Baloubet du Rouet

2003
🥇 FEI EUROPEAN CHAMPIONSHIPS

DRESSAGE
Hickstead, United Kingdom
— *Individual*
GOLD Ulla Salzgeber (GER) and Rusty

SILVER Jan Brink (SWE) and Briar
BRONZE Beatriz Ferrer-Salat (ESP) and Beauvalais
— *Team*
GOLD Germany: Ulla Salzgeber (Rusty), Heike Kemmer (Bonaparte), Klaus Husenbeth (Piccolino), and Isabell Werth (Satchmo)
SILVER Spain: Beatriz Ferrer-Salat (Beauvalais), Rafael Soto Andrade (Invasor), Ignacio Rambla (Distinguido), and Juan Antonio Jimenez-Cobo (Guizo)
BRONZE Great Britain: Emma Hindle (Wie Weltmeyer), Nicole McGivern (Active Walero), Richard Davison (Ballaseyr Royale), and Emile Faurie (Rascher Hope)

JUMPING
Donaueschingen, Germany
— *Individual*
GOLD Christian Ahlmann (GER) and Cöster
SILVER Ludger Beerbaum (GER) and Goldfever 3
BRONZE Marcus Ehning (GER) and For Pleasure
— *Team*
GOLD Germany: Marcus Ehning (For Pleasure), Christian Ahlmann (Cöster), Ludger Beerbaum (Goldfever 3), and Otto Becker (Cento)
SILVER France: Michel Robert (Galet d'Auzay), Éric Levallois (Diamant de Semilly), Michel Hécart (Quilano de Kalvarie), and Reynald Angot (Tlaloc M)
BRONZE Switzerland: Beat Mändli (Pozitano), Steve Guerdat (Tepic La Silla), Markus Fuchs (Tinka's Boy), and Willi Melliger (Gold du Talus)

EVENTING
Punchestown, Ireland
— *Individual*
GOLD Nicolas Touzaint (FRA) and Galan de Sauvagère
SILVER Linda Algotsson (SWE) and Stand By Me
BRONZE Pippa Funnell (GBR) and Walk On Star
— *Team*
GOLD Great Britain: Leslie Law (Shear L'Eau), Jeanette Brakewell (Over To You), William Fox-Pitt (Moon Man), and Pippa Funnell (Walk On Star)
SILVER France: Jean-Luc Force (Crocus Jacob), Jean Teulère (Hobby Du Mée), Arnaud Boiteau (Expo du Moulin), and Nicolas

Touzaint (Galan de Sauvagère)
BRONZE Belgium: Karin Donckers (Gormley), Carl Bouckaert (Welton Molecule), Dolf Desmedt (Bold Action), and Constantin van Rijckervorsel (Withcote Nellie)

2003

🏆 FEI WORLD CUP

DRESSAGE
Gothenburg, Sweden
GOLD Debbie McDonald (USA) and Brentina
SILVER Heike Kemmer (GER) and Albano 7
BRONZE Günter Seidel (GER) and Nikolaus 7

JUMPING
Las Vegas NV, United States
GOLD Marcus Ehning (GER) and Anka 191
SILVER Rodrigo Pessoa (BRA) and Baloubet du Rouet
BRONZE Malin Baryard-Johnsson (SWE) and H&M Butterfly Flip

2004

●●● OLYMPIC GAMES, ATHENS

DRESSAGE
— Individual
GOLD Anky van Grunsven (NED) and Salinero
SILVER Ulla Salzgeber (GER) and Rusty
BRONZE Beatriz Ferrer-Salat (ESP) and Beauvalais
— Team
GOLD Germany: Ulla Salzgeber (Rusty), Martin Schaudt (Weltall), Hubertus Schmidt (Wansuela Suerte), and Heike Kemmer (Bonaparte)
SILVER Spain: Beatriz Ferrer-Salat (Beauvalais), Rafael Soto (Invasor), Juan Antonio Jimenez (Guizo), and Ignacio Rambla (Oleaje)
BRONZE United States: Debbie McDonald (Bretina), Robert Dover (Kennedy), Gunter Seidel (Aragon), and Lisa Wilcox (Relevant 5)

JUMPING
— Individual
GOLD Rodrigo Pessoa (BRA) and Baloubet du Rouet

SILVER Chris Kappler (USA) and Royal Kaliber
BRONZE Marco Kutscher (GER) and Montender 2
— Team
GOLD United States: Peter Wylde (Fein Cera), McLain Ward (Sapphire), Chris Kappler (Royal Kaliber), and Beezie Madden (Authentic)
SILVER Sweden: Peter Eriksson (VDL Cardento 933), Peder Fredricson (H&M Magic Bengtsson), Malin Baryard-Johnsson (H&M Butterfly Flip), and Rolf-Göran Bengtsson (Mac Kinley)
BRONZE Germany: Christian Ahlmann (Cöster), Marco Kutscher (Montender 2), Otto Becker (Dobel's Cento), and Ludger Beerbaum (Goldfever 3)

EVENTING
— Individual
GOLD Leslie Law (GBR) and Shear L'Eau
SILVER Kim Severson (USA) and Winsome Adante
BRONZE Pippa Funnell (GBR) and Primmore's Pride
— Team
GOLD France: Jean Teulère (Espoir de la Mare), Nicolas Touzaint (Galan de Sauvagère), Didier Courrèges (Débat d'Estruval), Cédric Lyard (Finc Mcrvcillc), and Arnaud Boiteau (Expo du Moulin)
SILVER Great Britain: Pippa Funnell (Primmore's Pride), Leslie Law (Shear L'Eau), Mary King (King Solomon III), Jeanette Brakewell (Over To You), and William Fox-Pitt (Tamarillo)
BRONZE United States: Kimberly Severson (Winsome Adante), Amy Tryon (Poggio II), Darren Chiacchia (Windfall 2), John Williams (Carrick), and Julie Richards (Jacob Two Two)

2004

🏆 FEI WORLD CUP

DRESSAGE
Düsseldorf, Germany
GOLD Anky van Grunsven (NED) and Salinero
SILVER Edward Gal (NED) and Geldnet Lingh
BRONZE Hubertus Schmidt (GER) and Wansuela Suerte

JUMPING
Milan, Italy
GOLD Bruno Broucqsault (FRA) and Dilème de Cèphe
SILVER Meredith Michaels-Beerbaum (GER) and Shutterfly
BRONZE Markus Fuchs (SUI) and Tinka's Boy

EVENTING
Pau, France
GOLD Linda Algotsson (SWE) and My Fair Lady
SILVER Jean Teulère (FRA) and Bambi de Brière
BRONZE Karin Donckers (BEL) and Gormley

2005

⚕ FEI EUROPEAN CHAMPIONSHIPS

DRESSAGE
Hagen, Germany
— Individual
GOLD Anky van Grunsven (NED) and Salinero
SILVER Hubertus Schmidt (GER) and Wansuela Suerte
BRONZE Jan Brink (SWE) and Briar
— Team
GOLD Germany: Heike Kemmer (Bonaparte), Hubertus Schmidt (Wansuela Suerte), Ann-Kathrin Linsenhoff (Sterntaler), and Klaus Huscnbcth (Piccolino)
SILVER Netherlands: Anky van Grunsven (Salinero), Edward Gal (Totilas), Laurens van Lieren (Hexagon's Ollright), and Sven Rothenberger (Barclay 11)
BRONZE (JOINT) Spain: Beatriz Ferrer-Salat (Beauvalais), Juan Antonio Jiminez-Cobo (Guizo), Ignacio Rambla (Distinguido), and José Ignacio Lopez-Porras (Nevado Santa Clara)
BRONZE (JOINT) Sweden: Louise Nathhorst (Guinness), Tinne Vilhelmson (Just Mickey), Kristine von Krusenstierna (Wilson), and Jan Brink (Björsells Briar 899)

JUMPING
San Patrignano, Italy
— Individual
GOLD Marco Kutscher (GER) and Montender 2
SILVER Christina Liebherr (SUI) and LB No Mercy
BRONZE Jeroen Dubbeldam (NED) and Nassau
— Team
GOLD Germany: Marcus Ehning (Gitania 8),

Christian Ahlmann (Cöster), Marco Kutscher (Montender 2), and Meredith Michaels-Beerbaum (Checkmate 4)
SILVER Switzerland: Fabio Crotta (Mme Pompadour), Steve Guerdat (Pialotta), Markus Fuchs (La Toya III), and Christina Liebherr (LB No Mercy)
BRONZE Netherlands: Gerco Schröder (Eurocommerce Monaco), Leon Thijssen (Nairobi), Jeroen Dubbeldam (BMC Nassau), and Yves Houtackers (Gran Corrado)

EVENTING
Blenheim, United Kingdom
— Individual
GOLD Zara Phillips (GBR) and Toytown
SILVER William Fox-Pitt (GBR) and Tamarillo
BRONZE Ingrid Klimke (GER) and Sleep Late
— Team
GOLD Great Britain: Leslie Law (Shear L'Eau), Jeanette Brakewell (Over To You), William Fox-Pitt (Tamarillo), and Zara Phillips (Toytown)
SILVER France: Didier Willefert (Escape Lane), Gilles Viricel (Blakring), Arnaud Boiteau (Expo du Moulin), and Nicolas Touzaint (Hidalgo de L'Ile)
BRONZE Germany: Frank Ostholt (Air Jordan), Hinrich Romeike (Marius Voigt-Logistik), Anna Warnecke (Twinkle Bee), and Bettina Hoy (Ringwood Cockatoo)

2005

🏆 FEI WORLD CUP

DRESSAGE
Las Vegas NV, United States
GOLD Anky van Grunsven (NED) and Salinero
SILVER Edward Gal (NED) and Geldnet Lingh
BRONZE Debbie McDonald (USA) and Brentina

JUMPING
Las Vegas NV, United States
GOLD Meredith Michaels-Beerbaum (GER) and Shutterfly
SILVER Michael Whitaker (GBR) and Portofino 63
BRONZE Lars Nieberg (GER) and Lucie 55

EVENTING
Malmö, Sweden
GOLD Clayton Frerericks (AUS) and Ben Along Time
SILVER Andrew Hoy (AUS) and Mr. Pracatan
BRONZE Piia Pantsu Jönsson (FIN) and Ypäjä Karuso

2006

🏆 FEI WORLD EQUESTRIAN GAMES

Aachen, Germany
DRESSAGE
— Individual
Grand Prix Special
GOLD Isabell Werth (GER) and Satchmo
SILVER Anky van Grunsven (NED) and Salinero
BRONZE Andreas Helgstrand (DEN) and Blue Hors Matiné
Freestyle to Music
GOLD Anky van Grunsven (NED) and Salinero
SILVER Andreas Helgstrand (DAN) and Blue Hors Matiné
BRONZE Isabell Werth (GER) and Satchmo
— Team
GOLD Germany: Hubertus Schmidt (Wansuela Suerte), Heike Kemmer (Bonaparte), Nadine Capcllmann (Elvis VA), and Isabell Werth (Satchmo)
SILVER Netherlands: Laurens van Lieren (Hexagon's Ollright), Imke Schellekens-Bartels (Sunrise), Anky van Grunsven (Salinero), and Edward Gal (Securicor Lingh)
BRONZE United States: Leslie Morse (Tip Top 962), Gunter Seidel (Aragon), Steffen Peters (Floriano), and Debbie McDonald (Brentina)

JUMPING
— Individual
GOLD Jos Lansink (BEL) and Cumano
SILVER Beezie Madden (USA) and Authentic
BRONZE Meredith Michaels-Beerbaum (GER) and Shutterfly
— Team
GOLD Netherlands: Piet Raymakers (Van Schijndel's Curtis), Jeroen Dubbeldam (Up and Down), Albert Zoer (Okidoki), and Gerco Schröder (Eurocommerce Berlin)

SILVER United States: Margie Engle (Hidden Creek's Quervo Gold*), Laura Kraut (Miss Independent), McLain Ward (Sapphire), and Beezie Madden (Authentic)
BRONZE Germany: Ludger Beerbaum (L'Espoir), Christian Ahlmann (Cöster), Meredith Michaels-Beerbaum (Shutterfly), and Marcus Ehning (Noltes Küchengirl)

EVENTING
— Individual
GOLD Zara Phillips (GBR) and Toytown
SILVER Clayton Fredericks (AUS) and Ben Along Time
BRONZE Amy Tryon (USA) and Poggio II
— Team
GOLD Germany: Frank Ostholt (Air Jordan 2), Hinrich Romeike (Marius), Bettina Hoy (Ringwood Cockatoo), and Ingrid Klimke (Sleep Late)
SILVER Great Britain: Zara Phillips (Toytown), Daisy Dick (Spring Along), William Fox-Pitt (Tamarillo), and Mary King (Call Again Cavalier)
BRONZE Australia: Clayton Fredericks (Be Along Time), Megan Jones Kirby (Park Irish), Andrew Hoy (Master Monarch), and Sonia Johnson (Ringwould Jaguar)

2006

🏆 FEI WORLD CUP

JUMPING
Kuala Lumpur, Malaysia
GOLD Marcus Ehning (GER) and Sandro Boy
SILVER Jessica Kürten (GER) and Castle Forbes Libertina
BRONZE Beat Mändli (SUI) and Ideo du Thot

EVENTING
Malmö, Sweden
GOLD Nicolas Touzaint (FRA) and Galan de Sauvagère
SILVER Jean Lou Bigot (FRA) and Derby de Longueval
BRONZE Andreas Dibowski (GER) and FRH Little Lemon

2007

🏵 FEI EUROPEAN CHAMPIONSHIPS

DRESSAGE
La Mandria, Italy
— Individual
Grand Prix Special
GOLD Isabell Werth (GER) and Satchmo
SILVER Anky van Grunsven (NED) and Salinero
BRONZE Imke Schellekens-Bartels (NED) and Sunrise
Freestyle to Music
GOLD Anky van Grunsven (NED) and Salinero
SILVER Isabell Werth (GER) and Satchmo
BRONZE Imke Schellekens-Bartels (NED) and Sunrise
— Team
GOLD Netherlands: Anky van Grunsven (Salinero), Imke Schellekens-Bartels (Sunrise), Hans Peter Minderhoud (Exquis Nadine), and Laurens Van Lieren (Hexagon's Ollright)
SILVER Germany: Isabell Werth (Satchmo), Nadine Capellmann (Elvis VA), Ellen Schulten-Baumer (Donatha S), and Monica Theodorescu (Whisper)
BRONZE Sweden: Tinne Vilhelmson-Silfvén (Solos Carex), Jan Brink (Bjorsells Briar), Louise Nathhorst (Isidor), and Per Sandgaard (Orient)

JUMPING
Mannheim, Germany
— Individual
GOLD Meredith Michaels-Beerbaum (GER) and Shutterfly
SILVER Jos Lansink (BEL) and Cumano
BRONZE Ludger Beerbaum (GER) and Goldfever 3
— Team
GOLD Netherlands: Vincent Voorn (Alpapillon-Armanie), Gerco Schröder (Berlin), Jeroen Dubbeldam (Up and Down), and Albert Zoer (Okidoki)
SILVER Germany: Marcus Ehning (Küchengirl), Christian Ahlmann (Cöster), Meredith Michaels Beerbaum (Shutterfly), and Ludger Beerbaum (Goldfever 3)
BRONZE Great Britain: Michael Whitaker (Portofino 63), David McPherson (Pilgrim II), Ellen Whitaker (AK Locarno 62), and John Whitaker (Peppermill)

EVENTING
Pratoni del Vivaro, Italy
— Individual
GOLD Nicolas Touzaint (FRA) and Galan de Sauvagère
SILVER Mary King (GBR) and Call Again Cavalier
BRONZE Bettina Hoy (GER) and Ringwood Cockatoo
— Team
GOLD Great Britain: Oliver Townend (Flint Curtis), Daisy Dick (Spring Along), Mary King (Call Again Cavalier), and Zara Phillips (Toytown)
SILVER France: Didier Dhennin (Ismene du Temple), Éric Vigeanel (Coronado Prior), Arnaud Boiteau (Expo du Moulin), and Nicolas Touzaint (Galan de Sauvagère)
BRONZE Italy: Susanna Bordone (Ava), Fabio Magni (Loro Piana Southern), Robert Rotatori (Della Malaspina), and Vittoria Panizzon (Rock Model)

2007

🏆 FEI WORLD CUP

DRESSAGE
Las Vegas NV, United States
GOLD Isabell Werth (GER) and Warum Nicht
SILVER Imke Schellekens-Bartels (NED) and Sunrise
BRONZE Steffen Peter (USA) and Floriano

JUMPING
Las Vegas NV, United States
GOLD Beat Mändli (SUI) and Ideo du Thot
SILVER Daniel Deusser (GER) and Air Jordan Z
BRONZE Markus Beerbaum (GER) and Leena

2008

⚫⚫⚫ OLYMPIC GAMES, BEIJING

DRESSAGE
— Individual
GOLD Anky van Grunsven (NED) and Salinero
SILVER Isabell Werth (GER) and Satchmo
BRONZE Heike Kemmer (GER) and Bonaparte
— Team
GOLD Germany: Heike Kemmer (Bonaparte), Nadine Capellmann

(Elvis VA), and Isabell Werth (Satchmo)
SILVER Netherlands: Hans Peter Minderhoud (Nadine), Imke Schellekens-Bartels (Sunrise), and Anky van Grunsven (Salinero)
BRONZE Denmark: Anne van Olst (Clearwater), Nathalie zu Sayn-Wittgenstein (Digby), and Andreas Helgstrand (Don Schufro)

JUMPING
— Individual
GOLD Éric Lamaze (CAN) and Hickstead
SILVER Rolf-Göran Bengtsson (SWE) and Ninja La Silla
BRONZE Beezie Madden (USA) and Authentic
— Team
GOLD United States: McLain Ward (Sapphire), Laura Kraut (Cedric), Will Simpson (HH Carlsson Vom Dach), and Beezie Madden (Authentic)
SILVER Canada: Jill Henselwood (Special Ed), Éric Lamaze (Hickstead), Ian Millar (In Style), and Mac Cone (Ole)
BRONZE Switzerland: Christina Liebherr (LB No Mercy), Pius Schwizer (Nobless M), Nicklass Schurtenberger (Cantus), and Steve Guerdat (Jalisca Solier)

EVENTING
— Individual
GOLD Hinrich Romeike (GER) and Marius
SILVER Gina Miles (USA) and McKinlaigh
BRONZE Tina Cook (GER) and Miners Frolic
— Team
GOLD Germany: Peter Thomsen (The Ghost of Hamish), Frank Ostholt (Mr. Medicott), Andreas Dibowski (Butts Leon), Ingrid Klimke (FRH Butts Abraxxax), and Hinrich Romeike (Marius)
SILVER Australia: Shane Rose (All Luck), Sonja Johnson (Ringwould Jaguar), Lucinda Fredericks (Headley Britannia), Clayton Fredericks (Ben Along Time), and Megan Jones (Kirby Park Irish Jester)
BRONZE Great Britain: Sharon Hunt (Tanker Town), Daisy Berkeley (Spring Along), William Fox-Pitt (Parkmore Ed), Kristina Cook (Miners Frolic), and Mary King (Call Again Cavalier)

2008

🏆 FEI WORLD CUP

DRESSAGE
's-Hertogenbosch, Netherlands
GOLD Anky van Grunsven (NED) and Salinero
SILVER Isabell Werth (GER) and Warum Nicht
BRONZE Kyra Kyrklund (FIN) and Max

JUMPING
Gothenburg, Sweden
GOLD Meredith Michaels-Beerbaum (GER) and Shutterfly
SILVER Richard Fellers (USA) and Flexible
BRONZE Heinrich-Hermann Engemann (GER) and Aboyeur W

EVENTING
Deauville, France
GOLD Clayton Fredericks (AUS) and Ben Along Time
SILVER Pippa Funnell (GBR) and Ensign
BRONZE Frank Ostholt (GER) and Air Jordan 2

2009

🏵 FEI EUROPEAN CHAMPIONSHIPS

DRESSAGE
Windsor, United Kingdom
— Individual
Grand Prix Special
GOLD Adelinde Cornelissen (NED) and Parzival
SILVER Edward Gal (NED) and Totilas
BRONZE Laura Bechtolsheimer (GBR) and Mistral Højris
Freestyle to Music
GOLD Edward Gal (NED) and Totilas
SILVER Adelinde Cornelissen (NED) and Parzival
BRONZE Anky van Grunsven (NED) and Salinero
— Team
GOLD Netherlands: Imke Schellekens-Bartels (Sunrise), Anky van Grunsven (Salinero), Edward Gal (Totilas), and Adelinde Cornelissen (Parzival)
SILVER Great Britain: Maria Eilberg (Two Sox), Emma Hindle (Lancet 2), Carl Hester (Liebling II), and Laura Bechtolsheimer (Mistral Hørjis)
BRONZE Germany: Susanne Lebek (Potomac 4), Ellen Schulten-Baumer (Donatha S), Monica Theodorescu

(Whisper 128), and Matthias Alexander Rath (Sterntaler)

JUMPING
Windsor, United Kingdom
— Individual
GOLD Kevin Staut (FRA) and Kraque Boom
SILVER Carsten-Otto Nagel (GER) and Corradina 2
BRONZE Albert Zoer (NED) and Okidoki
— Team
GOLD Switzerland: Pius Schwizer (Ulysse), Daniel Etter (Peu à Peu 4), Clarissa Crotta (West Side van Meerputhoeve), and Steve Guerdat (Jalisca Solier)
SILVER Italy: Juan Carlos Garcia (Hamilton de Perhet), Giuseppe d'Onofrio (Landzeu 2), Natale Chiaudani (Seldana di Campalto), and Piergiorgio Bucci (Kanebo)
BRONZE Germany: Marcus Ehning (Plot Blue), Carsten-Otto Nagel (Corradina 2), Thomas Mühlbauer (Asti Spumante 7), and Meredith Michaels-Beerbaum (Checkmate 4)

EVENTING
Fontainebleau, France
— Individual
GOLD Kristina Cook (GBR) and Miners Frolic
SILVER Piggy French (GBR) and Some Day Soon
BRONZE Michael Jung (GER) and La Biosthétique Sam
— Team
GOLD Great Britain: Oliver Townend (Flint Curtis), Kristina Cook (Miners Frolic), William Fox-Pitt (Idalgo), and Nicola Wilson (Opposition Buzz)
SILVER Italy: Robert Rotatori (Della Malaspina), Juan Carlos Garcia (Iman du Golfe), Stefano Brecciaroli (Oroton), and Susanna Bordone (Blue Moss)
BRONZE Belgium: Karin Donckers (Gazelle de la Brasserie), Joris Van Springel (Bold Action), Virginie Caulier (Kilo), and Constantin Van Rijckevorsel (Our Vintage)

2009

🏆 FEI WORLD CUP

DRESSAGE
Las Vegas NV, United States

GOLD Steffen Peters (USA) and Ravel
SILVER Isabell Werth (GER) and Satchmo 78
BRONZE Anky van Grunsven (NED) and Painted Black

JUMPING
Las Vegas NV, United States
GOLD Meredith Michaels-Beerbaum (GER) and Shutterfly
SILVER McLain Ward (USA) and Sapphire
BRONZE Albert Zoer (NED) and Okidoki

EVENTING
Strzegom, Poland
GOLD Michael Jung (GER) and La Biosthétique Sam
SILVER Frank Ostholt (GER) and Air Jordan 2
BRONZE Clayton Fredericks (AUS) and Ben Along Time

2000
Olympic Games,
Sydney

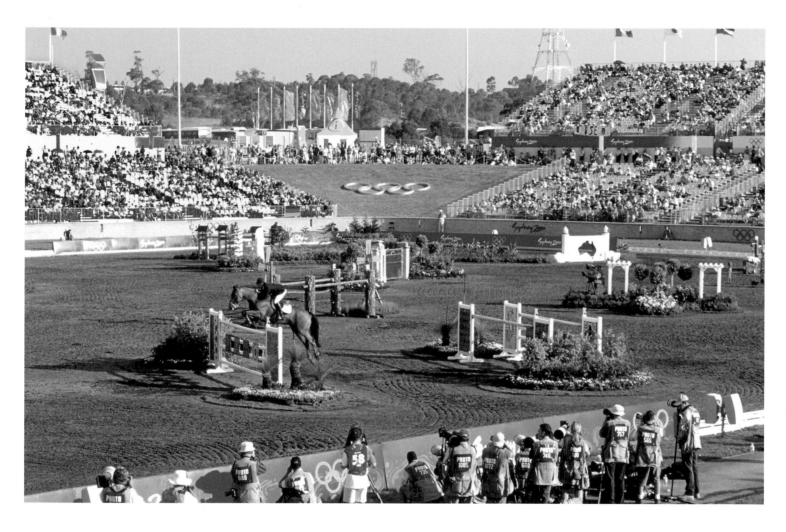

— dressage

Bonfire bowed out in finest style, providing Anky van Grunsven with her first Olympic title. She ended the supremacy of Isabell Werth and Gigolo, who had won two successive Olympic victories.

— jumping

Rodrigo Pessoa was on a roll, and the clear rounds he made to gain a team bronze medal heralded his subsequent victory in the individual competition. In the first round, the Brazilian rider kept an impressively cool head and completed another perfect round. However, in the final round, his nerves gave out and Baloubet du Rouet stopped twice, leading to his elimination. His defeat allowed Khaled Al-Eid to take the first Olympic medal (bronze) in Saudi Arabia's history.

— eventing

The dressage phase was revised, and the flying change was introduced into the tests. Australia won their third consecutive gold medal in the team competition.

The Sydney International Equestrian Centre, Horsley Park.

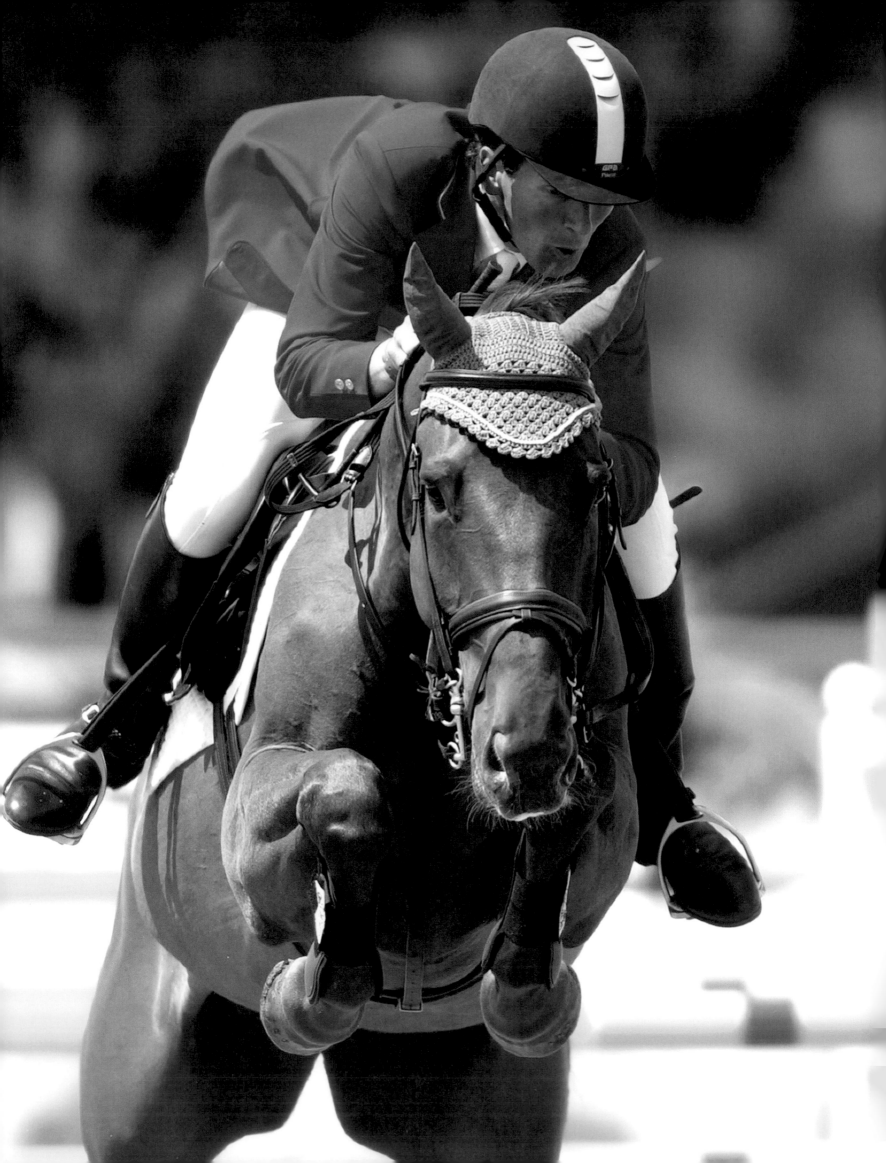

2001 FEI European Championships

— dressage

Verden, Germany
The German team proved itself unbeatable. This exclusively female team won gold with a resounding lead of 181 points over the Dutch, who were incapable of threatening the German quartet. This event was big news in the dressage world as it alone attracted an audience of seventy-five thousand. In addition, there were competitions for trainers, horse shows, and even camels trained to do flying changes.

— jumping

Arnhem, Netherlands
All went well for Ludger Beerbaum, who took the lead in the world rankings thanks to his CSI Grand Prix victory in St. Gallen with Gladdys S several weeks previously. He subsequently announced his decision to take part in the European Championships with this nine-year-old mare, declaring that it would be difficult for them to win an individual title together. However, at Arnhem several weeks later the new duo did indeed take the European title.

— eventing

Pau, France
For the first time in the history of the discipline, two consecutive European titles were won with the same rider and the same horse: Pippa Funnell with Supreme Rock. She also won team gold. For his part, Spanish rider Enrique Sarasola bagged the bronze medal with Dopé Doux, a horse that had made its brilliant debut ridden by French rider Marie-Christine Duroy.

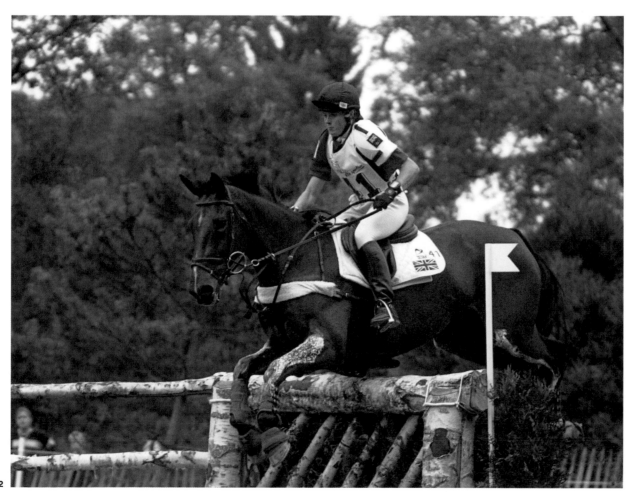

1. L. Beerbaum, European jumping champion, on Gladdys S.

2. P. Funnell, European individual and team eventing champion, on Supreme Rock.

< 1 2

2002
FEI World
Equestrian Games,
Jérez de la Frontera

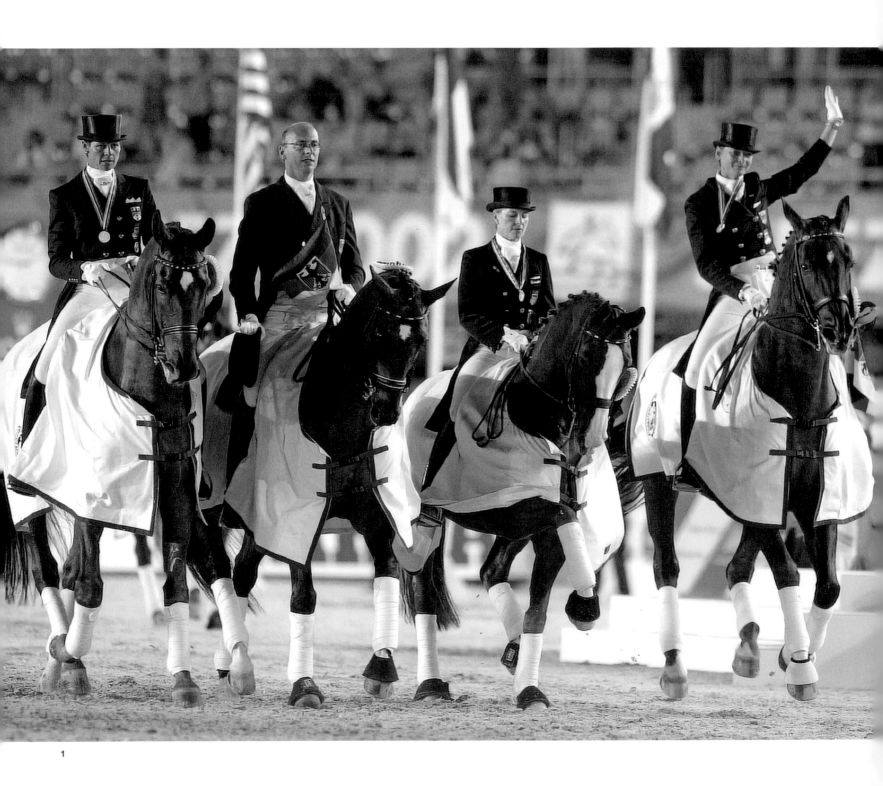

— dressage

Since 1975, Germany had been unbeaten in this discipline at world championship level, having succeeded the Soviet team, who had been champions in 1970. At Jérez, the US team came close to toppling the German colossus, but the Germans ultimately managed to retain the top spot on the podium.

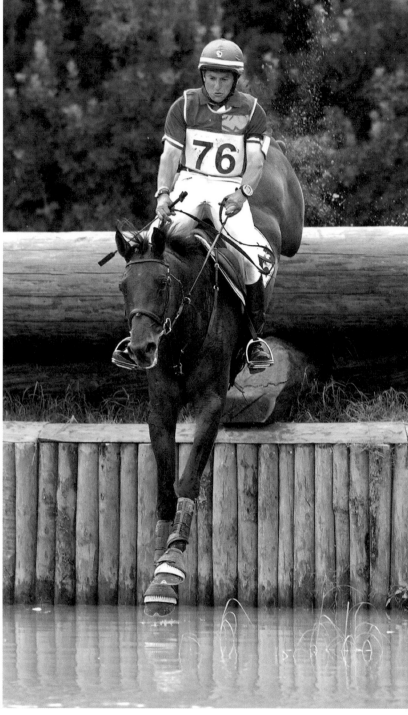

— jumping

Having trained first the Italian and then the Spanish teams, Henk Nooren (former rider in the Dutch team) turned his attention to the Swedish team. The gender-balanced team claimed a fine silver medal.

— eventing

Since Jean-Jacques Guyon and Pitou's win at the Mexico Olympic Games, France had not won any further individual world titles in eventing. Jean Teulère and Espoir de la Mare brought this long period in the doldrums to an end and became the first French pair to claim the world champion title.

1. The German team, gold medalists in dressage: (left to right) N. Capellmann (Farbenfroh), U. Salzgeber (Rusty 47), K. Husenbeth (Piccolino), A.-K. Linsenhoff (Renoir).

2. H. Nooren, next to Swedish rider H. Lundbäck, on Utfors Mynta.

3. J. Teulère on Espoir de la Mare.

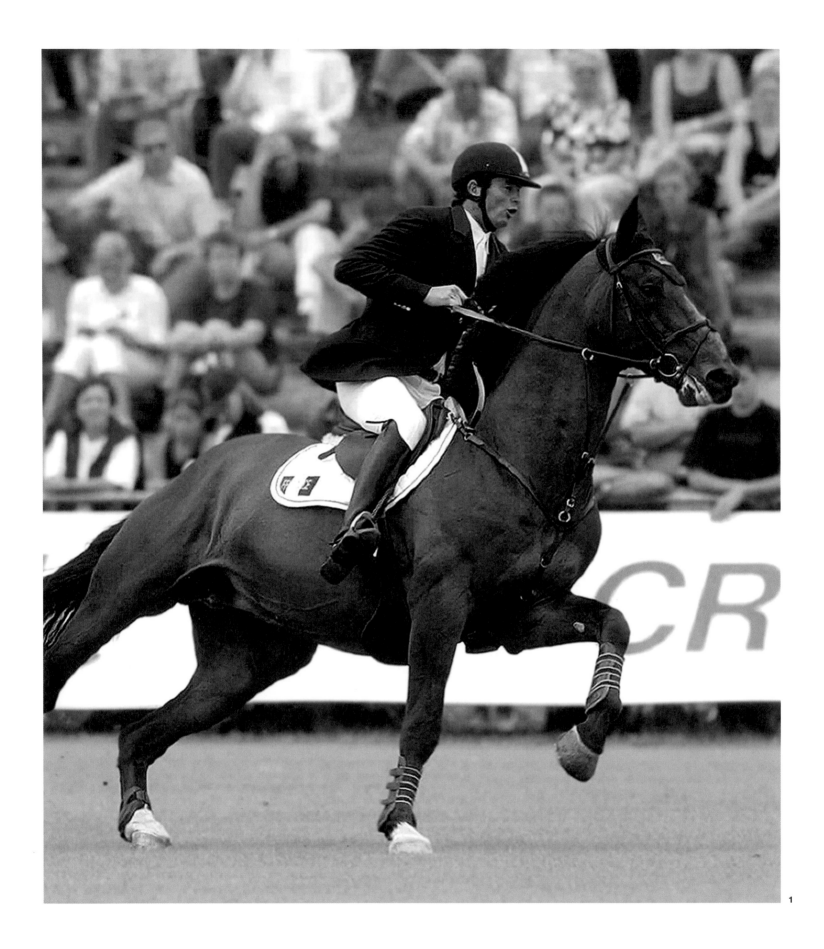

1

1. French riders
É. Levallois and Diamant
de Semilly, European
jumping team runners-up.

2. N. Touzaint, European
eventing champion,
on Galan de Sauvagère.

2003
FEI European
Championships

— dressage

Hickstead, United Kingdom
With Salinero injured, Anky van Grunsven announced that she would not participate in these championships. Nevertheless she was present to support her student Edward Gal, who made his debut in the national team. Together with Geldnet Lingh, the Dutchman ended twenty-ninth in the individual competition.

— jumping

Donaueschingen, Germany
A team silver boosted the medal record of Diamant de Semilly. Team world champion and ninth in the individual ranking at Jérez de la Frontera in 2002, he did not go on to win any more titles but did have an impressive career as sire, several times winning the title of best stallion in the world.

— eventing

Punchestown, Ireland
The next generation successfully tackled the extremely selective cross-country course. The youngest rider in the competition at just twenty-three years of age, Nicolas Touzaint took the individual title with Galan de Sauvagère. Pippa Funnell, who won the bronze with Walk On Star, had a string of almost legendary horses at her disposal. In 2003 she achieved a Grand Slam by winning the three greatest world CCI 4* competitions: Lexington and Burghley with Primmore's Pride, and Badminton with Supreme Rock. She also came sixth at Badminton in the same year with Cornerman and bagged third place at Saumur with Walk On Star.

2

2004
Olympic Games, Athens

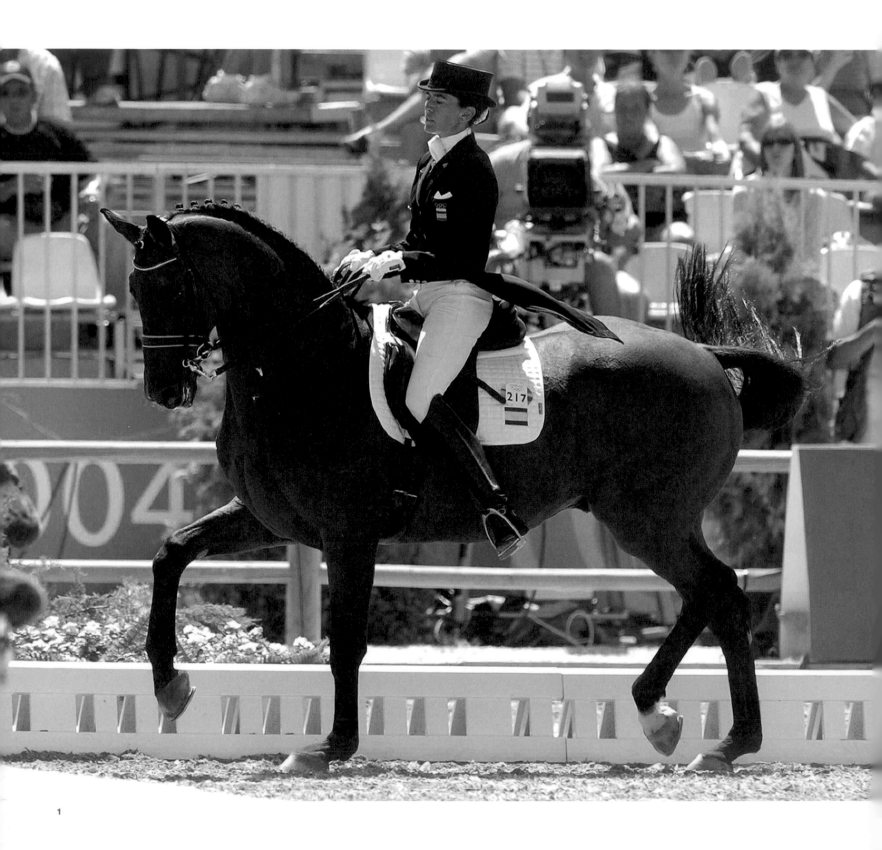

1

— dressage

Anky van Grunsven won her second consecutive gold medal while five months pregnant. For her part, Beatriz Ferrer-Salat presented Spain with its first Olympic medal in the history of dressage. The Spanish team shook up the established order of the last three Olympic Games by winning silver at the expense of the Dutch team.

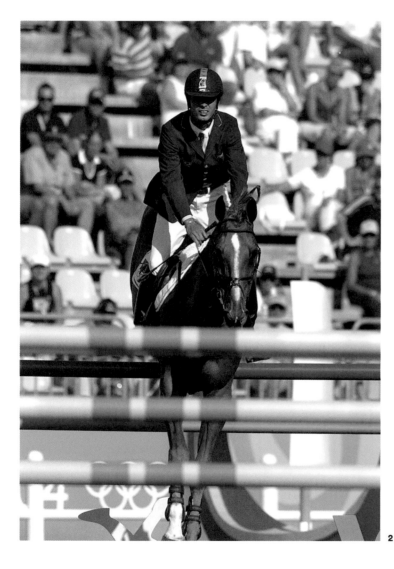

— eventing

It was during these Games that the historic format of the endurance leg was dropped. Demanding in terms of organization and space, it had given the horses a tough physical test by way of its four phases: roads and tracks, steeplechase, second roads and tracks, and cross country (respectively phases A, B, C, and D); only phase D was retained. Likewise the format that consisted of riding two different competitions for the team medals and the individual medals was revised. Under the new system, the team medal was awarded on the basis of three phases (dressage, cross country, and show jumping). Several hours later, the twenty-five best riders from individual rankings of the team competition took part in another show-jumping phase in order to determine the individual medals. Unfortunately for the sport, the battle for the team gold medal was fought not on the course but in committees and courts. Initially acknowledged as winners by the Appeal Committee, who overturned the judges' decision in the show-jumping phase, Bettina Hoy and the German team had their gold medal withdrawn by the Court of Arbitration for Sports. Instead it was awarded to the French team, with the individual medal going to the British rider Leslie Law. Even though her horse tested positive, Bettina Hoy did not receive any additional sanction.

— jumping

Irish rider Cian O'Connor was stripped of his gold medal on doping charges, and was suspended for three months. The disappearance of the urine B sample caused an uproar. As a result, Rodrigo Pessoa became Olympic champion. Similarly, the German team lost its own gold medal in another doping case. Ludger Beerbaum's mount, Goldfever 3, tested positive for betamethasone. Without them in the team, the Germans came in third, taking the bronze. The gold went to the United States, and the silver to Sweden.

1. B. Ferrer-Salat, silver medalist in dressage, on Beauvalais.

2. R. Pessoa, gold medalist in jumping, on Baloubet du Rouet.

3. L. Law, gold medalist in eventing, on Shear L'Eau.

2005
FEI European
Championships

— dressage

Hagen, Germany
The sportsmanship of the Spanish team undoubtedly made a big impression on the dressage world. Spain and Sweden were level in the team rankings, something rarely seen in this discipline, with a total of 213.125 percent each. In the case of a draw, the ranking of the fourth rider in each team is taken into account, with the better ranking determining the winner. In this case, Spain had the upper hand, and so Sweden was relegated to fourth place. But the Spanish Equestrian Federation, represented by chef d'équipe Bobby de Bobadilla, asked the FEI Dressage Committee to rank her team and the Swedes equally. Spain's request was accepted, and the FEI awarded an extra bronze medal to Sweden.

— jumping

San Patrignano, Italy
These championships were held in Europe's largest rehab center in order to promote the social benefits of sport and to showcase the positive result of projects of this kind. They met with great success.

— eventing

Blenheim, United Kingdom
A royal gold medal was won by Zara Phillips, daughter of Captain Mark Phillips (1972 Olympic team champion and 1988 runner-up) and Princess Anne (1971 individual European champion).

1. The Spanish and Swedish teams, tying for bronze in dressage.

2. Z. Phillips, European individual and team eventing champion, on Toytown.

3. M. Kutscher, European individual jumping champion, on Montender.

1

2

3 >

2006
FEI World Equestrian Games, Aachen

1

— dressage

For the first time at the FEI World Equestrian Games, two individual gold medals were awarded in this discipline, the first for the Grand Prix Special and the second for the Freestyle to Music. In the grandstand, almost fifty thousand spectators applauded Anky van Grunsven, who became world champion in the Freestyle. She beat the star attraction: Blue Hors Matiné, a nine-year-old mare ridden by the Dane Andreas Helgstrand. The audience applauded in time with the piaffes and passages of the public's favorite mare.

— jumping

The quarter-finals of these World Equestrian Games was thrilling, as each rider had to make four rounds, one on his own horse and the other three on the horses of his opponents. Three women and one man competed against one another: Meredith Michaels-Beerbaum, Beezie Madden, Edwina Alexander, and Jos Lansink. Over all sixteen rounds, only Edwina Alexander made an error. Parity between the other three riders meant that a jump-off was needed in order to decide between them. In this game of speed, Jos Lansink was the only rider to make a clear round, and he therefore became world champion.

— eventing

It would not have taken much for the gold medal to escape Zara Phillips. When she made a water jump on the cross-country course, she seriously lost her balance and tipped so far forward that, for a moment, her world title depended on nothing more than the laws of gravity. In the end, however, she added this title to that of 2005 European champion.

1. J. Lansink, gold medalist in jumping, on Cumano.

2. A. Helgstrand, silver medalist in the Freestyle to Music, on Blue Hors Matiné.

3. Z. Phillips, gold medalist in individual eventing, on Toytown.

2007
FEI European
Championships

2

Turin, Italy
This competition was the smash hit of these European Championships. The Dutch team won their first European title over Germany, who had not conceded the top spot since 1965. Anky van Grunsven won the only title still missing from her medal record. For the first time in a European Championships two individual titles were awarded, one for the Grand Prix Special and the other for Freestyle to Music.

Mannheim, Germany
There was plenty of tension for the teams hoping to qualify for the Beijing Olympic Games. The French trainer Gilles Bertran de Balanda castigated Florian Angot, who apparently did not obey orders during the Table C speed competition, while the Belgian trainer lambasted Judy-Ann Melchior who, after a fault and a circle, abandoned the event during the second round. As a result, neither country fielded teams for Beijing. In similar vein, the German team saw itself reduced to three after Marcus Ehning's withdrawal owing to various misfortunes, undermining their hopes of victory. Nevertheless, Ehning's team members managed a clear round, which earned them a worthy silver medal. The Netherlands carried off the gold, and Great Britain the bronze.

Pratoni Del Vivaro, Italy
On the verge of repeating her 2005 masterstroke, Zara Phillips saw all her medal chances disappear after a score of 19 penalties in a difficult jumping course. The royal rider had to settle for team gold. She relinquished her title to French rider Nicolas Touzaint, the current double European champion following his 2003 title.

1. M. Michaels-Beerbaum, European individual jumping champion, on Shutterfly.

2. N. Touzaint, once again European eventing champion, on Galan de Sauvagère.

< 1

2008 Olympic Games, Beijing

1

— dressage

From these Olympic Games onward, only the percentages of the three team riders in the Grand Prix Special and the Freestyle to Music would be taken into account for the individual medal. Isabell Werth was the favorite of these Games, and she won the Grand Prix and the Grand Prix Special, while an excellent performance from Anky van Grunsven with Salinero in the Freestyle allowed her to take the individual gold for the third time in a row. She remains the only rider from all three disciplines to have achieved this.

— jumping

Several doping accusations cast a shadow over an otherwise gripping competition. Norway was forced to return its bronze when Tony André Hansen tested positive for a banned substance. Although he was in the lead after the qualifying competitions, he was prohibited from continuing, along with three other riders who had also tested positive. These accusations tarnished the image of the sport, leading the FEI to develop a major anti-doping campaign. They overhauled the entire system for monitoring doping and medications, emphasizing an educational approach to the issue. New monitoring methods were implemented to make sure that all athletes and their staff were fully informed of all relevant information. During these Games the spotlight was on the individual competitions, and they were exceptionally challenging. Seven riders had to battle for the bronze medal, with a jump-off from which US rider Beezie Madden emerged triumphant. The suspense was palpable. The Canadian competitor Éric Lamaze, riding his fiery stallion Hickstead, confronted the Swedish rider Rolf-Göran Bengtsson on Ninja La Silla in another jump-off for the gold. Lamaze claimed the title after the Swede knocked down the wall of the last obstacle on the course.

— eventing

The first fall of a rider or a horse became cause for elimination. The double Olympic champion of these Games (individual and team), Hinrich Romeike, was an amateur rider, a dentist by profession, who spent only part of his day training with his horse.

1. A. van Grunsven, gold medalist in the Freestyle to Music, on Salinero.

2. É. Lamaze, gold medalist in individual jumping, on Hickstead.

2 >

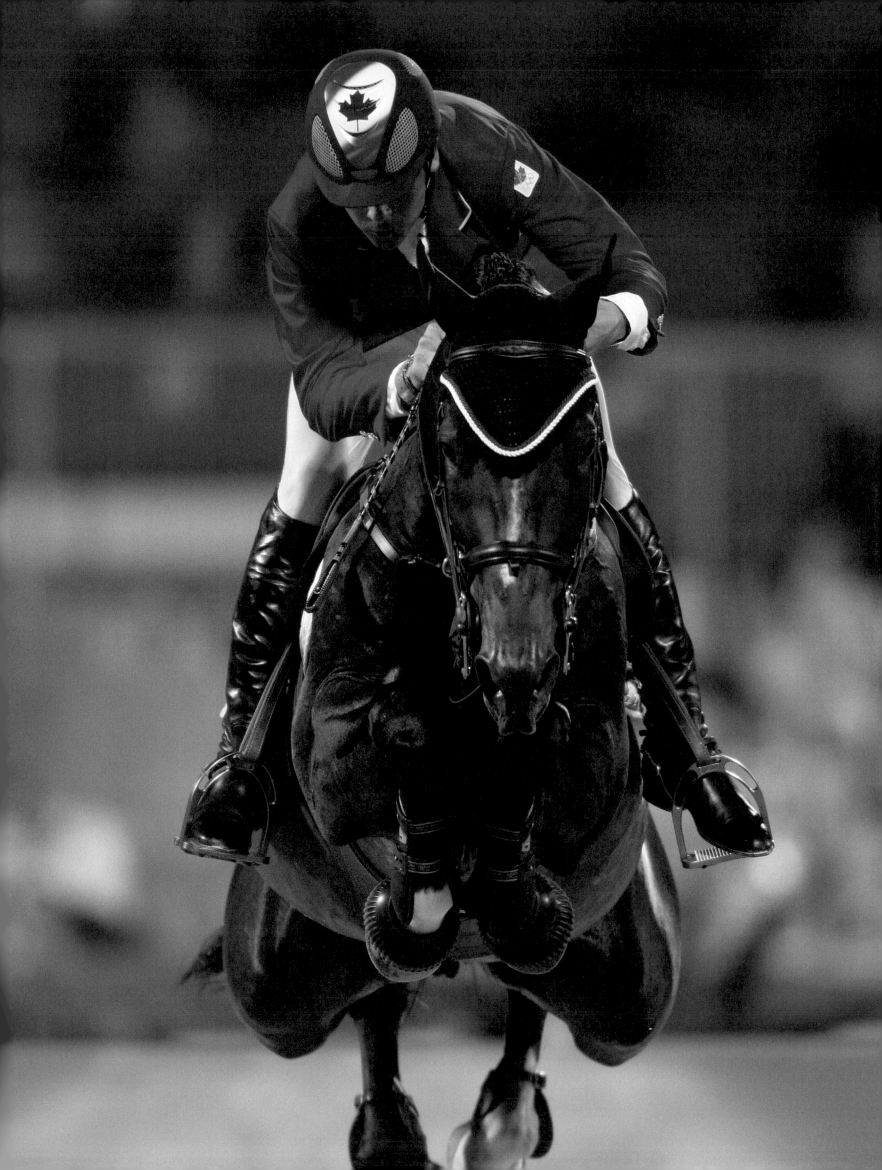

2009 FEI European Championships

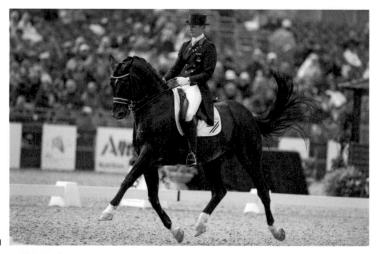

— dressage

Windsor, United Kingdom
Edward Gal riding Totilas gained an unprecedented score of 90.75 percent in the Freestyle to Music, prompting great excitement in the grandstand. Germany did even less well than in 2007 and was relegated to third place, just behind Great Britain and in the shadows of the Dutch dream team: Anky van Grunsven and Salinero, Adelinde Cornelissen and Parzival, Edward Gal and Totilas, and Imke Schellekens-Bartels and Sunrise.

— jumping

Windsor, United Kingdom
For the first time in history, the Italian team won the silver medal at a European Championship. Ten years after Alexandra Ledermann's success, the French rider Kevin Staut made his presence felt with Kraque Boom and put an end to a series of four individual titles for Germany.

— eventing

Fontainebleau, France
A double victory for Great Britain: individual gold for Kristina Cook, and team gold. It was the eighth consecutive European title for the British, and their twenty-first since the start of the championships. The Fontainebleau cross-country course was extremely demanding and only two riders finished it without penalties. Two French pairs withdrew from the competition before the final vet check—Jean Teulère and Espoir de la Mare, and Arnaud Boiteau and Expo du Moulin—as well as one Belgian rider, Constantin Van Rijckevorsel and Our Vintage. Oliver Townend's horse, Flint Curtis, failed the final vet check.

1. E. Gal, European Freestyle to Music champion, on Totilas.

2. The Dutch team, European dressage champions: (left to right) A. van Grunsven, I. Schellekens-Bartels, A. Cornelissen, E. Gal.

3. K. Cook, European individual and team eventing champion, on Miners Frolic.

4. K. Staut, European jumping champion, on Kraque Boom.

4 >

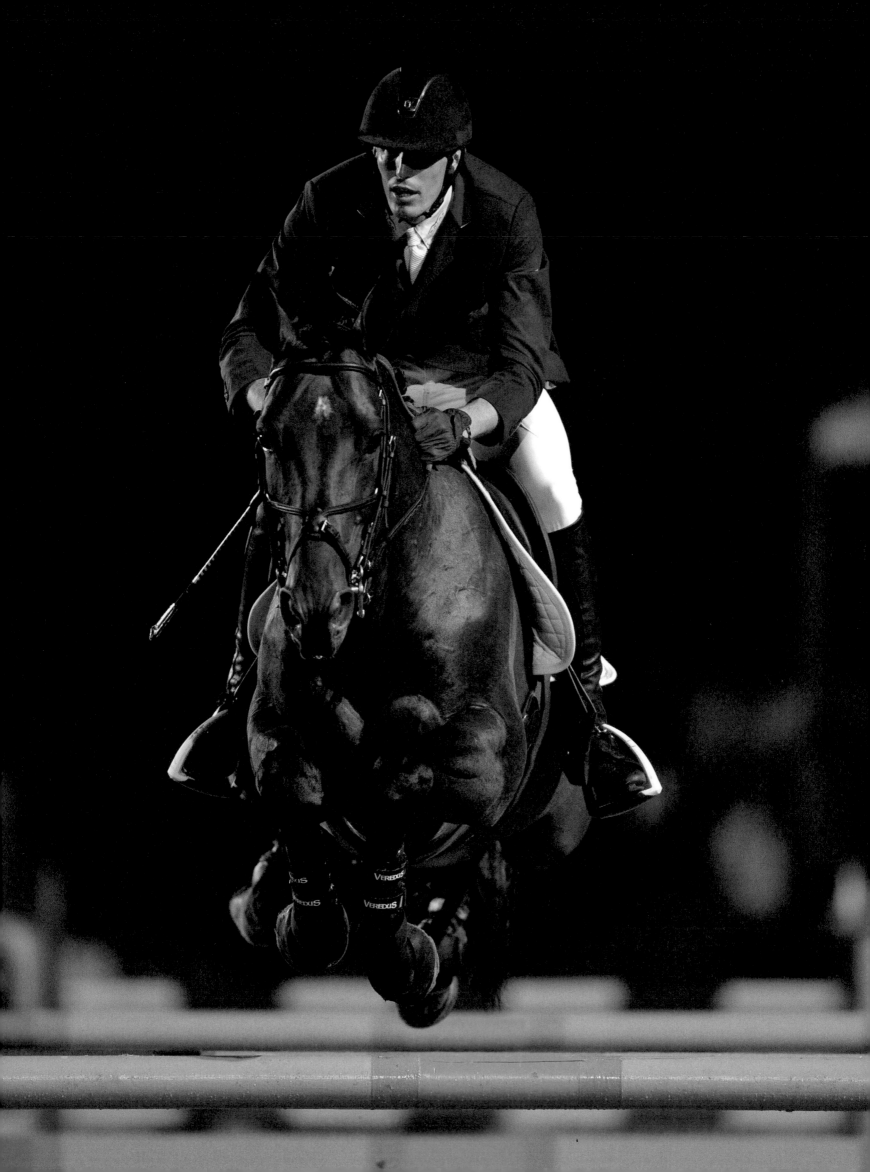

Rodrigo Pessoa

A magician like his father

Rodrigo was born on November 29, 1972, in Paris. He is the son of Nelson Pessoa, a highly respected rider known as "the Brazilian wizard," while his mother always supported her husband from behind the scenes. Both parents were originally from Rio de Janeiro. Rodrigo was immersed in the world of horses throughout his childhood, and he was fascinated by sports in general. Spurred by a spirit of competition, he began dedicating his free time to riding at the age of nine; by the time he was fourteen, he had decided to become a professional.

When he was eighteen, Rodrigo began working in the family stables, signed a sponsorship contract with Moët & Chandon, and launched his career at the highest competitive level. "When you're starting out as a professional, you have to dream big. I had great opportunities, and I knew how to seize them and use them for all they were worth. It took a lot of work, and there was very little downtime. That was the price you paid."

In 1988 he made his debut in international Grands Prix, and in 1998 he won his first title in a championship: the FEI World Cup Final in Helsinki with Baloubet du Rouet. The horse belonged to Diogo Pereira Coutinho and had been trained by his father and Jos Kumps. "I didn't ride him until he was eight. By the time he was nine, he'd started in the World Cups, so we decided to participate in the final to give him some experience. And he won!"

During the 1998 Rome FEI World Equestrian Games, the son, riding Lianos, outperformed the father, riding Baloubet. Rodrigo was crowned world champion after the final four with rotation of horses against Thierry Pomel, Franke Sloothaak, and Willi Melliger. "That's my fondest memory. I was competing against experienced riders, and I managed to get the very best out of each of those horses."

Later that year, Nelson hung up his riding boots and entrusted his protégé Baloubet to his son. Rodrigo knew how to make the best use of the horse. He won two victories in a row in the FEI World Cup Finals (1999 and 2000), and was crowned Olympic champion in Athens in 2004 retrospectively, after Olympic gold-winner Cian O'Connor's horse tested positive for doping.

A masterly horseman, Rodrigo performed consistently strongly, and was equally successful riding various horses. After the bitter disappointment of not being selected for the Rio de Janeiro Olympics, Rodrigo

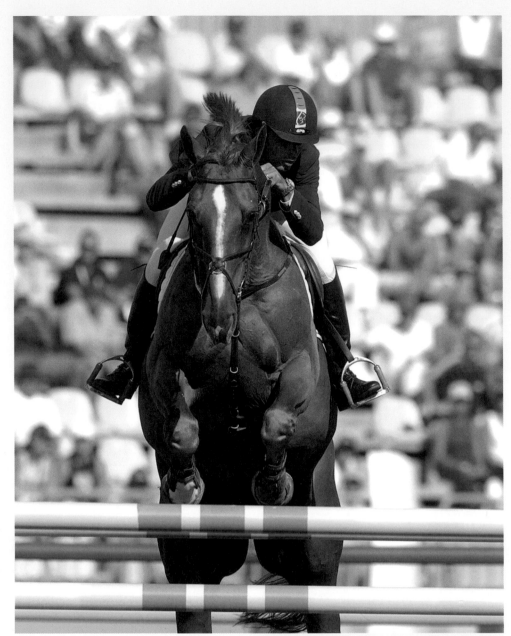

1

took some time off and devoted himself to a new challenge. He was named the national trainer for the Irish team, which was victorious in the first year of his mentorship, winning gold at the 2017 FEI European Championships. Nevertheless, Rodrigo has not given up on the possibility of competing in the Olympics again and is hoping to find a horse for future Games.

These days, Rodrigo is relishing family life with his wife, Alexa, and his daughters Cécilia who is thirteen years of age (from his first marriage), Sophia, aged seven, and Luciana Emilia, just eighteen months old. "The most important thing for me is to see my daughters grow up and become good citizens; I want to give them every opportunity to succeed in life."

The Brazilian has every reason to be proud of his career. "I respect achievement. I set myself three major objectives, and I've accomplished them with the support of my team. I have no regrets; we made some mistakes, but that's just part of the game."

2

3

Career Highlights

Jumping

1996
Team bronze
in the Atlanta
Olympics with
Tom Boy

1998
Individual gold
in the FEI World
Equestrian Games
in Rome with Lianos

2000
Team bronze
in the Sydney Olympics
with Baloubet
du Rouet

2004
Individual gold
at the Athens Olympics
with Baloubet
du Rouet

2007
Team gold and
individual silver
in the Pan American
Games in Rio
de Janeiro
with HH Rufus

2011
Team silver
in the Pan
American Games
in Guadalajara
with HH Ashley

"I respect achievement. I set myself three major objectives, and I've accomplished them with the support of my team. I have no regrets; we made some mistakes, but that's just part of the game."

— Rodrigo Pessoa

1. At the Athens Olympics on Baloubet du Rouet, 2004

2. At the Atlanta Olympics on Tomboy, 1996.

3. With his father, Nelson Pessoa, at their stud farm Haras de Ligny in Fleurus, Belgium.

Jos Kumps, Belgian trainer and rider, discusses Rodrigo's career

Jos has kept an eye on Rodrigo since he was a boy, playing the role of father figure when Nelson was away in competitions. It wasn't easy to be the son of Nelson Pessoa, and Rodrigo experienced a great deal of pressure in his childhood. "When he competed, the spectators followed him from beginning to end, debating whether he was as good as his father. Back then, there was no such thing as a psychological coach. He had to handle it on his own."

Rodrigo has always radiated a spirit of Olympian serenity. "Before the final in Rome, we went to see the vet check and then went back to the hotel because he needed some sleep. Meanwhile, the other riders were getting nervous watching videos of the horses in the final four. "We got there a half hour before the course walk! During the same championship we had already missed the course walk for the first round because we had forgotten we were in a different time zone. It was actually another rider who showed us the course. The rest of the team was incredibly stressed out, but not Rodrigo."

Jos also praises Rodrigo's horsemanship, which he believes is incomparable. "Competing in the WEG in Normandy with a horse like Status that would normally not have been up to the challenge—that's extraordinary. He's one of the only riders capable of giving a horse what it needs to perform, because he works with flexibility rather than force."

Some may regard Rodrigo as vain, but Jos has a different take on his personality. "He's much less extroverted than his father. Rodrigo prefers to spend time with his family. There are those who say he's arrogant, but that comes from the self-protective shell he had to develop when he was young. He spent the whole week in Rome being photographed with his fans, and just before the final a kid asked for his autograph. Rodrigo didn't look at him—just made a gesture with his hand. The kid must still think that Rodrigo was mean-spirited. But that's not true—he's a warmhearted guy."

William Fox-Pitt

The quiet champion

William was born in Hampstead in London on January 2, 1969, into a family immersed in equestrian sports: his parents, Oliver and Marietta, had competed several times at Burghley and Badminton. Riding from the age of four, William began his career foxhunting, before focusing on eventing. He rode as an amateur until he was fifteen, but his mother decided that he should become more serious and bought him a horse, Steadfast, with whom he won individual silver at the 1987 European Junior Championships in Pratoni del Vivaro. At the same time, he began a four-year engineering degree at Goldsmiths' College, University of London, honoring the agreement he had made with his mother. "That was the deal: my mother would help me financially with horse riding if I went to university, otherwise I had to pay for it myself. I didn't hesitate too long! Every weekend I went home to go riding."

As a result of his successes, William attracted the attention of Michael Turner, a High Court judge, who offered him Chaka, a horse that Judy Herbert had ridden at CCI 4★ level. "Michael wanted to encourage a young rider by giving him Chaka. He wanted him to be in a string of horses where he would be the leader. So I joined his stables." Thanks to this new teammate, William climbed the ladder, winning the legendary CCI 4★ at Burghley in 1994, and he began to dream of a top-level career. Having finished his degree, he began with two horses in Oxford, at the owner's stables, and remained there for almost ten years during which time he established his reputation.

In 2001, he decided to return to southwest England. "I bought some land where there was a dairy that we replaced with stables comprising about thirty stalls and lots of facilities." From then on, William went from success to success, becoming world number one in 2002, 2009, 2010, and 2014, and gaining a record number of six wins at Burghley, even though he has never won an international individual title. "I've had a good career, and I was very lucky to win so much and to ride so many top-class horses. One day I'd like to win a title, but if it is not to be, never mind! I've had some incredible times. I am very lucky to be alive, so how important is it to win another competition?"

Indeed, in October 2015, at the World Breeding Championships for Young Horses at Le Lion-d'Angers, riding Reinstated, the multi-medalist fell badly at Obstacle 20 in the seven-year-old category cross country. Suffering from severe head trauma, he spent two weeks in a coma. It would take him more than a year to get back in the saddle and return to full fitness. "Before my accident, the plan was to ride Chilli Morning at the Rio Olympics, and for me nothing had changed after the fall. For six months I couldn't see out of one eye, and so I went to an ophthalmologist twice a day to deal with this problem. My family thought that I was crazy and they just wanted me to be happy, so they pretended to believe it too, hoping that one day reality would catch up with me and I would open my eyes. I was lucky: I recovered just in time to go to Rio." Nevertheless William was not on top form and finished twelfth in the individual competition. If the accident did not change William's riding technique, it changed his way of seeing things. "You suddenly realize what really matters in life, and that missing out on the Olympic gold medal is not a big deal."

William hopes to continue his sporting career and has some promising young horses in his stables. He trains and runs clinics as much as possible in Europe and the United States, sharing his passion with his wife, Alice, herself a rider, and their four children, Oliver, Thomas, Chloe, and Emily. "The two boys don't really like riding, but we force them a bit because we're a family of riders, so they have to know how to do it. Also, one of my dreams, and theirs too, is to go on safari in South Africa, so they have to know how to ride. The girls, on the other hand, love riding and looking after their ponies. I won't push them into becoming riders because I think it's a difficult career. I want them to have a good life and I don't want them to sacrifice everything for horses if that's not what they love. It's not my dream that they should do what I did."

International rider Virginia Leng writes about her teammate

Virginia was already riding at the highest level when William's career began. Nevertheless, she has always admired his abilities. "He was always very talented and rode using his brain to get the best out of every horse. He was open to the advice of others. He talked to people extensively and watched his competitors a lot to understand and to learn. In my opinion, the real key to his success is his feeling for the horses that allowed him, and still allows him, to ride all kinds of horses today. He also has an amazing sense of balance. His position in relation to an obstacle, both before and after, is always perfect, which puts his horses at ease."

In addition to his innate talent, William is endowed with a mind of steel. "The more he progressed, the more he worked. He has a very cool temperament that has been very beneficial to him because he managed not to put pressure on himself and so was able to excel. When he missed victory at the Normandy World Equestrian Games, I was extremely sad for him, but all those incredible victories such as Burghley or Badminton made me happy because he showed the world what kind of a man he is."

William takes riding seriously, but in everyday life he likes to laugh and have fun. "He was an amazing teammate! He always had a joke and was very relaxed. Nothing was ever a problem—he kept saying that everything was going to be all right and that we shouldn't worry. All the same, I think that inside he was anxious and stressed about doing a good job and giving the best of himself, but he never let any of that show. So he helped the team relax and gave them confidence. It was very rare that he didn't make us laugh, whatever the situation."

1. At the 2016 Rio Olympics on Chilli Morning.

2. Receiving a medal from Queen Elizabeth II at the European Championships, Blair Castle, 2015.

3. Bronze medalist at the World Equestrian Games in Normandy, 2014. **3**

Career Highlights

Eventing

1995
Team gold at the FEI European Championships in Pratoni del Vivaro with Cosmopolitan II

1997
Individual silver and team gold at the FEI European Championships in Burghley with Cosmopolitan II

2001
Team gold at the FEI European Championships in Pau with Stunning

2002
Team bronze at the FEI World Equestrian Games in Jérez de la Frontera with Tamarillo

2003
Team gold at the FEI European Championships in Punchestown with Moon Man

2004
Team silver at the Athens Olympics with Tamarillo

2005
Individual silver and team gold at the FEI European Championships in Blenheim with Tamarillo

2006
Team silver at the FEI World Equestrian Games in Aachen with Tamarillo

2008
Team bronze at the Beijing Olympics with Parkmore Ed

2009
Team gold at the FEI European Championships in Fontainebleau with Idalgo

2010
Individual silver and team gold at the FEI World Equestrian Games in Lexington with Cool Mountain

2011
Team bronze at the FEI European Championships in Luhmühlen with Cool Mountain

2012
Team silver at the London Olympics with Lionheart

2013
Individual bronze at the FEI European Championships in Malmö with Chilli Morning

2014
Individual bronze and team silver at the FEI World Equestrian Games in Normandy with Chilli Morning

2015
Team silver at the FEI European Championships at Blair Castle with Bay My Hero

Anky van Grunsven

Leaving nothing to chance

1

It is difficult to imagine today, but Anky used to be frightened of horses. She was born at Erp, in the Netherlands, on January 2, 1968, and at the age of six received her first pony, Heleentje, from her father, who owned a construction company and who was passionate about horse riding. "It took me a year to summon up the courage to ride him. I was happy just grooming him!" Anky recalls. She cut her teeth in the neighboring pony club, for several years alternating between show jumping and dressage. Meeting Prisco, her first horse, made her choose dressage. "Prisco proved to be too energetic for me. I wasn't in control. Before my father allowed me to jump, he made me take dressage lessons. But once we started jumping, Prisco proved really bad! So I concentrated on dressage instead. I just wasn't brave enough to jump." In 1980 Anky and Prisco made their brilliant competitive debut.

At the end of her teenage years, Anky decided to become a professional rider and joined her family's newly renovated stables. "My father gave me a bookkeeper to help me keep track of my finances, and wished me luck. I had Prisco, Bonfire, and a small horse truck. I managed everything else myself; it was a good introduction to the real world." In order to make ends meet, Anky rode owners' horses and gave lessons until 10 p.m. for the modest sum of 10 Euros. "I didn't have a groom: I started at 7 a.m., fed the horses, mucked out the stalls, then rode my horses and gave lessons. I had to really push."

In 1988, the twenty-year-old rider took part in her first Olympic Games with Prisco. Doors opened for her, the price of her lessons increased, good horses joined her stables, and things took off, particularly when her trainer Sief Janssen became her partner and manager. At the same time, Bonfire, whom Anky had nurtured since he was two years old, reached the top of his game: the pair started to win all the prizes. Her reputation was made, and she was highly sought after throughout the world for both clinics and lectures. Almost unbeatable, Anky and Bonfire won nine individual medals, including the title of Olympic Champion at Sydney in 2000, before bowing out of competition. "He was such a sensitive horse, but he always fought for me. We were an incredible team. He lived with me until he was thirty."

Salinero stepped in and enabled Anky's reign at the summit of international dressage to continue: he helped her win Olympic titles at Athens in 2004 and Beijing in 2008, as well as a team bronze medal at the London Olympic Games in 2012.

In 2010, spurred on by her hunger to learn, Anky threw herself into a new challenge: reining. She had Whizashiningwalla BB on loan and turned her attention to this new discipline, running it in parallel with dressage. After the London Olympic Games, Salinero retired and Anky devoted herself entirely to reining. In 2015 she was a member of the Oranje team that won bronze at the European Championships at Aachen. It would be her final championship performance. "I had achieved my goals, I knew my limitations and I didn't think I could go any further, so I stopped."

Since then, she has divided her time between giving riding lessons and bringing up the children she has with Sief—Yannick, born in 2004 and already bitten by the show-jumping bug, and Ava Eden, born in 2007. It is their success and the prospect of handing over to them that excite her. "I don't miss competition. I enjoy training horses to compete at the highest level and I wouldn't like to go back to dressage rectangles."

Despite being the only athlete in the world to have won three consecutive Olympic titles in the same event, Anky never imagined having such a career. "I didn't launch my career in order to win medals but because I loved my sport. I am proud of what I've accomplished; it's proof that I have done a good job. Today I still love what I do and that is even more important to me than what I managed to win."

1. With Bonfire at the World Cup, 1997.

2. With Whizashiningwalla BB in the reining competition at the European Championships, Aachen, 2015.

2

Jokeleien Jansen, Bonfire's groom from 1998 to 2008, describes Anky

Jokelien was a major participant in the success of Anky and Bonfire and describes what it was like to be behind the scenes of success: "Anky loved to be completely in charge. She managed everything so that it was all perfect by her standards: from the vet and her horses' nutrition to the farrier, the groom, and the owners, etc. She even scheduled her personal outings, dinners out, or movie trips for Mondays only, and was always in bed early. She was extremely focused before big events, not just in the competition arena, but also for weeks in advance, planning and organizing her whole life."

Victory was not an end in itself for Anky. "Her aim was not to win at all costs, but to give the best of herself and of her horse in order to improve each day. If she came second in a championship but had done her best, that was no problem for her. But if she had made avoidable errors, she went over them again and again so that she could learn where she could make improvements. When this happened I had to leave her alone with her disappointment after an event so that she could reflect on and analyze her mistakes."

Jokelien sees Anky as always true to herself: down-to-earth, big-hearted, and with a zest for life. "Anky has plenty of humor and self-deprecation. Once she takes to you, she would do anything for you. She is such a positive person who always looks for the good in every situation and in every person. She has an incredible knack of putting things into perspective, with which she inspires everyone around her."

Career Highlights

Dressage

1991
Team bronze at the FEI European Championships at Donaueschingen with Bonfire

1992
Team silver at the Barcelona Olympics with Bonfire

1994
Individual gold in the Freestyle to Music and team silver at the FEI World Equestrian Games at The Hague with Bonfire

1995
Individual silver and team silver at the FEI European Championships at Mondorf-les-Bains with Bonfire

1996
Individual silver and team silver at the Atlanta Olympics with Bonfire

1997
Individual silver and team silver at the FEI European Championships at Verden with Bonfire

1998
Individual silver and team silver at the FEI World Equestrian Games in Rome with Bonfire

1999
Individual gold and team silver at the FEI European Championships at Arnhem with Bonfire

2000
Individual gold and team silver at the Sydney Olympics with Bonfire

2004
Individual gold at the Athens Olympics with Salinero

2005
Individual gold and team silver in the FEI European Championships at Hagen with Salinero

2006
Individual gold in the Freestyle to Music, individual silver in the Grand Prix Special, and team silver in the FEI World Equestrian Games at Aachen with Salinero

2007
Individual gold in the Grand Prix Special, individual silver in the Freestyle to Music, and team gold in the FEI European Championships at La Mandria with Salinero

2008
Individual gold and team bronze at the Beijing Olympics with Salinero

2009
Individual bronze in the Freestyle to Music and team gold at the FEI European Championships at Windsor with Salinero

2012
Team bronze at the London Olympics with Salinero

Reining

2015
Team bronze in the FEI European Championships at Aachen with Whizashiningwalla BB

Rusty

A brilliant performer in all situations

Rusty was born on April 2, 1988, on a stud farm in Burtnieki, Latvia. The horse, originally named Rotors, left his native land at the age of two. First sold in Belarus, the liver chestnut moved to Germany a few years later, entering Alexander Moksel's show-jumping stable. Moksel entrusted Rusty to Ulla Salzgeber, who ran a dressage training center along with her husband. She was looking for a backup horse, preferably sired by Rebuss, with a strong potential for show jumping as well as dressage. Ulla was immediately captivated by the six-year-old Rusty. "As soon as I rode him, I realized he

was the horse of my dreams. I could tell he'd perform brilliantly in dressage. He was already very well trained, and immediately understood exactly what was expected of him. I had no doubts about his future success. He wasn't all that good-looking—his musculature was ungainly, his tail was short and skimpy, his walk was awkward—but that was Rusty!"

Ulla was committed to giving her protégé the best training possible, aiming to achieve peak performance. The work was unrelenting. "I began riding him each morning and every afternoon, without

exception. I spent an hour working out at a walking pace. Thanks to this effort, I managed to change his walk and get all the control I needed." Her perseverance paid off, and the duo began to distinguish themselves in international competitions, resulting in their selection for the German team's third place reserve for the 1997 FEI European Championships in Verden. "When the title holder and first two backups became ill, we found ourselves on center stage. I couldn't believe it. We weren't remotely prepared, and Rusty was peacefully enjoying a vacation at the time. We finally got there, and came in

Rusty's rider Ulla Salzgeber reminisces

For Ulla and Rusty, it was love at first sight. "From start to finish, I always had absolute confidence in Rusty. He took control in our very first international competition. Everyone was telling me how incredible he was and how I absolutely had to enter the German championship to win a place in the national lineup. But at the time I wasn't really interested in competing at this level—I just wanted to enjoy myself."

Like all great champions, Rusty demonstrated incredible perseverance. "He was lord of the manor. He was a bit mischievous when he was young, but we spent the time necessary to get him more practiced in hand. Rusty always gave his best in the arena. If he sensed that I wasn't on top form, he'd just take over. He never let me down."

Ulla and Rusty shared a relationship of confidence and respect. "I knew him by heart, and vice versa. We were like husband and wife! Whenever I came into the stable, he'd whinny to wish me good morning. If he wasn't motivated to work out that day, I'd just send him out to the pasture. It was great! After two years together, he was like a pet dog following me everywhere. He trusted me completely."

sixth in individual rankings and won a team championship. Rusty wasn't perfect, but he was only nine years old—he wasn't ready for this yet."

Their success marked the beginning of an epic six-year trajectory during which they won numerous medals one after another, beginning with the team gold and the individual bronze in the 1998 FEI World Equestrian Games in Rome, and the group gold and individual silver in the 1999 FEI European Championships in Arnhem. Needless to say, the pair earned a place in the 2000 Olympic Games in Sydney. After claiming a gold medal along with the other members of the German team, Ulla and Rusty launched upon their Freestyle to Music accompanied by Carl Orff's *Carmina Burana*, their signature composition. Unfortunately, the music cut out after they had executed several figures, and they had to wait an hour before resuming their performance. "Rusty was incredible. He was walked in hand for the hour of waiting time, and when we started over, he gave his all. I don't know of any other horse who could recover his concentration the way Rusty did. And he demonstrated such amazing energy the second time, after an hour's interruption." Rusty and Ulla finally ended the competition with a bronze medal.

With the retirement of Isabell Werth's horse Gigolo, Rusty's fiercest competitor, the gelding assumed complete dominance in international dressage. Ulla and Rusty took the team and individual golds in 2001 and 2003 in the FEI European Championships, as well as the group gold and the individual bronze in the 2002 FEI World Equestrian Games in Jérez de la Frontera. This stunning trajectory was abruptly halted in the World Cup Final in 2003 when the champion tested

positive for a forbidden substance, testosterone proprionate, administered by his veterinarian to treat a hormonal imbalance. The German Federation banned the pair from competition for two months, but they received a dispensation allowing them to participate in the national championship with the objective of obtaining their qualification for the 2004 Olympics. Ulla and Rusty traveled to Athens, where they finished as individual silver medalists and team Olympic champions.

Following this culminating achievement, Ulla decided it was time for Rusty to retire. "He was only sixteen and he probably could have competed a bit longer, but he deserved to conclude his career with the Olympics— no need for him to win another European medal. He'd already won so many!" After a few performances over the following year, Rusty moved to Hungary, accompanied by his best friend, the pony Motte.

Seven years later, in 2013, Rusty had to be put down at the age of twenty-five. He had been cloned twice a few months before his death, producing two stallions named Rusty 1 and Rusty 2. "I saw a photo of one of the clones—for me, it had no connection with Rusty. You can't just clone an animal and expect to get the same personality or qualities. Horses develop distinct characters through their training."

(facing page)
With U. Salzgeber at the World Equestrian Games in Jérez de la Frontera, 2002.

The 2010s

RESULTS 2010–2019

2010

🏆 FEI WORLD EQUESTRIAN GAMES, LEXINGTON KY

DRESSAGE
— Individual
Grand Prix Special
GOLD Edward Gal (NED) and Totilas
SILVER Laura Bechtolsheimer (GBR) and Mistral Højris
BRONZE Steffen Peters (USA) and Ravel
Freestyle to Music
GOLD Edward Gal (NED) and Totilas
SILVER Laura Bechtolsheimer (GBR) and Mistral Højris
BRONZE Steffen Peters (USA) and Ravel
— Team
GOLD Netherlands: Edward Gal (Totilas), Imke Schellekens-Bartels (Sunrise), Hans Peter Minderhoud (Exquis Nadine), and Adelinde Cornelissen (Jerich Parzival)
SILVER Great Britain: Laura Bechtolsheimer (Mistral Højris), Carl Hester (Liebling II), Fiona Bigwood (Wie-Atlantico de Ymas), and Maria Eilberg (Two Sox)
BRONZE Germany: Isabell Werth (Warum Nicht FRH), Christoph Koschel (Donnperignon), Matthias Alexander Rath (Sterntaler), and Anabel Balkenhol (Dablino)

JUMPING
— Individual
GOLD Philippe Lejeune (BEL) and Vigo d'Arsouilles
SILVER Abdullah Al-Sharbatly (AS) and Seldana di Campalto
BRONZE Éric Lamaze (CAN) and Hickstead
— Team
GOLD Germany: Carsten-Otto Nagel (Corradina), Meredith Michaels-Beerbaum (Checkmate), Janne Friederike Meyer (Cellagon Lambrasco), and Marcus Ehning (Plot Blue)
SILVER France: Pénélope Leprevost (Mylord Carthago*HN), Patrice Delaveau (Katchina Mail), Olivier Guillon (Lord de Theize), and Kevin Staut (Silvana de Hus)
BRONZE Belgium: Dirk Demeersman (Bufero vh Panishof), Judy Ann Melchior (Cha Cha Z), Jos Lansink (Valentina van 't Heike), and Philippe Lejeune (Vigo d'Arsouilles)

EVENTING
— Individual
GOLD Michael Jung (GER) and La Biosthétique Sam
SILVER William Fox-Pitt (GBR) and Cool Mountain
BRONZE Andrew Nicholson (NZL) and Nereo
— Team
GOLD Great Britain: William Fox-Pitt (Cool Mountain), Mary King (Imperial Cavalier), Nicola Wilson (Opposition Buzz), and Kristina Cook (Miners Frolic)
SILVER Canada: Stéphanie Rhodes-Bosch (Port Authority), Selena O'Hanlon (Colomb), Hawley Bennet-Awad (Gin & Juice), and Kyle Carter (Madison Park)
BRONZE New Zealand: Andrew Nicholson (Nereo), Marc Todd (Grass Valley), Caroline Powell (Mac Macdonald), and Clarke Johnstone (Orient Express)

2010

🏆 FEI WORLD CUP

DRESSAGE
's-Hertogenbosch, Netherlands
GOLD Edward Gal (NED) and Totilas
SILVER Adelinde Cornelissen (NED) and Jerich Parzival
BRONZE Imke Schellekens-Bartels (NED) and Sunrise

JUMPING
Geneva, Switzerland
GOLD Marcus Ehning (GER) and Noltes Küchengirl (Plot Blue)
SILVER Ludger Beerbaum (GER) and Gotha
BRONZE Pius Schwizer (SUI) and Ulysse (Carlina)

2011

🏇 FEI EUROPEAN CHAMPIONSHIPS

DRESSAGE
Rotterdam, Netherlands
— Individual
Grand Prix Special
GOLD Adelinde Cornelissen (NED) and Parzival
SILVER Carl Hester (GBR) and Uthopia
BRONZE Laura Bechtolsheimer (GBR) and Mistral Højris
Freestyle to Music
GOLD Adelinde Cornelissen (NED) and Parzival
SILVER Carl Hester (GBR) and Uthopia
BRONZE Patrik Kittel (SWE) and Watermill Scandic
— Team
GOLD Great Britain: Emile Faurie (Elmegardens Marquis), Charlotte Dujardin (Valegro), Carl Hester (Uthopia), and Laura Bechtolsheimer (Mistral Højris)
SILVER Germany: Helen Langehanenberg (Damon Hill NRW), Christoph Koschel (Donnperignon), Isabell Werth (El Santo NRW), and Matthias Alexander Rath (Totilas)
BRONZE Netherlands: Sander Marijnissen (Moedwil), Hans Peter Minderhoud (Exquis Nadine), Edward Gal (Sisther de Jeu), and Adelinde Cornelissen (Parzival)

JUMPING
Madrid, Spain
— Individual
GOLD Rolf-Göran Bengtsson (SWE) and Ninja La Silla
SILVER Carsten-Otto Nagel (GER) and Corradina 2
BRONZE Nick Skelton (GBR) and Carlo 273
— Team
GOLD Germany: Marco Kutscher (Cornet Obolensky), Carsten-Otto Nagel (Corradina 2), Janne Friederike Meyer (Cellagon Lambrasco), and Ludger Beerbaum (Gotha FRH)
SILVER France: Michel Robert (Kellemoi de Pepita), Pénélope Leprévost (Mylord Carthago*HN), Kevin Staut (Silvana de Hus), and Olivier Guillon (Lord de Theize)
BRONZE Great Britain: Nick Skelton (Carlo 273), Guy Williams (Titus), Ben Maher (Tripple X III), and John Whitaker (Peppermill)

EVENTING
Luhmühlen, Germany
— Individual
GOLD Michael Jung (GER) and La Biosthétique Sam
SILVER Sandra Auffarth (GER) and Opgun Louvo
BRONZE Frank Ostholt (GER) and Little Paint
— Team
GOLD Germany: Michael Jung (La Biosthétique Sam), Sandra Auffarth (Opgun Louvo), Ingrid Klimke (FRH Butts Abraxxas), and Andreas Dobowski (FRH Fantasia)
SILVER France: Donatien Schauly (Ocarina du Chanois), Nicolas Touzaint (Neptune de Sartene), Stanislas de Zuchowicz (Quirinal de la Bastide), and Pascal Leroy (Minos de Petra)
BRONZE Great Britain: William Fox-Pitt (Cool Mountain), Piggy French (Jakarta), Nicola Wilson (Opposition Buzz), and Mary King (Imperial Cavalier)

2011

🏆 FEI WORLD CUP

DRESSAGE
Leipzig, Germany
GOLD Adelinde Cornelissen (NED) and Jerich Parzival
SILVER Nathalie zu Sayn-Wittgenstein (DEN) and Digby
BRONZE Ulla Salzgeber (GER) and Herzruf's Erbe

JUMPING
Leipzig, Germany
GOLD Christian Ahlmann (GER) and Taloubet Z
SILVER Éric Lamaze (CAN) and Hickstead
BRONZE Jeroen Dubbeldam (NED) and Simon

2012

⚫⚫⚫ OLYMPIC GAMES, LONDON

DRESSAGE
— Individual
GOLD Charlotte Dujardin (GBR) and Valegro
SILVER Adelinde Cornelissen (NED) and Parzival
BRONZE Laura Bechtolsheimer (GBR) and Mistral Højris
— Team
GOLD Great Britain: Carl Hester (Uthopia), Laura Bechtolsheimer (Mistral Højris), and Charlotte Dujardin (Valegro)
SILVER Germany: Dorothee Schneider (Diva Royal), Kristina Bröring Sprehe (Desperado FRH), and Helen Langehanenberg (Damon Hill NRW)
BRONZE Netherlands: Anky van Grunsven (Salinero), Edward Gal (Glock's Undercover), and Adelinde Cornelissen (Salinero)

JUMPING
— Individual
GOLD Steve Guerdat (SUI) and Nino des Buissonnets
SILVER Gerco Schröder (NED) and London
BRONZE Cian O'Connor (IRL) and Blue Loyd 12
— Team
GOLD Great Britain: Nick Skelton (Big Star), Ben Maher (Tripple X III), Scott Brash (Hello Sanctos), and Peter Charles (Vindicat W.)
SILVER Netherlands: Jur Vrieling (Bubalu), Maikel van der Vleuten (Verdi), Marc Houtzager (Tamino), and Gerco Schröder (London)
BRONZE Saudi Arabia: Prince Abdullah Al-Saud (Davos), Kamal Bahamdan (Noblesse des Tess), Ramzy Al-Duhami (Bayard), and Abdullah al Sharbatly (Sultan)

EVENTING
— Individual
GOLD Michael Jung (GER) and La Biosthétique Sam
SILVER Sara Algotsson Ostholt (SWE) and Wega
BRONZE Sandra Auffarth (GER) and Opgun Louvo
— Team
GOLD Germany: Peter Thomsen (Barny), Dirk Schrade (King Arthus), Sandra Auffarth (Opgun Louvo), Michael Jung (La Biosthétique Sam), and Ingrid Klimke (FRH Butts Abraxxas)
SILVER Great Britain: William Fox-Pitt (Lionheart), Nicola Wilson (Opposition Buzz), Zara Phillips (High Kingdom), Mary King (Imperial Cavalier), and Kristina Cook (Miners Frolic)
BRONZE New Zealand: Jonelle Richards (Flintstar), Caroline Powell (Lenamore), Jonathan Paget (Clifton Promise), Andrew Nicholson (Nereo), and Mark Todd (NZB Campino)

2012

🏆 FEI WORLD CUP

DRESSAGE
's-Hertogenbosch, Netherlands
GOLD Adelinde Cornelissen (NED) and Jerich Parzival
SILVER Helen Langehanenberg (GER) and Damon Hill
BRONZE Valentina Truppa (ITA) and Quixote Eremo del Castegno

JUMPING
's-Hertogenbosch, Netherlands
GOLD Richard Fellers (USA) and Flexible
SILVER Steve Guerdat (SUI) and Nino des Buissonnets
BRONZE Pius Schwizer (SUI) and Ulysse (Carlina)

2013

🏇 FEI EUROPEAN CHAMPIONSHIPS

DRESSAGE
Herning, Denmark
— Individual
Grand Prix Special
GOLD Charlotte Dujardin (GBR) and Valegro
SILVER Helen Langehanenberg (GER) and Damon Hill
BRONZE Adelinde Cornelissen (NED) and Parzival
Freestyle to Music
GOLD Charlotte Dujardin (GBR) and Valegro
SILVER Helen Langehanenberg (GER) and Damon Hill
BRONZE Adelinde Cornelissen (NED) and Parzival
— Team
GOLD Germany: Fabienne Müller-Lütkemeier (D'Agostino 5), Isabell Werth (Don Johnson FRH), Kristina Bröring-Sprehe (Desperados FRH), Helen Langehanenberg (Damon Hill)
SILVER Netherlands: Danielle Heijkoop (Siro), Hans Peter Minderhoud (Glock's Romanov), Edward Gal (Glock's Undercover), and Adelinde Cornelissen (Parzival)
BRONZE Great Britain: Michael George Eilberg (Half Moon Delphi), Gareth Hughes (DV Stenkjers Nadonna), Carl Hester (Uthopia), and Charlotte Dujardin (Valegro)

JUMPING
Herning, Denmark
— *Individual*
GOLD Roger-Yves Bost (FRA) and Myrtille Paulois
SILVER Ben Maher (GBR) and Cella
BRONZE Scott Brash (GBR) and Hello Sanctos
— *Team*
GOLD Great Britain: Ben Maher (Cella), Michael Whitaker (Viking), William Funnell (Billy Congo), and Scott Brash (Hello Sanctos)
SILVER Germany: Daniel Deusser (Cornet d'Amour), Carsten-Otto Nagel (Corradina 2), Christian Ahlmann (Codex One), and Ludger Beerbaum (Chiara 222)
BRONZE Sweden: Jens Fredricson (Lunatic), Angelica Augustsson (Mic Mac du Tillard), Henrik von Eckermann (Gotha FRH), and Rolf-Göran Bengtsson (Casall Ask)

EVENTING
Malmö, Sweden
— *Individual*
GOLD Michael Jung (GER) and Halunke FBW
SILVER Ingrid Klimke (GER) and FRH Escada
BRONZE William Fox-Pitt (GBR) and Chilli Morning
— *Team*
GOLD Germany: Michael Jung (La Biosthétique Sam), Dirk Schrade (Hop and Skip), Ingrid Klimke (FRH Escada), and Andreas Dobowski (FRH Butts Avedon)
SILVER Sweden: Niklas Lindbäck (Mister Pooh), Ludwig Svennerstål (Shamwari 4), Frida Andersen (Herta), and Sara Algotsson Ostholt (Reality 39)
BRONZE France: Donatien Schauly (Seculaire), Nicolas Touzaint (Lesbos), Karim Florent Laghouag (Punch de l'Esques), and Astier Nicolas (Piaf de B'neville)

2013
▼ FEI WORLD CUP

DRESSAGE
Gothenburg, Sweden
GOLD Helen Langehanenberg (GER) and Damon Hill
SILVER Adelinde Cornelissen (NED) and Jerich Parzival

BRONZE Edward Gal (NED) and Glock's Undercover

JUMPING
Gothenburg, Sweden
GOLD Beezie Madden (USA) and Simon
SILVER Steve Guerdat (SUI) and Nino des Buissonnets
BRONZE Kevin Staut (FRA) and Silvana*HDC

2014
🏆 FEI WORLD EQUESTRIAN GAMES, NORMANDY

DRESSAGE
— *Individual*
Grand Prix Special
GOLD Charlotte Dujardin (GBR) and Valegro
SILVER Helen Langehanenberg (GER) and Damon Hill NRW
BRONZE Kristina Bröring-Sprehe (GER) and Desperados FRH
Freestyle to Music
GOLD Charlotte Dujardin (GBR) and Valegro
SILVER Helen Langehanenberg (GER) and Damon Hill NRW
BRONZE Adelinde Cornelissen (NED) and Jerich Parzival
— *Team*
GOLD Germany: Helen Langehanenberg (Damon Hill NRW), Kristina Bröring-Sprehe (Desperados FRH), Fabienne Lütkemeier (D'Agostino FRH), and Isabell Werth (Bella Rose 2)
SILVER Great Britain: Charlotte Dujardin (Valegro), Carl Hester (Nip Tuck), Michael George Eilberg (Half Moon Delphi), and Gareth Hughes (DV Stenkjers Nadonna)
BRONZE Netherlands: Adelinde Cornelissen (Jerich Parzival), Diederik van Silfhout (Arlando NOP), Hans Peter Minderhoud (Glock's Johnson NOP), and Edward Gal (Glock's Voice)

JUMPING
— *Individual*
GOLD Jeroen Dubbeldam (NED) and Zenith SFN
SILVER Patrice Delaveau (FRA) and Orient Express*HDC
BRONZE Beezie Madden (USA) and Cortes C
— *Team*
GOLD Netherlands: Jeroen Dubbeldam (Zénith SFN),

Maikel van der Vleuten (VDL Groep Verdi), Jur Vrieling (VDL Bubalu), and Gerco Schröder (London)
SILVER France: Pénélope Leprevost (Flora de Mariposa), Simon Delestre (Qlassic Bois Margot), Patrice Delaveau (Orient Express*HDC), and Kevin Staut (Rêveur de Hurtebise*HDC)
BRONZE United States: Beezie Madden (Cortes C), Lucy Davis (Barron), McLain Ward (Rothchild), and Kent Farrington (Gazelle)

EVENTING
— *Individual*
GOLD Sandra Auffarth (GER) and Opgun Louvo
SILVER Michael Jung (GER) and Fischerrocana FST
BRONZE William Fox-Pitt (GBR) and Chilli Morning
— *Team*
GOLD Germany: Sandra Auffarth (Opgun Louvo), Michael Jung (Fischerrocana FST), Ingrid Klimke (SAP Escada FRH), and Dirk Schrade (Hop and Skip)
SILVER Great Britain: William Fox-Pitt (Chilli Morning), Kristina Cook (De Novo News), Zara Tindall (High Kingdom), and Harry Meade (Wild Lone)
BRONZE Netherlands: Elaine Pen (Vira N.O.P.), Tim Lips (Keyflow), Merel Blom (Rumour Has It N.O.P.), and Andrew Heffernan (Boleybawn Ace N.O.P.)

2014
▼ FEI WORLD CUP

DRESSAGE
Lyon, France
GOLD Charlotte Dujardin (GBR) and Valegro
SILVER Helene Langehanenberg (GER) and Damon Hill
BRONZE Edward Gal (NED) and Glock's Undercover

JUMPING
Lyon, France
GOLD Daniel Deusser (GER) and Cornet d'Amour
SILVER Ludger Beerbaum (GER) and Chaman, Chiara 222
BRONZE Scott Brash (GBR) and Ursula XII

2015
⚘ FEI EUROPEAN CHAMPIONSHIPS

DRESSAGE
Aachen, Germany
— *Individual*
Grand Prix Special
GOLD Charlotte Dujardin (GBR) and Valegro
SILVER Kristina Bröring-Sprehe (GER) and Desperados
BRONZE Hans Peter Minderhoud (NED) and Glock's Johnson
Freestyle to Music
GOLD Charlotte Dujardin (GBR) and Valegro
SILVER Kristina Bröring-Sprehe (GER) and Desperados FRH
BRONZE Beatriz Ferrer-Salat (ESP) and Delgado
— *Team*
GOLD Netherlands: Patrick van der Meer (Uzzo), Diederik van Silfhout (Arlando), Hans Peter Minderhoud (Glock's Johnson), and Edward Gal (Glock's Undercover)
SILVER Great Britain: Michael George Eilberg (Marakov), Fiona Bigwood (Orthilia), Carl Hester (Nip Tuck), and Charlotte Dujardin (Valegro)
BRONZE Germany: Jessica von Bredow-Werndl (Unee BB), Isabell Werth (Don Johnson), Matthias Alexander Rath (Totilas), and Kristina Bröring-Sprehe (Desperados)

JUMPING
Aachen, Germany
— *Individual*
GOLD Jeroen Dubbeldam (NED) and SFN Zenith
SILVER Grégory Whatelet (BEL) and Conrad de Hus
BRONZE Simon Delestre (FRA) and Ryan des Hayettes
— *Team*
GOLD Netherlands: Gerco Schröder (Glock's Cognac Champblanc), Maikel van der Vleuten (VDL Groep Verdi), Jur Vrieling (VDL Zirocco Blue), and Jeroen Dubbeldam (SFN Zenith)
SILVER Germany: Meredith Michaels-Beerbaum (Fibonacci 17), Christian Ahlmann (Taloubet Z), Ludger Beerbaum (Chiara 222), and Daniel Deusser (Cornet d'Amour)
BRONZE Switzerland: Romain Duguet (Quorida de Treho), Martin Fuchs (Clooney 51), Janika Sprunger (Bonne Chance Cw), and Paul Estermann (Castlefield Eclipse)

EVENTING
Blair Castle, United Kingdom
— *Individual*
GOLD Michael Jung (GER) and Fischertakinou
SILVER Sandra Auffarth (GER) and Opgun Louvo
BRONZE Thibaut Vallette (FRA) and Qing du Briot*ENE-HN
— *Team*
GOLD Germany: Michael Jung (Fischertakinou), Dirk Schrade (Hop and Skip), Ingrid Klimke (Hale Bob), and Sandra Auffarth (Opgun Louvo)
SILVER Great Britain: Kitty King (Persimmon), Pippa Funnell (Sandman 7), Nicola Wilson (One Two Many), and William Fox-Pitt (Bay My Hero)
BRONZE France: Thibaut Vallette (Qing du Briot*ENE-HN), Mathieu Lemoine (Bart L.), Karim Florent Laghouag (Entebbe de Hus), and Thomas Carlile (Sirocco du Gers)

2015
▼ FEI WORLD CUP

DRESSAGE
Las Vegas NV, United States
GOLD Charlotte Dujardin (GBR) and Valegro
SILVER Edward Gal (NED) and Glock's Undercover
BRONZE Jessica von Bredown-Werndl (GER) and Unee BB

JUMPING
Las Vegas NV, United States
GOLD Steve Guerdat (SUI) and Albfuehren's Paille
SILVER Pénélope Leprevost (FRA) and Vagabond de la Pomme
BRONZE Bertram Allen (IRL) and Molly Malone V

2016
⣿ OLYMPIC GAMES, RIO DE JANEIRO

DRESSAGE
— *Individual*
GOLD Charlotte Dujardin (GBR) and Valegro
SILVER Isabell Werth (GER) and Weihegold Old
BRONZE Kristina Bröring-Sprehe (GER) and Desperados FRH
— *Team*
GOLD Germany: Isabell

Werth (Weihegold), Kristina Bröring-Sprehe (Desperados FRH), Dorothee Schneider (Showtime FRH), and Sönke Rothenberger (Cosmo 59)
SILVER Great Britain: Spencer Wilton (Super Nova II), Fiona Bigwood (Orthilia), Carl Hester (Nip Tuck), and Charlotte Dujardin (Valegro)
BRONZE United States: Allison Brock (Rosevelt), Kasey Perry-Glass (Dublet), Steffen Peters (Legolas 92), and Laura Graves (Verdades)

JUMPING
— *Individual*
GOLD Nick Skelton (GBR) and Big Star
SILVER Peder Fredricson (SWE) and All In
BRONZE Éric Lamaze (CAN) and Fine Lady 5
— *Team*
GOLD France: Philippe Rozier (Rahotep de Toscane), Kevin Staut (Rêveur de Hurtebise*HDC), Roger-Yves Bost (Sydney Une Prince), and Pénélope Leprévost (Flora de Mariposa)
SILVER United States: Kent Farrington (Voyeur), Lucy Davis (Barron), McLain Ward (HH Azur), and Beezie Madden (Cortes C)
BRONZE Germany: Christian Ahlmann (Taloubet Z), Meredith Michaels-Beerbaum (Fibonacci 17), Daniel Deusser (First Class van Eeckelghem), and Ludger Beerbaum (Casello)

EVENTING
— *Individual*
GOLD Michael Jung (GER) and La Bisothétique Sam
SILVER Astier Nicolas (FRA) and Piaf de B'neville
BRONZE Phillip Dutton (USA) and Mighty Nice
— *Team*
GOLD France: Karim Florent Laghouag (Entebbe de Hus), Thibaut Vallette (Qing du Briot*ENE-HN), Mathieu Lemoine (Bart L), and Astier Nicolas (Piaf de B'neville)
SILVER Germany: Julia Krajewski (Samourai du Thot), Sandra Auffarth (Opgun Louvo), Ingrid Klimk (Sap Hale Bob), and Michael Jung (La Biosthétique Sam)
BRONZE Australia: Shane Rose (CP Qualified), Stuart Tinney (Pluto Moi), Sam Griffiths

(Paulank Brockagh),
and Christopher Burton
(Santano II)

2016

🏆 FEI WORLD CUP

DRESSAGE
Gothenburg, Sweden
GOLD Hans Peter Minderhoud (NED) and Glock's First
SILVER Tinne Vilhelmson Silfvén (SWE) and Don Auriello
BRONZE Jessica von Bredow-Werndl (GER) and Unee BB

JUMPING
Gothenburg, Sweden
GOLD Steve Guerdat (SUI) and Corbinian
SILVER Harrie Smolders (NED) and Emerald
BRONZE Daniel Deusser (GER) and Cornet d'Amour

2017

♀ FEI EUROPEAN CHAMPIONSHIPS

DRESSAGE
Gothenburg, Sweden
— *Individual*
Grand Prix Special
GOLD Isabell Werth (GER) and Weihegold OLD
SILVER Sönke Rothenberger (GER) and Cosmo 59
BRONZE Cathrine Dufour (DEN) and Cassidy
Freestyle to Music
GOLD Isabell Werth (GER) and Weihegold OLD
SILVER Sönke Rothenberger (GER) and Cosmo
BRONZE Cathrine Dufour (DEN) and Cassidy

— *Team*
GOLD Germany: Isabell Werth (Weihegold OLD), Sönke Rothenberger (Cosmo 59), Helen Langehanenberg (Damsey), and Dorothee Schneider (Sammy Davis Jr.)
SILVER Denmark: Cathrine Dufour (Cassidy), Anna Kasprzak (Donnperignon), Anna Zibrandtsen (Arlando), and Agnete Kirk Thinggaard (Jojo AZ)
BRONZE Sweden: Therese Nilshagen (Dante Weltino OLD), Patrik Kittel (Delaunay OLD), Tinne Vilhelmson Silfvén (Paridon Magi), and Rose Mathisen (Zuidenwind 1187)

JUMPING
Gothenburg, Sweden
— *Individual*
GOLD Peder Fredricson (SWE) and All In
SILVER Harrie Smolders (NED) and Don VHP Z
BRONZE Cian O'Connor (IRL) and Good Luck
— *Team*
GOLD Ireland: Shane Sweetnam (Chaqui Z), Bertram Allen (Hector van d'Abdijhoeve), Denis Lynch (All Star 5), and Cian O'Connor (Good Luck)
SILVER Sweden: Henrick von Eckermann (Mary Lou), Malin Baryard-Johnsson (Cue Channa 42), Douglas Lindelöw (Zacramento), and Peder Fredricson (All In)
BRONZE Switzerland: Nadja Peter Steiner (Saura de Fondcombe), Romain Duguet (Twentytwo des Biches), Martin Fuchs (Clooney 51), and Steve Guerdat (Bianca)

EVENTING
Strzegom, Poland
— *Individual*
GOLD Ingrid Klimke (GER) and Hale Bob OLD
SILVER Michael Jung (GER) and Fischerrocana FST
BRONZE Nicola Wilson (GBR) and Bulana
— *Team*
GOLD Great Britain: Nicola Wilson (Bulana), Kristina Cook (Billy The Red), Rosalind Canter (Allstar B), and Oliver Townend (Cooley SRS)
SILVER Sweden: Sara Algotsson Ostholt (Realty 39), Louise Svensson Jähde (Wieloch's Utah Sun), Niklas Lindbäck (Focus Filiocus), and Ludwig Svennerstal (Paramount Importance)
BRONZE Italy: Pietro Roman (Stellor Rebound), Pietro Sandei (Rubis de Prere), Vittoria Panizzoni (Chequers Play The Game), and Arianna Schivo (Quefira de l'Ormeau)

2017

🏆 FEI WORLD CUP

DRESSAGE
Omaha NE, United States
GOLD Isabell Werth (GER) and Weihegold
SILVER Laura Graves (USA) and Verdades
BRONZE Carl Hester (GBR) and Nip Tuck

JUMPING
Omaha NE, United States
GOLD McLain Ward (USA) and HH Azur
SILVER Romain Duguet (SUI) and Twentytwo des Biches

BRONZE Henrik von Eckermann (SWE) and Mary Lou

2018

🏆 FEI WORLD CUP

DRESSAGE
Paris, France
GOLD Isabell Werth (GER) and Weihegold
SILVER Laura Grabes (USA) and Verdades
BRONZE Jessica von Bredow-Werndl (GER) and Unee BB

JUMPING
Paris, France
GOLD Beezie Madden (USA) and Breitling LS
SILVER Devin Ryan (USA) and Eddie Blue
BRONZE Henrik von Eckermann (SWE) and Mary Lou

2018

🏆 FEI WORLD EQUESTRIAN GAMES, TRYON NC

DRESSAGE
— *Individual*
Grand Prix Special
GOLD Isabell Werth (GER) and Bella Rose
SILVER Laura Graves (USA) and Verdades
BRONZE Charlotte Dujardin (GBR) and Mount St. John Freestyle
Freestyle to Music
[Canceled owing to bad weather.]
— *Team*
GOLD Germany: Jessica von Bredow-Werndl (TSF Dalera BB), Dorothee Schneider (Sammy Davis Jr.),

Sönke Rothenberger (Cosmo), and Isabell Werth (Bella Rose)
SILVER United States: Steffen Peters (Suppenkasper), Adrienne Lyle (Salvino), Kasey Perry-Glass (Goerklingaards Dublet), and Laura Graves (Verdades)
BRONZE Great Britain: Spencer Wilton (Super Nova II), Emile Faurie (Dono di Maggio), Carl Hester (Hawtins Delicato), and Charlotte Dujardin (Mount St. John Freestyle).

JUMPING
— *Individual*
GOLD Simone Blum (GER) and DSP Alice
SILVER Martin Fuchs (SUI) and Clooney
BRONZE Steve Guerdat (SUI) and Bianca
— *Team*
GOLD United States: Devin Ryan (Eddie Blue), Adrienne Sternlicht (Cristalline), Laura Kraut (Zeremonie), and McLain Ward (Glock's Clinta)
SILVER Sweden: Henrik von Eckermann (Toveks Mary Lou), Malin Baryard-Johnsson (H&M Indiana), Fredrik Jönsson (Cold Play), and Peder Fredricson (H&M Christian K)
BRONZE Germany: Simone Blum (DSP Alice), Laura Klaphake (Catch Me If You Can OLD), Maurice Tebbel (Don Diarado), and Marcus Ehning (Pret A Tout)

EVENTING
— *Individual*
GOLD Rosalind Canter (GBR) and Allstar B.
SILVER Padraig McCarthy (IRL) and Mr. Chunky
BRONZE Ingrid Klimke (GER) and SAP Hale Bob

— *Team*
GOLD Great Britain: Gemma Tattersall (Arctic Soul), Piggy French (Quarrycrest Echo), Tom McEwen (Toledo de Kerser), and Rosalind Canter (Allstar B)
SILVER Ireland: Sam Watson (Horseware Ardagh Highlight), Cathal Daniels (Rioghan Rua), Padraig McCarthy (Mr. Chunky), and Sarah Ennis (Horseware Stellor Rebound)
BRONZE France: Alaine Pain Donatien Schauly (Pivoine des Touches), Maxime Livio (Opium des Verrières), LCL Thibaut Vallette (Qing du Briot*ENE-HN), and Sydney Dufresne (Trésor Mail)

2019

🏆 FEI WORLD CUP

DRESSAGE
Gothenburg, Sweden
GOLD Isabell Werth (GER) and Weihegold
SILVER Laura Graves (USA) and Verdades
BRONZE Helen Langehanenberg (GER) and Damsey

JUMPING
Gothenburg, Sweden
GOLD Steve Guerdat (SUI) and Alamo
SILVER Martin Fuchs (SUI) and Clooney 51
BRONZE Peder Fredricson (SWE) and All In (Catch Me Not S)

2010
FEI World Equestrian Games, Lexington KY

— dressage —

The rules are very strict when it comes to the physical condition of the horses, as Adelinde Cornelissen knows very well. A mainstay of the Dutch team and contender for an individual medal, she was eliminated in the Grand Prix after her horse Parzival bit his tongue and traces of blood were seen in his mouth by the judge at C. Her compatriot Edward Gal, riding the magnificent Totilas, secured the individual gold, winning the three dressage competitions. Together they handed the Netherlands the team gold medal.

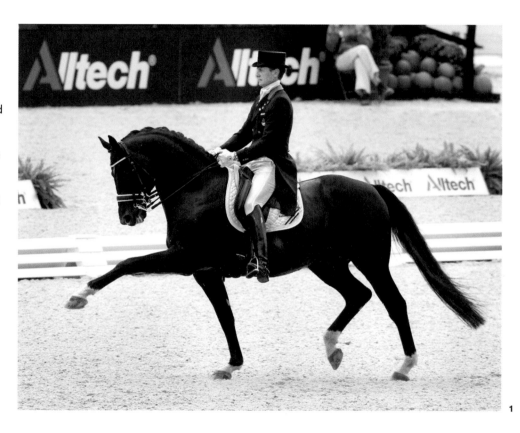

— jumping —

A heartstopping final of four with Abdullah al Sharbatly riding for Saudi Arabia, Rodrigo Pessoa for Brazil, Philippe Lejeune for Belgium, and Éric Lamaze for Canada. The riders had the opportunity to share the horses Seldana di Campalto, Rebozo, Vigo d'Arsouilles, and Hickstead. The latter was recognized as the best performer when he executed a clear round with every one of his riders. On the other hand, Seldana, the only mare in the final, gave the riders a hard time, racking up 12 penalties and attempting to kick them as they changed horse.

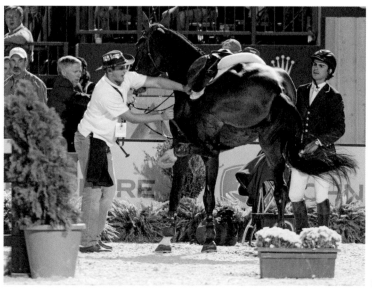

1. E. Gal and the phenomenal Totilas claimed victory in three dressage contests, both individual and team

2. Seldana, A. al Sharbatly's mare

3. M. Jung, gold medalist
in individual eventing, on
La Biosthétique Sam.

— eventing

For the first time in its history,
Germany won an individual gold
medal in a world championship
(World Equestrian Games included).
Michael Jung and La Biosthétique
Sam were unassailable, maintaining
their thirty-three dressage points
with an exemplary performance in
cross country and show jumping.

2011 FEI European Championships

dressage

Rotterdam, Netherlands
Great Britain created a sensation in the Grand Prix and the team medal rush. The British surpassed the record group score of the Dutch team (238,595 in the 2009 European Championship in Windsor) with a total of 238,678. To top it all off, in the Grand Prix Carl Hester earned a score of ten an amazing seven times in his first extended trot. The stallion Uthopia, a 16.2 hand (1.66 m) horse, was his mount for this performance. An entertaining detail about the duo: Hester acknowledges that, to minimize his size in the saddle, he shortened his stirrups as much as possible, and even had the tail of his coat shortened so that his legs could be seen.

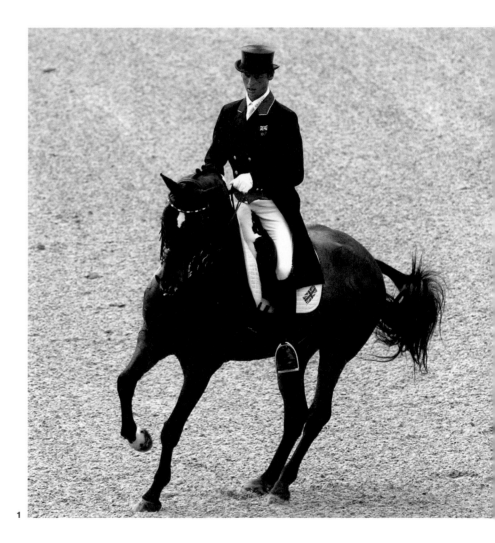

1

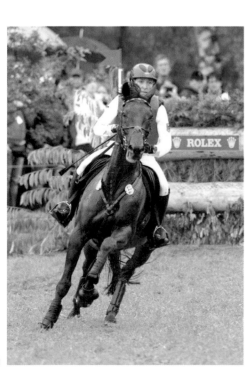

2

jumping

Madrid, Spain
The victory of the Swedish rider Rolf-Göran Bengtsson allowed him to hang on to the top world ranking for ten months. This performance also earned him the title of Best Swedish Athlete of the Year in 2011.

eventing

Luhmühlen, Germany
Ingrid Klimke took her place at the forefront of the competition from the first phase, and her fellow German team members took the next three places in the rankings. She remained in the lead after the cross country despite adverse course conditions caused by heavy rain and mud. But a daunting total of six poles knocked down during the jumping phase quashed any hopes of winning the individual medal.

1. C. Hester, silver medalist in both the Grand Prix Special and the Freestyle to Music, on Uthopia.

2. I. Klimke on FRH Butts Abbraxxas.

2012 Olympic Games, London

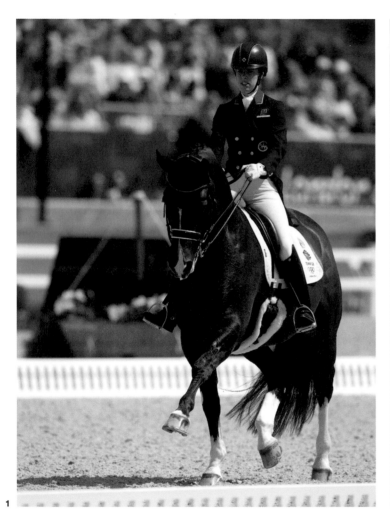

— dressage

Charlotte Dujardin was a revelation at these Olympic Games. After scarcely a year on the international circuit, she won the gold. Her first international appearance was in March 2011; the same applied to her partner in good fortune, Valegro. The Japanese rider Hiroshi Hoketsu, age seventy-one, participated in the Olympics for the third time in his career, following the Tokyo Games in 1964 when he was twenty-three, and the Beijing Olympics in 2008.

— jumping

The French rider Simon Delestre, riding Napoli du Ry, broke his right rein on the penultimate obstacle in the first round team medal competition. Having already received 4 penalties on the course, he was forced to make a volt, which was not counted but which cost him an additional two time penalties. This made a total of 6 penalties which, when added to the results of his compatriots, prevented France from continuing the competition for the medal.

— eventing

The Japanese have long been known for their devotion to eventing. In the London Games, there was widespread surprise when Yoshiaki Oiwa, who had dominated in dressage with Noonday de Condé, was eliminated during the cross-country phase. Kenki Sato, a fellow team member, was a Buddhist monk whose family is intrinsically linked to the art of horsemanship; he won the team and individual medals in the 2010 Asian Games. In London, Sato was also put to the test in the highly selective cross-country course and was eliminated.

1. C. Dujardin, gold medalist in dressage and individual and team eventing, on Valegro.

2. Japanese rider H. Hoketsu on Whisper.

3. S. Delestre on Napoli du Ry.

4. The Japanese equestrian and Buddhist monk K. Sato on Chippieh.

2013
FEI European Championships

1

— dressage

Herning, Denmark
Charlotte Dujardin beat her own
world record in the Grand Prix with a
total of 85.942 percent. Her previous
record (at London's Olympia Horse
Show in December 2012) was 84.447
percent. The spectators and judges
viewed a very eventful Grand Prix
Special. As if by design, the favorites
in the competition, Patrik Kittel,
Helen Langehanenberg, Charlotte
Dujardin, and Adelinde Cornelissen,
all made an error in their dressage
test, which resulted in the judges
ringing the bell.

— jumping

Herning, Denmark
Roger-Yves Bost's victory was
well deserved. In the five rounds,
he was the only rider to complete
clear rounds. "Bosty" ended the
competition with a total of
1.82 penalties (one time penalty
and 0.82 penalty from the Table C
speed competition).

— eventing

Malmö, Sweden
For the first time in twenty years,
Great Britain left the competition
without winning the team medal
in the European Championships.
In the cross-country course, Pippa
Funnell's horse ran out at Obstacle
22b, and Lucy Wiegersma fell when
her horse, Simon Porloe, caught
a leg over the boat on Obstacle 8.

2014
FEI World Equestrian Games, Normandy

— dressage

The World Equestrian Games pitted two great international dressage champions against each other: Isabell Werth for Germany and Charlotte Dujardin for Great Britain. In the first stage, the Grand Prix, Dujardin dominated the competition, riding Valegro, almost four points ahead of her rival. All the fans were counting on the Grand Prix Special to help the combative German contender to get her revenge. But to general disappointment Isabell Werth announced that her impressive mount Bella Rose was injured. The possibility of an individual medal evaporated. Bella Rose was the fourth serious competitor to withdraw from these World Games owing to injury. Totilas, Undercover, and Siro were also absent from the competition.

— jumping

The day before the jumping competition, the British rider Scott Brash, who had been a London Olympic team champion in 2012 and was among the favorites, fell victim to food poisoning from a suspect hamburger and was unable to start the competition in the best condition. Sleep-deprived and exhausted, Scott and his faithful Hello Sanctos committed a fault in the Table C speed competition.

— eventing

A few curious anecdotes slipped into the generally commendable record of these World Equestrian Games. For example, the crack rider Andrew Nicholson grabbed the New Zealand team vet by the lapel to order him away from his horse, believing that he had not given his horse sufficient care. Following this incident, Nicholson refused to represent his country in the 2015 competitions, which led his federation not to select him again. The multiple medal winner was notably absent from the Olympic team departing for Rio de Janeiro in the summer of 2016 and the one competing in Tryon for the 2018 FEI World Equestrian Games. Aside from this incident, the competition in Haras du Pin was hit hard by terrible weather conditions that forced the organizers to remove an entire section of the course in the interests of horse and rider safety. Just a single participant completed this extremely difficult course in the optimum time: New Zealand's Jonelle Price. Owing to her performance, she moved up from twenty-sixth place to fourth before the show-jumping phase. She maintained that ranking to the end, thanks to a clear round with her horse, Classic Moët, in the final phase of the competition.

2

1. S. Brash and Hello Sanctos.

2. S. Auffarth, world champion in individual and team eventing, on Opgun Louvo.

< 1

2015 FEI European Championships

— dressage

Aachen, Germany
The Totilas affair caused some upset during these championships. The horse, which had had a remarkable early career in the hands of Edward Gal, was ridden by Mathias Alexander Rath for Germany. He seemed to be lame and in poor physical condition. There was a rather large discrepancy in the marks, especially between French judge Jean-Michel Roudier and America's Anne Gribbons. A number of experts wondered why the bell had not rung for Totilas's elimination. The career of this magnificent horse thus ended on a bad note.

1

1. M. 1. M. A. Rath and Totilas.

2. M. Jung receiving his prize from Queen Elizabeth II.

3. Dutch riders on the top step of the team jumping podium.

— jumping

Aachen, Germany
A year after gaining his world title at the FEI World Equestrian Games in Normandy, with all the levelheadness for which he is known, Jeroen Dubbeldam was crowned European champion, riding SFN Zenith as before. He also won the gold team medal alongside his fellow countrymen Maikel van der Vleuten and Jur Vrieling.

— eventing

Blair Castle, United Kingdom
Germany became the European team champion with two riders on the individual podium. Not one of the German riders, whether team or individual, knocked down a pole in the show-jumping phase. Michael Jung took his third European title, riding three different horses, one of them the youngest in the competition, Fishertakinou, originally named Takinou d'Hulm.

2

3

2016
Olympic Games, Rio de Janeiro

1

These Games provided moments of incredible intensity. First there were the tears shed by Dutch rider Adelinde Cornelissen, silver medalist in the London Olympics, who abandoned the competition in the middle of the Grand Prix, even though everything appeared to be going smoothly. Bitten by an insect two days before the event, her horse, Jerich Parzival, experienced a swollen jaw and a fever that peaked at over 104° F (40° C).

Although everything had returned to normal, Adelinde decided to spare her faithful nineteen-year-old partner. More tears were to follow, though this time they were tears of joy: Charlotte Dujardin riding Valegro succeeded in repeating her achievement at the 2012 London Olympics, wining Olympic gold once again. These two athletes both decided to retire their mounts this year and to let them enjoy their well-earned rest.

1. A. Cornelissen on Parzival.

2. The victorious French eventing team: (left to right) T. Valette, A. Nicolas, K. F. Laghouag, M. Lemoine.

3. M. Jung, gold medalist in individual eventing, on La Biosthétique Sam.

There was an incredible gold-medal win for the French team, who had experienced disappointments and seemed completely devastated the day before the competition. Simon Delestre, the team's number one, was obliged to forfeit owing to the lameness of his horse, Ryan des Hayettes. He was replaced by his backup Philippe Rozier, riding Rahotep de Toscane. Two days before the first qualifying competitions, Flora de Maripossa, Pénélope Leprevost's mare, had colic. She nevertheless tried out in the qualifying competition and fell. Defying all these setbacks, the team remained stalwart and ended up winning the gold.

Michael Jung won his second individual Olympic title. He thus joined the Dutch Charles Pahud de Mortanges (1928 and 1932) and the New Zealander Mark Todd (1984 and 1988) in the very exclusive club of Olympic dual medalists.

2

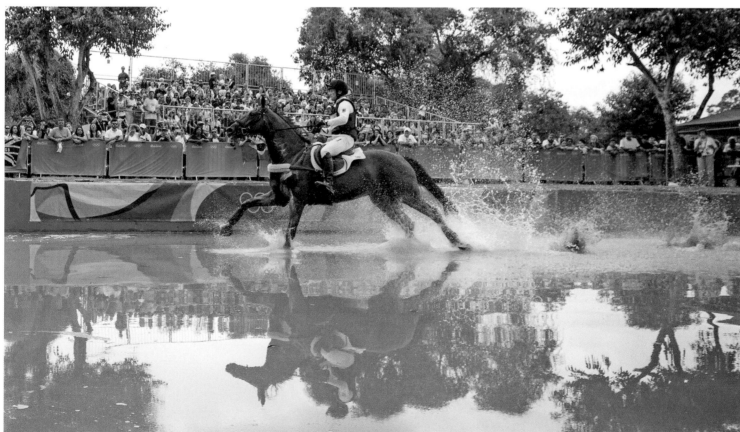

3

2018
FEI World Equestrian Games, Tryon NC

For the first time in the history of the World Equestrian Games, individual titles in all three disciplines were won by women.

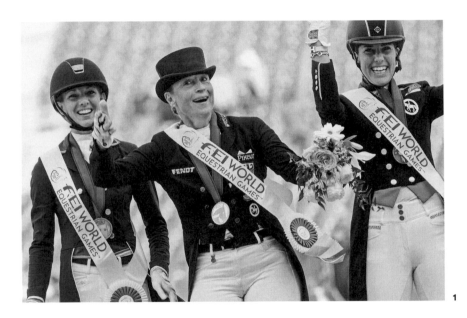

1

— dressage

For the dressage riders, these Games were complicated, to say the least. Hurricane Florence forced the organizers to cancel the Freestyle to Music. Normally, two individual titles and one team title are awarded, but the discipline's devotees were left unsatisfied. Isabell Werth, "the queen of dressage," dominated the competition in the Grand Prix Special and won a third individual world title and a fifth team title. She had some serious rivals to contend with: Sönke Rothenberger, who came in fourth, made a powerful impression, and the fresh partnership of Charlotte Dujardin and Mount St John Freestyle, nine years old, were tipped as fierce contenders when it came to the Freestyle.

— jumping

It was an unusual team competition. At the end of the two rounds, the US and Swedish teams were exactly tied on 20.59 penalties. A jump-off would be the tiebreaker: after a breathtaking, edge-of-the-seat round, the two teams were still even because they had lined up three clear rounds and one 4-penalty round each. The stopwatch was the deciding factor. Just over a second ahead of the Swedes, the Americans became the world champions. With the change in the rules for the individual competition, there was concern that the finals might be somewhat tepid without the final-four rotation of horses to decide the medals. And yet, what a final! The German rider Simone Blum, twenty-nine, became the second woman in history to win the title, mounted on DSP Alice. She thus followed in the footsteps of the Canadian rider Gail Greenough, who had paved the way in Cedar Valley in 1986.

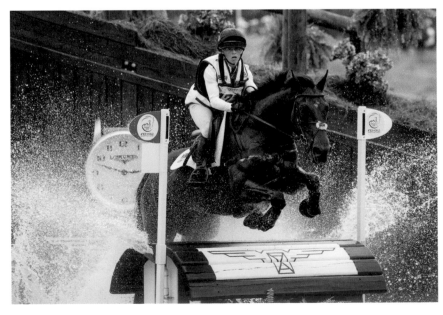

2

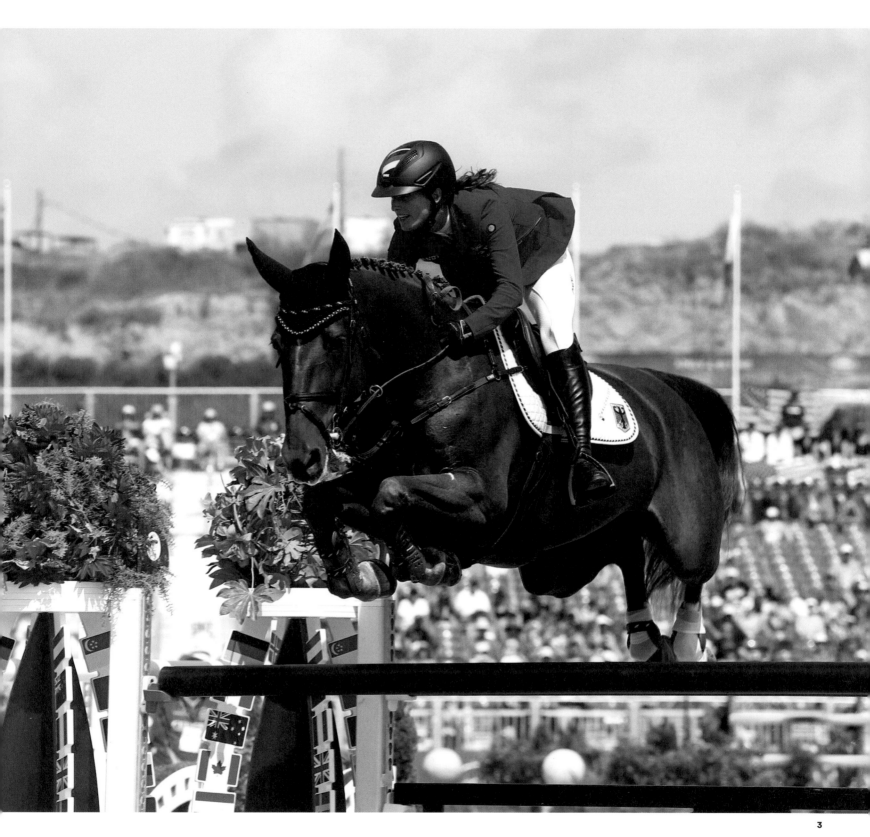

1. The dressage podium: (left to right) L. Graves, I. Werth, C. Dujardin.

2. R. Canter, gold medalist in individual and team eventing, on Allstar B.

3. S. Blum, gold medalist in individual and bronze medalist in team jumping, on DSP Alice.

— eventing

For the second time in history of the FEI World Equestrian Games, Japan lined up a full team at the beginning of the eventing competition. The score was incredible, with the Japanese team just missing out on a podium spot behind Great Britain (gold), Ireland (silver), and France (bronze). Japan outperformed major countries including Germany, New Zealand, and the USA.

Jeroen Dubbeldam

A brilliant rider, loyal to his country

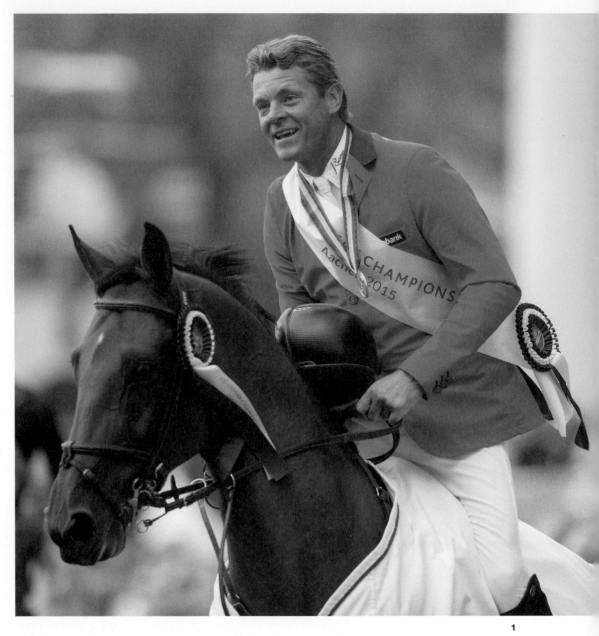

Some riders are skilled trainers as well as talented competitors, and Jeroen belongs to this selective group. He was born in 1973 in Zwolle, the Netherlands, and began learning to ride at a young age with his father, a horse dealer and riding school owner. When he was just thirteen, Jeroen decided to focus all his energy on excelling in riding; everything fell into place with his early international success in the junior competitions, followed by young rider competitions when he was sixteen. Willi Melliger, a leading name in Swiss equestrian sports, spotted Jeroen when he was in his last year of high school. Impressed by the boy's riding skills, he offered him a job in his stable. "I quit school and left immediately," recalls Jeroen. After gaining experience with Melliger, he moved on to the stables of the horse dealer Gerhard Etter, who owned Killarney, Jeroen's mount for the first individual gold medal of his career at the 1994 FEI European Jumping Championships for Young Riders in Millstreet.

After six and a half years in Switzerland, Jeroen returned home. "I went back to my father's stables, but after six years on my own it was hard to reacclimatize myself to family rules! So I moved an hour away from my parents, to Twente, where I rented five stalls." Now twenty-three, this intrepid young man caught the eye of businessman Bennie Holtkamp, who purchased De Sjiem for him. The horse had a stormy temperament, but after an initially challenging training period Jeroen managed to tame him. They achieved great things together, including an Olympic title at the Sydney Games of 2000. "I'm not sure that he was the best horse of my career, but he was certainly the most important. He got me into the limelight. Thanks to that horse, I reached top competitive levels and built what I have today. He allowed me to make my dreams a reality."

Two years later, at the 2002 FEI World Equestrian Games in Jérez de la Frontera, the pair fell just short of victory. "De Sjiem was a very unusual horse; you had to understand him completely to make the best use of him in the final four. We were in a good position, but I failed in the final. I had to do a loop because I didn't have enough space. My hopes were dashed. I was frustrated for a long time. That's why I was so happy when I was able to get my revenge in Caen."

De Sjiem's retirement in 2005 didn't mark the end of Jeroen's career. He participated in the Netherlands' victory in the Aachen FEI World Equestrian Games in 2006 and the FEI European Championships in Mannheim in 2007, riding Up and Down. After a four-year hiatus, he returned, riding Simon for a third place in the FEI World Cup Finals in Leipzig. But Jeroen's Olympic aspirations were crushed when Simon was sold to the American rider Beezie Madden. Jeroen perfected another high-level horse, training Utascha SFN, who was sold in 2013 to Qatar. On Zenith SFN, Jeroen was back on top, winning individual gold at the FEI World Equestrian Games in Normandy in 2014, and at the FEI European Championships in Aachen in 2015. "From a technical point of view, my proudest victory was in the Aachen Championships. Everything went perfectly."

Since his seventh place in the 2016 Rio de Janeiro Games with Zenith, Jeroen has retired for the time being. "If I came across the right horse, of course I'd give the championships another try." He now devotes his time to the stable that he manages with his girlfriend, Annelies Vorsselmans. Their staff of seven works to train the next generation of champions and prepare horses for sale. He is also involved in coaching talented young riders, including the Porter brothers, Lucas and Wilson, and the Japanese rider Karen Polle.

In his leisure time, the multiple medalist enjoys spending time with his family. He watches Twente Football Club soccer matches with his sons Rick, nineteen, and Chris, sixteen. He also accompanies his fifteen-year-old daughter Nina to competitions. "She loves to ride. We'll see where it leads. If she wants to make a career of it, I'll support her." A modest man, Jeroen nevertheless admits that he is "pleased and proud" with his record of achievements. He dreams of a prosperous future for his business. "I hope the stables will be running well ten years from now. I don't think I'll still be riding myself then, but I hope Annelies will be competing at a high level and that our horse-selling activities will be thriving."

"When he believes in a horse, he builds it up and creates an ideal partnership in which the whole is greater than the sum of the parts."

— Rob Ehrens

1. At the FEI European Championships in Aachen with Zenith, 2015.

2. At the Sydney Olympics with De Sjiem, 2000.

Rob Ehrens, Dutch chef d'équipe, gives his account of Dubbeldam and his career

Rob Ehrens believes that Jeroen has a unique talent. "Since the early years of his career, his greatest resource has been his ability to focus on the horse and bring out its best qualities. When he believes in a horse, he builds it up and creates an ideal partnership in which the whole is greater than the sum of the parts. When you watch Zenith, for example, you don't say the horse is incredible—it's Jeroen who's incredible!"

The chef d'équipe hails the brilliant rider's devotion to the Dutch team at a time when the profit motive has become a driving force. "He's one of the few riders who puts his country before everything else. He's never run after money in competitions. His favorite events are the Nations Cups and championships. He always tries to spare his horses and avoids overtaxing them. He saves their energy and strength for these competitions."

The two men have a genuinely trusting relationship, and they know they can count on one another. "Between the World Equestrian Games in Normandy and his amazing performance the following year in Aachen, Jeroen almost disappeared from the international stage, but when he told me he was ready, I took him at his word and I didn't have a moment's hesitation selecting him."

Rob is unstinting in his praise of Jeroen's ability to surpass previous achievements. "He performs even better when he's under pressure. Whatever the circumstances, Jeroen remains calm and levelheaded, focused on what he has to do. He knows how to be present when he needs to be, and that's what makes him one of the true champions of our sport."

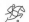
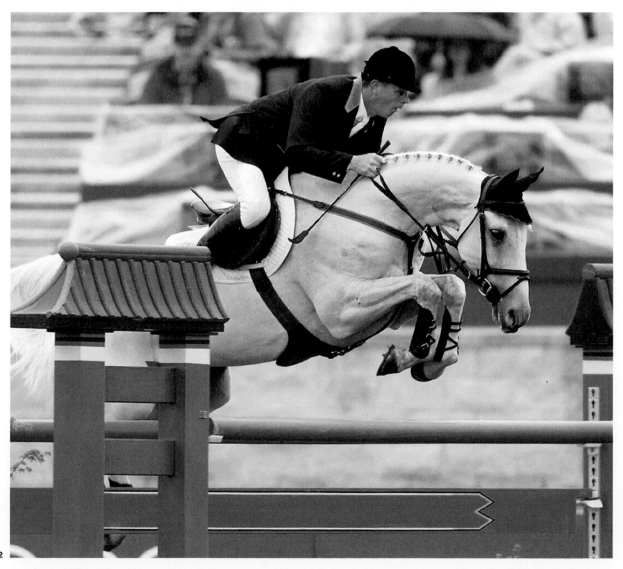

2

Michael Jung

A family success story

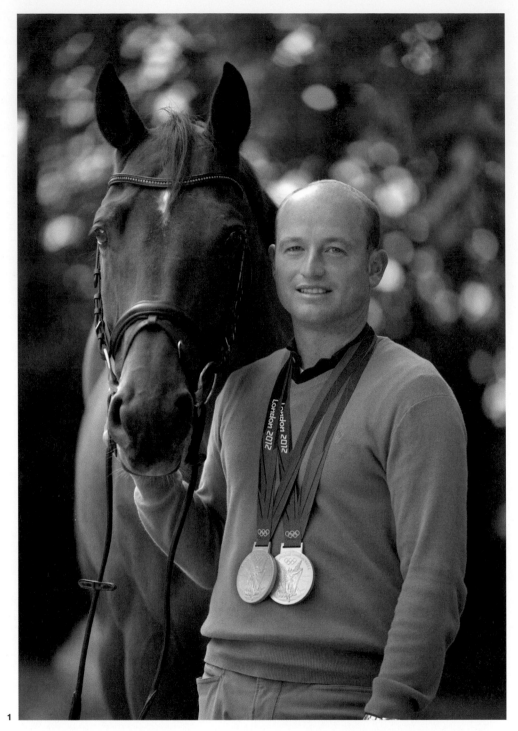

There is no doubt that Michael Jung has incredible talent, but his success is also due to the team, largely made up of his family, who support him. Day after day, they are busy in pursuit of his victories, and it works perfectly.

Michael was born on July 31, 1982, in Bad Soden am Taunus, near Frankfurt, Germany. Soon after, the Jungs moved to the family's riding school at Horb-Altheim in Baden-Württemberg, where Michael was introduced to the joys of riding, along with his brother Philip, two years his senior. "I was in the saddle even before I learned to walk—I never knew life without horses. First I played with my brother and the pony I was given for my fourth birthday, and then finally I started riding at my father's stables." Michael began competing in both show jumping and dressage at the age of eight, but had to wait until he was fourteen before he could enter eventing competitions on Dawai: his father, Joachim, who is also a distinguished champion in dressage and eventing, believed it was important to start with a solid foundation. There followed many successes in junior competitions with Maricos, including a German championship title and a team gold medal at the 1999 European Championships in Vittel.

At the same time, Michael was pursuing his schoolwork but dreaming of the day when he could devote his life exclusively to his horses. "I didn't know if I was good enough to reach the top level. At that time I just wanted to ride all day and be with the horses—I wasn't aiming for medals."

At aged eighteen, the long-awaited day finally arrived when he could work with horses full time. To increase his chances of success, every winter Michael worked on perfecting his technique with different riders. Gradually, this genius developed his string of horses at his parents' stables, gaining the trust of owners, amassing victories, and thereby gaining his first sponsor, who helped his development in this extremely expensive sport.

It was in 2003 that the first signs of Michael's career potential on the international scene really emerged, when Michael won the title of FEI European Eventing Champion in the young riders category. Unfortunately, he did not manage to replicate this victory in the senior circuit, as his horses fell victim to repeated health problems. It was not until 2005 and the arrival at his stables of La Biosthétique Sam, then aged six, that his career began to take off in earnest.

Together, Michael and Sam began to enjoy more and more success, and, after an initial bronze medal at the 2009 FEI European Championships at Fontainebleau, the eventing titles started to stack up: they became European champions, world

champions, and double individual Olympic champions—also gaining an Olympic team title in 2012, the pair achieving the double that year. After a decade at the top of his game, in September 2018 Michael announced the retirement of his protégé, now eighteen years old and considered by some as the best eventing horse ever. "Sam is the horse of my life. We managed to create a real partnership. At first we didn't think it would be so good, but every year, after working over the winter, he showed huge progress, and that didn't ever stop until the end. The world championship win at Lexington will remain in our hearts, as it was our first major championship. London was also very special, then Rio too…. Being on the podium and realizing that I had repeated the feat, four

2

Hans spotted the prodigy from the beginning, the young rider circuit, noticing in particular his tenacity. "You could give him any horse and he always managed to perform well, even if they weren't modern types of horses. Every year he has tried to be better with different horses. His style has evolved enormously over the years. At first, he was doing all he could to be efficient and fast in the crosscountry, but sometimes it looked a bit crude. Working with Marcus Ehning on his jumping from a young age has greatly changed his riding style and technique. Michael has learned a lot and now rides with very light, fluid, and subtle actions."

The team surrounding Michael plays a big role in his development and success. "There are better teammates than Michael! His success is due to the team he created around him with his family and friends. He's basically with them all day long, in a very protective bubble where he can flourish. Michael is not a bad teammate, but he tends to do things in his own way. If you ask him for help, then he gives it willingly, but he won't do it spontaneously."

Hans recognizes Michael's commitment to his career and to success. Nothing matters except his horses. "Michael is a winner. For him, there are no options other than victory. He does everything to be better than the others. He has always been like that, even when he was very young. Today, everything has become more professional around him, but he still has the same desire. He has confidence in his system. He doesn't enter young horses into competition until he is sure they are capable of winning, or at least making it to the podium."

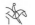

Career Highlights

Eventing

2009

Individual bronze at the FEI European Championships in Fontainebleau with La Biosthétique Sam

2010

Individual gold at the FEI World Equestrian Games in Lexington with La Biosthétique Sam

2011

Individual and team gold at the FEI European Championships in Luhmühlen with La Biosthétique Sam

2012

Individual and team gold at the Olympic Games in London with La Biosthétique Sam

2013

Individual and team gold at the FEI European Championships in Malmö with Halunke FBW

2014

Individual silver and team gold at the FEI World Equestrian Games in Normandy with Halunke FBW

2015

Individual and team gold at the FEI European Championships in at Blair Castle with Fischertakinou

2016

Individual gold and team silver at the Olympic Games in Rio de Janeiro with La Biosthétique Sam

2017

Individual silver at the FEI European Championships in Strzegom with Fischerrocana FST

years later, with the same horse, was an absolutely incredible feeling."

But Sam is not the only horse to partner Michael's successes: Halunke FBW, Fischertakinou, and Fischerrocana FST have also played their part in the German rider's history of triumphs. "I like training up young horses, it's always a new challenge. You have to think about it and adapt the training to each horse with its own solutions. It's an incredible feeling when you take a first jump with a horse and a few years later you end up in a major championship with him."

In addition to his eventing career, Michael also competes in show jumping at the highest level, responding to the family stable's policy of adapting to each horse and working it toward its chosen discipline. "If one day I end up with more horses for top-level show jumping, then of course I will try for the championships. In fact, it's a bit of a dream to be a part of the German show-jumping team."

Today, running a stable of thirty-five horses employing fifteen people, and still surrounded by his family, the multiple champion still refuses to rest on his laurels, working single-mindedly toward his next victories, devoting all his time to his sport. At thirty-six, Michael does not seem in a hurry to start a family, and intends to continue to dedicate himself to his passion: riding every day and winning.

1. and **3.** At the London Olympics on La Biosthétique Sam, 2012

2. Cheered on by his mother in the FEI European Championships, 2011.

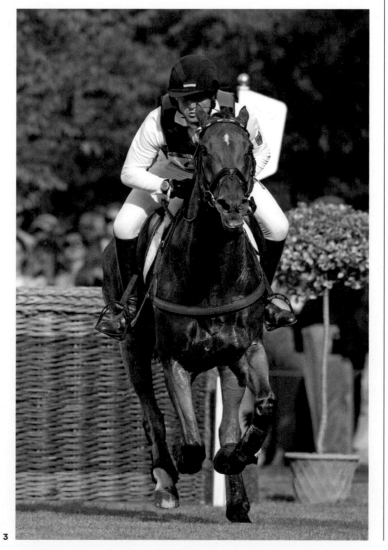

3

Charlotte Dujardin

Working ever harder to achieve success

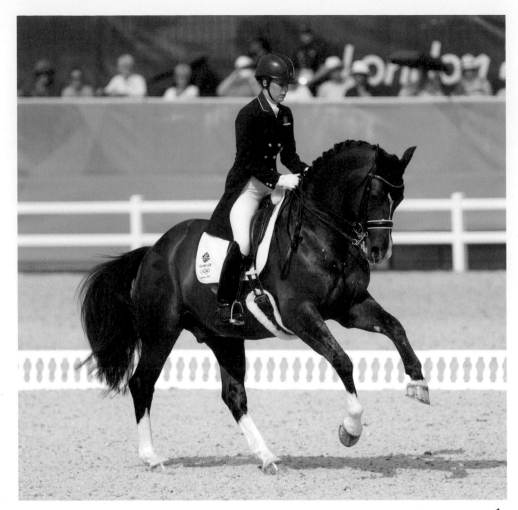

1

As a multiple world-record holder, Charlotte Dujardin has reigned supreme in international dressage for half a decade.

Born on July 13, 1985, in Enfield, Greater London, Charlotte grew up the daughter of a mother who was passionate about show jumping and a businessman father who was terrified of horses. In the saddle from the age of two, Charlotte's equestrian career began alongside her sister, riding Shetland ponies. "We had fun racing around the fields of neighboring farmers who often yelled at us because we were destroying their crops!"

Soon, Charlotte began entering show-jumping competitions, riding various ponies that her mother had bought as foals and trained up to sell and finance her passion. The young rider was supervised by a dressage trainer who pushed her, unsuccessfully, toward this discipline. One day, Charlotte came across a DVD by Carl Hester explaining his method, and the spark was lit. "I was completely seduced and became obsessed with dressage." She then joined the stables belonging to dressage star Debbie Thomas, who taught her the basics. "At that time I had an Irish thoroughbred for show jumping. I started to teach him some of the dressage movements I saw on Carl's videos and which I tried to understand and reproduce in the saddle. Everything I did was just following my instincts."

At sixteen, Charlotte decided to leave school and devote herself to her passion. She joined the team led by international judge and rider Judy Harvey, where she spent four years, reaching young riders level. While taking part in a selection training course at the beginning of 2007 with her horse Fernandez, she was spotted by Carl Hester who, when he had ridden her horse and realized the incredible work she had already done on the six-year-old, encouraged the

judges to select her. Carl's encouragement filled her with enthusiasm once more, and Charlotte took a few lessons with him, hoping to join his team, despite it being full. She then struck lucky and won a place for ten days, initially replacing a groom who was on vacation. Eleven years later, Charlotte is still there.

The adventure began in earnest when Charlotte was entrusted with the training of Valegro, a powerful four-year-old KWPN horse. She learned to cope with the gelding, who was bursting with talent but also endowed with a Herculean strength that was difficult to control. The pair enjoyed numerous successes in Young Horse competitions, and if Carl was watching his protégés and secretly thinking that a bright future awaited them, he had to wait until 2010 and their first international event, on the occasion of the Sunshine Tour in Spain, to see the pair's talent take off. There was no doubt: they would be champions.

It was the beginning of a triumphant journey. Winning team gold and coming sixth in the individual competition at the 2011 FEI European Championships in Rotterdam, the pair went on to win more titles the following year and clinched their selection for the London Olympics. Charlotte and Valegro were crowned double Olympic champions, in both the individual and the team competitions. In the 2014

World Equestrian Games, nothing stood in their way: they remained undefeated for almost two years, and had won the 2013 European title in Herning along the way. "With Valegro, we had an incredible connection right from the start. We did everything together and we constantly helped each other to get there. At first we had no idea what we were doing. It was an incredible feeling of mutual trust and respect."

The pair were temporarily brought back to earth at the CDIO 5★ in Aachen in July 2014, where they found the heat hard to endure and incurred an unusual number of faults in the Grand Prix. They finished sixth but still won the Freestyle to Music. The scare was short-lived, however: a month later, in Caen, Charlotte and her horse were crowned world champions. This victory put them back in the running as they enjoyed two unbeaten years until their final event together—the Rio de Janeiro Games in 2016, which they won hands down with a new world record thanks to a score of 93.857 percent in the Freestyle to Music. "I wanted people to remember Valegro as one of the best horses in the world." This was the bay's last lap, and he left to enjoy a well-deserved retirement. He now lives happily alongside Charlotte and her team.

Since then, Charlotte has had to train another high-level mount and prove that,

while her success was partly due to the exceptional Valegro, it was also the result of her incredible riding skills and determination. Having found her perfect partner in Mount St. John Freestyle, Charlotte entered the 2018 FEI World Equestrian Games at Tryon, where she brought home the bronze medal in the Grand Prix Special. Charlotte describes the event: "At these Games she [Mount St. John Freestyle] proved she was one of the greats. She had never competed against such opponents, in front of such demanding judges, and she demonstrated the extent of her talents. Bringing back an individual medal was undreamed of."

Charlotte believes in the future, because she has an incredible string of horses at her stables that should allow her to choose between five horses for the 2020 Tokyo Games, all of whom she has patiently trained with Carl Hester and Alan Davies, his groom. "I do not have the money to buy Grand Prix horses, but even if I had the option I would not want to do it. The relationship that is created when you start with a young horse is wonderful: you get to know them, we adapt to each other, we understand their personality, and this makes everything easier in the future."

Hungry for victory, Charlotte will surely see her name in gold letters on many more trophies.

Trainer, teammate, and friend Carl Hester on Charlotte

From the start, Carl was struck by Charlotte's incredible appetite for learning. "She was prepared to work very hard. Nothing was a problem: she wanted to ride all my horses without exception and I loved this dedication. She wanted to ride and to make it. She was extremely quick to learn and understand things. She had an incredible feeling for the Grand Prix movements and everything you explained to her was immediately understood."

Over ten years of collaboration, Carl has seen his protégée open up, develop, and become a legend. He witnessed her blossoming behind the scenes as well. "It hasn't always been easy working with Charlotte. At first we had a lot of fun, and then when she achieved success she became a bit more difficult. Suddenly everyone wanted a piece of her; she was growing up and had trouble dealing with it. Now we have found a balance and I find it very inspiring to see her every day. Riding can be a very lonely sport where you are working alone with the horses, so Charlotte and I are amazingly lucky to be together."

Carl doesn't deny it: sometimes the road has been difficult, especially when the fear of disappointment is involved. "Things have become complicated over time with the pressure. At first it was just an amazing pleasure because she was very young and Valegro was, too. Nobody had any particular expectations. When we went to London for the Games, I couldn't sleep, while Charlotte just loved and enjoyed what was going on. By contrast, at the Rio Games, Valegro's final event, the pressure was full-on. We wanted the story to end as it had started, and we didn't want just anything to happen to taint Valegro's career. I had never seen Charlotte nervous before that day."

For Carl, Charlotte's success is the result of her unwavering commitment. "She is incredibly ambitious and totally devoted to her horses. She aims high and manages to deal with what that produces. She always puts her horses before everything else and that's what makes her such a champion. She gives everything possible to succeed, by calculating all the possible parameters, her fitness, her hours on horseback, etc. Fortunately she has a boyfriend who supports her and understands her daily life, so she does have a separate life. Mine is to go on vacation and have fun, but that's not what she likes!

1. At the London Olympics with Valegro, 2012.

2. Two-time gold medalist in the London Olympics with Valegro, 2012.

3. At the FEI European Championships in Aachen, 2015.

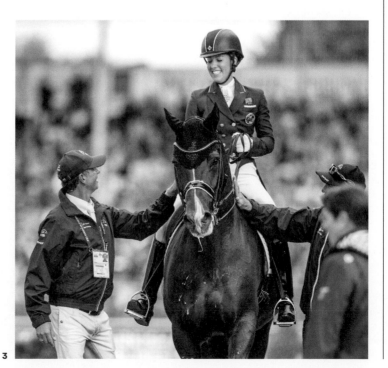

Career Highlights

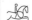

Dressage

2011
Team gold at the FEI European Championships in Rotterdam with Valegro

2012
Individual and team gold at the London Olympics with Valegro

2013
Individual gold at the Grand Prix Special and Freestyle to Music and team bronze at the FEI European Championships in Herning with Valegro

2014
Individual gold at the Grand Prix Special and Freestyle to Music and team silver at the FEI World Equestrian Games in Normandy with Valegro

2015
Individual gold at the Grand Prix Special and Freestyle to Music and team silver at the FEI European Championships in Aachen with Valegro

2016
Individual gold and team silver at the Rio de Janeiro Olympics with Valegro

2018
Individual bronze at the Grand Prix Special and team bronze at the FEI World Equestrian Games in Tryon with Mount St. John Freestyle

Big Star

Born to win

Big Star was born on June 1, 2003, in Schoorl in the Netherlands, under the watchful eye of his breeder, Cees Klaver. The foal, who was originally named What A Quick Star K, was sired by the renowned Quick Star; his grandsire on his mother's side was Nimmerdor. The handsome bay enjoyed grazing in Dutch pastures for two years before beginning his training for equestrian sports. Although his breeder believed strongly in the young horse's potential, the KWPN stud-book selection committee was less impressed. Big Star behaved perfectly during training sessions, but he was overwhelmed by the surroundings on the big day. He delivered a below-average performance, and the judges disqualified him.

Alan Waldman, the highly regarded US horse dealer, nevertheless decided to buy a half-share in Big Star, believing the young horse had strong potential. Big Star made his debut in show jumping at the age of three and demonstrated his qualities: respect, perfect bascule and front legs movement, and extraordinary focus despite his energy and young age.

The horse began his brilliant career entering competitions at the age of four, ridden by Mischa Everse. She was the wife of Mario Everse, Big Star's co-owner, who had bought out the breeder's initial share. The couple refined Big Star's skills in competitions for young KWPN stallions in the Netherlands. Alan Waldman rode the champion steed himself for several months, and the horse continued to dazzle audiences with his amazing jumping abilities.

Big Star's talents made a powerful impression on Laura Kraut, the partner of experienced rider Nick Skelton. Nick recalls: "Laura was with the American team in the Netherlands, training for the 2008 Beijing Olympics. They went to watch a little competition nearby, and they saw Big Star jump just as they arrived. Laura ran to ask whether the horse was for sale, and Alan Waldman, who had no doubts about Big Star's abilities, replied that he wouldn't consider letting him go except to a top-notch rider." Nick arrived in the Netherlands two days later, tried Big Star, fell under his spell, and arranged to have the horse bought by his sponsors, Gary and Beverley Widdowson. "When you see a horse jump like that, you just have to buy him! He already demonstrated scope, quickness, and respect, and he was athletic and powerful."

The stallion launched his career at the very highest level, performing in 5★ events in the summer of 2010. He burst onto center stage the following winter in Wellington by winning his first 5 ft. 3 in. (1.6 m) Grand Prix when he was just eight years old. His trajectory was clear. Nick explains, "I never had any doubts about his potential. We just had to help him mature and wait until we could hone his performance to the highest level."

They didn't have to wait long. In 2012, this extraordinary horse was selected for the London Olympics. Big Star committed a fault during the final round by knocking down a bar, and fell from first to fifth place in the individual competition. The team nevertheless shared in Great Britain's collective win. "If we'd been in a format like the European or World Championships, he would have won because he was the horse that performed the most clear rounds."

Big Star and Nick continued to shine, performing at the top level and carrying off the very challenging Grand Prix of the CSIO 5★ in Aachen. But they experienced a serious setback when Big Star was injured in August 2013. After almost ten months of convalescence, the superstar steed returned quietly to center stage, but he was injured again in July 2014. In the autumn of 2015 spectators saw him tackle competitions with heights of 4 ft. 5 in. (1.35 m), and he made his grand comeback in May 2016. Thirteen rounds later and without a Grand Prix, he took off for the Rio Olympics. Although Great Britain performed poorly in the team competition, Nick and Big Star attained the summit of their career and claimed the gold. "He faulted once at Rio in the first three rounds because he wasn't really focusing on the height. Once he understood, he was absolutely fantastic, and he flew through the finals!"

The road continued to Barcelona for the final of the Nations Cup, where the team participated in the British triumph. Then it was on to the CSI 4★-W in Toronto where they ended up third in the World Cup. Following an injury to Big Star at the end of the year, Nick decided to retire the horse, and he hung up his own boots as well. "His owners would have liked us to continue, but after all Big Star had done for us, he'd earned his retirement. I thought it was best for both of us to bow out at the high point of our careers."

1. Nick Skelton and Big Star make their farewell appearance in Windsor, May 14, 2017.

2. At the London Olympics, 2012.

> # "He was simply an incredible horse. In my entire career in equestrian sports, I don't think I've ever seen a better one."
>
> — Nick Skelton

Rider Nick Skelton reminisces

Nick was Big Star's partner in all his triumphs, and he hails the horse's extraordinary talents. Skelton has ridden numerous top performers, but Big Star stands apart. "He never had any deficiencies or issues that required hard work on my part. He was naturally gifted and always responsive to anything I'd ask him to do. He was simply an incredible horse. In my entire career in equestrian sports, I don't think I've ever seen a better one. In my opinion, his greatest qualities were his temperament and the fact that he really loved to jump. He had all the scope and responsiveness you could ever wish for."

Having proved himself in sporting competitions, Big Star is now a sought-after stud, and some of his offspring are already show-jumping winners. "Big Star is as great as ever; he's back at home, we ride him every day, and he seems healthy and content. You'll see him in the paddock and sometimes even in parades at competitions."

The powerful bay is imposing in the jumping arena, but he's an unassuming presence in the stables. "I don't think he's aware that he's a stallion! He's very calm and never makes any commotion. He can even travel along with mares. He's a very undemanding horse, and it's easy to look after him."

Career Highlights

Jumping

2012
Team gold in the London Olympics with Nick Skelton

2016
Individual gold in the Rio de Janeiro Olympics with Nick Skelton

2

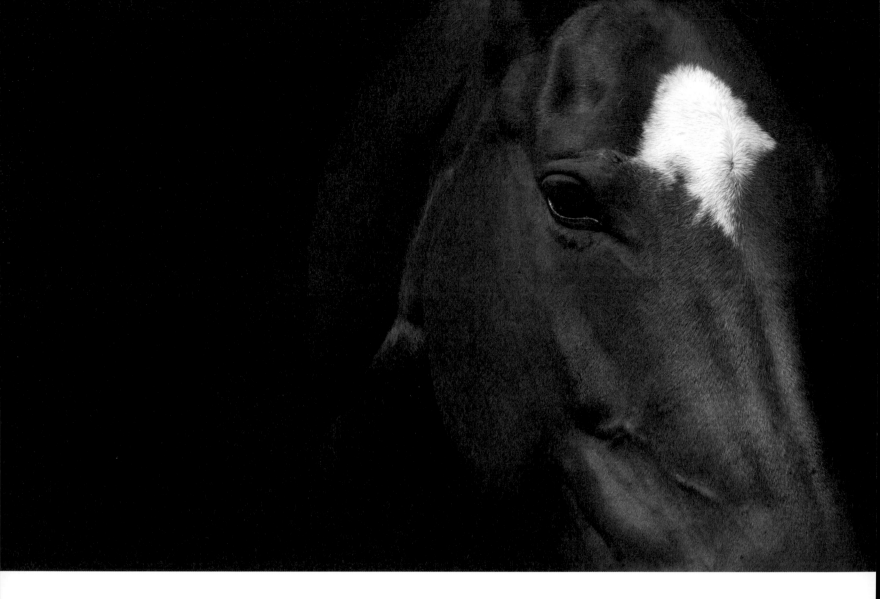

Conclusion

Equestrian sports have given us more than one hundred years of incredible moments, and we believe there are many more to come, each as rich as the last.

At a time when many private individual and team competitions are springing up and attracting more and more participants, equestrian sports find themselves at a turning point. If the remarkable figures who appear in these pages are anything to go by, the riders of tomorrow will continue to give their all to uphold their standards, pick up medals, wear their national colours with pride, and give us many unforgettable memories, thrilling spectators in the grandstands and those following events on television. Riders, grooms, trainers, and owners will join in the celebrations as winners mount the podium, and horses will demonstrate their talents, legendary courage, and fighting spirit.

Whether it is at the next Olympic Games, the European Championships, the World Equestrian Games, or the World Cup Final, you may be sure of witnessing a sport at its very peak.

Glossary

Bandages Cloth bandages wrapped around horses' legs for protection in the stall or during transport. The pressure encourages circulation in the extremities, and thus the recovery of stressed tendons.

Barrel Section of the horse's body on the lower side of the chest, behind the forelegs, where the girth, a device that secures the saddle to the horse's back, is passed.

Change of lead The horse's movement as it transitions from a gallop on the right foot to a gallop on the left foot, or vice-versa, during the propulsion phase. This movement is observed in dressage exercises, but is also routinely taught to horses in other disciplines.

Coffin Cross-country obstacle consisting of a sequence of three jumps spaced between one and four strides apart and always including a ditch as the middle component. The horse jumps a set of rails, canters downhill to a ditch, then continues uphill to another jump.

Course designer The mastermind of the competition. The course designer is responsible for constructing the course and the layout of the various obstacles, based on the categories and level of the competition.

Cross country One of the three eventing competitions, the other two being dressage and show jumping. During this test, horses and riders confront fixed obstacles of various types, following a rugged, natural course that runs up- and downhill.

Ditch Cross-country course obstacle in the form of a trench, over which the competitor has to jump.

Downhill fence Cross-country obstacle involving a sharply descending gradient, also known as a "downhill bank." If it is taken in the opposite direction, it is referred to as an "uphill bank." A sequence of two or three such obstacles is called a "step fence."

Dressage letters Letters placed around the rectangular dressage arena on all four sides and in the middle, used to give riders and judges reference points for the execution and judging of dressage figures as they are performed.

Dressage rectangle Enclosure within which the horses and riders perform their dressage routines.

Eventing An equestrian competition composed of three tests dressage, cross country, and show jumping.

Final of four, or **horse rotation** Competition that was formerly the final event of the World Championships, and later the World Equestrian Games, during which the four top riders competed by changing their horses one after another. The winner was the rider with the lowest score after riding the four horses.

Forward seat A riding position introduced by the Italian rider Federico Caprilli in the late nineteenth century. The rider is balanced on his feet, suspended over, rather than seated on, the saddle.

Grand Prix Dressage competition consisting of mandatory figures, used to determine the team rankings in major international championships.

Grand Prix Special A competition at the same level as the Grand Prix, but longer and more focused. In large international championships, it allows the ranking of the best pairs in the Grand Prix, so that only the top competitors are retained for the Musical Freestyle. It is a competition of the highest level, which brings out the horse's perfect lightness, characterized by the total absence of resistance and the complete development of collection and impulsion, which includes all the school paces and all the fundamental movements.

Half-pass Dressage figure in which the horse moves forward and sideways, crossing its legs. The outside foreleg slightly precedes the hind leg, and the neck and head are turned in the direction of movement.

Hunting competition Opening competition in championships (including the World Cup, the Olympic Games, and the World Equestrian Games) in which the knockdowns are calculated by adding seconds to the total time. One knockdown represents 4 seconds. The ranking is then determined according to the final total time scores.

Jump-off Speed-jumping contest that is used to rank riders who have executed a clear round on the initial course. The barrage usually has a reduced number of obstacles that must be jumped

without error within a limited time period.

Knock down Penalty incurred when a show-jumping pair pushes over the bar of an obstacle, costing 4 points. For the penalty to be applied, the obstacle's overall structure must be affected. If a lower bar falls but neither the height nor the width of the obstacle is affected, no penalty is incurred.

Kür *see* **Musical Freestyle**

Lateral work Exercising the horse on both sides to work the horse's hind- and/or forequarters, requiring that the animal's shoulders and haunches move independently.

Military The discipline that formed the basis for contemporary eventing. It was an endurance test involving the jumping of obstacles and was used by the military to test horses.

Musical Freestyle or **Kür** Dressage competition in which the teams compete in a routine they have created themselves set to a musical score. Certain figures are mandatory and must be included in the rider's performance.

Paddock The field in which horses are allowed to run free, or in which riders walk and warm up their horses before competitions.

Passage Dressage figure involving a short, collected, elevated, cadenced trot. It is distinguished by a brief but clear suspension between the moment the horse raises its two diagonally opposing legs and the moment it sets them down.

Piaffe Dressage movement consisting of a highly diagonalized, elevated trot during which the horse shifts from one diagonal to the other.

Side saddle A riding position reserved for women, who were mounted with both legs on the same side of the horse. A special saddle was required.

Rappel In the discipline of dressage, this test was replaced by the Grand Prix Special in the 1977 European Championships. This test was formerly used to determine the top competitors following the Grand Prix for awarding individual medals.

Reconnaissance Period before the show-jumping and cross-country contests during which riders can explore

the course on foot to determine their trajectories, counting the strides between obstacles and inspecting them up close.

Refusal The inability of a horse-and-rider team to jump an obstacle during cross-country or show-jumping events. They have the option of returning and trying again. Depending on the discipline, riders are eliminated after a specified number of refusals.

Reservist Rider chosen as backup for those selected for international championship teams. These riders participate if, and only if, other team members encounter a problem (an injury, for example) that prevents them from competing.

Roads and tracks Phases A and C of the endurance race, originally part of the eventing discipline. The first of these two endurance contests warmed up the horses in preparation for Phase B, and the second provided a recovery time following the steeplechase in preparation for Phase D, the cross-country course. This format was abandoned in the 2004 Olympic Games in Athens.

Steeplechase The steeplechase formed Phase B, the second of the four phases that made up the endurance test in eventing. It included jumping course obstacles, usually in a hippodrome, within a specified time limit and at a very high speed that exceeded 1,968 ft. per minute (600 meters a minute). This format was abandoned in the 2004 Olympic Games in Athens.

Veterinary visit Examination of a horse by a certified veterinarian in the context of international contests or championships. An assessment of the horse's physical condition is carried out both before and after it has competed in order to ensure its health. If a veterinarian rejects a horse during a preliminary visit, the animal is not permitted to compete. If a horse is rejected following the competition, it is eliminated.

Water crossing Cross-country obstacle, often combined with fences of varying degrees of difficulty. The depth of the water is now limited to 1 ft. (30 cm).

Acknowledgments

This book would not have been possible without the assistance, support, and collaboration of the many individuals who made important personal contributions to this anthology.

We owe a debt of thanks to all those who agreed to be interviewed for the book, generously giving their time: Christopher Bartle, Ludger Beerbaum, Jeroen Dubbeldam, Charlotte Dujardin, Marie-Christine Duroy de Laurière, Rob Ehrens, Joe Fargis, Beatriz Ferrer-Salat, William Fox-Pitt, Alain Francqueville, Mary Gordon-Watson, Lucinda Green, Anky van Grunsven, Carl Hester, Susanna D'Inzeo, Jokeleien Jansen, Michael Jung, Ingrid Klimke, Jos Kumps, Kathy Kusner, Janou Lefebvre, Virginia Leng, Luis Lucio, Dieter Ludwig, Harry Meade, Hanz Mezler, Warwick Morgan, Margit Otto-Crépin, Rodrigo Pessoa, Jonelle Price, Marcel Rozier, Ulla Salzgeber, Vanessa Schockemöhle, Nick Skelton, Susanne Strübel, Christine Stückelberger, Blyth Tait, Mark Todd, Isabell Werth, John Whitaker, Jörn Winkler, and Madeleine Winter-Schulze. They helped conjure up portraits of many extraordinary characters in the equestrian world, recounting their remarkable stories.

Many thanks to our publisher, Flammarion, and especially to Gaëlle Lassée and Emmanuelle Rolland, for their faith in this project. Thanks also to the Fédération Équestre Internationale, particularly Ingmar De Vos, Sabrina Ibáñez, and Olivia Robinson, who worked closely with us on this adventure and allowed us full access to their archives.

We would also like to thank our families for their unfailing support:

Marie: Catherine and Bruno, my parents; François and Astrid, my brother and sister; and my partner, Lorenzo.

Benoit: Marcel and Anne-Marie, my parents; my sister, Sophie; my husband, François; and Nina, Paul, and Lily.

Finally, we are very grateful to all our friends and family for their assistance and encouragement.

Photographic Credits